EUROPEAN PAINTINGS in the Museum of Fine Arts, Boston

EUROPEAN PAINTINGS
in the
Museum of Fine Arts, Boston

An Illustrated Summary Catalogue

by Alexandra R. Murphy

Museum of Fine Arts, Boston

Copyright 1985 by
Museum of Fine Arts
Boston, Massachusetts 02115
Library of Congress Catalogue
Card No. 84-60020
ISBN 0-87846-230-9
Printed in the U.S.A. by
Acme Printing Co.
Medford, Massachusetts
Bound by Mueller Trade Bindery
Middletown, Connecticut
Designed by Carl Zahn

Cover illustration:
Giovanni Paolo Pannini, Italian
(Roman), 1691-1765
Picture Gallery with Views of Modern Rome
1975.805. Charles Potter Kling Fund

Contents

Preface

The Museum of Fine Arts, which had been incorporated in 1870, first opened to the public on July 4, 1876. On view in the new Copley Square building were some thirty-one European pictures, which together with the sixteen American works, made up the Museum's whole collection of paintings. However, the early visitors were surely not disappointed for the works on view included French, Dutch, English, German, and Italian paintings highlighted by the two great Bouchers, *Halt at the Spring* and *Returning from Market*, which had been the gifts of the Parker family in 1871 and the young institution's first two acquisitions in the European field. From the very beginning, Trustees and staff had set out with great ambition to collect and to exhibit the finest possible examples of European art from every school and nation; this fully-illustrated summary catalogue of the more than sixteen hundred paintings now in the collection bears witness to their success.

As one can see from this catalogue, European paintings were collected steadily and energetically from the beginning, but it was only in 1902 that the newly-appointed Director, Edward Robinson, appointed John Briggs Potter as Keeper of Paintings. There was as yet no Department of Paintings, but rather a tripartite "Division of Western Art", the other two sections being Textiles and "Other Collections". However, in 1911 M. Jean Guiffrey took a three-year leave from his post at the Louvre to become the first Curator of Paintings in Boston. In 1915 the paintings collection was given its due with the opening of the new Evans Wing on the Fenway side of the Museum. These beautiful skylit galleries, designed by Guy Lowell for the exhibition of paintings, were the gift of Mrs. Robert Dawson Evans in memory of her husband, Robert Dawson Evans (1843-1909), a merchant and collector and a Trustee of the Museum. These galleries have served the collection and the community wonderfully well over the years. The galleries underwent some renovation and modification in 1960-63, and in 1986 — through the generosity of another generation of Bostonians — they will have finally been totally renovated with new materials, improved natural lighting, and modern air-conditioning and humidity control to provide the happiest conditions both for works of art and their viewers.

It has often been noted that this collection is very much a reflection of Boston's taste. It was built up not through the occasional princely gift, but through continuous collecting — Boston families' year-in and year-out love of paintings: Bostonians collected great works of art, enjoyed them in their homes, and — with gratifying regularity — generously gave them to the Museum of Fine Arts for the enjoyment of their fellow-citizens. The exhibition catalogue of 1984, *The Great Boston Collectors,* made clear the superb contributions of some of these collectors including Robert Treat Paine II, John Taylor Spaulding, and the families of Juliana Cheney Edwards and Quincy Adams Shaw. Equally important have been the donors of gallery space, especially Mrs. Evans, and those who provided purchase funds, for the collection results from long-term collaboration of donors with curators. The Museum has made the most of such funds to buy great works which were not available in local collections: thus one thinks of 1936-37 which saw the purchase of two masterpieces, Gauguin's *D'où venons-nous?* and Renoir's *Bal à Bougival,* or of 1958 alone when Director Perry T. Rathbone, who also served for a number of years as Acting Curator of Paintings, encouraged the purchase of the great Rosso *Dead Christ with Angels* together with Munch's *The Voice* and Picasso's *Standing Figure*.

The present catalogue follows the *Catalogue of Paintings,* 1921, prepared by Jean Guiffrey and John Briggs Potter, and which included both European and American works including watercolors, which were catalogued as "paintings" until 1945. Philip Hendy, the Museum's second Curator of Paintings, who subsequently became director of the National Gallery, London, prepared a volume of *Selected Oil and Tempera Paintings,* in 1932, and W.G. Constable, Curator from 1937 to 1957, in 1955 published a *Summary Catalogue of European Paintings.*

This catalogue relies both on the work of Mr. Constable and contributions of nearly every staff member in the Department of Paintings over the past thirty years. Thus we especially acknowledge Angelica Rudenstine for her work on Italian pictures during the 1960s, as well as Thomas Maytham, Madeleine Caviness, Laura Luckey, Lucretia Giese, and Sandra Emerson Helmer. This project got underway in earnest when John Walsh became Mrs. Russell W. Baker Curator of Paintings in 1977, and it has been directed by Theodore E. Stebbins, Jr., John Moors Cabot Curator of American Paintings during the past two years.

Coordinator of this work and primary author throughout has been Alexandra R. Murphy, Assistant Curator of Paintings, her primary collaborator has been Priscilla Myrick Diamond, who coordinated photographs, indices, and much other material with great skill and dedication. We have been given valued assistance in this project by Scott Schaefer, Helen Hall, Cynthia Schneider, Matthew Rutenberg, Frances Preston, Larry Nichols, Margaret W. Kimball, Penelope Peters, Pamela England and Sam Heath, and by Elizabeth Jones and Alain Goldrach, Paintings Conservators, Jean Woodward, Brigitte Smith, and James Barter.

We are especially grateful to colleagues outside the Museum who have generously helped: Katherine Baetjer, Everett Fahy, Pierre Rosenberg, Jacques Foucart, Sydney Freedberg, Mina Gregori, Ian Kennedy, Simon Levie, Robert Manning, Erich Schleier, Seymour Slive, John Spike, Elena Tsypkin, Ellis Waterhouse, Eric Young and Henri Zerner who have generously responded to all manner of inquiries. Mrs. W.G. Constable and Mrs. Haven Parker have contributed funds for the scholarly research in memory of W.G. Constable; and Mrs. Parker, counseling from her own experience with the *Summary Catalogue* of 1955, has been the most truly understanding and encouraging of supporters. The National Endowment for the Arts, a federal agency, has generously supported the publication costs of the catalogue.

JAN FONTEIN, *Director*

Notes to the Reader

European Paintings in the Museum of Fine Arts includes all paintings and pastels belonging to the Museum as of December 31, 1984, by artists born in and/or working primarily in Europe (including Russia and European-oriented sections of the Middle East) from the twelfth through the twentieth centuries.

Artists are listed under their proper names with a cross-reference for particularly common sobriquets. Anonymous artists appear under the appropriate national school, and artists identified only by a distinctive work or characteristic are listed under the rubric "Master of" Artists for whom a proper name has been created or assumed come under that name, with the name placed in quotation marks if there is reason to question its accuracy. In instances of joint authorship, the work is listed under the artist believed to have had major responsibility for it, with a cross-reference under the name of the second artist.

Our use of qualifications in attribution conforms to the following rules:

Artist's name:
used whenever we believe, with reasonable certainty, that the painting was executed by the artist named.

Attributed to:
used when we believe the painting is probably the work of the artist named but we wish to indicate a measure of doubt, usually because the present condition of the picture precludes certainty; or because the named artists' *oeuvre* is insufficiently defined to permit certainty of attribution.

Workshop of:
or
Studio of:
used for works believed to have been executed by an assistant or pupil under the direction of the named artist. This distinction does not preclude the possibility that the work is in part by the artist named.

Pupil of:
used for works believed to have been executed under the direction of the artist named but entirely by the hand of a student.

Follower of:
used for paintings dependent upon the work of the named artist and executed within the general sphere of his influence.

Style of:
used for works dependent upon the work of the named artist but executed at a substantial remove, and generally implying a later period.

Imitator of:
used for paintings dependent upon the work of the named artist and believed to have been intended to deceive.

Copy after:
used for copies after identifiable works of art by a named artist. Copies are listed under the original artist and the copyists are identified and cross-referenced when known.

The years given for each artist are birth and death dates except when qualified with the word "active," in which case they represent the artist's known period of productivity (the second date may be identified specifically as the date of death).

In order to provide a geographic and temporal frame of reference for works of uncertain attribution, we have followed the practice of introducing the named artist's nationality and dates if these are not available in an entry immediately preceding.

Accession numbers at the Museum of Fine Arts reflect the date of acquisition. In the case of objects acquired during the first century of the Museum's history, only the final two digits are used to identify the year: 70.176 means the 176th object acquired by the Museum in 1870; while for the Museum's second century, beginning in 1970, the full four-digit date is used: 1970.176. A small number of paintings on long-term loan to the Museum have been included in the catalogue, and are identified by an italicized date following the decimal point (e.g. 1333.*12*).

Titles are given in English unless a particular irony or comment was intended by the artist's use of a foreign language. Whenever an artist's own title for a work can be

identified, it has been taken as the principal title, sometimes relegating well-known popular titles to alternate status. In a small number of cases, untranslatable titles or aphorisms have been preserved as alternatives. Information about sitters, the origin of a work of art, or the source for a copy has often been included following a title as explanatory information.

The identification of media for most paintings has been based on visual examination; when, however, an unusual tempera medium is designated or a mixture of media is described, the source is either the artist himself or scientific testing. Panel in all cases specifies a simple wood support, and wood fabrications are identified as plywood, masonite, or pressed wood, as appropriate. In cases of compound support, the phrase "mounted on" indicates, in our best judgment, a secondary, probably later, addition. A multilayered original support is designated with the repetition of an unqualified "on".

Dimensions, height preceding width, are those of the support, unless design and support differ by more than two centimeters in either direction. When the difference exceeds two centimeters and both design and support appear to be unaltered, two sets of dimensions are provided. For paintings on canvas, the use of design dimensions alone generally implies relining; for panel paintings, however, the use of design dimensions only may indicate either a panel altered at a later date or a panel whose dimensions are masked by a permanent frame. Measurements were taken in centimeters and translated to inches. For essentially rectangular pictures, the dimensions are normally from the lower left-hand corner of the face of the support/design; for shaped paintings, dimensions reflect greatest height and greatest width, unless otherwise described. For altarpieces, overall measurements refer to the greatest dimensions when framed and fully opened.

Inscriptions, signatures, dates, and studio stamps have been typeset to reflect as fully as possible the orthography of the original in capitalization, punctuation, and spelling.

Ellipsis marks have been used for elements that are no longer legible but can be supposed to have existed; letters, words, or digits within brackets are subject to variable reading. Signatures believed to be false additions are so described. From the reverse of a picture, only those inscriptions and signatures believed to be by the artist himself have been transcribed. Signatures and inscriptions no longer visible because of relining or transfer have been recorded without qualification if photographic documentation exists, or with the qualifier "said to have borne" when only tradition provides the reading.

The Museum of Fine Arts honors the wishes of its donors with regard to credit lines: thus, for example, paintings bequeathed to the Museum by several members of the Edwards Family over a period of years as well as those purchased over the years with funds given by the family are all credited to the "Edwards Collection" as the donors wished.

Catalogue

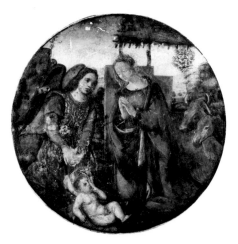

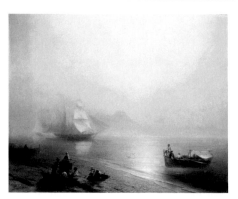

Afro
see
Basaldella, Afro

Agnolo di Domenico di Donnino, Attributed to
Italian (Florentine), 1466-after 1515
06.2416
Virgin and Angel Adoring the Infant Christ
Tempera transferred from panel to canvas
84.5 cm. (33¼ in.) diameter
Original panel said to have borne inscription:
Hoc opus pinxit Agnolo di Donnino
Bequest of Mrs. Martin Brimmer

Aivazovsky, Ivan Konstantinovich
Russian, 1817-1900
1981.509
*Fishermen and their Families on the Shore of the
Bay of Naples*
Oil on canvas
133.5 x 171.0 cm. (52½ x 67⅜ in.)
Lower left: Aivasovsky / 1873
Gift of Katharine H. Putnam, by exchange

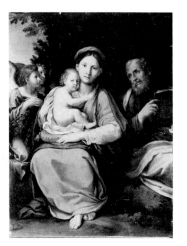

Albani, Francesco
Italian (Bolognese), 1578-1660
1983.250
The Holy Family with Angels
Oil on copper
36.2 x 27.4 cm. (14¼ x 10¾ in.)
*Gift of Mr. and Mrs. John W. Haverty in Memory of
John Cardinal Wright and Henry H. and Zoe Oliver
Sherman Fund*

Albers, Josef
German (worked in United States),
1888-1976
66.23
Variant: Three Reds around Blue
Oil on masonite
57.2 x 75.6 cm. (22½ x 29¾ in.)
Lower right: A 48
Gift of Mr. and Mrs. Herbert M. Agoos

Aligny, Claude Théodore Félix Caruelle d'
French, 1798-1871
49.1730
Italian Hills
Oil on paper mounted on canvas
41.2 x 68.8 cm. (16¼ x 27⅛ in.)
Lower left: TCA (monogram)
Seth K. Sweetser Fund

Alma-Tadema, Sir Lawrence
Dutch (worked in England), 1836-1912
17.3239
Tibullus at Delia's House (Opus XXXVIII)
Oil on panel
43.5 x 64.6 cm. (17⅛ x 25⅜ in.)
Lower right, on chair: L Alma Tadema
Robert Dawson Evans Collection

Alma-Tadema, Sir Lawrence
Dutch (worked in England), 1836-1912
Res. 39.94
Promise of Spring (Opus CCCIII)
Oil on panel
38.0 x 22.5 cm. (15 x 8⅞ in.)
Center right: L Alma Tadema / Op CCCIII
Bequest of Frances M. Baker

Alma-Tadema, Sir Lawrence
Dutch (worked in England), 1836-1912
41.117
Woman and Flowers (Opus LIX)
Oil on panel
49.8 x 37.2 cm. (19⅝ x 14⅝ in.)
Center left, on table edge: L. ALMA-TADEMA · 1868
Gift of Edward Jackson Holmes

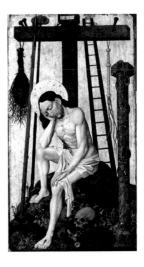

Alma-Tadema, Sir Lawrence, Attributed to
Dutch (worked in England), 1836-1912
65.434
Figure Studies (recto and verso)
Oil on panel
20.6 x 15.3 cm. (8⅛ x 6 in.)
Bequest of Mrs. Edward Jackson Holmes

Alsatian, second half, 15th century
56.262
Christ as the Man of Sorrows
Tempera on panel
69.2 x 39.4 cm. (27¼ x 15½ in.)
Gift in Memory of W. G. Russell Allen by his Friends

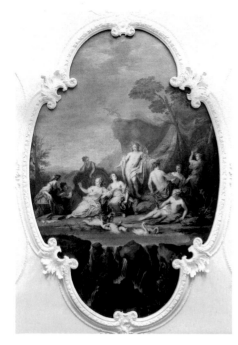

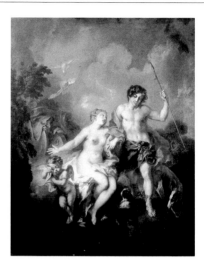

Amigoni, Jacopo
Italian (Venetian), 1675-1752
 with additions attributed to
Brerewood, Francis
British, about 1694-1781

27.462a
Apollo and the Muses
Oil on canvas, extended
Original design: 125.7 x 190.5 cm. (49½ x 75 in.)
Present design: 275.6 x 190.5 cm. (108½ x 75 in.)
Gift of Eben Howard Gay

Amigoni, Follower of
Res. 21.79
Venus and Adonis
Oil on canvas
126.0 x 100.5 cm. (49⅝ x 39⅝ in.)
William Sturgis Bigelow Collection

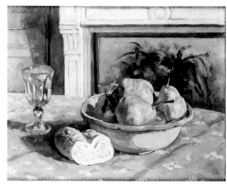

Amigoni, Follower of
Res. 21.80
Pan and Syrinx
Oil on canvas
126.5 x 100.5 cm. (49¾ x 39⅝ in.)
William Sturgis Bigelow Collection

André, Albert
French, 1869-1954

38.777
Petunias
Gouache on paperboard mounted on panel
48.8 x 65.5 cm. (19¼ x 25¾ in.)
Lower right: Al. André 1893
Anonymous Gift

André, Albert
French, 1869-1954

38.778
Bowl of Pears, Bread, and a Glass on a Table
Oil on canvas
43.0 x 55.5 cm. (16⅞ x 21⅞ in.)
Upper left: Albert André
Anonymous Gift

André, Albert
French, 1869-1954

48.517
Woman at Tea
Oil on paper mounted on canvas
50.8 x 59.4 cm. (20 x 23⅜ in.)
Upper right: Alb. André
Bequest of John T. Spaulding

Andrea del Sarto (Andrea d'Agnolo, called
Andrea del Sarto), Copy after
Italian (Florentine), 1488-1530
 attributed to
Puligo, Domenico
Italian (Florentine), 1492-1527

17.3226
Virgin and Child (fragment; after a painting in
the Wallace Collection, London)
Oil on canvas

60.4 x 65.5 cm. (23¾ x 25¾ in.)
Robert Dawson Evans Collection

Andrea del Sarto, Copy after

25.103
*Virgin and Child with the Infant Saint John the
Baptist* (free copy after the Barbadori *Holy Family,*
now lost)
Oil on canvas
Design: 117.0 x 90.0 cm. (46 x 35⅜ in.)
*Bequest of Susan Greene Dexter in Memory of Charles
and Martha Babcock Amory*

Andrieu, Pierre
 see
Delacroix, Copy after

Fra Angelico (Guido di Piero, later Fra Giovanni
da Fiesole, called Fra Angelico), Workshop of
Italian (Florentine), 1395/1400-1455

14.416
*Virgin and Child with Angels, Saints Peter, Paul,
and George, and a Donor*
Tempera on panel
Panel: 29.7 x 29.1 cm. (11¾ x 11½ in.)
Design: 25.2 x 24.8 cm. (9⅞ x 9¾ in.)
Gift of Mrs. W. Scott Fitz

Fra Angelico, Copy after
by
Nardi, Pietro
Italian (Florentine), active 1860

01.6216
The Coronation of the Virgin (after a painting in
the Galleria degli Uffizi, Florence)
Tempera on panel
Design: 115.6 x 113.0 cm. (45½ x 44½ in.)
Reverse: Pietro Nardi di Firenze / Fece nell' anno
1859-60
The Gardner Brewer Collection

Fra Angelico, Copy after
Res. 26.35
The Adoration of the Kings and *the Annunciation*
(after a painting in the Museo di San Marco,
Florence)
Tempera on panel
42.4 x 25.1 cm. (16¾ x 9⅞ in.)
William Sturgis Bigelow Collection

Fra Angelico, Follower of
see
Master of the Sherman Predella

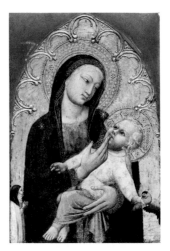

Antigna, Jean Pierre Alexandre, Copy after
French, 1817-1878

Res. 14.24
Scene during the War of the Vendée
Oil on canvas
142.3 x 190.5 cm. (56 x 75 in.)
Gift of Mrs. F. W. Towle

Antonio di Arcangelo (called Antonio del
Ceraiolo)
Italian (Florentine), active 1520-1538
68.786
*Virgin and Child with the Young Saint John the
Baptist*
Oil on panel
87.9 cm. (34⅝ in.) diameter
Gift of Mr. and Mrs. Ogilvie Comstock

Antonio Veneziano
Italian (Venetian), active 1369-1388
84.293
Virgin and Child
Tempera on panel
56.0 x 37.4 cm. (22 x 14¾ in.)
Gift of Mrs. C. B. Raymond

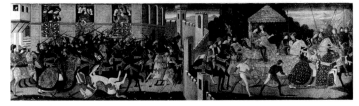

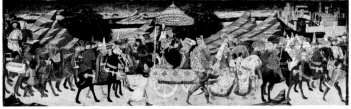

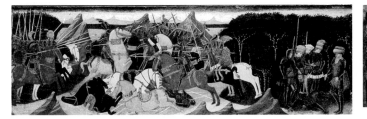

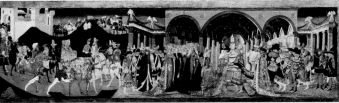

Apollonio di Giovanni di Tomaso
Italian (Florentine), 1415/17-1465
 and
Marco del Buono Giamberti
Italian (Florentine), 1402-1489

06.2441a
Tournament Honoring Aeneas [reassembled cassone; for end panels, see Italian (Florentine), second half, 15th century]

Tempera on panel
38.0 x 140.0 cm. (15 x 55⅛ in.)
Bequest of Mrs. Martin Brimmer

15.910
Battle of Pharsalus (cassone panel)
Tempera on panel
41.0 x 131.0 cm. (16 x 51½ in.)
Francis Bartlett Fund

23.252
Journey of the Queen of Sheba (cassone panel)
Tempera on panel
41.1 x 134.5 cm. (16⅛ x 53 in.)
Herbert James Pratt Fund

30.495
Meeting of Solomon and the Queen of Sheba (cassone panel)
Tempera on panel
52.5 x 185.5 cm. (20⅝ x 73 in.)
Bequest of Mrs. Harriet J. Bradbury

Apollonio di Giovanni di Tomaso,
Attributed to
Italian (Florentine), 1415/17-1465
 and
Marco del Buono Giamberti, Attributed to
Italian (Florentine), 1402-1489

18.319
Triumphal Procession (The Return of Pazzino dei Pazzi?) (cassone panel)
Tempera on panel
48.6 x 170.5 cm. (19⅛ x 67⅛ in.)
Horace Wayland Wadleigh Fund

Appel, Karel
Dutch, 1921-

61.198
Willem Sandberg
Oil on canvas
130.2 x 81.0 cm. (51¼ x 31⅞ in.)
Lower right: K. Appel '56
Tompkins Collection

Arapoff, Paul Alexis
Russian (worked in United States), 1904-1948
52.473
Flowers with a Picture of the Resurrection of Christ
Oil on canvas
91.0 x 76.0 cm. (35¾ x 29⅞ in.)
Lower right: ARAPOFF
Gift of the Division of Education

Arikha, Avigdor
Rumanian/Israeli (works in France) 1929-
66.209
Haute Rouge I
Oil on canvas
146.0 x 88.9 cm. (57½ x 35 in.)
Lower left: ARIKHA
Gift of Mr. and Mrs. Samuel Glaser

Armenian or Turkish, 1806
23.161
Scenes from the Life of Christ, with Saints and Symbols of the Four Evangelists
Oil on canvas
54.5 x 94.9 cm. (21½ x 37⅜ in.)
Center left: 1806
Gift of Frank Gair Macomber

Arthois, Jacques d'
Flemish, 1613-1686
84.249
Road through a Forest
Oil on canvas
124.5 x 176.0 cm. (49 x 69¼ in.)
Lower right, on rock: Jacques d Arthois
Gift of Mrs. Francis Brooks

Austrian (Danube School), first half, 16th century
49.396
Saint Matthias (recto) and *Saint Margaret* (verso)
Oil on panel
Overall: 42.2 x 28.7 cm. (16⅝ x 11¼ in.)
Design: 33.7 x 20.3 cm. (13¼ x 8 in.) and 33.8 x 20.3 cm. (13¼ x 8 in.)
M. Theresa B. Hopkins Fund

Austrian (Danube School), first half, 16th century
49.395
Saint Dorothy (recto) and *Saint James the Great*
(verso)
Oil on panel
Overall: 42.2 x 29.2 cm. (16⅝ x 11½ in.)
Design: 33.3 x 20.0 cm. (13⅛ x 7⅞ in.) and
33.5 x 20.3 cm. (13⅛ x 8. in.)
M. Theresa B. Hopkins Fund

Austrian (Tyrolese), first quarter, 15th century
44.77
Coronation of the Virgin with the Holy Trinity
Tempera and oil on panel
76.5 x 46.5 cm. (30⅛ x 18¼ in.)
*Painting Department Special Fund and Samuel
Putnam Avery Fund*

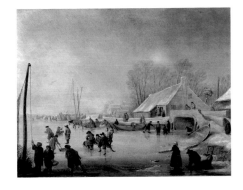

Austrian (?), mid-18th century
07.759
Two Cherubs
Oil on panel
27.0 x 23.5 cm. (10½ x 9¼ in.)
Denman Waldo Ross Collection

Avercamp, Barent
Dutch, 1612/13-1679
60.982
Skating on a Frozen River
Oil on panel
33.8 x 45.0 cm. (13¼ x 17¾ in.)
Falsely signed, lower right: HA (monogram)
Gift of Mr. and Mrs. Edward A. Taft

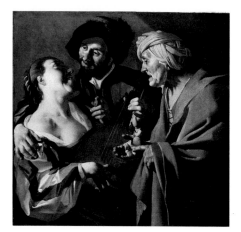

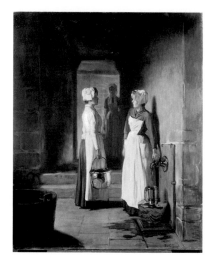

Baburen, Dirck van
Dutch, 1590/95-1624
50.2721
The Procuress
Oil on canvas
101.5 x 107.6 cm. (40 x 42⅜ in.)
Lower left, on base of lute: TBaburen f 16[...]
(T and B joined)
M. Theresa B. Hopkins Fund

Baertling, Olle
Swedish, 1911-
1970.251
VIO 1960
Oil on canvas
97.2 x 198.1 cm. (38¼ x 78 in.)
Gift of Dr. Teddy Brunius

Bail, Joseph
French, 1862-1921
23.465
At the Fountain
Oil on canvas
73.7 x 59.8 cm. (29 x 23½ in.)
Lower right: Bail Joseph
Bequest of Ernest Wadsworth Longfellow

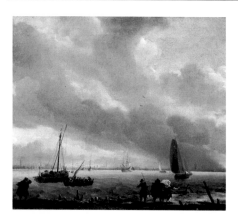

Bakhuysen, Ludolf
Dutch, 1631-1708
49.1708
View across the River Y toward Amsterdam
Oil on canvas
42.1 x 49.5 cm. (16⅝ x 19½ in.)
Lower right: L B[...]K[...]
Ernest Wadsworth Longfellow Fund

Bargue, Charles
French, about 1825-1883
03.601
Turkish Sentinel
Oil on panel
28.0 x 21.0 cm. (11 x 8¼ in.)
Lower right, on wall: BARGVE / 77
Bequest of Susan Cornelia Warren

Barland, Adam
British, active 1843-1863
Res. 15.4
Storm on the Coast of Scotland
Oil on canvas
30.3 x 55.7 cm. (11⅞ x 21⅞ in.)
Lower right: Adam Barland. 1859
Gift of George A. Goddard

"Barna da Siena"
Italian (Sienese), active mid-14th century

15.1145
The Mystical Marriage of Saint Catherine
Tempera on panel
Panel: 138.9 x 111.0 cm. (54⅝ x 43¾ in.)
Design: 134.8 x 107.1 cm. (53⅛ x 42⅛ in.)
Above lower register: Arico di Neri Arighetti
fece fare questa tavola (modern)
Sarah Wyman Whitman Fund

Barnaba da Modena
Italian (Modenese), active 1361-1383

15.951
Virgin and Child
Tempera on panel
Panel: 100.3 x 62.8 cm. (39½ x 24¾ in.)
Design: 88.6 x 59.7 cm. (34⅞ x 23½ in.)
Gift of Mrs. W. Scott Fitz

Barret, George
British, 1728/32-1784

Res. 24.24
Lake with Mountains and Ruined Castle
Oil on canvas
102.3 x 127.7 cm. (40¼ x 50¼ in.)
Gift of the Children of William Sohier

Bartolomeo Corradini (later Fra Carnevale;
previously styled Master of the Barberini Panels)
Italian (School of the Marches), active 1445-died
1484

37.108
Presentation of the Virgin in the Temple
Oil and tempera on panel
146.5 x 96.5 cm. (57⅝ x 38 in.)
Charles Potter Kling Fund

Bartolomeo Veneto, Workshop of
Italian (Venetian), active 1502-died 1546

65.435
Saint Catherine of Alexandria
Oil on panel
38.6 x 34.6 cm. (15¼ x 13⅝ in.)
Bequest of Mrs. Edward Jackson Holmes

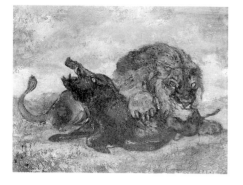

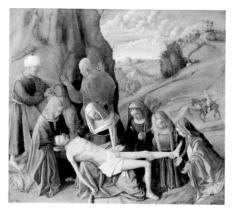

Barye, Antoine Louis
French, 1795-1875
26.774
Lion and Boar
Oil on canvas
18.6 x 24.5 cm. (7⅜ x 9⅝ in.)
Stamped, lower right: BARYE
Seal on reverse: VENTE BARYE
William Sturgis Bigelow Collection

Basaiti, Marco
Italian (Venetian), active 1496-1530
90.201
The Lamentation over the Dead Christ
Oil on panel
57.1 x 65.5 cm. (22½ x 25¾ in.)
Gift of Edward Perry Warren

Basaldella, Afro
Italian, 1912-1976
59.1004
Night Watchman
Oil on canvas
120.0 x 80.0 cm. (47¼ x 31½ in.)
Lower right: afro. 1955.
Gift of Mr. and Mrs. Joseph Pulitzer, Jr.

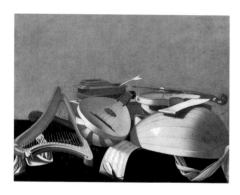

Baschenis, Evaristo
Italian (Bergamese), 1617-1677
64.1947
Musical Instruments
Oil on canvas
72.5 x 98.0 cm. (28½ x 38⅝ in.)
Charles Potter Kling Fund

Bassano, Jacopo, Attributed to
Italian (Venetian), 1510-1592
21.2285
Portrait of a Man
Oil on canvas
81.3 x 65.0 cm. (32 x 25⅝ in.)
*Gift of Ernest Wadsworth Longfellow, Alice M.
Longfellow, and Mrs. Annie A. Longfellow Thorp*

Bassano, Jacopo
Italian (Venetian), 1510-1592
and
Bassano, Francesco
Italian (Venetian), 1549-1592
01.6
The Mocking of Christ
Oil on canvas
188.5 x 135.2 cm. (74¼ x 53¼ in.)
Anonymous Gift

Bayes, Walter John
British, 1869-1956

Res. 32.6
Interior of a Cinema (study for *Oratio Obliqua*)
Oil on canvas
42.7 x 32.5 cm. (16¾ x 12¾ in.)
Tompkins Collection

Beaumont, Hugues de
French, 1874-1947

24.23
Terrace of the Palace of Versailles under Snow
Oil on canvas
43.0 x 58.7 cm. (16⅞ x 23⅛ in.)
Lower right: Hugues de Beaumont
Gift of Colonel Michael Friedsam

Beccafumi, Domenico (Domenico di Giacomo di Pace), Copy after
Italian (Sienese), 1486-1551

50.861
Saint Dominic and the Burning of the Heretical Books
Oil on canvas
26.1 x 37.5 cm. (10¼ x 14¾ in.) (inclusive of irregular painted border)
Charles Potter Kling Fund

Beccafumi, Copy after

50.862
The Martyrdom of Saint Sigismond and his Family
Oil on canvas
26.0 x 37.5 cm. (10¼ x 14¾ in.) (inclusive of irregular painted border)
Charles Potter Kling Fund

Beckmann, Hannes
German (worked in United States), 1909-1977

65.503
Neither-Nor
Oil on masonite
76.4 x 76.4 cm. (30⅛ x 30⅛ in.)
Lower left: h. b. 61
A. Shuman Collection

Beckmann, Max
German, 1884-1950

58.24
The Tempest
Oil on paperboard mounted on plywood
179.4 x 66.0 cm. (70⅝ x 26 in.)
Lower right: BecKman
Gift of Mrs. Max Beckmann

Beckmann, Max
German, 1884-1950

67.984
Still Life with Three Skulls
Oil on canvas
55.2 x 89.5 cm. (21¾ x 35¼ in.)
Lower right: beckmann / A 45.
Gift of Mrs. Culver Orswell

Beechey, Sir William
British, 1753-1839

35.1221
Portrait of a Man (said to be Humphrey
Donaldson)
Oil on canvas
77.0 x 64.3 cm. (30¼ x 25¼ in.)
Gift of Frederick L. Jack

Beechey, Sir William, Attributed to
British, 1753-1839

21.2532
Portrait of a Woman (said to be Miss Moysey)
Oil on canvas
117.0 x 89.5 cm.(46 x 35¼ in.)
*Gift of Mrs. Ernest Wadsworth Longfellow in Memory
of her father, Israel M. Spelman*

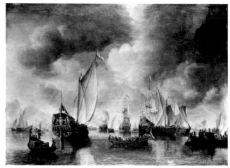

Beechey, Sir William, Copy after
30.498
Princess Amelia (after a painting in the Royal
Collection, Windsor)
Oil on canvas
91.5 x 71.0 cm. (36 x 28 in.)
Bequest of Mrs. Harriet J. Bradbury

Beers, Jan van
Belgian, 1852-1927

1979.201
Portrait of a Man
Oil on panel
31.8 x 39.9 cm. (12½ x 15¾ in.)
Lower left: JAN VAN BEERS
Seth K. Sweetser Fund

Beerstraaten, Johannes
Dutch, active third quarter, 17th century

17.1421
***Yacht of the Princes of Orange and Other Ships
in a Light Breeze*** *(The Return of the Fleet)*
Oil on panel
76.0 x 107.0 cm. (29⅞ x 42⅛ in.)
Lower right: J Beerstraaten
Gift of Arthur B. Emmons

Beest, Albertus van
Dutch (worked in United States), 1820-1860

69.1125
Men in a Boat
Oil on canvas
20.0 x 30.5 cm. (7⅞ x 12⅛ in.)
Lower right: Van Beest
Gift of Misses Aimée and Rosamond Lamb

Begeyn, Abraham Jansz.
Dutch, about 1635-1697

21.10539
Mountain Landscape with Peasants and Animals
Oil on canvas
83.5 x 62.7 cm. (32⅞ x 24⅝ in.)
William Sturgis Bigelow Collection

Belgian, fourth quarter, 18th century – first quarter, 19th century

74.11
Two Women in a Kitchen
Oil on canvas
41.8 x 49.0 cm. (16½ x 19¼ in.)
Bequest of Charles Sumner

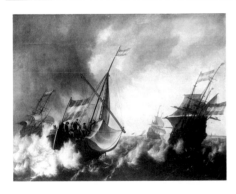

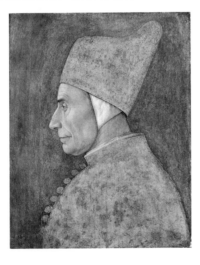

Bellevois, Jacob Adriaensz.
Dutch, 1621-1676

07.499
Ships in a Storm
Oil on canvas
Design: 128.0 x 176.8 cm. (50⅜ x 69⅝ in.)
James Fund

Bellini, Gentile
Italian (Venetian), active 1460-died 1507

36.934
Portrait of a Doge
Tempera on panel
53.5 x 42.5 cm. (21 x 16¾ in.)
Anna Mitchell Richards Fund

Bellini, Giovanni, Copy after
Italian (Venetian), about 1430-1516

20.851
Christ Carrying the Cross (after a painting known in many versions)
Oil and tempera on panel
38.2 x 30.2 cm. (15 x 11⅞ in.)
Bequest of Dr. Emma B. Culbertson

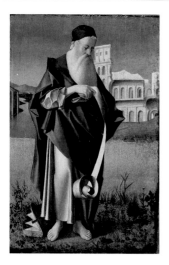

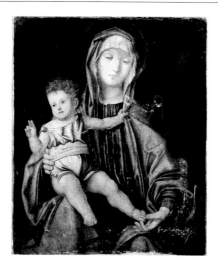

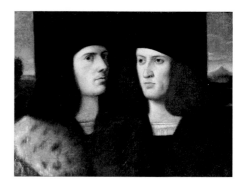

Bellini, Giovanni, Copy after, 16th century
41.654
Saint Jerome (after an altarpiece in the Kaiser-Friedrich Museum, Berlin, now destroyed)
Oil on panel
69.2 x 45.1 cm. (27¼ x 17¾ in.)
Gift of Frieda Schiff Warburg in Memory of her husband, Felix M. Warburg

Bellini, Giovanni, Follower of
17.3224
Virgin and Child
Tempera on canvas
55.9 x 47.6 cm. (22 x 18⅜ in.)
Robert Dawson Evans Collection

Belliniani, Vittore, Attributed to
Italian (Venetian), active 1507-died 1529
50.3412
Two Young Men in Furred Coats
Oil on canvas
43.7 x 59.3 cm. (17¼ x 23⅜ in.)
Gift of Ralph Lowell

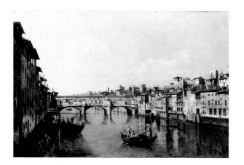

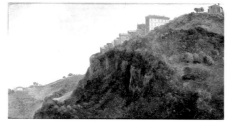

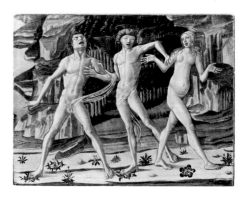

Bellotto, Bernardo
Italian (Venetian), 1720-1780
25.1
The Ponte Vecchio, Florence
Oil on canvas
55.9 x 87.6 cm. (22 x 34½ in.)
Maria Antoinette Evans Fund

Benouville, Jean Achille
French, 1815-1891
41.120
Italian Hill Town
Oil on paper mounted on canvas
14.5 x 28.0 cm. (5¾ x 11 in.)
Gift of Edward Jackson Holmes

Benvenuto di Giovanni
Italian (Sienese), 1436-about 1518
56.512
The Expulsion from Paradise
Tempera on panel
25.8 x 34.5 cm. (10⅛ x 13⅝ in.)
Charles Potter Kling Fund

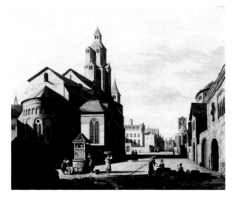

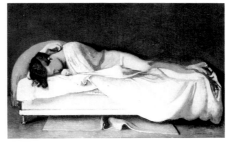

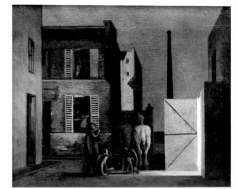

Berckheyde, Gerrit Adriaensz.
Dutch, 1638-1698
38.1652
Church of Saint Cecilia, Cologne
Oil on panel
33.0 x 40.5 cm. (13 x 16 in.)
Lower right: G Berck Heyde / [...]
Gift of Mrs. Charles Gaston Smith's Group

Berman, Eugene
Russian (worked in France), 1899-1972
Res. 32.4
Young Man Asleep
Oil on canvas
88.7 x 146.5 cm. (34⅞ x 57⅝ in.)
Lower right: E Berman 1931
Reverse: E. Berman / Paris 1931 / Jeune Homme
Couché
Tompkins Collection

Berman, Eugene
Russian (worked in France), 1899-1972
Res. 32.20
City by Night
Oil on canvas
81.0 x 100.0 cm. (31⅞ x 39⅜ in.)
Lower right: E Berman 1930
Reverse: E. Berman / Paris 1930 / Nocturne
Gift by Contribution

Berman, Leonid
Russian (worked in France), 1896-1976
Res. 32.2
Boats near Boulogne
Oil on canvas
65.0 x 46.0 cm. (25⅝ x 18⅛ in.)
Lower left: Leonid B.
Tompkins Collection

Berman, Leonid
Russian (worked in France), 1896-1976
Res. 32.3
Boats on the Shore
Oil on canvas
73.0 x 50.0 cm. (28¾ x 19⅝ in.)
Lower left: Leonid Berman 29
Tompkins Collection

Bernard, Emile
French, 1868-1941
61.165
The Artist's Grandmother
Oil on canvas
60.0 x 50.4 cm. (23⅝ x 19⅞ in.)
Upper right: Emile Bernard / 1887
Francis Welch Fund

Bernardino di Mariotto
Italian (Umbrian), active about 1498-died 1566
46.1428
Virgin and Child
Tempera on panel
Panel: 69.9 x 42.6 cm. (27½ x 16¾ in.)
Design: 58.0 x 31.3 cm. (22⅞ x 12⅜ in.)
Gift of Quincy A. Shaw

Berrettini, Pietro (called Pietro da Cortona),
Attributed to
Italian (Roman), 1596-1669
42.422
Virgin and Child with Saints (unfinished)
Oil on canvas
72.5 x 61.0 cm. (28½ x 24 in.)
Gift of A. F. Mondschein

Bertin, Jean Victor
French, 1775-1842
44.39
Entrance to the Park at St.-Cloud
Oil on canvas
25.9 x 36.0 cm. (10¼ x 14⅛ in.)
Lower left: V Bertin
Bequest of Julia C. Prendergast in Memory of her brother, James Maurice Prendergast

Bertin, Jean Victor
French, 1775-1842
1981.721
Landscape with Bathers and Shepherds
Oil on canvas
Original design: 109.8 x 113.1 cm. (43¼ x 44½ in.)
Present design: 127.3 x 113.1 cm. (50⅛ x 44½ in.)
Lower right: BERTIN 1804
Gift of Julia Appleton Bird

Bertucci, Giovanni Battista
Italian (Romagnan), active 1503-died about 1516
25.214
The Holy Family
Oil and tempera on panel
64.0 x 47.5 cm. (25¼ x 18¾ in.)
Herbert James Pratt Fund

Bettera, Bartolomeo
Italian (Bergamese), 1624-1687
Res. 13.3
Musical Instruments and Sculpture in a Classical Interior
Oil on canvas
96.6 x 131.7 cm. (38 x 51⅞ in.)
Gift of the Heirs of George A. Kettell

Bettera, Bartolomeo
Italian (Bergamese), 1624-1687
49.1789
Musical Instruments
Oil on canvas
34.8 x 54.4 cm. (13¾ x 21⅜ in.)
Gift of Arthur Wiesenberger

Bevan, Robert
British, 1865-1925
Res. 32.5
Adelaide Road, N.W.
Oil on canvas
51.0 x 72.0 cm. (20⅛ x 28⅜ in.)
Lower left: Robert Bevan
Tompkins Collection

Bevan, Robert
British, 1865-1925
Res. 32.19
Parade at Aldridge's
Oil on canvas
63.4 x 76.3 cm. (25 x 30 in.)
Gift by Contribution

Beverloo, Cornelis van (called Corneille)
Dutch, 1922-
56.1298
Black Girl in a Room
Oil on canvas
65.0 x 54.0 cm. (25⅝ x 21¼ in.)
Lower right: Corneille 51
Gift of J. A. Vandenbergh

Bidauld, Jean Joseph Xavier
French, 1758-1846
43.130
Monte Cavo from Lake Albano
Oil on canvas
32.5 x 45.6 cm. (12¾ x 18 in.)
Charles Edward French Fund

Bird, Edward
British, 1772-1819
Res. 26.8
Dancing to the Fiddle
Oil on canvas
25.7 x 33.2 cm. (10⅛ x 13⅛ in.)
Lower left, on bench: E BIRD
Gift of Frances R. Morse, Henry Lee Morse, and Mary Lee Elliot, Children of Samuel Torrey Morse

Bissier, Julius Heinrich
German, 1893-1965

68.113
5 April 64
Oil on linen mounted on canvas
39.4 x 49.5 cm. (15½ x 19½ in.)
Center right: 5 · April 64 / Julius Bissier
Sophie M. Friedman Fund, by exchange

Blauensteiner, Leopold
Austrian, 1880-1947

1983.321
Concertmaster of the Waltz Orchestra
(Ganglberger)
Oil on canvas mounted on plywood
152.1 x 138.4 cm. (59⅞ x 54 in.)
Reverse: L. BLAUENSTEINER / GANGLBERGER
Juliana Cheney Edwards Collection

Bles, Herri met de
see
Herri met de Bles

Blin de Fontenay, Jean Baptiste, Style of
French, 1653-1715

39.647
Still Life with Flowers
Oil on canvas
121.0 x 111.0 cm. (47⅝ x 43¾ in.)
Juliana Cheney Edwards Collection

Bloemaert, Adriaen
Dutch, after 1609-1666

94.168
Herdsman by a Lake
Oil on canvas
68.0 x 90.0 cm. (26¾ x 35⅝ in.)
Bequest of Mrs. Turner Sargent

Bloemen, Jan Frans van (called Orrizonte),
Attributed to
Flemish, 1662-1749

Res. 15.5
Italian Mountain Town with Bathers
Oil on canvas
58.0 x 51.0 cm. (22⅞ x 21⅛ in.)
Gift of George A. Goddard

Blommers, Bernardus Johannes
Dutch, 1845-1914
15.878
Cottage Interior
Oil on canvas
25.3 x 31.2 cm. (10 x 12¼ in.)
Lower right: Blommers
William R. Wilson Donation

Boccaccino, Boccaccio
Italian (Cremonese), active about 1493-died
1524/25
61.957
Virgin and Child
Oil and tempera on panel
81.3 x 62.3 cm. (32 x 24½ in.)
*Given in Memory of Governor Alvan T. Fuller by the
Fuller Foundation*

Boccaccino, Boccaccio, Attributed to
Italian (Cremonese), active about 1493-died
1524/25
23.502
Virgin and Child
Oil on panel, altered on both sides
Center panel: 57.0 x 31.1 cm. (22⅜ x 12¼ in.)
Right addition: 57.0 x 6.0 cm. (22⅜ x 2⅜ in.)
Left addition: 57.0 x 8.9 cm. (22⅜ x 3½ in.)
Bequest of Ernest Wadsworth Longfellow

Bock, Théophile Emile Achille de
Dutch, 1851-1904
17.3244
Pool in the Forest
Oil on panel
11.0 x 22.8 cm. (4⅜ x 9 in.)
Lower left: Th de Bock
Robert Dawson Evans Collection

Boddington, Henry John
British, 1811-1865
46.364
Gipsy Camp
Oil on canvas
30.5 x 40.6 cm. (12 x 16 in.)
Lower left: H J Boddington 184[...]
Gift of Miss Laura Furness

Bodmer, Karl
Swiss (worked in France), 1809-1893
06.3
Oaks and Wild Boars
Oil on canvas
134.0 x 106.8 cm. (52¾ x 42 in.)
Lower left: K Bodmer
Bequest of Francis Skinner

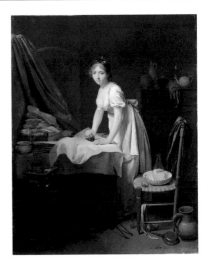

Bohemian, second quarter, 14th century

50.2716
Death of the Virgin
Tempera on panel
100.0 x 71.0 cm. (39⅜ x 28 in.)
*William Francis Warden Fund; Seth K. Sweetser
Fund, The Henry C. and Martha B. Angell
Collection, Juliana Cheney Edwards Collection, Gift of
Martin Brimmer, and Gift of Reverend and Mrs.
Frederick Frothingham; by exchange*

Bohemian, fourth quarter, 14th century

34.1459
Virgin and Child
Tempera on panel
Panel: 10.8 x 8.3 cm. (4¼ x 3¼ in.)
Design: 8.6 x 6.0 cm. (3⅜ x 2⅜ in.)
Maria Antoinette Evans Fund

Boilly, Louis Léopold
French, 1761-1845

1983.10
Young Woman Ironing
Oil on canvas
40.7 x 32.4 cm. (16 x 12¾ in.)
Lower right: L. LBoilly (second L and B joined)
Charles H. Bayley Picture and Painting Fund

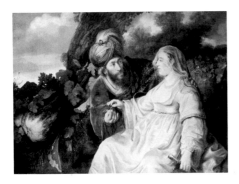

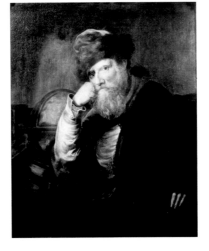

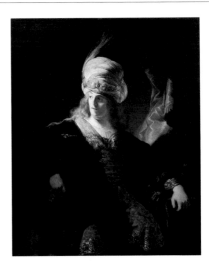

Bol, Ferdinand
Dutch, 1616-1680

17.3268
Judah and Tamar
Oil on canvas
123.2 x 172.4 cm. (48½ x 67⅞ in.)
Lower left: F. Bol. fecit / 1644-
Robert Dawson Evans Collection

Bol, Copy after, 17th century

17.3269
Philosopher (after a painting in the Hermitage
Museum, Leningrad)
Oil on canvas
110.5 x 89.5 cm. (43½ x 35¼ in.)
Robert Dawson Evans Collection

Bol, Imitator of

17.3231
Young Man in Oriental Costume
Oil on canvas
151.2 x 123.5 cm. (59½ x 48⅝ in.)
Robert Dawson Evans Collection

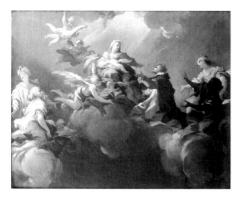

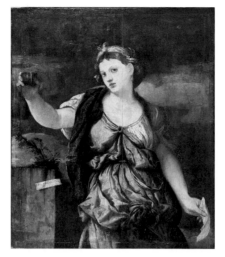

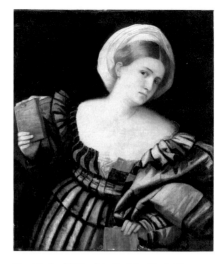

Bonecchi, Matteo
Italian (Tuscan), about 1672-1752
40.548
The Glory of Saint Dominic
Oil on canvas
47.0 x 57.8 cm. (18½ x 22¾ in.)
Given in Memory of William Crowninshield Endicott by his wife

Bonifazio di Pitati (called Bonifazio Veronese)
Italian (Venetian), 1487-1553
74.24
Sophonisba Taking Poison
Oil on canvas
97.1 x 82.5 cm. (38¼ x 32½ in.)
Lower left, on wall: Hon bene protob [...]ptas [...] auna
Lower right, on scroll: Sofo[...]
Bequest of Charles Sumner

Bonifazio di Pitati (called Bonifazio Veronese)
Italian (Venetian), 1487-1553
01.6215
Woman Holding Two Tablets (the Cumaean Sibyl?)
Oil on canvas
91.2 x 78.0 cm. (35⅞ x 30¾ in.)
Gift of Henry Lee Higginson in Memory of Edward H. Hooper

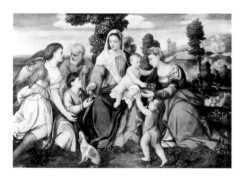

Bonifazio di Pitati (called Bonifazio Veronese)
Italian (Venetian), 1487-1553
26.768
The Holy Family with Saint Dorothy and the Infant John the Baptist, and Tobias with an Angel
Oil on canvas
103.0 x 152.1 cm. (40½ x 59⅞ in.)
William Sturgis Bigelow Collection

Bonifazio di Pitati (called Bonifazio Veronese), Attributed to
Italian (Venetian), 1487-1553
23.457
Saint Lucy and the Young Saint John the Baptist (fragment)
Oil on canvas
91.6 x 38.8 cm. (36 x 15¼ in.)
Bequest of Ernest Wadsworth Longfellow

Bonington, Richard Parkes
British, 1802-1828
03.740
The Use of Tears
Oil on canvas
40.2 x 32.3 cm. (15⅞ x 12¾ in.)
Bequest of Josiah Bradlee

Bonington, Imitator of
84.281
Lover's Declaration
Oil on paperboard
27.8 x 22.3 cm. (11 x 8¾ in.)
Falsely signed, lower right: R. P. Bonington.
Bequest of Thomas Gold Appleton

Bonnard, Pierre
French, 1867-1947
48.520
Paris Boulevard at Night
Oil on paperboard
45.0 x 58.2 cm. (17¾ x 22⅞ in.)
Lower right: Bonnard / 19[00]
Bequest of John T. Spaulding

Bonnat, Joseph Florentin Léon
French, 1833-1922
98.1005
Henry Lillie Pierce
Oil on canvas
131.5 x 101.5 cm. (51¾ x 40 in.)
Upper left: Lⁿ. Bonnat / 1895
Gift of Charles Frost Aldrich and Talbot Aldrich

Bonnat, Joseph Florentin Léon
French, 1833-1922
30.766
Mary Sears (later Mrs. Francis Shaw)
Oil on canvas
126.5 x 75.0 cm. (49¾ x 29½ in.)
Lower left: Lⁿ Bonnat / 1878
Gift of Miss Clara Endicott Sears

Borch, Gerard ter
Dutch, 1617-1681
47.372
Portrait of a Woman
Oil on canvas
46.5 x 38.1 cm. (18¼ x 15 in.)
M. Theresa B. Hopkins Fund

Borch, Gerard ter
Dutch, 1617-1681
61.660
Man on Horseback
Oil on panel
54.8 x 41.1 cm. (21⅝ x 16⅛ in.)
Juliana Cheney Edwards Collection

Bordone, Paris Paschalinus, Copy after
Italian (Venetian), 1500-1571

42.388
The Mystical Marriage of Saint Catherine (after a
painting in the Galleria Nazionale, Parma)
Oil on canvas
196.0 x 235.0 cm. (77⅛ x 92½ in.)
*Bequest of Eunice Whitney Felton in Memory of her
husband, C. C. Felton*

Bosboom, Johannes
Dutch, 1817-1891

23.520
Interior of a Church
Oil on canvas
79.8 x 66.4 cm. (31⅜ x 26⅛ in.)
Lower left: Bosboom
*Bequest of David P. Kimball in Memory of his wife,
Clara Bertram Kimball*

Bosch, Hieronymus, and Workshop
Flemish, active 1480-died 1516

53.2027
Ecce Homo
Oil on panel
Design: 73.0 x 57.2 cm. (28¾ x 22½ in.)
*William K. Richardson Fund, William Francis
Warden Fund, and Juliana Cheney Edwards
Collection*

Bosch, Hieronymus, Workshop of
Flemish, active 1480-died 1516

56.172
Instruments of the Passion of Christ
Oil on panel
Panel: 15.6 x 68.2 cm. (6⅛ x 26⅞ in.)
Design: 14.0 x 66.2 cm. (5½ x 26 in.)
Gift of Arthur Kauffmann

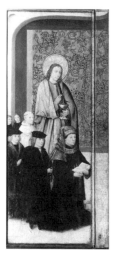
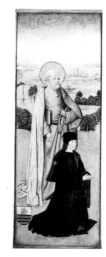
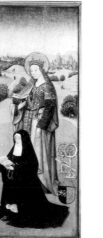

Bosch, Follower of
56.171a,b
(a) ***Donor and Male Family Members with Saint John the Evangelist*** (outer face); ***Donor with Saint Peter*** (inner face)
(b) ***Donor and Female Family Members with Saint Mary Magdalen*** (outer face); ***Donor and an Infant with Saint Catherine of Alexandria*** (inner face)

Oil on panel
(a) Overall: 79.4 x 35.9 cm. (31¼ x 14⅛ in.)
Design, inner face: 68.6 x 25.5 cm. (27 x 10 in.)
(b) Overall: 79.6 x 35.9 cm. (31⅜ x 14⅛ in.)
Design, inner face: 68.8 x 25.4 cm. (27⅛ x 10 in.)
Gift of Arthur Kauffmann

Bosch, Follower of
Res. 08.17
Purgatory
Oil on panel
86.5 x 65.7 cm. (34 x 25⅞ in.)
Gift of E. M. Raymond

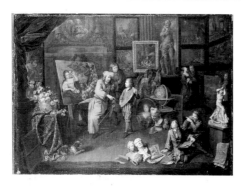

Bossche, Balthazar van den, II
Flemish, 1681-1715

28.857
Artist's Studio
Oil on canvas
59.1 x 84.3 cm. (23¼ x 33⅛ in.)
Bequest of Sarah Hammond Blane in Memory of her father, Walter Cooper Greene

Both, Jan,
Dutch, about 1618-1652

34.239
Bandits Leading Prisoners
Oil on canvas
165.5 x 217.5 cm. (65⅛ x 85⅝ in.)
Lower left, on rock: JBoth. f. (J and B joined)
Seth K. Sweetser Fund

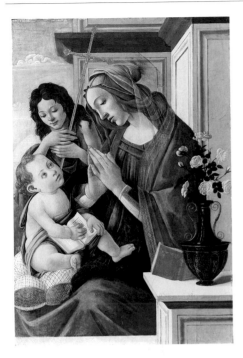

Botticelli (Alessandro Filipepi, called Botticelli),
Workshop of
Italian (Florentine), 1444/45-1510

95.1372
*Virgin and Child with the Young Saint John the
Baptist*
Tempera on panel
123.8 x 84.4 cm. (48¾ x 33¼ in.)
Sarah Greene Timmins Fund

Botticelli, Follower of

17.3225
Virgin and Child
Tempera on panel
99.0 x 57.0 cm. (39 x 22⅜ in.)
Robert Dawson Evans Collection

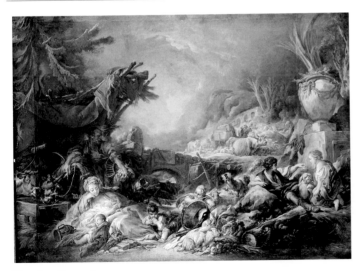

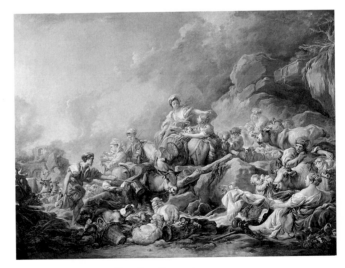

Boucher, François
French, 1703-1770

71.2
Halt at the Spring
Oil on canvas
208.5 x 290.0 cm. (82⅛ x 114⅛ in.)
Center right, on pedestal of vase: FBoucher (F and
B joined) / 1765
Gift of the Heirs of Peter Parker

Boucher, François
French, 1703-1770

71.3
Returning from Market
Oil on canvas
209.4 x 290.6 cm. (82½ x 114⅜ in.)
Lower left, on stone: F. Boucher / 1767
Gift of the Heirs of Peter Parker

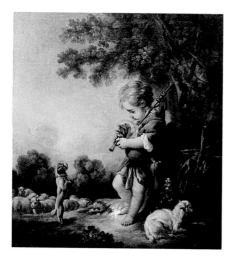

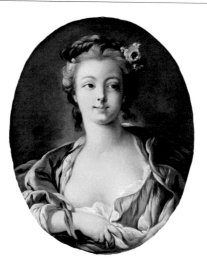

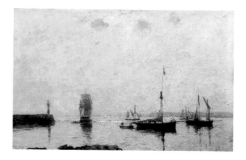

Boucher, François
French, 1703-1770
61.958
Shepherd Boy Playing Bagpipes
Oil on canvas
55.2 x 49.8 cm. (21¾ x 19⅝ in.)
*Given in Memory of Governor Alvan T. Fuller by the
Fuller Foundation*

Boucher, François
French, 1703-1770
65.2637
Portrait of a Woman (Madame Boucher?)
Oil on canvas
57.0 x 46.0 cm. (22⅜ x 18⅛ in.)
The Forsyth Wickes Collection

Boudin, Louis Eugène
French, 1824-1898
19.98
Harbor Entrance
Oil on canvas
37.2 x 59.6 cm. (14⅝ x 23½ in.)
Lower left: E. Boudin / 73
The Henry C. and Martha B. Angell Collection

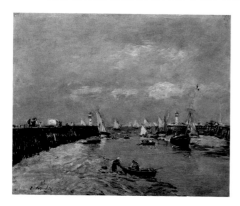

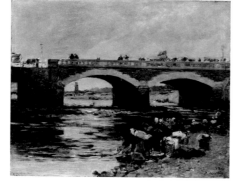

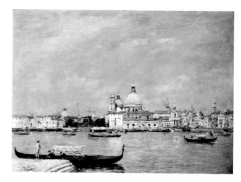

Boudin, Louis Eugène
French, 1824-1898
23.480
Entrance to the Port of Trouville, Low Tide
Oil on panel
32.3 x 40.6 cm. (12¾ x 16 in.)
Lower left: 96 / E. Boudin
Bequest of Ernest Wadsworth Longfellow

Boudin, Louis Eugène
French, 1824-1898
23.512
Washerwomen near a Bridge
Oil on panel
32.0 x 41.0 cm. (12⅝ x 16⅛ in.)
Lower right: 82 / E. Boudin
*Bequest of David P. Kimball in Memory of his wife,
Clara Bertram Kimball*

Boudin, Louis Eugène
French, 1824-1898
25.111
*Venice, Santa Maria della Salute from San
Giorgio*
Oil on canvas
46.3 x 65.4 cm. (18¼ x 25¾ in.)
Lower left: Venise 95 / E. Boudin
Juliana Cheney Edwards Collection

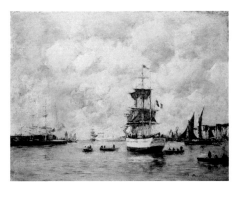

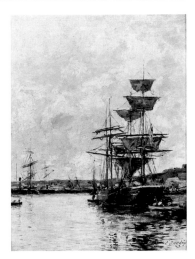

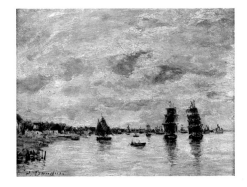

Boudin, Louis Eugène
French, 1824-1898
Res. 27.90
Port of Le Havre
Oil on canvas
39.8 x 54.2 cm. (15⅝ x 21⅜ in.)
Lower right: E Boudin
Bequest of Elizabeth Howard Bartol

Boudin, Louis Eugène
French, 1824-1898
37.1212
Ships at Le Havre
Oil on panel
35.0 x 26.5 cm. (13¾ x 10⅜ in.)
Lower right: E. Boudin / 87
Gift of Miss Amelia Peabody

Boudin, Louis Eugène
French, 1824-1898
48.521
Port Scene
Oil on panel
15.5 x 21.2 cm. (6⅛ x 8⅜ in.)
Lower left: E. Boudin.
Bequest of John T. Spaulding

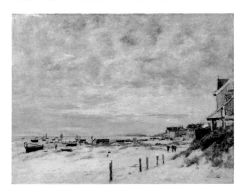

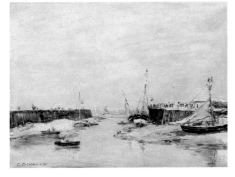

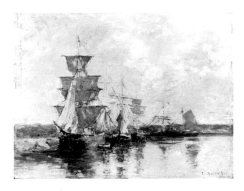

Boudin, Louis Eugène
French, 1824-1898
64.1905
Beach Scene
Oil on canvas
54.5 x 75.0 cm. (21½ x 29½ in.)
Lower right: E Boudin / 16 juillet 80
Bequest of Mrs. Stephen S. Fitzgerald

Boudin, Louis Eugène
French, 1824-1898
65.2638
Harbor of Trouville, Low Tide
Oil on panel
23.7 x 32.7 cm. (9⅜ x 12⅞ in.)
Lower left: E. Boudin - 85
The Forsyth Wickes Collection

Boudin, Louis Eugène
French, 1824-1898
67.906
Harbor Scene
Oil on panel
23.3 x 32.4 cm. (9⅛ x 12¾ in.)
Lower right: E. Boudin.
Gift of Mrs. Henry Bliss

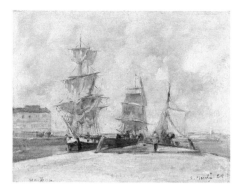
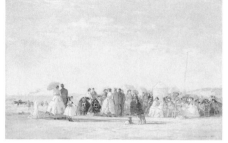
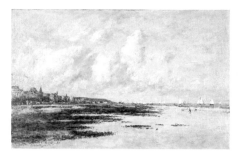

Boudin, Louis Eugène
French, 1824-1898

1971.425
Harbor at Honfleur
Oil on paper mounted on panel
20.3 x 26.8 cm. (8 x 10½ in.)
Lower left: Honfleur
Lower right: E. Boudin 65
Anonymous Gift

Boudin, Louis Eugène
French, 1824-1898

1974.565
Fashionable Figures on the Beach
Oil on panel
35.5 x 57.5 cm. (14 x 22⅝ in.)
Lower right: E. Boudin - 65
Gift of Mr. and Mrs. John J. Wilson

Boudin, Louis Eugène
French, 1824-1898

1981.719
Deauville at Low Tide
Oil on canvas
55.0 x 95.0 cm. (21⅝ x 37⅜ in.)
Lower right: E. Boudin - 97 / Deauville - 10 Aout
Bequest of Mary H. J. Parker

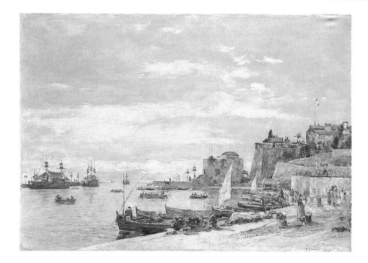

Boudin, Louis Eugène
French, 1824-1898

1322.12
Quay at Villefranche
Oil on canvas
50.7 x 74.5 cm. (19⅞ x 29⅜ in.)
Lower right: E. Boudin 92. / Villefranche 27 fev.
92.
*Deposited by the Trustees of the White Fund,
Lawrence, Massachusetts*

Boudin, Louis Eugène, Imitator of

43.186
Beach Scene with Figures
Oil on paper mounted on board
10.0 x 16.5 cm. (3⅞ x 6½ in.)
Falsely signed, lower right: E.B -
Bequest of Dr. Isador H. Coriat

Boughton, George Henry
British (worked in United States), 1833-1905

16.67
Young Woman Waiting by the Sea
Oil on panel
53.5 x 35.0 cm. (21 x 13¾ in.)
Lower left: GHBoughton (initials joined)
Gift of John A. Lowell Blake

Bouguereau, William Adolphe
French, 1825-1905

08.186
Fraternal Love
Oil on canvas
147.0 x 113.8 cm. (57⅞ x 44¾ in.)
Lower right: W. BOVGVEREAV. 1851.
Gift of the Estate of Thomas Wigglesworth

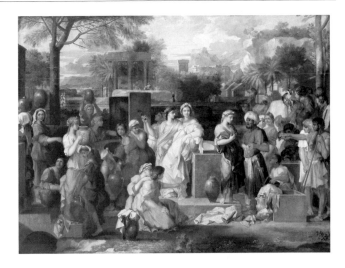

Bourdon, Sébastien
French, 1616-1671

68.23
Christ and the Woman of Samaria
Oil on canvas
144.5 x 199.2 cm. (56⅞ x 78⅜ in.)
Juliana Cheney Edwards Collection

Bourdon, Sébastien
French, 1616-1671

68.24
Rebecca and Eleazer
Oil on canvas
144.0 x 199.0 cm. (56¾ x 78⅜ in.)
Juliana Cheney Edwards Collection

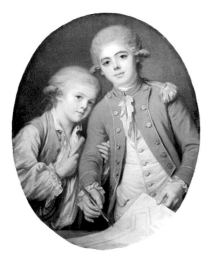

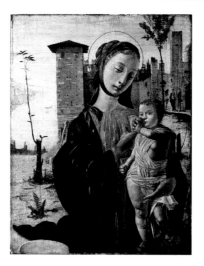

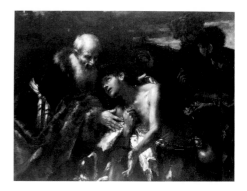

Boze, Joseph
French, 1744-1826

65.2636
Portrait of Two Boys
Oil on canvas
72.5 x 58.5 cm. (28½ x 23 in.)
The Forsyth Wickes Collection

Bramantino (Bartolomeo Suardi, called
Bramantino)
Italian (Milanese), about 1465-1530

13.2859
Virgin and Child
Oil and tempera on panel
45.9 x 35.2 cm. (18⅛ x 13⅞ in.)
Picture Fund

Brandl, Peter
Bohemian, 1668-1735

1973.89
The Return of the Prodigal Son
Oil on canvas
123.8 x 163.9 cm. (48¾ x 64½ in.)
Ernest Wadsworth Longfellow Fund

Braque, Georges
French, 1881-1963

Res. 32.21
Peaches, Pears, and Grapes on a Table
Oil on canvas
31.3 x 65.3 cm. (12⅜ x 25¾ in.)
Lower left: G Braque / 21
Gift by Contribution

Braque, Georges
French, 1881-1963

57.523
Still Life with Blue Plums and a Glass of Water
Oil on canvas
23.2 x 73.1 cm. (9⅛ x 28¾ in.)
Lower left: G. Braque / 25-
Gift of Mr. and Mrs. Paul Rosenberg

Bredael, Jan Frans van, Attributed to
Flemish, 1688-1750

28.859
Soldiers in Camp
Oil on canvas
79.0 x 108.0 in. (31⅛ x 42½ in.)
*Bequest of Sarah Hammond Blane in Memory of her
father, Walter Cooper Greene*

Brekelenkam, Quiringh Gerritsz. van, Copy after
Dutch, active 1648–died 1667/8

Res. 19.129
Old Woman Counting Money by Candlelight
(Vanitas) (copy after an engraving by Hendrik Bary after a design by Brekelenkam)
Oil on canvas
31.1 x 23.5 cm. (12¼ x 9¼ in.)
Gift of Mr. and Mrs. William de Forest Thomson

Brerewood, Francis
 see
Amigoni, Jacopo
 with
Brerewood, Francis

Breton, Jules
French, 1827–1906

41.115
Woman with a Taper (study for *Religious Procession in Brittany*)
Oil on canvas
54.0 x 39.9 cm. (21¼ x 15¾ in.)
Lower left: Jules Breton / 1873
Gift of Edward Jackson Holmes

Brissot de Warville, Félix Saturnin
French, 1818–1892

19.102
Farmyard
Oil on panel
35.7 x 45.7 cm. (14 x 18 in.)
Lower left: F Brissot
The Henry C. and Martha B. Angell Collection

British, second quarter, 16th century

35.1751
Sir William Butts
Tempera and oil on panel
74.7 x 60.2 cm. (29⅜ x 23¾ in.)
Center left: ANNO DNI · 154[...]
Center right: [...]TA[...]IS SVAE XXX[...]
Charles Edward French Fund

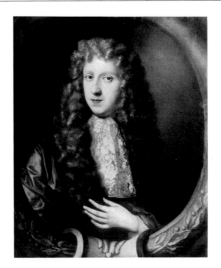

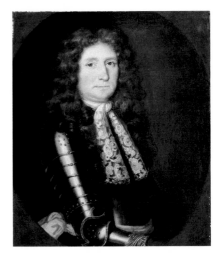

British, third quarter, 17th century
96.650
Portrait of a Man (said to be John Elliot)
Oil on canvas
99.0 x 83.0 cm. (39 x 32⅝ in.)
Upper left: JOHN ELLIOT. / THE APOSTLE OF THE
INDIANS / NASCIT. 1604: OBIT. 1690.
Gift of Miss Rose Standish Whiting

British, fourth quarter, 17th century
30.490
Portrait of a Man in a Brown Robe
Oil on canvas
76.0 x 63.5 cm. (29⅞ x 25 in.)
Bequest of Mrs. Harriet J. Bradbury

British, fourth quarter, 17th century
1983.37
Sir Edmund Andros
Oil on canvas
73.7 x 62.1 cm. (29 x 24½ in.)
*Bequest of Henry Lee Shattuck in Memory of Morris
Gray*

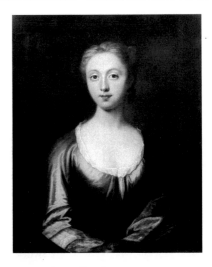

British (?), fourth quarter, 17th century
Res. 08.16
Portrait of a Man
Oil on panel
76.2 x 61.0 cm. (30 x 24 in.)
Falsely signed, upper left: A VAN DYCK C 1647
Gift of Henry S. Grew

British, second quarter, 18th century
21.138
Portrait of a Man (said to be Edward Duffield)
Oil on canvas
63.4 x 50.4 cm. (25 x 19⅞ in.)
On stretcher: Effigus Edward Duffield Depicta a G.
Hesselius.
Seth K. Sweetser Fund

British, first half, 18th century
25.102
Portrait of a Woman
Oil on canvas
70.0 x 57.3 cm. (27½ x 22½ in.)
*Bequest of Susan Greene Dexter, in Memory of
Charles and Martha Babcock Amory*

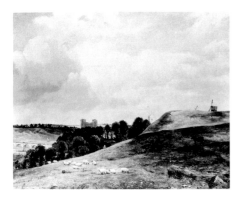

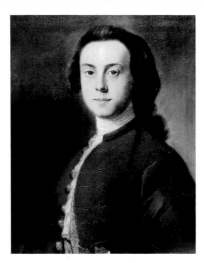

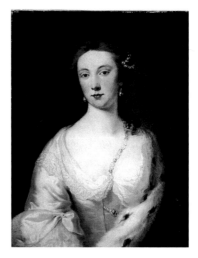

British, first half, 18th century
26.765
River Valley and Castle
Oil on canvas
70.0 x 88.0 cm. (27½ x 34⅝ in.)
William Sturgis Bigelow Collection

British, mid-18th century
29.931
Portrait of a Man
Pastel on paper
54.6 x 45.7 cm. (21½ x 18 in.)
Falsely signed, lower left: I Blackburn · Pinxit
1760 ·
Archibald Cary Coolidge Fund

British, mid-18th century
35.1227
Portrait of a Woman (said to be Jennie
Cameron)
Oil on canvas
67.7 x 52.8 cm. (26⅝ x 20¾ in.)
Gift of Frederick L. Jack

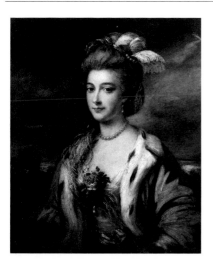

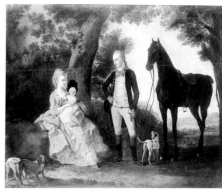

British, mid-18th century, Imitator of
34.30
Portrait of a Woman
Oil on canvas
76.5 x 63.4 cm. (30⅛ x 25 in.)
Gift of Wickliffe Draper

British, third quarter, 18th century
74.20
Peasants Approaching a Cottage
Oil on panel
36.8 x 53.3 cm. (14½ x 21 in.)
Lower center: 1776
Bequest of Charles Sumner

British, third quarter, 18th century
31.975
Henry Perkins Weston with his Family
Oil on canvas
91.0 x 114.0 cm. (35⅞ x 44⅞ in.)
Ellen Page Hall Fund, William Alfred Paine Fund,
Martha Silsbee Fund, Maria Antoinette Evans Fund,
Eva Channing Fund, and Anne Lewis Renton Fund

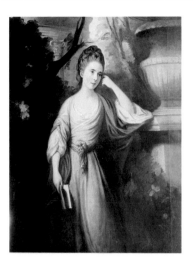

British, third quarter, 18th century
33.19
Portrait of a Woman
Oil on canvas
123.0 x 100.0 cm. (48⅜ x 39⅜ in.)
Given in Memory of Dr. William Hewson Baltzell by his wife, Alice Cheney Baltzell

British, third quarter, 18th century
Res. 37.241
Sandy Lane with a Cottage and Peasants
Oil on panel
31.0 x 36.5 cm. (12¼ x 14⅜ in.)
Gift of the Estate of William A. Sargent

British, fourth quarter, 18th century
23.542
Two Children in a Landscape
Oil on canvas
31.0 x 35.7 cm. (12¼ x 14 in.)
Bequest of David P. Kimball in Memory of his wife, Clara Bertram Kimball

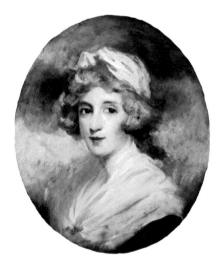

British, fourth quarter, 18th century
29.787
Portrait of a British Officer
Oil on canvas
76.5 x 63.3 cm. (30⅛ x 24⅞ in.)
Bequest of George Nixon Black

British, fourth quarter, 18th century
61.177
Portrait of a Man
Oil on canvas
145.2 x 97.8 cm. (57⅛ x 38½ in.)
Gift of Howland Warren, Richard Warren and Mary W. Murphy

British, fourth quarter, 18th century
65.2656
Portrait of a Young Woman with a Kerchief
Pastel on paper mounted on canvas
47.0 x 40.0 cm. (18½ x 15¾ in.)
The Forsyth Wickes Collection

British, second half, 18th century
74.14
Portrait of a Man
Oil on canvas
82.6 x 68.9 cm. (32½ x 27¼ in.)
Bequest of Charles Sumner

British, second half, 18th century
17.587
William Henry, Duke of Gloucester
Oil on canvas
60.5 x 49.0 cm. (23⅞ x 19¼ in.)
Denman Waldo Ross Collection

British, 18th century
23.537
Portrait of a Man and his Son
Oil on canvas
127.2 x 102.0 cm. (50⅛ x 40⅛ in.)
*Bequest of David P. Kimball in Memory of his wife,
Clara Bertram Kimball*

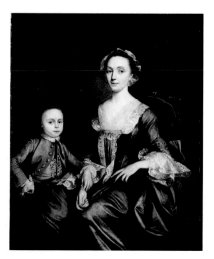

British, 18th century
23.538
Portrait of a Woman and her Son
Oil on canvas
126.5 x 101.8 cm. (49¾ x 40⅛ in.)
*Bequest of David P. Kimball in Memory of his wife,
Clara Bertram Kimball*

British, about 1800
Res. 42.26
Ship in a Storm
Oil on canvas
108.0 x 140.0 cm. (42½ x 55⅛ in.)
Bequest of Mrs. Bryce J. Allan

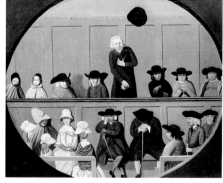

British, fourth quarter, 18th century or first
quarter, 19th century
64.456
Quaker Meeting (variant of a painting entitled
Gracechurch Street Meeting, Society of Friends,
London)
Oil on canvas
64.0 x 76.2 cm. (25¼ x 30 in.)
Bequest of Maxim Karolik

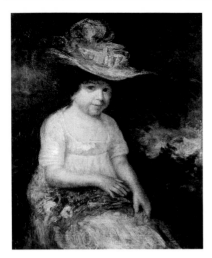

British, first quarter, 19th century
19.112
Portrait of a Young Girl
Oil on canvas
75.2 x 62.4 cm. (29⅝ x 24⅝ in.)
The Henry C. and Martha B. Angell Collection

British, first quarter, 19th century
23.518
Cottages by a River
Oil on canvas
41.0 x 51.5 cm. (16⅛ x 20¼ in.)
*Bequest of David P. Kimball in Memory of his wife,
Clara Bertram Kimball*

British, second quarter, 19th century
03.603
Portrait of a Man
Oil on canvas
76.0 x 63.5 cm. (29⅞ x 25 in.)
Bequest of Susan Cornelia Warren

British, second quarter, 19th century
03.604
Portrait of a Woman
Oil on canvas
76.2 x 63.5 cm. (30 x 25 in.)
Bequest of Susan Cornelia Warren

British, second quarter, 19th century
46.58
Fishing Village
Oil on canvasboard mounted on canvas
40.9 x 66.7 cm. (16⅛ x 26¼ in.)
Falsely signed, lower left: R P B
Gift of the Salada Tea Company

British, first half, 19th century
06.1897
Peasant Woman on a Country Lane
Oil on panel
29.7 x 26.0 cm. (11¾ x 10¼ in.)
Denman Waldo Ross Collection

British, first half, 19th century
11.1374
Landscape with a Blind Man Crossing a Bridge
Oil on canvas
101.5 x 142.8 cm. (40 x 56¼ in.)
Picture Fund and Contributions by Mrs. W. Scott Fitz, Mrs. Henry S. Grew, Mrs. David P. Kimball and Alexander Cochrane

British, first half, 19th century
22.9
Man on Horseback on a Beach
Oil on paperboard
25.4 x 30.3 cm. (10 x 11⅞ in.)
William Sturgis Bigelow Collection

British, first half, 19th century
23.514
Italian Town on a Lake
Oil on canvas
35.5 x 49.5 cm. (14 x 19½ in.)
Bequest of David P. Kimball in Memory of his wife, Clara Bertram Kimball

British, fourth quarter, 19th century
31.505
Alma Stanley in "The Street Walker"
Pastel on paper
252.0 x 97.0 cm. (99¼ x 38⅛ in.)
The Hayden Collection

British, 19th century
06.2419
Sheep Lying in a Country Lane
Oil on canvas
33.2 x 48.8 cm. (13⅛ x 19¼ in.)
Bequest of Mrs. Martin Brimmer

British, 19th century
20.854
Portrait of a Boy
Oil on paperboard
36.9 x 26.8 cm. (14½ x 10½ in.)
Gift of Miss Mary Woodman

British, 19th century
30.730
Ship Wrecked on a Beach
Oil on paperboard
20.0 x 29.0 cm. (7⅞ x 11⅜ in.)
Bequest of Mr. and Mrs. William Caleb Loring

British, 19th century
1331.12
Cottage with Cows and Cowherds by a River
Oil on canvas
74.7 x 99.5 cm. (29⅜ x 39⅛ in.)
*Deposited by the Trustees of the White Fund,
Lawrence, Massachusetts*

Bronzino (Agnolo di Cosimo di Mariano, called
Bronzino), Attributed to
Italian (Florentine), 1503-1572
29.786
Portrait of a Young Man Writing
Oil on panel
Original panel: 64.0 x 48.5 cm. (25¼ x 19⅛ in.)
Extended panel: 66.0 x 49.8 cm. (26 x 19⅝ in.)
Bequest of George Nixon Black

Brouwer, Adriaen
Dutch, 1605/06-1638
56.1185
Peasants Carousing in a Tavern
Oil on panel
33.3 x 49.2 cm. (13⅛ x 19⅜ in.)
Ernest Wadsworth Longfellow Fund

Browning, Robert Barrett
British, 1849-1912
82.232
Solitude
Oil on canvas
151.0 x 235.7 cm. (59½ x 92¾ in.)
Lower left: 18 RBB 79 (letters joined)
Gift of Mrs. Bloomfield H. Moore

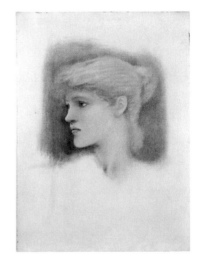

Bruegel, Pieter, the Elder, Workshop of
Flemish, active about 1551-died 1569

49.82
Combat between Carnival and Lent
Oil on panel
36.5 x 63.5 cm. (14⅜ x 25 in.)
*Seth K. Sweetser Fund, Abbot Lawrence Fund, Ernest
Wadsworth Longfellow Fund, Warren Collection, and
Juliana Cheney Edwards Collection*

Brugghen, Hendrick ter
Dutch, 1588-1629

58.975
Boy Singing
Oil on canvas
85.2 x 73.6 cm. (33½ x 29 in.)
Center right: HTBrugghen fecit 16 · 27 · (HTB
joined)
Ernest Wadsworth Longfellow Fund

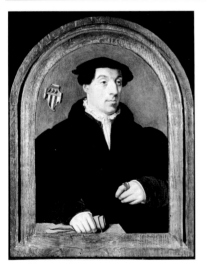

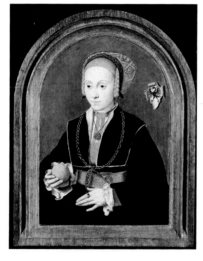

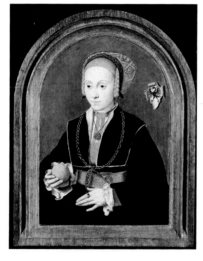

Bruyn, Barthel, the Elder
German, 1493-1555

66.11
Johann von Aich
Oil on panel
Panel: 42.0 x 32.9 cm. (16½ x 13 in.)
Design: 33.5 x 24.2 cm. (13⅛ x 9½ in.)
Ernest Wadsworth Longfellow Fund

Bruyn, Barthel, the Elder
German, 1493-1555

66.12
Margarethe von Aich
Oil on panel
Panel: 41.8 x 32.8 cm. (16½ x 12⅞ in.)
Design: 33.6 x 23.8 cm. (13¼ x 9⅜ in.)
M. Theresa B. Hopkins Fund

Burne-Jones, Sir Edward Coley
British, 1833-1898

05.105
Study of a Young Woman's Head
Oil on canvas
61.0 x 45.7 cm. (24 x 18 in.)
Gift of Robert Walcott

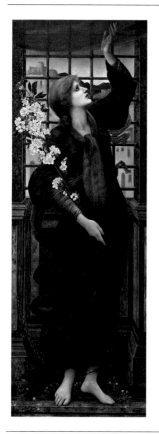

Burne-Jones, Sir Edward Coley, and Studio
British, 1833-1898

40.778
Hope
Oil on canvas
179.0 x 63.5 cm. (70½ x 25 in.)
Lower right: E:BURNE:JONES: / Finished 1896:
*Given in Memory of Mrs. George Marston Whitin by
her four daughters, Mrs. Laurence Murray Keeler,
Mrs. Sydney Russell Mason, Mrs. Elijah Kent Swift
and Mrs. William Carey Crane*

Burnier, Richard
Dutch (worked in Germany), 1826-1884

22.586
Girl Tending Cows
Oil on canvas
72.3 x 101.7 cm. (28½ x 40 in.)
Lower right: R. Burnier 7.5.
Gift of Henry Grew Crosby

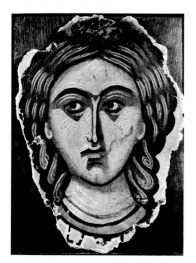

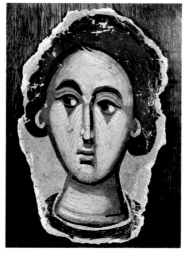

Byzantine, 12th-14th centuries
51.1620
Head of a Female Saint (from the church of
Hagiou Staurou, near Jerusalem)
Fresco transferred to panel
37.4 x 27.0 cm. (14¾ x 10⅝ in.)
M. Theresa B. Hopkins Fund

Byzantine, 12th-14th centuries
51.1621
Head of a Male Saint (from the church of Hagiou
Staurou, near Jerusalem)
Fresco transferred to panel
34.7 x 22.4 cm. (13⅝ x 8⅞ in.)
M. Theresa B. Hopkins Fund

Paintings commonly described under the rubric of
Byzantine but actually dating from the centuries
after the Byzantine Empire can be found under the
headings of the broadly defined national schools
with which they are associated, e.g., Greek, Italian,
Russian, etc.

Caillebotte, Gustave
French, 1848-1894

1979.196
Fruit Displayed on a Stand
Oil on canvas
76.5 x 100.5 cm. (30⅛ x 39⅝ in.)
Lower right: G. Caillebotte
Fanny P. Mason Fund in Memory of Alice Thevin

Calame, Alexandre
Swiss, 1810-1864

96.45
Lake at the Edge of a Forest
Oil on canvas
40.0 x 56.5 cm. (15¾ x 22¼ in.)
Lower right: A Calame 18 April 48.
Gift of Miss Caroline Louise Williams French

Caliari, Paolo
 see
Veronese, Paolo

Canal, Giovanni Antonio (called Canaletto)
Italian (Venetian), 1697-1768

39.290
Bacino di San Marco, Venice
Oil on canvas
124.5 x 204.5 cm. (49 x 80½ in.)
*Abbott Lawrence Fund, Seth K. Sweetser Fund, and
Charles Edward French Fund*

Canal, Giovanni Antonio (called Canaletto)
Italian (Venetian), 1697-1768

55.1106
The Fonteghetto della Farina, Venice
Oil on canvas
37.1 x 51.0 cm. (14⅝ x 20⅛ in.)
Anonymous Gift

Canal, Giovanni Antonio
Style of

17.590
Grand Canal, Venice
Oil on canvas
36.6 x 58.0 cm. (14⅜ x 22⅞ in.)
Denman Waldo Ross Collection

Candido
 see
Witte, Peter de

Cappella, Francesco
 see
Daggiu, Francesco

Caro, Lorenzo de
Italian, active mid-18th century

1984.139
Triumph of David
Oil on canvas
Present design: 67.5 x 49.6 cm. (26⅝ x 19½ in.)
Henry H. and Zoe Oliver Sherman Fund

Carpaccio, Vittore, Attributed to
Italian (Venetian), active 1490-died 1523/6

17.1081
Portrait of a Woman
Tempera on panel
41.0 x 30.8 cm. (16⅛ x 12⅛ in.)
Edward Wheelwright Fund

Carpaccio, Vittore, Attributed to
Italian (Venetian), active 1490-died 1523/6

17.1080
Portrait of a Man
Tempera on panel
41.0 x 30.9 cm. (16⅛ x 12⅛ in.)
Edward Wheelwright Fund

Carpenter, Margaret
British, 1793-1872

39.795
Sir Charles William Doyle
Oil on canvas
76.4 x 63.4 cm. (30⅛ x 25 in.)
Purchased with a Gift from William de Krafft

Carracci, Annibale, Follower of
Italian (Bolognese), 1560-1609

42.490
Landscape with Bathers
Oil on canvas
40.3 x 61.2 cm. (15⅞ x 24⅛ in.)
Bequest of Ernest Wadsworth Longfellow, Bequest of Nathaniel T. Kidder, The Henry C. Angell and Martha B. Angell Collection, William Sturgis Bigelow Collection, Gift of Dr. Harold W. Dana, and Gift by Subscription, by exchange

Carriera, Rosalba
Italian (Venetian), 1675-1757

53.942
Portrait of a Woman Dressed with Jewels
Pastel on paper
83.5 x 50.8 cm. (25 x 20 in.)
Gift of Mrs. Albert J. Beveridge

Carriera, Rosalba
Italian (Venetian), 1675-1757

53.943
Portrait of a Woman Wearing a Laurel Wreath
Pastel on paper
83.5 x 50.8 cm. (25 x 20 in.)
Gift of Mrs. Albert J. Beveridge

Carriera, Rosalba
Italian (Venetian), 1675-1757

65.2655
Louis XV as a Young Man
Pastel on paper
47.0 x 35.6 cm. (18½ x 14 in.)
The Forsyth Wickes Collection

Carrière, Eugène
French, 1849-1906

34.1457
Paul Verlaine
Oil on canvas mounted on panel
19.2 x 16.6 cm. (7½ x 6½ in.)
Seth K. Sweetser Fund

Carrière, Eugène
French, 1849-1906
36.894
Portrait of a Man (the artist?)
Oil on canvas
21.5 x 16.5 cm. (8½ x 6½ in.)
Across upper edge: a Mon Ami Bertaux. Eug.
Carrière / 1879
Gift of Frank Gair Macomber

Casorati, Felice
Italian, 1886-1966
Res. 32.7
City Dwellers
Oil on canvas
150.0 x 84.5 cm. (59 x 33¼ in.)
Lower right: CASORATI
Reverse: CITTADINI
Tompkins Collection

Casorati, Felice
Italian, 1886-1966
Res. 32.8
A Student
Oil on plywood panel
123.7 x 86.7 cm. (48¾ x 34⅛ in.)
Lower right: CASORATI
Tompkins Collection

Castel, Moshe
Israeli, 1909-
53.2189
Sacrifice
Oil on canvas
54.5 x 73.2 cm. (21½ x 28⅞ in.)
Lower left: Castel (repeated above in Hebrew)
Gift of James N. Rosenberg

Cavallino, Bernardo
Italian (Neapolitan), 1622-1654
36.269
Saint Cecilia
Oil on canvas
92.7 x 74.2 cm. (36½ x 29¼ in.)
William Sturgis Bigelow Collection, by exchange

Cavallucci, Antonio
Italian (Roman), 1752-1795
1979.35
Saint Benedict Joseph Labre
Oil on canvas
59.5 x 45.5 cm. (23⅜ x 17⅞ in.)
Seth K. Sweetser Fund

Cazin, Stanislas Henri Jean Charles
French, 1841-1901

15.882
Cottage in the Dunes
Oil on canvas
46.0 x 55.5 cm. (18⅛ x 21⅞ in.)
Lower right: J C. CAZIN
William R. Wilson Donation

Cazin, Stanislas Henri Jean Charles
French, 1841-1901

17.3273
Sand Dunes at Sunset
Oil on canvas
73.3 x 60.0 cm. (28⅞ x 23⅝ in.)
Lower right: J. C. CAZIN
Robert Dawson Evans Collection

Cazin, Stanislas Henri Jean Charles
French, 1841-1901

20.593
Riverbank with Bathers
Oil on canvas
131.2 x 147.0 cm. (51⅝ x 57⅞ in.)
Lower right: J C. CAZIN - 18[...]1
*Peter Chardon Brooks Memorial Collection
Gift of Mrs. Richard M. Saltonstall*

Cazin, Stanislas Henri Jean Charles
French, 1841-1901

21.1330
Farm beside an Old Road
Oil on canvas
65.1 x 81.6 cm. (25⅝ x 32⅛ in.)
Lower left: J C CAZIN
Bequest of Anna Perkins Rogers

Cazin, Stanislas Henri Jean Charles
French, 1841-1901

43.135
Village Street with a Rainbow
Oil on canvas
60.0 x 73.5 cm. (23⅝ x 28⅞ in.)
Lower left: J.C. CAZIN
Gift of Mrs. Sumner Pingree

Ceresa, Carlo
Italian (Bergamese), 1609-1679

17.575
Lorenzo Ghirardello
Oil on canvas
115.2 x 95.2 cm. (45⅜ x 37½ in.)
On letter: Spectab[...] [Do?] Lor[...] /
Ghirardello[...] Cr[...] / Bergam[...]
Denman Waldo Ross Collection

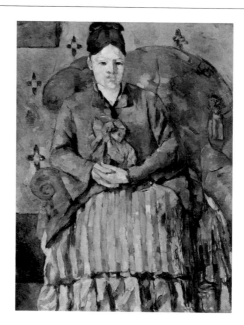

Cesari, Giuseppe (called Cavaliere D'Arpino)
Italian (Roman), 1568-1640

1983.301
Rest on the Flight into Eygpt
Oil on copper
43.2 x 31.7 cm. (17 x 12½ in.)
Lower Left: F.22.
Gift of John Goelet

Cézanne, Paul
French, 1839-1906

44.776
Madame Cézanne in a Red Armchair
Oil on canvas
72.5 x 56.0 cm. (28½ x 22 in.)
Bequest of Robert Treat Paine, 2nd.

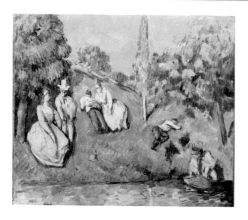

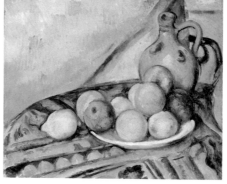

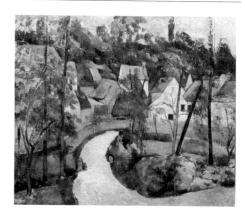

Cézanne, Paul
French, 1839-1906

48.244
Couples Relaxing by a Pond
Oil on canvas
47.0 x 56.2 cm. (18½ x 22⅛ in.)
Tompkins Collection

Cézanne, Paul
French, 1839-1906

48.524
Fruit and a Jug on a Table
Oil on canvas
32.3 x 40.8 cm. (12¾ x 16 in.)
Bequest of John T. Spaulding

Cézanne, Paul
French, 1839-1906

48.525
Turn in the Road
Oil on canvas
60.5 x 73.5 cm. (23⅞ x 28⅞ in.)
Bequest of John T. Spaulding

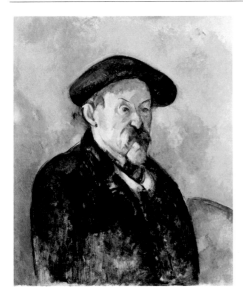

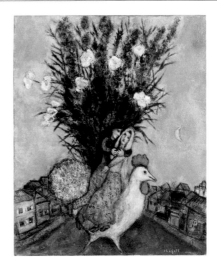

Cézanne, Paul
French, 1839-1906

1972.950
Self-Portrait with a Beret
Oil on canvas
64.0 x 53.5 cm. (25¼ x 21 in.)
Charles H. Bayley Picture and Painting Fund and partial Gift of Elizabeth Paine Metcalf

Chagall, Marc
Russian (worked in France), 1887-1985

1978.156
Village Street
Oil on canvas
46.0 x 38.0 cm. (18⅛ x 15 in.)
Lower right: Chagall Marc
Bequest of Anna Feldberg

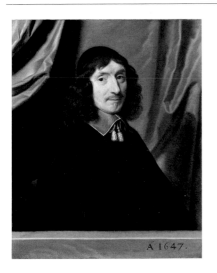

Champaigne, Philippe de
French, 1602-1674

06.119
Valentin Valleron de Parrochel
Oil on canvas
73.8 x 60.0 cm. (29 x 23⅝ in.)
On ledge, lower right: A° 1647.
Denman Waldo Ross Collection

Chardin, Jean Siméon
French, 1699-1779

80.512
Kitchen Table
Oil on canvas
39.8 x 47.5 cm. (15⅝ x 18¾ in.)
Lower right: chardin / 175[5?]
Gift of Mrs. Peter Chardon Brooks

Chardin, Jean Siméon
French, 1699-1779

83.177
Still Life with Tea Pot, Grapes, Chestnuts, and a Pear
Oil on canvas
32.0 x 40.0 cm. (12⅝ x 15¾ in.)
Lower left: chardin / 17[...]
Gift of Martin Brimmer

Chardin, Jean Siméon, Follower of
48.526
Fruit and a Silver-Gilt Goblet on a Ledge
Oil on canvas
33.0 x 43.0 cm. (13 x 17⅞ in.)
Bequest of John T. Spaulding

Charreton, Victor Léon Jean Pierre
French, 1864-1937

48.527
Château at Murols in Winter
Oil on canvas
100.0 x 73.5 cm. (39⅜ x 28⅞ in.)
Lower right: Victor Charreton
Bequest of John T. Spaulding

Charreton, Victor Léon Jean Pierre
French, 1864-1937

48.528
Autumn at Crouzol
Oil on cardboard mounted on cardboard
59.8 x 72.5 cm. (23½ x 28½ in.)
Bequest of John T. Spaulding

Chartran, Théobald
French, 1849-1907
30.496
Harriet White Bradbury
Oil on canvas
142.5 x 97.0 cm. (56⅛ x 38⅛ in.)
Upper right: Chartran / N.Y. 1904.
Bequest of George Robert White

Chartran, Théobald
French, 1849-1907
30.497
George Robert White
Oil on canvas
147.5 x 97.8 cm. (58⅛ x 38½ in.)
Upper right: Chartran / N.Y. 1904
Bequest of George Robert White

Chattel, Fredericus Jacobus van Rossum du
Dutch, 1856-1917
Res. 24.79
Canal in Autumn
Oil on canvas
82.3 x 66.8 cm. (32⅜ x 26⅛ in.)
Lower left: Fred J du Chattel
Bequest of Lucy Williams Burr

Chinnery, George, Follower of
British (worked in India and Canton), 1774-1852

50.3792
Portrait of Hou Qua
Oil on canvas
75.0 x 56.0 cm. (29½ x 22 in.)
*Gift of Mrs. Thomas Motley, Mrs. William Jason
Mixter, Mrs. George B. Dabney, Henry H. Fay,
Frederick L. Dabney and Thomas N. Dabney, in
Memory of Daniel N. and Elisabeth E. Spooner*

Chintreuil, Antoine
French, 1816-1873

22.78
Peasants in a Field
Oil on canvas
95.8 x 134.0 cm. (37¾ x 52¾ in.)
Lower left: Chintreuil
Gift of Mrs. Charles G. Weld

Ciceri, Eugène
French, 1813-1890

13.456
Village of Bouron
Oil on panel
31.9 x 46.1 cm. (12½ x 18⅛ in.)
Lower right: Eug Ciceri / 52
Bequest of Mrs. Edward Wheelwright

Ciceri, Eugène
French, 1813-1890

13.460
*Artist in the Gorge aux Loups, Forest of
Fontainebleau*
Oil on panel
47.3 x 37.0 cm. (18⅝ x 14⅝ in.)
Lower left: Eug Ciceri / 52
Bequest of Mrs. Edward Wheelwright

Ciceri, Eugène
French, 1813-1890

13.464
On the Loing River
Oil on panel
31.6 x 46.0 cm. (12½ x 18 in.)
Lower right: Eug Ciceri 52
Bequest of Mrs. Edward Wheelwright

Cignani, Carlo, Copy after
Italian (Bolognese), 1628-1719

28.856
Triumph of Love (after a fresco in the Palazzo del
Giardino, Parma)
Oil on canvas
Design: 92.8 x 135.4 cm. (36½x 53¼ in.)
Bequest of Sarah Hammond Blane

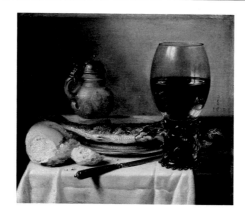

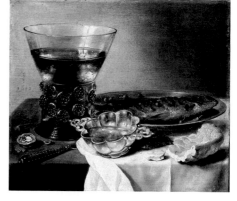

Cipriani, Giovanni Battista, Attributed to
Italian, 1727-1785

17.3230
Portrait of a Child Holding a Doll
Oil on canvas
79.8 x 69.0 cm. (31⅜ x 27⅛ in.)
Robert Dawson Evans Collection

Claesz., Pieter
Dutch, 1597/98-1660

13.458
*Still Life with Stoneware Jug, Wine Glass,
Herring, and Bread*
Oil on panel
30.0 x 35.8 cm. (11¾ x 14⅛ in.)
Center right: PC (monogram) / 1642
Bequest of Mrs. Edward Wheelwright

Claesz., Pieter
Dutch, 1597/98-1660

13.459
*Still Life with Silver Brandy Bowl, Wine Glass,
Herring, and Bread*
Oil on panel
29.9 x 35.9 cm. (11¾ x 14⅛ in.)
Center left: PC (monogram) / 1642
Bequest of Mrs. Edward Wheelwright

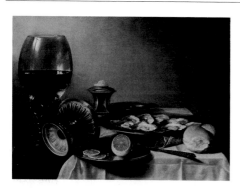

Claesz., Pieter
Dutch, 1597/98-1660

56.883
Still Life with Wine Goblet and Oysters
Oil on panel
50.2 x 70.1 cm. (19¾ x 27⅝ in.)
Center left: PC (monogram) / 163[...]
*Gift of Mrs. H. P. Ahrnke in Memory of her
great-aunt, Mrs. Francis B. Greene*

Claude
 see
Gellée, Claude

Clays, Paul Jean
Belgian, 1819-1900

10.547
Ships on the River Waal
Oil on panel
59.0 x 91.0 cm. (23¼ x 35⅞ in.)
Lower right: P. J. Clays.1871
Gift of Mrs. W. Scott Fitz

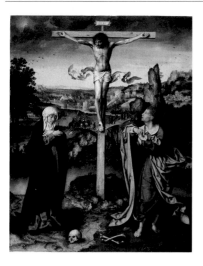

Cleve, Joos van
Flemish, active 1511-died 1540/41

12.170
The Crucifixion
Oil on panel
80.4 x 63.1 cm. (31⅝ x 24⅞ in.)
The Picture Fund

Cock, César de
Belgian, 1823-1904

19.94
Pool in the Forest
Oil on canvas
63.5 x 87.2 cm. (25 x 34⅜ in.)
Lower right: Cesar De Cock / 1873
The Henry C. and Martha B. Angell Collection

Cock, César de
Belgian, 1823-1904

23.484
Stream through the Forest
Oil on canvas
43.7 x 64.3 cm. (17¼ x 25⅜ in.)
Lower right: Cesar De Cock / 1879
Bequest of Ernest Wadsworth Longfellow

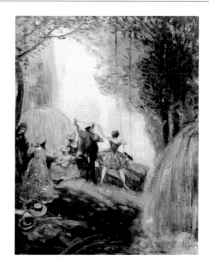

Colonia, Adam
Dutch, 1634-1685

Res. 17.104
The Announcement to the Shepherds
Oil on canvas
80.9 x 66.0 cm. (31⅞ x 26 in.)
Bequest of Elizabeth C. D. Chandler

Conca, Sebastiano
Italian (Roman), 1680-1764

88.342
Sibyl
Oil on canvas
96.7 x 85.6 cm. (38⅛ x 33¾ in.)
Lower right: Sebastianus. Conca fecit 1726
Gift of William Everett

Conder, Charles
British, 1868-1909

42.570
Dance by the Fountains
Oil on canvas
78.2 x 61.5 cm. (30¾ x 24¼ in.)
Lower left: CONDER
Gift of George R. Fearing, Jr.

Constable, John
British, 1776-1837

30.731
Weymouth Bay from the Downs above Osmington Mills
Oil on canvas
56.0 x 77.3 cm. (22 x 30⅜ in.)
Bequest of Mr. and Mrs. William Caleb Loring

Constable, John
British, 1776-1837

45.841
Sea Beach, Brighton (unfinished)
Oil on canvas
65.1 x 99.5 cm. (25⅝ x 39⅛ in.)
Ernest Wadsworth Longfellow Fund

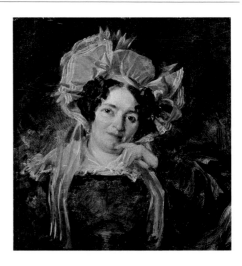

Constable, John
British, 1776-1837

48.266
Stour Valley and Dedham Church
Oil on canvas
55.5 x 77.8 cm. (21⅞ x 30⅝ in.)
Warren Collection

Constable, John
British, 1776-1837

61.241
Portrait of a Woman
Oil on paperboard
22.6 x 21.5 cm. (8⅞ x 8½ in.)
Gift of Ira S. Parke

Constable, John, Attributed to
British, 1776-1837

23.489
A Hilltop
Oil on paper mounted on canvas
32.0 x 49.7 cm. (12⅝ x 19⅝ in.)
Bequest of Ernest Wadsworth Longfellow

Constable, John, Copy after

95.1373
The White Horse (after a painting in the Frick Collection, New York)
Oil on canvas
102.4 x 137.3 cm. (40¼ x 54 in.)
Henry Lillie Pierce Fund

Constable, John, Copy after

17.3247
Summer Afternoon after a Shower (free copy after a painting in the Tate Gallery, London)
Oil on canvas
40.7 x 50.8 cm. (16 x 20 in.)
Robert Dawson Evans Collection

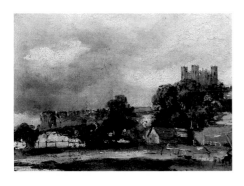

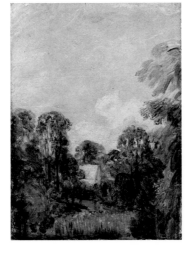

Constable, John, Follower of

84.279
Rochester Castle
Oil on paper mounted on panel
25.0 x 35.2 cm. (9⅞ x 13⅞ in.)
Bequest of Thomas Gold Appleton

Constable, John, Follower of

54.1413
Cottage in a Dell
Oil on paper mounted on panel
24.7 x 18.0 cm. (9¾ x 7⅛ in.)
Bequest of Walter J. Noonan

Constable, John, Style of

55.504
A River Valley
Oil on paper mounted on canvas
12.0 x 21.0 cm. (4¾ x 8¼ in.)
Warren Collection

Constable

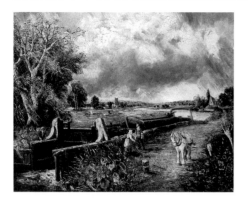 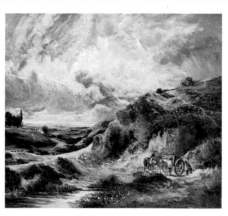

Constable, John, Imitator of
17.3250
A Lock
Oil on canvas
79.8 x 98.2 cm. (31⅜ x 38⅝in.)
Falsely signed, lower right: Jon C[...]Tal
Robert Dawson Evans Collection

Constable, John, Imitator of
1330.12
A Heath
Oil on canvas
82.0 x 95.5 cm. (32¼ x 37⅝ in.)
Deposited by the Trustees of the White Fund, Lawrence, Massachusetts

Constable, Lionel Bicknell
British, 1828-1887
46.398
A Glade
Oil on paper mounted on canvas
24.5 x 30.2 cm. (9⅝ x 11⅞ in.)
Warren Collection

Corneille
see
Beverloo, Cornelis van

Corneille de la Haye (called Corneille de Lyon)
French, active 1534-died 1575
21.137
Portrait of a Young Man
Oil on panel
18.0 x 15.3 cm. (7⅛ x 6 in.)
Helen and Alice Colburn Fund

Corneille de la Haye (called Corneille de Lyon)
French, active 1534-died 1575
24.264
Portrait of a Man
Oil on panel
16.4 x 13.3 cm. (6½ x 5¼ in.)
Charles Augustus Vialle Fund

56

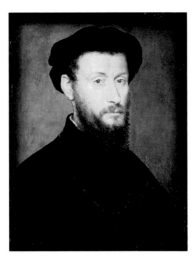

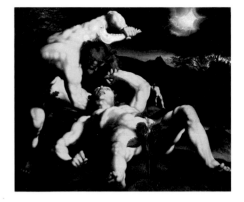

Corneille de la Haye (called Corneille de
Lyon), Workshop of
French, active 1534-died 1575
19.764
Françoise de Longwy
Oil on panel
14.7 x 11.7 cm. (5¾ x 4⅝ in.)
Francis Bartlett Fund

Corneille de la Haye (called Corneille de
Lyon), Workshop of
French, active 1534-died 1575
28.821
Portrait of a Man
Oil on panel
17.1 x 13.4 cm. (6¾ x 5¼ in.)
Seth K. Sweetser Fund

Cornelis Cornelisz. van Haarlem, Copy after
Dutch, 1562-1638
60.960
Cain Killing Abel (after an engraving by Jan
Muller of a lost painting by Cornelis)
Oil on panel
63.9 x 79.4 cm. (25⅛ x 31¼ in.)
M. Theresa B. Hopkins Fund

Corot, Jean Baptiste Camille
French, 1796-1875
75.2
Dante and Virgil
Oil on canvas
260.5 x 170.5 cm. (102½ x 67⅛ in.)
Lower right: C. COROT
Gift of Quincy Adams Shaw

Corot, Jean Baptiste Camille
French, 1796-1875
76.4
Bathers in a Clearing
Oil on canvas
92.0 x 73.2 cm. (36¼ x 28⅞ in.)
Stamped, lower right: VENTE / COROT
Gift of James Davis

Corot, Jean Baptiste Camille
French, 1796-1875
90.199
Forest of Fontainebleau
Oil on canvas
90.2 x 128.8 cm. (35½ x 50¾ in.)
Lower left: COROT
Gift of Mrs. Samuel Dennis Warren

Corot, Jean Baptiste Camille
French, 1796-1875
91.27
Portrait of a Man
Oil on canvas
34.0 x 23.7 cm. (13⅜ x 9⅜ in.)
Lower left: COROT
Gift of Mrs. Samuel Dennis Warren

Corot, Jean Baptiste Camille
French, 1796-1875
94.318
The Piazzetta, Venice
Oil on paper mounted on paperboard
16.0 x 25.0 cm. (6¼ x 9⅞ in.)
Stamped, lower left: VENTE / COROT
Bequest of Frederick Frothingham

Corot, Jean Baptiste Camille
French, 1796-1875
16.1
Souvenir of a Meadow at Brunoy
Oil on canvas
90.6 x 115.9 cm. (35⅝ x 45⅝ in.)
Lower right: COROT
Gift of Augustus Hemenway in Memory of Louis and Amy Hemenway Cabot

Corot, Jean Baptiste Camille
French, 1796-1875
19.79
Old Man Seated on a Trunk
Oil on paper mounted on prestwood
32.1 x 23.0 cm. (12⅝ x 9 in.)
Lower right: COROT
Lower left: Janvier 1826 (scratched into paint)
The Henry C. and Martha B. Angell Collection

Corot, Jean Baptiste Camille
French, 1796-1875

17.3234
Bacchanal at the Spring: Souvenir of Marly-le-Roi
Oil on canvas
82.1 x 66.3 cm. (32⅜ x 26⅛ in.)
Lower left: COROT
Robert Dawson Evans Collection

Corot, Jean Baptiste Camille
French, 1796-1875

19.80
Old Beech Tree
Oil on paper mounted on canvas
55.8 x 46.0 cm. (22 x 18⅛ in.)
Lower right: COROT
The Henry C. and Martha B. Angell Collection

Corot, Jean Baptiste Camille
French, 1796-1875

19.81
Woman with a Pink Shawl (unfinished)
Oil on canvas
67.8 x 56.0 cm. (26¾ x 22 in.)
Stamped, lower left: VENTE / COROT
The Henry C. and Martha B. Angell Collection

Corot, Jean Baptiste Camille
French, 1796-1875

19.82
Farm at Recouvrières, Nièvre
Oil on canvas
47.5 x 70.3 cm. (18¾ x 27⅝ in.)
Lower right: COROT. 1831 (scratched into paint);
COROT
The Henry C. and Martha B. Angell Collection

Corot, Jean Baptiste Camille
French, 1796-1875

23.477
Ville d'Avray
Oil on canvas
27.2 x 45.9 cm. (10¾ x 18⅛ in.)
Lower left: COROT
Bequest of Ernest Wadsworth Longfellow

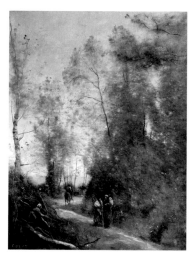

Corot, Jean Baptiste Camille
French, 1796-1875

23.511
Young Woman Weaving a Wreath of Flowers
Oil on canvas
70.2 x 47.0 cm. (27⅝ x 18½ in.)
Lower left: COROT
Bequest of David P. Kimball in Memory of his wife,
Clara Bertram Kimball

Corot, Jean Baptiste Camille
French, 1796-1875

23.515
Farmyard at Sin, near Douai, with Children
at Play
Oil on canvas
33.1 x 46.6 cm. (13 x 18⅜ in.)
Lower right: COROT
Bequest of David P. Kimball in Memory of his wife,
Clara Bertram Kimball

Corot, Jean Baptiste Camille
French, 1796-1875

24.214
Turn in the Road
Oil on canvas
62.5 x 48 cm. (24⅝ x 18⅞ in.)
Lower left: COROT
Gift of Robert Jordan from the Collection of Eben D.
Jordan

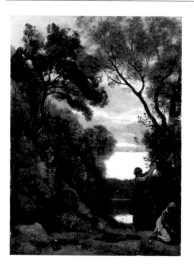

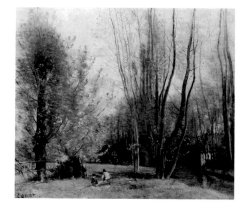

Corot, Jean Baptiste Camille
French, 1796-1875

35.1163
Twilight (Laurel Gatherers)
Oil on canvas
50.3 x 37.0 cm. (19¾ x 14⅝ in.)
Lower left: COROT
Bequest of Mrs. Henry Lee Higginson, Sr., in Memory
of her husband

Corot, Jean Baptiste Camille
French, 1796-1875

39.668
Morning near Beauvais
Oil on canvas
36.0 x 41.5 cm. (14⅛ x 16⅜ in.)
Lower left: COROT
Juliana Cheney Edwards Collection

Corot, Jean Baptiste Camille, Attributed to
French, 1796-1875

94.136
Pond at Sunset
Oil on panel
35.3 x 52.3 cm. (13⅞ x 20⅝ in.)
Lower right: COROT
Bequest of James W. Paige

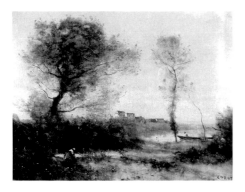

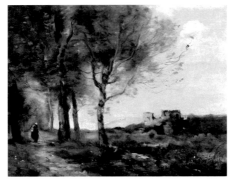

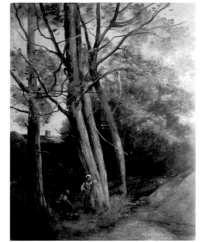

Corot, Jean Baptiste Camille, Attributed to
French, 1796-1875
24.215
Souvenir of the Banks of the Saône
Oil on canvas
41.0 x 54.2 cm. (16⅛ x 21⅜ in.)
Lower right: COROT
*Gift of Robert Jordan from the Collection of Eben D.
Jordan*

Corot, Jean Baptiste Camille, Copy after
17.3249
A Ruin (after a painting in the National Gallery of
Scotland, Edinburgh)
Oil on canvas
40.6 x 54.0 cm. (16 x 21¼ in.)
Falsely signed, lower right: COROT
Robert Dawson Evans Collection

Corot, Jean Baptiste Camille, Copy after
19.85
*Acacia Trees in the Park of M. Louis Dubuisson
in Brunoy* (free copy after a painting in a private
collection, New York)
101.0 x 80.5 cm. (39¾ x 31¾ in.)
Falsely signed, lower left: COROT
The Henry C. and Martha B. Angell Collection

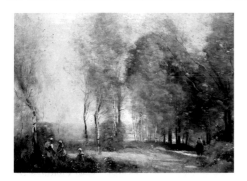

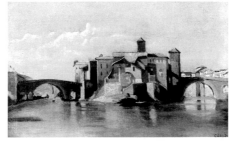

Corot, Jean Baptiste, Camille, Copy After
19.172
Peasants in a Clearing near Arras (after a
painting known from a reproduction)
Oil on canvas
42.7 x 61.7 cm. (16¾ x 24¼in.)
Falsely signed, lower left: COROT
Bequest of Alexander Cochrane

Corot, Jean Baptiste Camille, Copy after
23.118
Island of San Bartolomeo, Rome (after a painting
in a private collection, Cannes)
Oil on paper mounted on canvas
26.5 x 43.0 cm. (10⅜ x 16 in.)
Falsely signed, lower right: COROT
Harriet Otis Cruft Fund

Corot, Jean Baptiste Camille, Style of
Res. 27.51
Woods and a River with an Iron Bridge
Oil on panel
19.6 x 40.4 cm. (7¾ x 15⅞ in.)
Falsely signed, lower right: COROT (now partially
effaced)
Gift of Mrs. Ellerton James

Corot, Jean Baptiste Camille, Imitator of
Res. 27.91
Landscape
Oil on canvas
22.3 x 35.2 cm. (8¾ x 13⅞ in.)
Falsely signed, lower right: COROT
Bequest of Miss Elizabeth Howard Bartol

Correggio (Antonio Allegri, called Correggio),
Copy after
Italian (School of Parma) active about 1514-died
1534
12.378
The Mystical Marriage of Saint Catherine (after a
painting in the Museo di Capodimonte, Naples)
Oil on canvas
26.0 x 22.0 cm. (10¼ x 8⅝ in.)
*Gift of Miss Sarah Harding Blanchard from the
Estate of Henry Williamson Haynes*

Correggio, Copy after
Res. 17.103
Holy Night (after a painting in the Staatliche
Kunstsammlungen, Dresden)
Oil on canvas
103.0 x 76.2 cm. (40½ x 30 in.)
Bequest of Elizabeth C. D. Chandler

Correggio, Follower of
56.265
Head of a Cherub
Fresco transferred to panel
21.5 x 20.0 cm. (8½ x 7⅞ in.)
Charles Potter Kling Fund

Corvi, Domenico
Italian (Roman), 1721-1803
90.76
Virgin and Child
Oil on canvas
60.0 x 48.5 cm. (23⅝ x 19⅛ in.)
Bequest of Mrs. Henry Edwards

Corvus, Johannes, Attributed to
Flemish (worked in England), active 1512-died
after 1544
48.1142
Catherine of Aragon
Oil on panel
58.0 x 45.8 cm. (22⅞ x 18 in.)
Elizabeth Day McCormick Collection

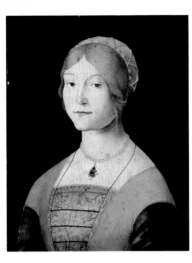

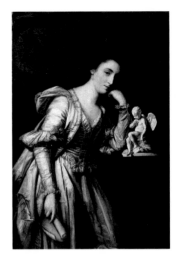

Costa, Giovanni
Italian, 1826-1903
04.1616
Ruins in the Roman Campagna
Oil on panel
21.0 x 43.0 cm. (8¼ x 16⅞ in.)
Lower left: G. COSTA
Bequest of Sarah Wyman Whitman

Costa, Lorenzo
Italian (Ferrarese), about 1460-1535
25.227
Portrait of a Woman with a Pearl Necklace
Oil on panel (panel restored along proper left,
44.0 x 3.6 - 6.6 cm.)
44.0 x 33.9 cm. (17⅜ x 13⅜ in.)
Bequest of Mrs. Thomas O. Richardson

Cotes, Francis
British, 1726-1770
54.1411
Portrait of a Woman with a Statuette of Cupid
(fragment of a double portrait)
Oil on canvas
121.8 x 84.0 cm. (48 x 33⅛ in.)
Bequest of Walter J. Noonan

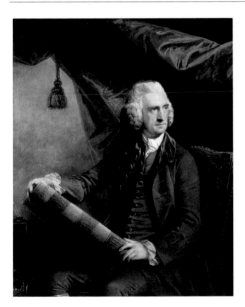

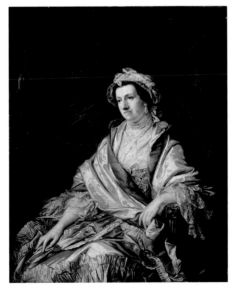

Cotes, Francis
British, 1726-1770
48.277
Benjamin Vaughan
Oil on canvas
127.0 x 102.0 cm. (50 x 40⅛ in.)
Center left: FCotes pxt. 1768 (F and C joined)
*Gift of Samuel Vaughan and Mary Vaughan
Marvin*

Cotes, Francis
British, 1726-1770
48.278
Mrs. Benjamin Vaughan (born Hannah
Halfhide)
Oil on canvas
127.5 x 102.0 cm. (50¼ x 40⅛ in.)
Center left: FCotes px[...] 1766. (F and C joined)
*Gift of Samuel Vaughan and Mary Vaughan
Marvin*

Courbet, Jean Désiré Gustave
French, 1819-1877
18.620
The Quarry *(La Curée)*
Oil on canvas
210.2 x 183.5 cm. (82¾ x 72¼ in.)
Lower right: G. Courbet.
Henry Lillie Pierce Fund

Courbet, Jean Désiré Gustave
French, 1819-1877
48.530
Hollyhocks in a Copper Bowl
Oil on canvas
60.0 x 49.0 cm. (23⅝ x 19¼ in.)
Lower left: 72. / G. Courbet.
Bequest of John T. Spaulding

Courbet, Jean Désiré Gustave
French, 1819-1877
55.982
Stream in the Forest
Oil on canvas
157.0 x 114.0 cm. (61¾ x 44⅞ in.)
Lower right: G. Courbet
Gift of Mrs. Samuel Parkman Oliver

Courbet, Jean Désiré Gustave
French, 1819-1877
57.702
Reclining Nude
Oil on paper mounted on canvas
104.7 x 143.4 cm. (41¼ x 56½ in.)
Lower left: G. Courbet
Gift of Mrs. Samuel Parkman Oliver

Courbet, Jean Désiré Gustave, and Studio
French, 1819-1877

24.454
Wooded Hillside in Winter
Oil on canvas
54.5 x 45.0 cm. (21½ x 17¾ in.)
Lower left: G. Courbet
Seth K. Sweetser Fund

Courbet, Jean Désiré Gustave, Imitator of
 attributed to
Pata, Cherubino
French, 1827-after 1899

41.113
Landscape in the Franche-Comté
Oil on canvas
54.6 x 65.5 cm. (21½ x 25¾ in.)
Falsely signed, lower left: G. Courbet
Gift of Edward Jackson Holmes

Couture, Thomas
French, 1815-1879

80.484
Head of a Young Woman
Oil on canvas
50.0 x 43.1 cm. (19⅝ x 17 in.)
Lower right: T.C.
Gift by Contribution

Couture, Thomas
French, 1815-1879

77.236
Two Soldiers (study for *The Enrollment of the
Volunteers of 1792*)
Oil on canvas
81.8 x 65.5 cm. (32¼ x 25¾ in.)
Lower left: T.C. / Etude faite pour / des
enrôlements volontaires / de 1792.
Gift by Contribution

Couture, Thomas
French, 1815-1879

91.28
Portrait of a Woman
Oil on canvas
46.3 x 37.6 cm. (18¼ x 14¾ in.)
Lower left: T C
Gift of Mrs. Samuel Dennis Warren

Couture, Thomas
French, 1815-1879

99.4
Family Group
Oil on canvas
40.5 x 32.0 cm. (16 x 12⅝ in.)
James Fund

Couture, Thomas
French, 1815-1879

20.594
Head of a Woman in Profile
Oil on canvas
55.8 x 46.3 cm. (22 x 18¼ in.)
Lower left: T.C.
Peter Chardon Brooks Memorial Collection
Gift of Mrs. Richard M. Saltonstall

Couture, Thomas
French, 1815-1879

23.462
A Soldier (study for *The Enrollment of the Volunteers of 1792*)
Oil on paperboard
45.9 x 36.5 cm. (18⅛ x 14⅜ in.)
Bequest of Ernest Wadsworth Longfellow

Couture, Thomas
French, 1815-1879

23.499
A Widow
Oil on canvas
92.2 x 73.6 cm. (36¼ x 29 in.)
Lower left: T. Couture. / 1840
Bequest of Ernest Wadsworth Longfellow

Couture, Thomas
French, 1815-1879

23.570
A Miser (study for *Timon of Athens*)
Oil on canvas
81.2 x 65.3 cm. (32 x 25¾ in.)
Lower left: T.C.
Bequest of Ernest Wadsworth Longfellow

Couture, Thomas
French, 1815-1879

24.226
Nymph and Cupids
Oil on canvas
35.0 x 27.5 cm. (13¾ x 10⅞ in.)
Lower right: Th. Couture .60
Gift of Robert Jordan from the Collection of Eben D. Jordan

Cox, Jan
Belgian, 1919-1980

59.341
Second Loss of Eurydice
Oil on canvas
156.5 x 160.2 cm. (61⅝ x 63⅛ in.)
S. A. Denio Collection

Cozzarelli, Guidoccio di Giovanni, and Workshop
Italian (Sienese), 1450-1516

21.1460
Virgin and Child with Saints John the Baptist and Jerome
Tempera on panel
Panel: 71.9 x 49.3 cm. (28¼x 19⅜ in.)
Design: 65.5 x 43.0 cm. (25¾ x 16⅞ in.)
William Sturgis Bigelow Collection

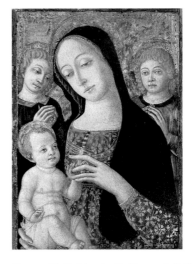

Cozzarelli, Guidoccio di Giovanni, Follower of

06.121
Virgin and Child with Angels
Tempera on panel
44.0 x 31.2 cm. (17⅜ x 12¼ in.)
Ross Collection
Denman Waldo Ross Collection

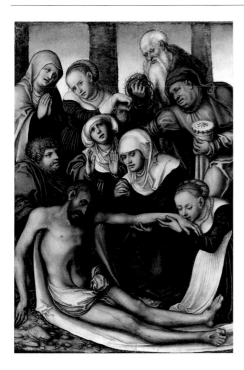

Cranach, Lucas, the Elder
German, 1472-1553

74.28
The Lamentation
Oil on panel
60.3 x 40.1 cm. (23¾ x 15¾ in.)
Lower left, on rock: 1538 / winged dragon symbol
Bequest of Charles Sumner

Cranach, Lucas, the Elder
German, 1472-1553

1970.348
The Lamentation with the Two Thieves Crucified
Oil on panel
38.1 x 26.7 cm. (15 x 10½ in.)
Center, on middle cross: winged dragon symbol
Seth K. Sweetser Fund

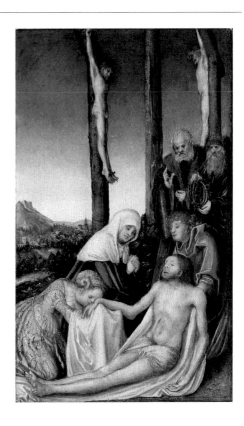

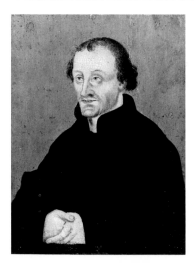

Cranach, Lucas, the Elder, Imitator of
15.288
Melancthon (freely after a portrait known in
several versions)
Oil on panel
20.4 x 15.1 cm. (8 x 6 in.)
Falsely signed, center right: winged dragon
symbol
Gift of George A. Goddard

Cranach, Lucas, the Younger
German, 1515-1586
11.3035
Portrait of a Woman
Oil on panel
63.8 x 47.0 cm. (25⅛ x 18½ in.)
Center right: winged dragon symbol / 1549
Special Fund for the Purchase of Paintings

Crespi, Giuseppe Maria
Italian (Bolognese), 1665-1747
45.101
Chancellor Florius Senesius
Oil on canvas
115.5 x 96.0 cm. (45½ x 37¾ in.)
M. Theresa B. Hopkins Fund

Crespi, Giuseppe Maria
Italian (Bolognese), 1665-1747
69.958
Woman Playing a Lute
Oil on canvas
121.3 x 153.0 cm. (47¾ x 60¼ in.)
Charles Potter Kling Fund

Creti, Donato
Italian (Bolognese), 1671-1749
1984.138
The Cumaean Sibyl
Oil on canvas
43.5 x 36.5 cm. (17⅜ x 14⅜ in.)
Upper left: [...]ASCETU / DE / VIRGINE / DONATO
CRETI / BOLO[...]NE : F.
*Purchased by Friends of John Walsh, in Honor of his
tenure as Mrs. Russell Baker Curator of Paintings*

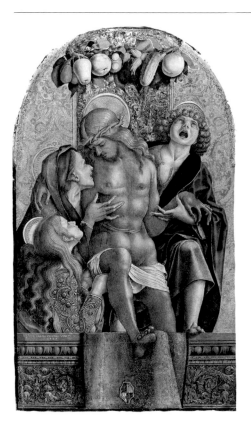

Crivelli, Carlo
Italian (Venetian), active 1457-died 1495
02.4
*The Virgin with the Dead Christ and Saints
Mary Magdalen and John*
Tempera on panel
88.5 x 52.6 cm. (34⅞ x 20¾ in.)
Lower left, on pediment: OPVS · CAROLI ·
CRIVELLI · VENETI / ·1·4·8·5·
James Fund and Anonymous Gift

Crome, John
British, 1768-1821
06.2418
Windmill near Norwich
Oil on canvas
63.7 x 76.5 cm. (25⅛ x 30⅛ in.)
Bequest of Mrs. Martin Brimmer

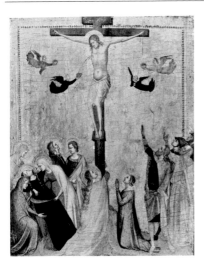

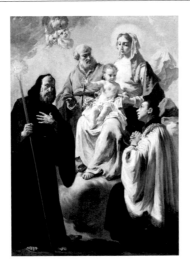

Daddi, Bernardo, Workshop of
Italian (Florentine), active about 1320-1348

23.211
The Crucifixion
Tempera on panel
Overall: 40.2 x 32.1 cm. (15⅞ x 12⅝ in.)
Design: 36.7 x 28.2 cm. (14½ x 11⅛ in.)
Helen Collamore Fund

Daggiù, Francesco (called Francesco Capella)
Italian (Venetian), 1714-1784

45.100
*The Holy Family in Glory with Saints Francis of
Paola and Aloysius Gonzaga*
Oil on canvas
167.3 x 122.0 cm. (65⅞ x 48 in.)
Ernest Wadsworth Longfellow Fund

Dagnan-Bouveret, Pascal Adolphe Jean
French, 1852-1929

23.527
Woman in Breton Costume Seated in a Meadow
(study for *Breton Women at a Pardon*)
Oil on canvas
41.5 x 32.5 cm. (16⅜ x 12¾ in.)
Lower right: P·A·J· DAGNAN-B 1887
*Bequest of David P. Kimball in Memory of his wife,
Clara Bertram Kimball*

Dagnan-Bouveret, Pascal Adolphe Jean
French, 1852-1929

24.216
Willows by a Stream
Oil on canvas
65.4 x 81.4 cm. (25¾ x 32 in.)
Lower right: PAJ DAGNAN-B
*Gift of Robert Jordan from the Collection of Eben D.
Jordan*

Dahl, Michael, and Workshop
Swedish (worked in England), 1656-1743

35.1229
Portrait of a Baron
Oil on canvas
126.5 x 102.0 cm. (49¾ x 40⅛ in.)
Gift of Frederick L. Jack

Daubigny, Charles François
French, 1817-1878

04.1615
Farm by a River
Oil on panel
23.8 x 43.5 cm. (9⅜ x 17⅛ in.)
Lower right: Daubigny 18[...]
Bequest of Sarah Wyman Whitman

Daubigny, Charles François
French, 1817-1878

90.200
Road through the Forest
Oil on canvas
64.5 x 92.5 cm. (25⅜ x 36⅜ in.)
Lower right: Daubigny
Gift of Mrs. Samuel Dennis Warren

Daubigny, Charles François
French, 1817-1878

17.3237
Rising Ground near Villeneuve-St. Georges
Oil on panel
39.4 x 66.5 cm. (15½ x 26⅛ in.)
Lower left: C Daubigny 1875
Robert Dawson Evans Collection

Daubigny, Charles François
French, 1817-1878

17.3242
Village Road
Oil on panel
29.6 x 44.9 cm. (11⅝ x 17⅝ in.)
Lower left: Daubigny 1861
Robert Dawson Evans Collection

Daubigny, Charles François
French, 1817-1878

18.18
Château-Gaillard at Sunset
Oil on canvas
38.1 x 68.5 cm. (15 x 27 in.)
Gift of Mrs. Josiah Bradlee

Daubigny, Charles François
French, 1817-1878

19.87
Farm on the Bank of a River
Oil on panel
38.4 x 66.7 cm. (15⅛ x 26¼ in.)
Lower left: Daubigny 1873
The Henry C. and Martha B. Angell Collection

Daubigny, Charles François
French, 1817-1878
19.90
House of Mère Bazot, Valmandois
Oil on panel
31.5 x 59.4 cm. (12⅜ x 23⅜ in.)
Lower left: Daubigny 1872
The Henry C. and Martha B. Angell Collection

Daubigny, Charles François
French, 1817-1878
20.1864
Woman Washing Clothes at the Edge of a River
Oil on canvas
36.2 x 76.5 cm. (14¼ x 30⅛ in.)
Lower left: Daubigny
Gift of Louisa W. and Marian R. Case

Daubigny, Charles François
French, 1817-1878
23.400
Ile-de-Vaux on the Oise near Auvers
Oil on panel
40.5 x 68.5 cm. (16 x 27 in.)
Lower left: Daubigny 1876
Bequest of Mrs. David P. Kimball

Daubigny, Charles François
French, 1817-1878
40.547
Barge on a River
Oil on panel
21.5 x 41.0 cm. (8½ x 16⅛ in.)
Lower left: Daubigny
Gift of Mrs. George H. Davenport

Daubigny, Charles François, Attributed to
French, 1817-1878
19.89
Sunset by a River
Oil on canvas
49.2 x 90.2 cm. (19⅜ x 35½ in.); known to have
been cut down substantially late in 19th century
Lower right, probably later addition:
Daubigny [...]
The Henry C. and Martha B. Angell Collection

Daubigny, Imitator
19.91
Riverbank in Spring
Oil on panel
38.3 x 67.0 cm. (15⅛ x 26⅜ in.)
Lower right: Daubigny 1866
The Henry C. and Martha B. Angell Collection

Daubigny, Karl Pierre
French, 1846-1886
37.1216
Windmills near Dordrecht
Oil on panel
34.4 x 58.0 cm. (13½ x 22⅞ in.)
Lower left: Karl Daubigny 1873
Gift of Miss Amelia Peabody

Daumier, Honoré Victorin
French, 1808-1879
41.726
Horsemen
Oil on canvas
60.4 x 85.3 cm. (23¾ x 33⅝ in.)
Tompkins Collection

Daumier, Honoré Victorin
French, 1808-1879
43.31
Man on a Rope
Oil on canvas
110.5 x 72.3 cm. (43½ x 28½ in.)
Tompkins Collection

Daumier, Honoré Victorin
French, 1808-1879
48.531
Triumphant Advocate
Oil on canvas
60.2 x 45.0 cm. (23¾ x 17¾ in.)
Lower right: hD
Bequest of John T. Spaulding

Decamps, Alexandre Gabriel
French, 1803-1860
03.738
Don Quixote Charging the Sheep
Oil on canvas
40.5 x 32.5 cm. (16 x 12¾ in.)
Lower right: DC.
Bequest of Josiah Bradlee

Decamps, Alexandre Gabriel
French, 1803-1860
07.87
Farmyard
Oil on panel
21.7 x 40.7 cm. (8½ x 16 in.)
Lower right: DECAMPS
Otis Norcross Fund

Decamps, Alexandre Gabriel
French, 1803-1860
19.109
Windmill
Oil on canvas
19.0 x 24.5 cm. (7½ x 9⅝ in.)
Lower left: DC
The Henry C. and Martha B. Angell Collection

Decamps, Alexandre Gabriel
French, 1803-1860
23.508
Young Beggars
Oil on canvas
27.0 x 33.5 cm. (10⅝ x 13⅛ in.)
Bequest of David P. Kimball in Memory of his wife, Clara Bertram Kimball

Decamps, Alexandre Gabriel, Attributed to
French, 1803-1860
41.118
Old Port, Singapore
Oil on canvas
35.0 x 57.0 cm. (13¾ x 22⅜ in.)
Lower right: DECAMPS 1860
Stamped, lower left: VENTE / DECAMPS
Gift of Edward Jackson Holmes

Degas, Hilaire Germain Edgar
French, 1834-1917
03.1034
Race Horses at Longchamp
Oil on canvas
34.1 x 41.8 cm. (13⅜ x 16½ in.)
Lower left: E Degas
S. A. Denio Collection

Degas, Hilaire Germain Edgar
French, 1834-1917

09.295
Landscape
Pastel over monotype on paper
Sheet: 26.7 x 35.6 cm. (10½ x 14 in.)
Plate: 25.4 x 34.0 cm. (10 x 13⅜ in.)
Lower left: degas
Denman Waldo Ross Collection

Degas, Hilaire Germain Edgar
French, 1834-1917

09.296
Landscape
Pastel over monotype on paper
Sheet: 31.1 x 41.3 cm. (12¼ x 16¼ in.)
Plate: 30.3 x 40.0 cm. (11⅞ x 15¾ in.)
Lower right: degas
Denman Waldo Ross Collection

Degas, Hilaire Germain Edgar
French, 1834-1917

20.164
Dancers in Rose
Pastel on paper
84.1 x 58.1 cm. (33⅛ x 22⅞ in.)
Lower left: degas
Seth K. Sweetser Fund

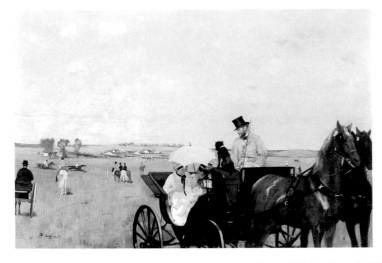
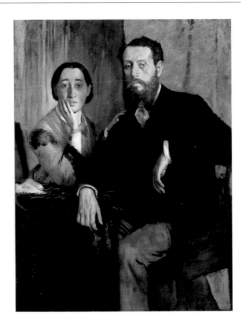

Degas, Hilaire Germain Edgar
French, 1834-1917

26.790
Carriage at the Races
Oil on canvas
36.5 x 55.9 cm. (14⅜ x 22 in.)
Lower left: Degas
1931 Purchase Fund

Degas, Hilaire Germain Edgar
French, 1834-1917

31.33
Edmondo and Thérèse Morbilli
Oil on canvas
116.5 x 88.3 cm. (45⅞ x 34¾ in.)
Gift of Robert Treat Paine, 2nd

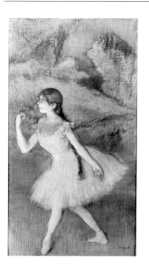

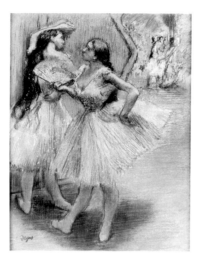

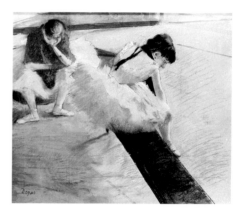

Degas, Hilaire Germain Edgar
French, 1834-1917

35.27
Dancer
Pastel on paper mounted on cardboard
77.0 x 45.0 cm. (30¼ x 17¾ in.)
Lower right: degas
Tompkins Collection

Degas, Hilaire Germain Edgar
French, 1834-1917

38.890
Two Dancers in the Wings
Pastel on paper mounted on cardboard
59.5 x 46.5 cm. (23¼ x 18¼ in.)
Lower left: degas
Given by Mrs. Robert B. Osgood in Memory of Horace D. Chapin

Degas, Hilaire Germain Edgar
French, 1834-1917

39.669
Dancers Resting
Pastel on paper mounted on cardboard
50.0 x 58.5 cm. (19⅝ x 23 in.)
Lower left: degas
Juliana Cheney Edwards Collection

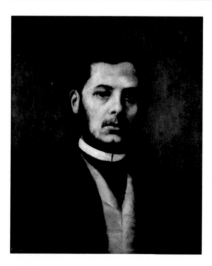

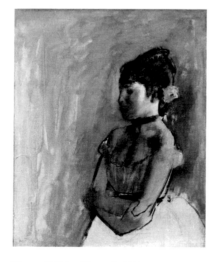

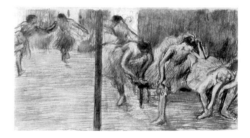

Degas, Hilaire Germain Edgar
French, 1834-1917

48.532
Portrait of a Man
Oil on canvas
55.4 x 45.5 cm. (21¾ x 17⅞ in.)
Stamped, lower left: degas
Bequest of John T. Spaulding

Degas, Hilaire Germain Edgar
French, 1834-1917

48.534
Ballet Dancer with Arms Crossed (study for *Dancers Backstage*)
Oil on canvas
61.4 x 50.5 cm. (24⅛ x 19⅞ in.)
Stamped, lower left: degas
Bequest of John T. Spaulding

Degas, Hilaire Germain Edgar
French, 1834-1917

54.1557
Dancers in the Lobby
Charcoal with pastel on paper mounted on cardboard
45.5 x 85.0 cm. (17⅞ x 33½ in.)
Stamped, lower left: degas
Gift of Arthur Wiesenberger

Degas, Hilaire Germain Edgar
French, 1834-1917

48.533
*Degas' Father Listening to Lorenzo Pagans
Playing the Guitar*
Oil on canvas
81.6 x 65.2 cm. (32⅛ x 25⅝ in.)
Bequest of John T. Spaulding

Degas, Hilaire Germain Edgar
French, 1834-1917

69.49
Visit to a Museum
Oil on canvas
91.8 x 68.0 cm. (36⅛ x 26¾ in.)
Stamped, lower left: degas
Anonymous Gift

Degas, Hilaire Germain Edgar
French, 1834-1917

1980.390
Cliffs on the Edge of the Sea
Pastel on paper
44.3 x 58.5 cm. (17⅜ x 23 in.)
Lower left: (signed indistinctly)
*Gift of Lydia Pope Turtle and Isabel Pope Conant in
Memory of their father, Hubert Pope*

Delacroix, Ferdinand Victor Eugène
French, 1798-1863

95.179
Lion Hunt
Oil on canvas
91.7 x 117.5 cm. (36⅛ x 46¼ in.)
Lower right: Eug. Delacroix 1858.
S. A. Denio Collection

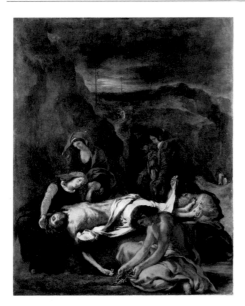

Delacroix, Ferdinand Victor Eugène
French, 1798-1863

96.21
The Entombment of Christ
Oil on canvas
162.6 x 132.1 cm. (64 x 52 in.)
Lower left: Eug. Delacroix · / 1848
Gift by Contribution in Memory of Martin Brimmer

Delacroix, Ferdinand Victor Eugène,
Attributed to
French, 1798-1863

03.742
The Descent from the Cross
Oil over pen and ink on paper mounted on panel
32.3 x 47.0 cm. (12¾ x 18½ in.)
Bequest of Josiah Bradlee

Delacroix, Copy after

03.741
Christ on the Lake of Gennesaret (after a painting
in a private collection, Zurich)
Oil on paperboard
25.0 x 31.6 cm. (9⅞ x 12⅜ in.)
Falsely signed, lower right: Eug. Delacroix
Bequest of Josiah Bradlee

Delacroix, Copy after
 attributed to
Andrieu, Pierre, French, 1821-1892

21.1452
*Winter: Juno Beseeching Aeolus to Destroy the
Fleet of Aeneas* (after a painting in the Museu de
Arte, São Paulo)
Oil on paperboard
29.0 x 25.0 cm. (11⅜ x 9⅞ in.)
Stamped, lower left: VENTE / ANDRIEU / E.
DELACROIX
William Sturgis Bigelow Collection

Delacroix, Copy after
 attributed to
Andrieu, Pierre, French, 1821-1892

21.1453
*Autumn: Bacchus Returning from the Indies
Finds Ariadne Abandoned* (after a painting in the
Museu de Arte, São Paulo)
Oil on paperboard
28.6 x 23.5 cm. (11¼ x 9¼ in.)
Stamped, lower left: VENTE / ANDRIEU / E.
DELACROIX
William Sturgis Bigelow Collection

Delacroix, Copy after
 attributed to
Andrieu, Pierre, French, 1821-1892
21.1454
Summer: Diana Surprised at her Bath by Actaeon
(after a painting in the Museu de Arte, São Paulo)
Oil on paperboard
28.8 x 23.3 cm. (11⅜ x 9⅛ in.)
Stamped, lower left: VENTE / ANDRIEU / E.
DELACROIX
William Sturgis Bigelow Collection

Delacroix, Copy after
 attributed to
Andrieu, Pierre, French, 1821-1892
21.1455
Spring: Orpheus Coming to the Aid of Eurydice
(after a painting in the Museu de Arte, São Paulo)
Oil on paperboard
28.8 x 24.8 cm. (11⅜ x 9¾ in.)
Stamped, lower left: VENTE / ANDRIEU / E.
DELACROIX
William Sturgis Bigelow Collection

Delaroche, Hippolyte (called Paul Delaroche)
French, 1797-1856
11.1449
Marquis de Pastoret
Oil on canvas
155.3 x 122.6 cm. (61⅛ x 48¹/₆ in.)
Lower left: P. DelaRoche

Upper right (now barely visible): CLAUDE
EMMANUEL JOSEPH PIERRE / MARQUIS DE
PASTORET / CHANCELIER DE FRANCE / TUTEUR
DES ENFANTS DE FRANCE
Susan Cornelia Warren Fund and the Picture Fund

Denner, Balthasar, Follower of
German, 1685-1749
74.18
Head of an Old Man
Oil on canvas
45.9 x 35.4 cm. (18⅛ x 13⅞ in.)
Bequest of Charles Sumner

Derain, André
French, 1880-1954
48.535
Landscape in Southern France
Oil on canvas
50.4 x 60.8 cm. (19⅞ x 23⅞ in.)
Lower right: A derain
Bequest of John T. Spaulding

Derain, André
French, 1880-1954
48.536
Geneviève Taillade in an Orange Jacket
Oil on canvas
61.5 x 50.5 cm. (24¼ x 19⅞ in.)
Lower right: a. derain
Bequest of John T. Spaulding

Desbarolles, Adolphe
French, 1801-1886
1982.385
Harbor at Dunkirk
Oil on canvas
19.1 x 28.3 cm. (7½ x 11⅛ in.)
Falsely signed, lower left: COROT
Bequest of Rowland Burdon-Muller

Deshayes, Eugène
French, 1828-1890
74.5
Landscape with a Mill
Oil on canvas
32.8 x 24.5 cm. (12⅞ x 9⅝ in.)
Lower left: Eug. Deshayes 60
Bequest of Charles Sumner

Detaille, Jean Baptiste Edouard
French, 1848-1912
24.218
Cavalry Charge
Oil on canvas
149.0 x 121.0 cm. (58⅝ x 47⅝ in.)
Lower left: EDOUARD DETAILLE / 1902
Gift of Robert Jordan from the Collection of Eben D. Jordan

Devis, Arthur
British, 1712-1787
53.2856
Portrait of a Man Standing beside a Table
Oil on canvas
50.8 x 36.0 cm. (20 x 14⅛ in.)
Center left, on back chair rail: ADevis fe / 1745
Anonymous Gift

Devis, Arthur
British, 1712-1787
53.2857
Portrait of a Woman Seated beside a Table
Oil on canvas
50.7 x 35.8 cm. (20 x 14⅛ in.)
Anonymous Gift

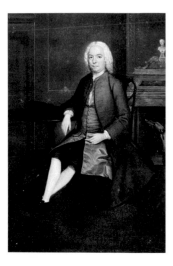

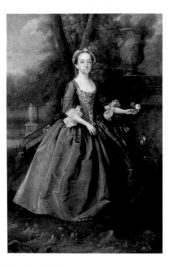

Devis, Arthur
British, 1712-1787
53.2858
Portrait of a Man Seated beside a Table
Oil on canvas
50.8 x 35.6 cm. (20 x 14 in.)
Anonymous Gift

Devis, Arthur
British, 1712-1787
53.2859
Portrait of a Woman Standing in a Garden
Oil on canvas
50.7 x 35.6 cm. (20 x 14 in.)
Anonymous Gift

De Wint, Peter
British, 1784-1849
35.1488
Barges on a River
Oil on paperboard mounted on panel
35.1 x 49.0 cm. (13⅞ x 19¼ in.)
Gift of the Estate of Heloise E. Hersey

Diaz de la Peña, Narcisse Virgile
French, 1808-1876
77.138
Path in the Forest
Oil on panel
26.0 x 35.2 cm. (10¼ x 13⅞ in.)
Lower left: N. Diaz.
Gift by Contribution through James William Paige

Diaz de la Peña, Narcisse Virgile
French, 1808-1876
84.278
Turkish Café
Oil on paperboard
14.1 x 21.8 cm. (5½ x 8⅝ in.)
Bequest of Thomas Gold Appleton

Diaz de la Peña, Narcisse Virgile
French, 1808-1876
94.137
Forest Interior
Oil on panel
37.0 x 60.0 cm. (14⅝ x 23⅝ in.)
Lower left: N. DIAZ. 1840.
Bequest of James William Paige

Diaz de la Peña, Narcisse Virgile
French, 1808-1876

03.600
Bohemians Going to a Fête
Oil on canvas
101.0 x 81.3 cm. (39¾ x 32 in.)
Lower left: N. DIAZ.
Bequest of Susan Cornelia Warren

Diaz de la Peña, Narcisse Virgile
French, 1808-1876

03.739
Venus and Cupid (II)
Oil on paperboard mounted on panel
32.5 x 19.9 cm. (12¾ x 7⅞ in.)
Lower left: N. Diaz · 47
Bequest of Josiah Bradlee

Diaz de la Peña, Narcisse Virgile
French, 1808-1876

07.137
Pool in the Forest
Oil on canvas
56.2 x 75.3 cm. (22⅛ x 29⅝ in.)
Lower left: N. Diaz. 58-
Gift of the Estate of Elizabeth Howes

Diaz de la Peña, Narcisse Virgile
French, 1808-1876

17.3246
Fields at Barbizon
Oil on panel
32.0 x 43.5 cm. (12⅝ x 17⅛ in.)
Lower right: N. Diaz. 67.
Robert Dawson Evans Collection

Diaz de la Peña, Narcisse Virgile
French, 1808-1876

17.3253
Young Women Bathing
Oil on panel
41.0 x 26.0 cm. (16⅛ x 10¼ in.)
Lower right: N. Diaz
Robert Dawson Evans Collection

Diaz de la Peña, Narcisse Virgile
French, 1808-1876

19.105
Path through the Forest near Fontainebleau
Oil on panel
49.3 x 61.0 cm. (19⅜ x 24 in.)
Lower right: N. Diaz.
The Henry C. and Martha B. Angell Collection

Diaz de la Peña, Narcisse Virgile
French, 1808-1876

23.478
Venus and Cupid (I)
Oil on canvas
41.9 x 33.6 cm. (16½ x 13¼ in.)
Lower left: N. Diaz
Bequest of Ernest Wadsworth Longfellow

Diaz de la Peña, Narcisse Virgile
French, 1808-1876

23.479
Forest Interior with Faggot Gatherer
Oil on panel
45.0 x 54.0 cm. (17¾ x 21¼ in.)
Lower left: N. Diaz. 57.
Bequest of Ernest Wadsworth Longfellow

Diaz de la Peña, Narcisse Virgile
French, 1808-1876

24.236
Flowers
Oil on canvas
40.0 x 25.0 cm. (15¾ x 9⅞ in.)
Lower right: N. Diaz.
Bequest of Ellen F. Moseley through Margaret LeMoyne Wentworth and Helen Freeman Hull

Diaz de la Peña, Narcisse Virgile
French, 1808-1876

30.501
Young Women in Turkish Costume
Oil on canvas
36.7 x 28.2 cm. (14½ x 11⅛ in.)
Lower left: N Diaz.
Bequest of Harriet J. Bradbury

Diaz de la Peña, Narcisse Virgile
French, 1808-1876

41.116
Young Women Resting in a Forest Clearing
Oil on panel
30.0 x 45.7 cm. (11¾ x 18 in.)
Lower left: N. Diaz.
Gift of Edward Jackson Holmes

Diaz de la Peña, Narcisse Virgile
French, 1808-1876
48.537
Clearing in the Forest
Oil on panel
18.4 x 23.5 cm. (7¼ x 9¼ in.)
Lower left: N. Diaz.
Bequest of John T. Spaulding

Diaz de la Peña, Narcisse Virgile
French, 1808-1876
59.779
Three Women (study for *The Assumption of the Blessed Virgin*)
Oil on panel
59.5 x 39.5 cm. (23⅜ x 15½ in.)
Lower right: N. Diaz.
Anonymous Gift

Dieterle van Marcke de Lumnen, Marie
French, 1856-1935
15.883
Going to Market
Oil on canvas
58.8 x 48.6 cm. (23⅛ x 19⅛ in.)
Lower left: Marie Dieterle
William R. Wilson Donation

Dieterle van Marcke de Lumnen, Marie
French, 1856-1935
20.1869
Cows in a Pasture
Oil on canvas
68.6 x 95.8 cm. (27 x 37¾ in.)
Lower left: Marie Dieterle van Marcke
Gift of Louisa W. and Marian R. Case

Dolci, Carlo, Studio of
Italian (Bolognese), 1616-1686
Res. 15.87
Salome with the Head of Saint John the Baptist
Oil on canvas
118.5 x 94.8 cm. (46⅝ x 37⅜ in.)
Gift of Mrs. Otis Kimball

Doré, Paul Gustave Louis Christophe
French, 1832-1883
73.8
Summer
Oil on canvas
266.5 x 200.1 cm. (104⅞ x 78¾ in.)
Lower left: Gve Doré
Gift of Richard Baker

Dou, Gerard, Imitator of
Dutch, 1613-1675
22.643
Hermit Praying
Oil on panel
45.0 x 35.0 cm. (17¾ x 13¾ in.)
Zoe Oliver Sherman Collection

Drolling, Martin, Copy after
French, 1752-1817
90.81
Interior of a Kitchen (after a painting in the
Musée du Louvre, Paris)
Oil on canvas
64.8 x 81.2 cm. (25½ x 32 in.)
Bequest of Mrs. Henry Edwards

Droochsloot, Joost Cornelisz.
Dutch, 1586-1666
04.1613
View of the Hague, Holland
Oil on panel
41.9 x 87.2 cm. (16½ x 34⅜ in.)
Lower left, on shed: JC DS. 1624 (J and C joined)
Bequest of Sarah Wyman Whitman

Droochsloot, Joost Cornelisz.
Dutch, 1586-1666
04.1614
Dutch Town in Winter
Oil on panel
41.0 x 86.5 cm. (16⅛ x 34 in.)
Center left, on the arch: JC DS. 162[...]
(J and C joined)
Bequest of Sarah Wyman Whitman

Drouais, François Hubert, Attributed to
French, 1727-1806
65.2640
Portrait of a Woman in Turkish Costume (said to
be Mlle. de Romans)
Oil on canvas
60.3 x 49.7 cm. (23¾ x 19⅝ in.)
The Forsyth Wickes Collection

Drouais, Hubert, Follower of
French, 1699-1767
43.9
Portrait of a Woman
Oil on canvas
71.8 x 58.5 cm. (28¼ x 23 in.)
Gift of George Holden Tinkham

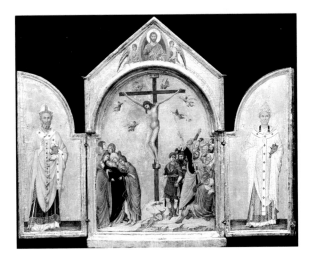

Duccio di Buoninsegna and Workshop
Italian (Sienese), active 1278-died 1319

45.880
The Crucifixion and Christ Blessing with Saints
Nicholas and Gregory (triptych)
Tempera on panel
Center: 61.0 x 39.5 cm. (24 x 15½ in.);
left wing: 45.0 x 19.0 cm. (17¾ x 7½ in.);
right wing: 45.0 x 19.0 cm. (17¾ x 7½ in.)
Grant Walker and Charles Potter Kling Funds

Ducreux, Joseph, Copy after
French, 1735-1802
1981.722
Marie Antoinette as a Young Girl (after a lost
engagement portrait)
Oil on canvas
64.5 x 53.5 cm. (25⅜ x 21 in.)
Gift of Julia Appleton Bird

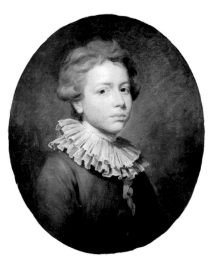

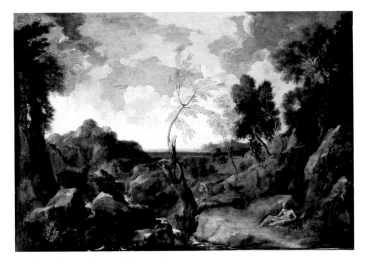

Ducreux, Follower of
65.2641
Portrait of a Boy
Oil on canvas
54.6 x 45.6 cm. (21½ x 18 in.)
The Forsyth Wickes Collection

Dughet, Gaspard (called Gaspard Poussin)
French (worked in Rome), 1615-1675
52.393
Landscape with Saint Jerome and the Lion
Oil on canvas
122.2 x 180.0 cm. (48⅛ x 70 in.)
Seth K. Sweetser Fund

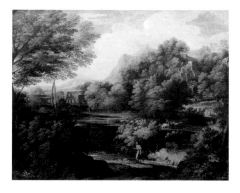

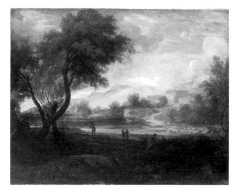

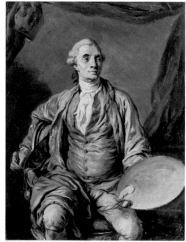

Dughet, Copy after
39.729
Landscape with a Traveler and Two Shepherds
(after a painting known through an engraving by
Adrian von Hackert)
Oil on canvas
74.2 x 97.7 cm. (29¼ x 38½ in.)
Bequest of Dudley Leavitt Pickman

Dughet, Style of
16.108
River Landscape with Distant Hills
Oil on canvas
74.0 x 97.0 cm. (29⅛ x 38¼ in.)
Bequest of Mrs. George Hollingsworth

Duplessis, Joseph Silfrede
French, 1725-1802
65.2643
Jean-Marie Vien with a Palette (study for a
painting in the Musée du Louvre, Paris)
Oil on paper mounted on canvas
31.7 x 24.8 cm. (12½ x 9¾ in.)
The Forsyth Wickes Collection

Dupont, Gainsborough, Attributed to
see
Gainsborough, Copy after

Dupré, Jules
French, 1811-1889
03.602
Cattle on the Dunes
Oil on canvas
81.0 x 100.0 cm. (34⅞ x 39⅜ in.)
Lower left: Jules Dupré
Bequest of Susan Cornelia Warren

Dupré, Jules
French, 1811-1889
17.3240
Trees in a Marsh
Oil on canvas
33.0 x 46.3 cm. (13 x 18¼ in.)
Lower left: [...] Dupré
Robert Dawson Evans Collection

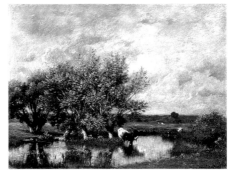

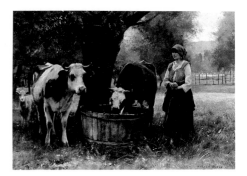

Dupré, Jules
French, 1811-1889
19.116
Cottage by the Sea
Oil on panel
22.0 x 46.0 cm. (8⅝ x 18⅛ in.)
Lower left: Jules D[...]p[...]e
The Henry C. and Martha B. Angell Collection

Dupré, Jules
French, 1811-1889
23.510
Watering Place
Oil on canvas
38.1 x 51.8 cm. (15 x 20⅜ in.)
Lower right: Jules Dupré
Bequest of David P. Kimball in Memory of his wife,
Clara Bertram Kimball

Dupré, Julien
French, 1851-1910
19.17
Young Woman Watering Cattle
Oil on canvas
38.3 x 55.0 cm. (15⅛ x 21⅝ in.)
Lower right: JULIEN DUPRÉ -
A. Shuman Collection

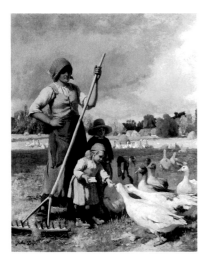

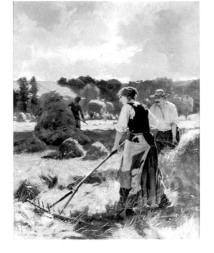

Dupré, Julien
French, 1851-1910
20.1865
Children Feeding Geese
Oil on canvas
81.5 x 65.0 cm. (32⅛ x 25⅝ in.)
Lower left: Julien Dupré 1881
Gift of Louise W. and Marian R. Case

Dupré, Julien
French, 1851-1910
31.907
Haymaking
Oil on canvas
81.4 x 64.8 cm. (32 x 25½ in.)
Lower right: JULIEN DUPRÉ - 1892
Gift of Frances W. Fabyan in Memory of
Edith Westcott Fabyan

Dupré, Léon Victor
French, 1816-1879
23.493
Water Meadows and Cattle
Oil on panel
8.8 x 15.8 cm. (3½ x 6¼ in.)
Lower right: Victor Dupre
Bequest of Ernest Wadsworth Longfellow

Durrant, Jennifer
English, 1942-

1977.12
October 1974 Painting
Acrylic on canvas
243.8 x 265.4 cm. (96 x 104½ in.)
Sophie M. Friedman Fund

Dutch, first half, 16th century
20.860
The Resurrection of Christ (recto) and
The Instruments of the Passion (verso)
Oil on panel
87.5 x 37.0 cm. (34½ x 14⅝ in.)
Gift of George Cabot Lodge

Dutch, second quarter, 17th century
23.525
Portrait of a Girl in Frisian Costume Holding a
Rose and a Basket of Cherries
Oil on panel
92.0 x 70.2 cm. (36¼ x 27⅝ in.)
Bequest of David P. Kimball in Memory of his wife,
Clara Bertram Kimball

Dutch, second quarter, 17th century
44.40
Portrait of a Man
Oil on panel
55.2 x 42.8 cm. (21¾ x 16⅞ in.)
Upper left: ETA · SVAE · 45 / 1640 (appears twice)
Bequest of Julia C. Prendergast in Memory of her
brother, James Maurice Prendergast

Dutch, third quarter, 17th century
74.9
Don Juan and Constance (from *Het Spaens*
Heydinnetje by Jacob Cats)
Oil on canvas
70.6 x 59.5 cm. (27¾ x 23⅜ in.)
Lower left, on quiver: Illegible initials or
monogram / 1673
Bequest of Charles Sumner

Dutch, third quarter, 17th century
23.529
Portrait of a Woman
Oil on canvas mounted on panel
35.4 x 27.3 cm. (13⅞ x 10¾ in.)
Bequest of David P. Kimball in Memory of his wife,
Clara Bertram Kimball

Dutch, third quarter, 17th century
38.986
Cottage beside a Road
Oil on panel
45.0 x 64.0 cm. (17¾ x 25¼ in.)
Falsely signed, lower right: JR
Illegibly signed, lower right, and dated: 1662
Gift of the Estate of Mrs. Waldo O. Ross

Dutch, third quarter, 17th century
52.1831
Landscape with River and Distant Hills
Oil on canvas
85.3 x 119.8 cm. (33⅝ x 47⅛ in.)
Anonymous Gift

Dutch, 17th century
94.176
Man Playing a Lute
Oil on panel
28.8 x 25.4 cm. (11⅜ x 10 in.)
Turner Sargent Collection

Dyck, Anthony van
Flemish, 1599-1641

03.25
Marie Anne Schotten
Oil on canvas
183.0 x 119.7 cm. (72 x 47⅛ in.)
Isaac Sweetser Fund and Contributions

Dyck, Anthony van
Flemish, 1599-1641

30.445
Isabella, Lady de la Warr
Oil on canvas
213.4 x 137.2 cm. (84 x 54 in.)
Harriet J. Bradbury Fund

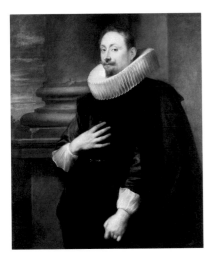

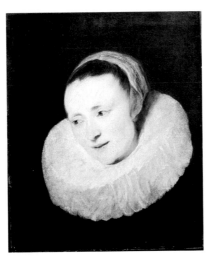

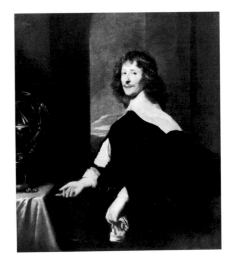

Dyck, Anthony van
Flemish, 1599-1641
39.558
Peeter Symons
Oil on canvas
114.5 x 96.3 cm. (45⅛ x 37⅞ in.)
Anonymous Gift in Memory of Francis Bartlett

Dyck, Anthony van, Attributed to
Flemish, 1599-1641
31.188
Margareta Snyders (born de Vos)
Oil on canvas
52.2 x 45.3 cm. (20½ x 17⅞ in.)
Maria Antoinette Evans Fund

Dyck, Anthony van, Studio of
Flemish, 1599-1641
44.835
Portrait of a Man with an Armillary Sphere
Oil on canvas
125.0 x 108.7 cm. (49¼ x 42¾ in.)
*Gift of Mrs. William Dexter in Memory of her mother,
Mrs. Bayard Thayer*

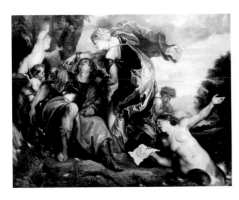

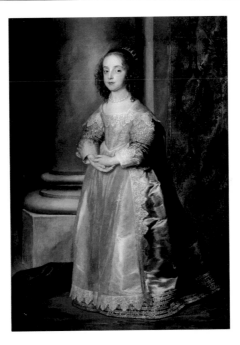

Dyck, Anthony van, Studio of
Flemish, 1599-1641
47.1269
Rinaldo and Armida
Oil on canvas
112.5 x 145.8 cm. (44⅛ x 57⅜ in.)
Bequest of Miss Georgiana Sargent

Dyck, Anthony van, Studio of
Flemish, 1599-1641
61.391
Princess Mary, Daughter of Charles I
Oil on canvas
Original design: 134.5 x 106.3 cm. (53 x 41⅞ in.)
Present design: 149.0 x 106.3 cm. (58⅝ x 41⅞ in.);
extended 10.0 cm. (3⅞ in.) at top and 4.5 cm. (1¾
in.) at bottom
*Given in Memory of Governor Alvan T. Fuller by the
Fuller Foundation*

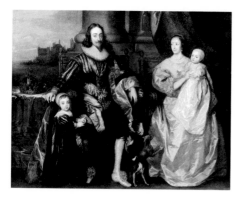

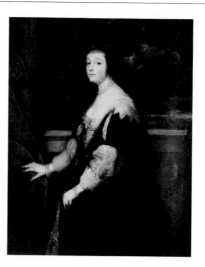

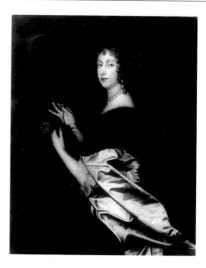

Dyck, van, Copy after
09.400
Charles I of England and Queen Henrietta Maria with Prince Charles and Princess Mary (after a painting in the Royal Collection, Windsor)
Oil on canvas
198.0 x 239.0 cm. (78 x 94⅛ in.)
Gift of Maria Antoinette Evans in the name of Robert Dawson Evans

Dyck, van, Copy after
17.3262
Beatrice de Cusance, Princess of Cantecroix and Duchess of Lorraine (after a full-length portrait in the Royal Collection, Windsor)
Oil on canvas
126.3 x 102.1 cm. (49¾ x 40¼ in.)
Robert Dawson Evans Collection

Dyck, van, Copy after
25.100
Cecilia Killigrew (after a double portrait of Mrs. Killigrew and Mrs. Morton in Wilton House, Salisbury)
Oil on canvas
115.0 x 90.2 cm. (45¼ x 35½ in.)
Bequest of Susan Greene Dexter in Memory of Charles and Martha Babcock Amory

Dyck, van, Copy after
37.1210
Ann Carr, Countess of Bedford, (after a painting in Petworth House, Surrey)
Oil on canvas
122.0 x 96.5 cm. (48 x 38 in.)
Gift of Miss Amelia Peabody

Dyck, van, Copy after
43.145
The Lamentation over the Dead Christ (after a painting in the collection of the Duke of Newcastle on loan to the Art Gallery and Museum, Nottingham)
Oil on canvas
132.8 x 249.5 cm. (52¼ x 98¼ in.)
Gift of Mrs. Bayard Warren and Mrs. Phyllis S. Tuckerman

Eeckhout, Gerbrand van den
Dutch, 1621-1674

74.4
Soldiers in a Guardroom
Oil on panel
36.2 x 29.2 cm. (14¼ x 11½ in.)
Bequest of Charles Sumner

Elle, Ferdinand, Attributed to
Flemish, about 1585 - about 1638

17.3222
Marguerite Maillet
Oil on canvas
199.7 x 124.4 cm. (78⅝ x 49 in.)
Center right: MARGVERITE MAILLET / ·1627·
Robert Dawson Evans Collection

Ensor, James
Belgian, 1890-1949

60.124
Still Life with Sea Shells
Oil on panel
44.5 x 55.0 cm. (17½ x 21⅝ in.)
Lower right: Ensor 1923
Gift of G. Peabody Gardner

Espagnat, Georges d'
French, 1870-1950

19.1318
Spring at Triel
Oil on canvas
59.7 x 71.8 cm. (23½ x 28¼ in.)
Lower right: gdE
John Pickering Lyman Collection

Etty, William
British, 1787-1849

22.370
Nude Woman Reclining in a Landscape
Oil on canvas
51.0 x 61.0 cm. (20⅛ x 24 in.)
Gift of John H. Sturgis

Etty, William
British, 1787-1849

38.8
Nude Woman Seated in a Landscape
Oil on paperboard mounted on masonite
58.0 x 48.0 cm. (22⅞ x 18⅞ in.)
Frederick Brown Fund

Eversen, Adrianus
Dutch, 1818-1897
22.631
Street in Amersfoort, Holland
Oil on canvas
54.0 x 69.5 cm. (21¼ x 27⅜ in.)
Lower left: A Eversen
Reverse: A Eversen / 1857
Gift of Mrs. Ellen Page Hall

Fabre, François Xavier
French, 1766-1837
24.342
Portrait of a Man (said to be Rosario Persico)
Oil on canvas
99.0 x 78.6 cm. (39 x 31 in.)
S. A. Denio Collection

Fantin-Latour, Ignace Henri Jean Théodore
French, 1836-1904
25.110
La Toilette
Oil on canvas
Design: 49.5 x 60.7 cm. (19½ x 23⅞ in.)
Lower left: Fantin
Juliana Cheney Edwards Collection

Fantin-Latour, Ignace Henri Jean Théodore
French, 1836-1904
40.232
Roses in a Vase
Oil on canvas
35.6 x 28.0 cm. (14 x 11 in.)
Upper left: Fantin 72
Frederick Brown Fund

Fantin-Latour, Ignace Henri Jean Théodore
French, 1836-1904

41.532
Embroiderers before a Window
Oil on paper (artist's own lithograph of same subject) mounted on canvas
21.3 x 32.3 cm. (8⅜ x 12¾ in.)
Lower right: Fantin
Bequest of Dora N. Spaulding

Fantin-Latour, Ignace Henri Jean Théodore
French, 1836-1904

48.540
Flowers and Fruit on a Table
Oil on canvas
60.0 x 73.3 cm. (23⅝ x 28⅞ in.)
Lower right: Fantin - 1865.
Bequest of John T. Spaulding

Fantin-Latour, Ignace Henri Jean Théodore
French, 1836-1904

60.792
Plate of Peaches
Oil on canvas
18.1 x 32.0 cm. (7⅛ x 12⅝ in.)
Upper left: Fantin / · 1862 ·
M. Theresa B. Hopkins Fund

Farrer, Thomas Charles
British (worked in United States), about 1839-1891

62.265
Mount Hope Bay, Rhode Island
Oil on canvas
29.8 x 64.0 cm. (11¾ x 25¼ in.)
Lower right: TCF 63 (monogram)
M. and M. Karolik Collection of American Paintings, 1815-1865

Ferrari, Gaudenzio, Follower of
Italian (Lombard), about 1480-1546

22.636
Virgin and Child with the Infant Saint John the Baptist
Oil on panel
63.5 x 44.2 cm. (25 x 17⅜ in.)
Zoe Oliver Sherman Collection
Gift of Zoe Oliver Sherman in memory of Mrs. Samuel Parkman Oliver

Fetti, Domenico
Italian (Roman), about 1589-1624

46.1145
Parable of the Good Samaritan
Oil on panel
67.4 x 83.6 cm. (26½ x 32⅞ in.)
Herbert James Pratt Fund

Fetti, Domenico
Italian (Roman), about 1589-1624
1979.767
Saint Mary Magdalen Penitant
Oil on canvas
99.0 x 77.3 cm. (39 x 30⅜ in.)
Charles Potter Kling Fund

Fieravino, Francesco (called Il Maltese), Style of
Italian (Roman), active second half, 17th century
74.7
Still Life with Musical Instruments, a Clock, and a Fringed Rug
Oil on canvas
73.6 x 97.3 cm. (29 x 38¼ in.)
Bequest of Charles Sumner

Fieravino, Style of
74.8
Still Life with Globes, Atlas, a Clock and a Fringed Rug
Oil on canvas
73.5 x 97.1 cm. (28⅞ x 38¼ in.)
Bequest of Charles Sumner

Fiorenzo di Lorenzo
Italian (Umbrian), about 1440-1522/25
20.431
Virgin and Child with Saint Jerome
Oil on panel
53.0 x 39.0 cm. (20⅞ x 15⅜ in.)
Gift of Mrs. W. Scott Fitz

Fiorenzo di Lorenzo
Italian (Umbrian), about 1440-1522/25
47.232
Saint Sebastian
Fresco transferred to canvas
179.0 x 63.3 cm. (70½ x 24⅞ in.)
Charles Potter Kling Fund

Flemish (?), 15th century
85.2
Virgin and Child with a Donor
Oil on panel
52.5 x 35.3 cm. (20⅝ x 13⅞ in.)
Upper left, on tapestry: NICOLAVS VO[...] NP
Everett Fund

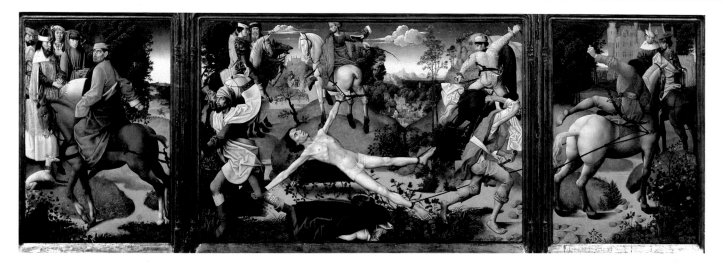

Flemish, fourth quarter, 15th century

63.660

Martyrdom of Saint Hippolytus with a Bishop and Saints Catherine, Bavo, and Elizabeth of Hungary

Tempera and oil on panel

Design: left wing, 87.6 x 59.7 cm. (34½ x 23½ in.); center, 87.6 x 133.7 cm. (34½ x 52⅝ in.); right wing, 87.6 x 59.7 cm. (34½ x 23½ in.)

Walter M. Cabot Fund

Matyrdom of St. Hippolytus
Outer wings

Flemish, 15th century, Imitator of

27.788

Portrait of a Woman

Oil on panel

29.0 x 24.0 cm. (11⅜ x 9½ in.)

Maria Antoinette Evans Fund

Flemish, first quarter, 16th century
68.787
Saint Barbara
Oil on panel
67.4 x 30.2 cm. (26½ x 11⅞ in.)
*Gift of Mrs. W. Ellery Sedgwick in Memory of
Miss Elizabeth Perkins*

Flemish, second quarter, 16th century
17.3267
Portrait of Two Women and a Man (fragment)
Oil transferred from panel to canvas
76.4 x 72.3 cm. (30⅛ x 28½ in.)
Robert Dawson Evans Collection

Flemish, first half, 16th century
15.289
The Crucifixion with the Virgin and Saint John
Oil on panel
34.5 x 25.5 cm. (13⅝ x 10 in.)
Gift of George A. Goddard

Flemish, first half, 16th century
42.282a, b
Angels with the Instruments of the Passion
Oil on panel
(a) 54.4 x 16.6 cm. (21⅜ x 6½ in.)
(b) 54.2 x 16.6 cm. (21⅜ x 6½ in.)
Gift of Mary C. Wheelwright

Flemish (artist working in Italy), first half, 16th century
22.640
Rest on the Flight into Egypt
Oil on canvas
78.0 x 59.0 cm. (30¾ x 23¼ in.)
Zoe Oliver Sherman Collection

Flemish, 16th century
 see
Michaelangelo, Copy after

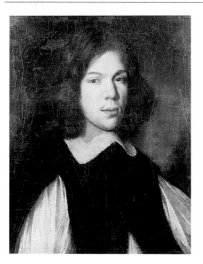

Flemish, third quarter, 17th century
16.389
Portrait of a Young Man
Oil on canvas
61.0 x 51.0 cm. (24 x 20⅛ in.)
Said to have been inscribed on reverse: aeta. sue 21
/ 1650
Gift of Miss Rose Lamb

Flemish, 17th century, Style of
20.787
Virgin and Child
Oil on canvas
64.8 x 45.8 cm. (25½ x 18 in.)
Gift of Mr. and Mrs. deForest Thomson

Flemish, 18th century
Res. 17.100
Virgin and Child Surrounded by a Wreath of Flowers
Oil on canvas
76.0 x 57.1 cm. (29⅞ x 22½ in.)
Bequest of Elisabeth C. D. Chandler

Flemish (or British?), first half, 18th century
27.462b, c, d, e
Aristocrats and Peasants in Landscapes (four overdoors)
Oil on canvas
Design: 55.0 x 113.0 cm. (21⅝ x 44½ in.)
Gift of Eben Howard Gay

Flinck, Govaert
Flemish, 1615-1660

03.1143
Mercury and Aglauros
Oil on canvas
72.4 x 91.0 cm. (28½ x 35⅞ in.)
Falsely signed, lower left: Rembran[...] 1652
Martha Ann Edwards Fund

Floch, Joseph
Austrian (worked in United States), 1895-1977

1982.445
Models in the Studio
Oil on canvas
146.0 x 103.5 cm. (57½ x 40¾ in.)
Lower left: Floch / 35
*Gift of Martin Deutsch from the Collection of Helene
Deutsch*

Forabosco, Gerolamo
Italian (Venetian), about 1604-1679

18.654
Portrait of a Woman
Oil on canvas
57.9 x 46.9 cm. (22¾ x 18½ in.)
Gift of Dr. Henry K. Oliver

Forain, Jean Louis
French, 1852-1931

25.154
Evidence in the Case (La Pièce à Conviction)
Oil on canvas
60.8 x 73.5 cm. (23⅞ x 28⅞ in.)
Upper right: forain
Tompkins Collection

Forain, Jean Louis
French, 1852-1931

48.542
Witness Confounded
Oil on canvas
54.6 x 66.0 cm. (21½ x 26 in.)
Lower left: forain (twice) / 1926
Bequest of John T. Spaulding

**Fortuny y Carbó, Mariano José Maria
Bernardo**
Spanish, 1838-1874

23.494
Cavalry Battle
Oil on panel
11.5 x 17.8 cm. (4½ x 7 in.)
Lower left: Fortuny 1871
Bequest of Ernest Wadsworth Longfellow

Fortuny y Carbó, Mariano José Maria Bernardo
Spanish, 1838-1874

24.17
Antiquaries
Oil on canvas
47.1 x 66.3 cm. (18½ x 26⅛ in.)
Lower right: M Fortuny
S. A. Denio Collection

Fortuny y Carbó, Mariano José Maria Bernardo
Spanish, 1838-1874

34.31
Tomb in North Africa
Oil on paperboard
15.8 x 23.4 cm. (6¼ x 9¼ in.)
Stamped, lower left: Fortuny
Gift of Wickliffe Draper

Fragonard, Jean Honoré
French, 1732-1801

44.777
The Good Mother
Oil on canvas
65.0 x 54.0 cm. (25⅝ x 21¼ in.)
Bequest of Robert Treat Paine, 2nd

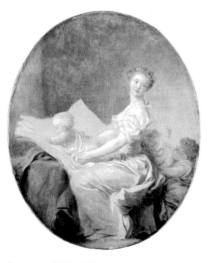

Fragonard, Jean Honoré
French, 1732-1801

65.2644
Mother and Child
Oil on canvas
46.4 x 37.5 cm. (18¼ x 14¾ in.)
The Forsyth Wickes Collection

Français, François Louis
French, 1814-1897

79.323
Stream in the Forest near Plombières
Oil on canvas
Support: 101.3 x 76.2 cm. (39⅞ x 30 in.)
Design: 98.2 x 70.8 cm. (38⅝ x 27⅞ in.)
Lower right: Français
Gift of Edward D. Boit

Français, François Louis
French, 1814-1897

37.598
Sunset
Oil on canvas
47.1 x 56.3 cm. (18½ x 22⅛ in.)
Lower right: Français 1878
Bequest of Ernest Wadsworth Longfellow

Francés, Nicolás
Spanish, active 1434-died 1468

36.895
Mass of Saint Gregory
Tempera on panel
35.6 x 23.8 cm. (14 x 9⅜ in.)
Gift of Frank Gair Macomber

Francesco del Cairo
Italian (Lombard), 1598-1674

26.772
Herodias with the Head of Saint John the Baptist
Oil on canvas
119.3 x 95.0 cm. (47 x 37⅜ in.)
William Sturgis Bigelow Collection

Francesco di Giorgio (Francesco Maurizio di Giorgio di Martini Pollaiuolo)
Italian (Sienese), 1439-1501/02

41.921
Virgin and Child with Saints Jerome and Anthony of Padua and Two Angels
Tempera on panel
70.8 x 52.5 cm. (27⅞ x 20⅝ in.)
Gift of Edward Jackson Holmes

Fraser, Donald Hamilton
British, 1929-

58.328
Landscape with Buildings
Oil on canvas
91.5 x 122.0 cm. (36 x 48 in.)
Upper left: Fraser
Tompkins Collection

Fraser, Donald Hamilton
British, 1929-

58.721
Still Life
Oil on canvas
76.2 x 50.8 cm. (30 x 20 in.)
Lower right: Fraser
Tompkins Collection

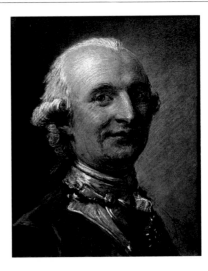

Frédou, Jean Martial
French, 1711-1795

65.2658
Portrait of a Man
Pastel on paper
29.8 x 23.5 cm. (11¾ x 9¼ in.)
Lower right: fredou
The Forsyth Wickes Collection

French, 12th century, Imitator of
49.8
The Flight into Egypt
Fresco transferred to panel
209.5 x 159.5 cm. (82½ x 62¾ in.)
Ernest Wadsworth Longfellow Fund

French, 12th century, Imitator of
49.9
The Visitation
Fresco transferred to panel
209.5 x 117.5 cm. (82½ x 46¼ in.)
Ernest Wadsworth Longfellow Fund

French, mid-16th century
35.1482
Portrait of a Man
Oil on panel
39.5 x 27.8 cm. (15½ x 11 in.)
Upper right: 1551
Gift of Miriam Shaw and Francis Shaw, Jr.

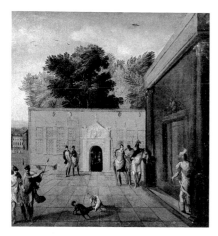

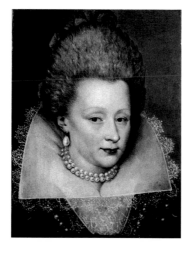

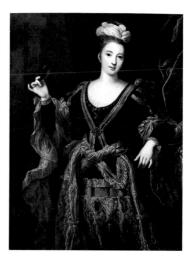

French, fourth quarter, 16th century
51.1922
Soldiers in a Courtyard
Oil on canvas
75.2 x 72.7 cm. (29⅝ x 28⅝ in.)
Gift of Mr. and Mrs. Joseph Winterbotham

French, fourth quarter, 16th century
65.2642
Portrait of a Woman
Oil on panel
Design: 36.0 x 27.2 cm. (14⅛ x 10¾ in.)
The Forsyth Wickes Collection

French, fourth quarter, 17th century
85.255
Portrait of a Woman Holding a Mask
Oil on canvas
121.0 x 96.3 cm. (47⅝ x 37⅜ in.)
Bequest of Mrs. M. B. Sigourney

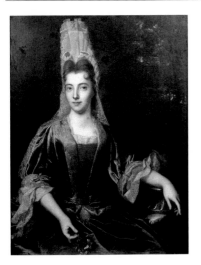

French, fourth quarter, 17th century
25.104
Portrait of a Woman Holding an Orange Blossom
Oil on canvas
107.5 x 83.0 cm. (42⅜ x 32⅝ in.)
Bequest of Susan Greene Dexter in Memory of Charles and Martha Babcock Amory

French, second half, 17th century
1979.555
Laurent Drelincourt
Oil on panel
15.0 x 9.2 cm. (5⅞ x 3⅝ in.)
Lower center: LAURENT DRELINCOURT / Ministre a Niort.
Gift of Gladys E. Rossiter

French, first quarter, 18th century
41.528
Portrait of a Woman
Oil on canvas
75.0 x 60.0 cm. (29½ x 23⅝ in.)
Bequest of Sarah Wyman Whitman

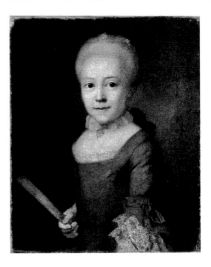

French, first quarter, 18th century*
65.2667
Portrait of a Woman
Pastel on paper
44.0 x 34.5 cm. (17⅜ x 13⅝ in.)
The Forsyth Wickes Collection
*Signature uncovered after printing (see **Vien**)

French, second quarter, 18th century
65.2639
Head of a Young Girl
Oil on panel
25.5 x 22.6 cm. (10 x 9⅞ in.)
The Forsyth Wickes Collection

French, second quarter, 18th century
68.738
Portrait of Young Girl
Oil on canvas
43.0 x 35.4 cm. (16⅞ x 13⅞ in.)
Gift of Misses Aimée and Rosamond Lamb

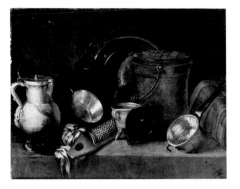

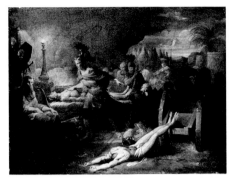

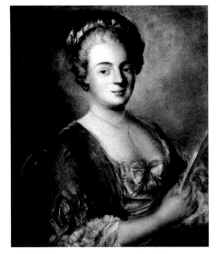

French (?), second half, 18th century
Res. 21.82
Still Life with Kitchen Utensils
Oil on canvas
Design: 67.5 x 89.2 cm. (26⅝ x 35⅛ in.)
William Sturgis Bigelow Collection

French, third quarter, 18th century
77.151
Achilles Displaying the Body of Hector before
Priam and the Body of Patroclus (sketch for 1769
Prix de Rome competition)
Oil on paper mounted on canvas
33.6 x 46.8 cm. (13¼ x 18⅜ in.)
Gift of Mrs. John Cheney

French, third quarter, 18th century
65.2657
Portrait of a Woman
Pastel on paper
57.2 x 48.3 cm. (22½ x 19 in.)
The Forsyth Wickes Collection

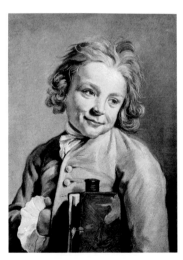

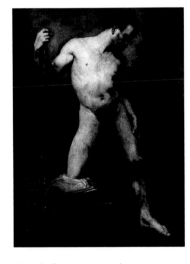

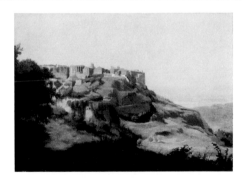

French, third quarter, 18th century
65.2663
Portrait of a Boy Holding a Portfolio
Pastel on paper
47.6 x 35.6 cm. (18¾ x 14 in.)
Inscribed on portfolio: de la fosse
The Forsyth Wickes Collection

French, first quarter, 19th century
91.26
Study of a Male Nude
Oil on canvas
80.7 x 62.0 cm. (31¾ x 24⅜ in.)
Center left: [T?]. G.
Gift of Mrs. Samuel Dennis Warren

French, first quarter, 19th century
47.236
Tivoli
Oil on canvas
31.0 x 45.5 cm. (12¼ x 17⅞ in.)
Abbott Lawrence Fund

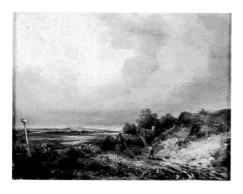

French (?), first quarter, 19th century
21.1447
Cottage at the Foot of a Hill
Oil on canvas
16.2 x 21.1 cm. (6⅜ x 8¼ in.)
William Sturgis Bigelow Collection

French (?), first quarter, 19th century
50.863
Portrait of a Woman
Oil on canvas
73.0 x 59.5 cm. (28⅝ x 23⅜ in.)
S. A. Denio Collection

French, third quarter, 19th century
29.1040
Portrait Study of a Young Man
Oil on paper mounted on canvas
35.2 x 27.2 cm. (13⅞ x 10¾ in.)
Gift of Jacques Abellini through Miss A. Curtis

French, second half, 19th century
40.18
Bacchante (after a marble bust by Albert Ernest Carrier-Belleuse)
Oil on canvas
63.0 x 51.5 cm. (24¾ x 20¼ in.)
Gift of Armand Lowengard

French, 18th or 19th century
22.637
Virgin and Child
Oil on canvas
40.6 x 34.4 cm. (16 x 13½ in.)
Zoe Oliver Sherman Collection

French
see also
Alsatian

Frère, Charles Théodore
French, 1814-1888
Res. 24.1
Scene in Cairo
Oil on canvas
38.6 x 61.8 cm. (15⅛ x 24⅜ in.)
Lower left: TH. FRERE . / AU CAIRE.
Gift of Francis A. Foster

Frère, Charles Théodore
French, 1814-1888
Res. 27.53
Camel
Oil on panel
24.0 x 33.0 cm. (9½ x 13 in.)
Lower right: TH. FRÈRE.
Gift of Mrs. Ellerton James

Frère, Charles Théodore
French, 1814-1888
65.436
Oasis at Sunset
Oil on panel
21.2 x 37.1 cm. (8⅜ x 14⅝ in.)
Lower left: TH. FRÈRE.
Bequest of Mrs. Edward Jackson Holmes

Fromentin, Eugène
French, 1820-1876
94.138
Khan in Algiers
Oil on panel
34.1 x 54.0 cm. (13⅜ x 21¼ in.)
Lower right: Eug. Fromentin
Bequest of James William Paige

Fromentin, Eugène
French, 1820-1876
17.3254
Standard Bearer
Oil on canvas
59.0 x 89.3 cm. (23¼ x 35⅛ in.)
Lower right: Eug. Fromentin
Robert Dawson Evans Collection

Fromentin, Eugène
French, 1820-1876
1970.372
North African Landscape
Oil on paper mounted on canvas
17.4 x 32.0 cm. (6⅞ x 12⅝ in.)
Lower center: Eug. Fromentin
Gift of Maurice Goldberg

Frueauf, Rueland, the Elder
Austrian, 1440/50-1507

49.1076
The Education of the Infant Christ
Oil and tempera on panel
62.0 x 72.2 cm. (24⅜ x 28⅜ in.)
Lower left, on prie-dieu: 1506
Ernest Wadsworth Longfellow Fund

Frumi, Lotte
Czechoslovakian, active mid-20th century

67.647
Ezra Pound
Oil on canvas
80.0 x 59.7 cm. (31½ x 23½ in.)
Lower right: Frumi / 1964
Anonymous Gift

Furini, Francesco
Italian (Florentine), 1603-1649

22.638
Head of a Young Woman (fragment)
Oil on canvas
44.8 x 37.5 cm. (17⅝ x 14¾ in.)
Zoe Oliver Sherman Collection

Fyt, Jan
Flemish, 1611-1661
and
Quellinus, Erasmus
Flemish, 1607-1678

50.2728
Still Life in an Architectural Setting
Oil on canvas
112.3 x 82.9 cm. (44¼ x 32⅝ in.)
Ernest Wadsworth Longfellow Fund

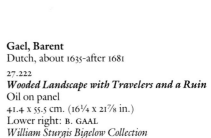

Gaddi, Agnolo di Taddeo
Italian (Florentine), active 1369-died 1396
45.515
The Crucifixion with the Virgin and Saint John
Tempera on panel
61.1 x 36.3 cm. (24 x 14¼ in.)
Gift of Mr. and Mrs. J. Templeman Coolidge

Gael, Barent
Dutch, about 1635-after 1681
Res. 11.4
Horse Fair
Oil on canvas
50.5 x 57.7 cm. (19⅞ x 22¾ in.)
Gift of the estate of Miss Martha E. Dowse

Gael, Barent
Dutch, about 1635-after 1681
27.222
Wooded Landscape with Travelers and a Ruin
Oil on panel
41.4 x 55.5 cm. (16¼ x 21⅞ in.)
Lower right: B. GAAL
William Sturgis Bigelow Collection

Gainsborough, Thomas
British, 1727-1788
12.809
John Eld of Seighford Hall, Stafford
Oil on canvas
238.6 x 153.0 cm. (94 x 60¼ in.)
Lower right, on base of pedestal: By the
Command / And at the Expence / of the
Subscribers
Special Painting Fund

Gainsborough, Thomas
British, 1727-1788
17.3266
Mrs. Edmund Morton Pleydell
Oil on canvas
126.5 x 104.8 cm. (49¾ x 41¼ in.)
Robert Dawson Evans Collection

Gainsborough, Thomas
British, 1727-1788
24.225
Portrait of a Young Girl
Oil on canvas
61.5 x 50.0 cm. (24¼ x 19⅝ in.)
*Gift of Robert Jordan from the Collection of Eben D.
Jordan*

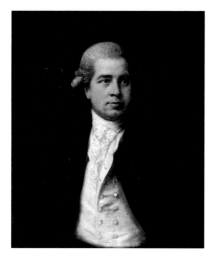

Gainsborough, Thomas
British, 1727-1788
25.108
John Taylor
Oil on canvas
76.0 x 64.6 cm. (29⅞ x 25⅜ in.)
Juliana Cheney Edwards Collection

Gainsborough, Thomas
British, 1727-1788
25.133
Mrs. Thomas Matthew
Oil on canvas
77.0 x 64.7 cm. (30¼ x 25½ in.)
Juliana Cheney Edwards Collection

Gainsborough, Thomas
British, 1727-1788
25.134
Captain Thomas Matthew
Oil on canvas
77.5 x 64.5 cm. (30½ x 25⅜ in.)
Juliana Cheney Edwards Collection

Gainsborough, Thomas
British, 1727-1788
53.2553
Haymaker and Sleeping Girl (Mushroom Girl)
Oil on canvas
227.3 x 149.9 cm. (89½ x 59 in.)
M. Theresa B. Hopkins Fund and Seth K. Sweetser Fund

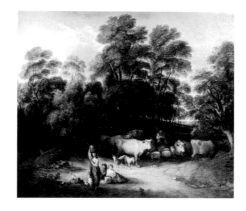

Gainsborough, Copy after
 attributed to
Dupont, Gainsborough
British, 1754-1797
49.553
Landscape with Milkmaids and Cattle (after a painting in the Taft Museum, Cincinnati)
Oil on canvas
121.5 x 147.0 cm. (47¾ x 57⅞ in.)
Juliana Cheney Edwards Collection

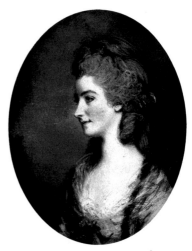

Gardner, Daniel
British, 1750-1805
65.2659
Portrait of a Woman
Pastel on paper
25.7 x 20.3 cm. (10⅛ x 8 in.)
The Forsyth Wickes Collection

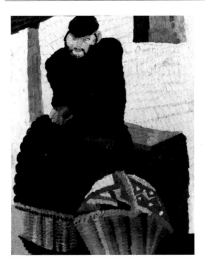

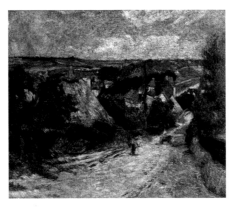

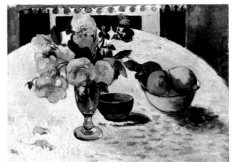

Gaudier-Brzeska, Henri
French (worked in Britain), 1891-1915
65.1683b
Portrait of a Whitechapel Jew
Oil on canvas
91.5 x 71.1 cm. (36 x 28 in.)
Otis Norcross Fund

Gauguin, Paul
French, 1848-1903
48.545
Entrance to the Village of Osny
Oil on canvas
60.0 x 72.6 cm. (23⅝ x 28⅝ in.)
Bequest of John T. Spaulding

Gauguin, Paul
French, 1848-1903
48.546
Flowers and a Bowl of Fruit on a Table
Oil on canvas mounted on paperboard
42.8 x 62.9 cm. (16⅞ x 24¾ in.)
Bequest of John T. Spaulding

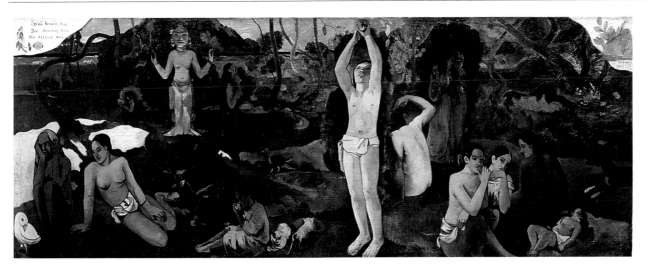

Gauguin, Paul
French, 1848-1903
36.270
Where Do We Come From? What Are We?
Where Are We Going? (D'où venons-nous? Que
sommes-nous? Où allons-nous?)
Oil on canvas
139.1 x 374.6 cm. (54¾ x 147½ in.)
Upper left: D'où Venons Nous / Que Sommes
Nous / Où Allons Nous
Upper right: P. Gauguin / 1897.
Tompkins Collection

Gauguin, Paul
French, 1848-1903
48.547
Women and a White Horse
Oil on canvas
73.2 x 91.7 cm. (28⅞ x 36⅛ in.)
Lower right: P. Gauguin 1903
Bequest of John T. Spaulding

Gauguin, Paul
French, 1848-1903
64.2205
Forest Interior
Oil on canvas
55.5 x 46.1 cm. (21⅞ x 18⅛ in.)
Lower right: 1884 / P. Gauguin
Gift of Laurence K. Marshall

Gauguin, Paul
French, 1848-1903
1976.42
Landscape with Two Breton Women
Oil on canvas
72.4 x 92.0 cm. (28½ x 36¼ in.)
Lower left: P. Gauguin 89
Gift of Harry and Mildred Remis

Gaulli, Giovanni Battista (called Baciccio),
Copy after
Italian (Roman), 1639-1709
28.823
Pope Clement IX (after a painting in the
Accademia di San Luca, Rome)
Oil on canvas mounted on masonite
48.9 x 37.0 cm. (19¼ x 14⅝ in.)
Bequest of Miss Elizabeth Welles Perkins

Geddes, Andrew, Attributed to
British, 1783-1844
17.3255
Portrait of a Woman with a Child
Oil on canvas
139.5 x 109.1 cm. (54⅞ x 43 in.)
Robert Dawson Evans Collection

Gelder, Aert de
Dutch, 1645-1727
39.45
Schoolmaster with his Pupils
Oil on canvas
100.2 x 127.0 cm. (39½ x 50 in.)
Upper left: A[...]Ge[...]de[...] f
Ernest Wadsworth Longfellow Fund

Gelder, Aert de
Dutch, 1645-1727
57.182
Rest on the Flight into Egypt
Oil on canvas
110.0 x 118.8 cm. (43¼ x 46¾ in.)
M. Theresa B. Hopkins Fund

Gellée, Claude (called Le Lorrain)
French (worked in Rome), 1600-1682
12.1050
Apollo and the Muses on Mount Helicon
Oil on canvas
99.7 x 136.5 cm. (39¼ x 53¾ in.)
Lower center: PARNASS[...]PARN[...]SS[...] /
CL[...]D[...] (indistinct)
Picture Fund

Gellée, Claude (called Le Lorrain)
French (worked in Rome), 1600-1682
44.72
Mill on a River
Oil on canvas
61.5 x 84.5 cm. (24¼ x 33¼ in.)
Lower left, on fallen lintel: CLA[...]E · IV 1631
Seth K. Sweetser Fund

Gellée, Claude, Copy after
47.1058
Seaport at Sunset (free copy after *The
Embarkation of Saint Ursula* in the National
Gallery, London)
Oil on canvas
118.0 x 148.0 cm. (46½ x 58¼ in.)
Lower center, on bale: 164[9?]
*Charles Edward French Fund and Abbott Lawrence
Fund*

Gellée, Claude, Imitator of
Res. 21.89
Harbor Scene
Oil on canvas
72.7 x 96.4 cm. (28⅝ x 38 in.)
William Sturgis Bigelow Collection

Gennari, Benedetto, II
Italian (Bolognese), 1633-1715
94.173
Adoration of the Shepherds
Oil on canvas
Design: 96.3 x 127.6 cm. (37⅞ x 50¼ in.)
Turner Sargent Collection

Gérard, Marguerite
French, 1761-1837

65.2645
Portrait of a Man in his Study
Oil on panel
21.7 x 16.0 cm. (8½ x 6¼ in.)
The Forsyth Wickes Collection

Géricault, Jean Louis André Théodore,
Copy after
French, 1791-1824

88.724
Study for Wounded Cuirassier (after an oil
sketch in the Brooklyn Museum)
Oil on paperboard mounted on masonite
38.2 x 32.2 cm. (15 x 12⅝ in.)
Gift of Samuel Dennis Warren

Gerini, Lorenzo di Niccolò
Italian (Florentine), active 1392-1411

04.237
Martyrdom of Saint Bartholomew
Oil and tempera on panel
28.8 x 31.0 cm. (11⅜ x 12¼ in.)
Gift of Miss Catherine Sherwood

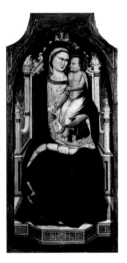

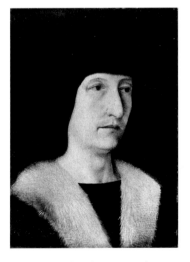

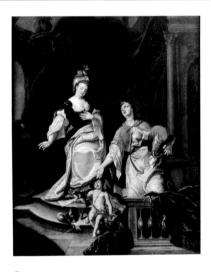

Gerini, Niccolò di Pietro
Italian (Florentine), active 1368-died 1415

16.64
Virgin and Child
Tempera on panel
Design: 146.0 x 70.5 cm. (57½ x 27¾ in.)
Lower left: [...]NNI DNI · M · / CCCC IIII
Lower right: ·DEL MES / DI LUGLIO
Gift of Mrs. W. Scott Fitz

German (?), fourth quarter, 15th century
38.1839
Portrait of a Man in a Fur-trimmed Coat
Oil on panel
25.8 x 18.6 cm. (10⅛ x 7⅜ in.)
Zoe Oliver Sherman Collection

German, 1753
Res. 17.102
*Minerva with Personifications of the Arts and
Sciences*
Oil on panel
47.5 x 37.0 cm. (18¾ x 14⅝ in.)
Lower left: [...] / 1753
Bequest of Elizabeth C. D. Chandler

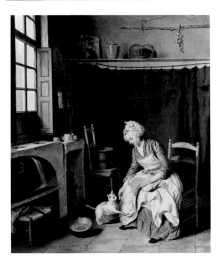

German, second half, 18th century
65.2650
Servant Girl Plucking a Chicken
Oil on canvas
89.0 x 71.0 cm. (35 x 28 in.)
The Forsyth Wickes Collection

German, third quarter, 19th century
13.454
Village in the Bavarian Alps
Oil on canvas
51.1 x 63.7 cm. (20⅛ x 25⅛ in.)
Lower left, on rail: DWie 69 (D and W in monogram)
Bequest of Mrs. Edward Wheelwright

German (Cologne School), mid-15th century
41.707
Scenes from the Life of Saint Ursula: The Baptism of Saint Ursula and the Virgins in Rome (above); *Saint Ursula and the Virgins Depart from Basel* (below)
Oil on panel
127.5 x 54.0 cm. (50⅛ x 21¼ in.)
Gift of George H. Edgell

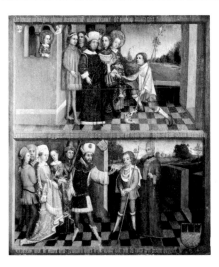

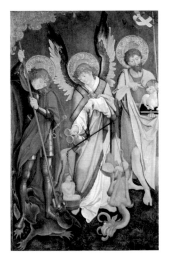

German (Cologne School), mid-15th century
51.2398
Scenes from the Life of Saint Ursula: Saint Ursula's Response is Delivered (above); *Atherius and his Parents Make an Agreement Following Saint Ursula's Wishes* (below)
Oil on panel
129.0 x 111.5 cm. (50¾ x 43⅞ in.)
Gift of Mrs. Gardiner Fiske

German (Franconian), first half, 16th century
07.485
Saints George, Michael, and John the Baptist
Oil on panel
194.3 x 123.2 cm. (76½ x 48½ in.)
Gift of Edward Waldo Forbes

German
see also
Alsatian

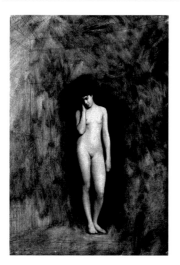

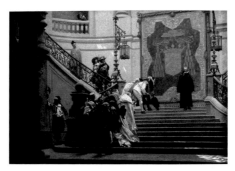

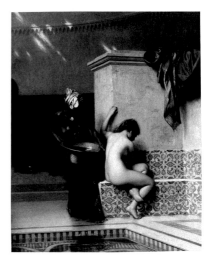

Gérôme, Jean Léon
French, 1824-1904

87.410
Greek Slave (fragment)
Oil on canvas
54.0 x 37.0 cm. (21¼ x 14⅝ in.) (design extends
onto present tacking margins)
Gift of George A. Goddard

Gérôme, Jean Léon
French, 1824-1904

03.605
L'Eminence Grise
Oil on canvas
68.5 x 101.0 cm. (27 x 39¾ in.)
Lower right: J.L. GEROME
Bequest of Susan Cornelia Warren

Gérôme, Jean Léon
French, 1824-1904

24.217
Moorish Bath
Oil on canvas
50.8 x 40.8 cm. (20 x 16 in.)
Upper right, on top of bench: J. L. GEROME.
*Gift of Robert Jordan from the Collection of Eben D.
Jordan*

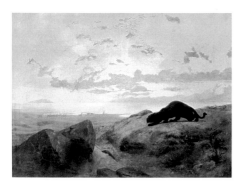

Gérôme, Jean Léon
French, 1824-1904

30.232
Black Panther Stalking a Herd of Deer
Oil on canvas
52.3 x 74.0 cm. (20⅝ x 29⅛ in.)
Lower left: JL. GEROME / 1851 ·
Anonymous Gift

Gérôme, Jean Léon
French, 1824-1904

1324.12
Oasis
Oil on canvas
65.1 x 82.0 cm. (25⅝ x 32 in.)
Lower left: J. L. GEROME.
*Deposited by the Trustees of the White Fund,
Lawrence, Massachusetts*

Ghirlandaio, Domenico (Domenico di
Tomaso Bigordi, called Domenico Ghirlandaio),
Workshop of
Italian (Florentine), about 1448-1494

03.567
Virgin and Child with Two Angels
Oil transferred from panel to canvas
92.0 cm. (36¼ in.) diameter
Bequest of George W. Wales

Ghirlandaio, Workshop of
Italian (Florentine), about 1448-1494
22.5
Virgin and Child with The Coronation of the Virgin
Oil on panel
Design: *Virgin and Child:* 16.3 x 12.7 cm.
(6⅜ x 5 in.); *Coronation:* 7.3 x 15 cm.
(2⅞ x 5⅞ in.)
Gift of Mrs. Thomas O. Richardson

Giacometti, Alberto
Swiss (worked in France), 1901-1966
62.283
Head of Diego
Oil on canvas
45.0 x 35.0 cm. (17¾ x 13¾ in.)
Lower right: Alberto Giacometti
Tompkins Collection

Giaquinto, Corrado
Italian (Roman), 1703-1765
1981.19
Martyrdom of Saint Marta (sketch for a fresco in the church of S. Giovanni Calibita, Rome)
Oil on canvas
52.2 x 73.7 cm. (20½ x 29 in.)
Charles Potter Kling Fund

Giaquinto, Corrado
Italian (Roman), 1703-1765
1981.20
Saints Ippolito, Taurino, and Ercolano (sketch for a fresco in the church of S. Giovanni Calibita, Rome)
Oil on canvas
52.6 x 74.4 cm. (20¾ x 29¼ in.)
Charles Potter Kling Fund

Gijsbrechts, Cornelis Norbertus
Flemish, active 1659-1675
58.357
Vanitas Still Life
Oil on canvas
84.4 x 78.0 cm. (33¼ x 30¾ in.)
Abbott Lawrence Fund

Gilman, Harold
British, 1876-1919
Res. 32.9
Beech Wood
Oil on canvas
61.5 x 51.3 cm. (24¼ x 20¼ in.)
Lower right: H. Gilman
Tompkins Collection

Giordano, Luca
Italian (Neapolitan), 1632-1705
82.112
The Communion of the Apostles
Oil on canvas
188.0 x 305.0 cm. (74 x 120⅛ in.)
Gift of Mrs. Louis Thies

Giordano, Luca
Italian (Neapolitan), 1632-1705
23.459
The Entombment of Christ
Oil on canvas
68.8 x 80.0 cm. (27⅛ x 31½ in.)
Bequest of Ernest Wadsworth Longfellow

Giordano, Luca
Italian (Neapolitan), 1632-1705
47.1566
Apollo in his Chariot
Oil on canvas
118.5 x 176.5 cm. (46⅝ x 69½ in.)
Gift of Mrs. Harriet Ropes Cabot in Memory of Mrs. A. Lawrence Lowell

Giordano, Luca
Italian (Neapolitan), 1632-1705
1984.409
Venus Giving Arms to Aeneas
Oil on canvas
225.1 x 202.2 cm. (88⅝ x 79⅝ in.)
Charles Potter Kling Fund and Henry H. and Zoe Oliver Sherman Fund

Giordano, Luca, Attributed to
Italian (Neapolitan), 1632-1705
Res. 23.136
Isaac Blessing Jacob
Oil on canvas
100.2 x 136.6 cm. (39½ x 53⅝ in.)
Bequest of Helen O. Bigelow

Giovanni di Paolo di Grazia
Italian (Sienese), active about 1420-died 1482
30.772
The Virgin of Humility
Tempera on panel
Panel: 62.0 x 48.8 cm. (24⅜ x 19¼ in.)
Design: 55.5 x 42.2 cm. (21⅞ x 16⅝ in.)
Maria Antoinette Evans Fund

Girodet de Roucy Trioson, Anne Louis,
Follower of
French, 1767-1824

27.449
Portrait of a Woman Seated beneath a Tree
Oil on canvas
130.0 x 97.0 cm. (51⅛ x 38⅛ in.)
Seth K. Sweetser Fund

**Girolamo di Benvenuto di Giovanni del
Guasta**
Italian (Sienese), 1470-about 1524

44.831
Carmelite Saint
Tempera on panel
28.5 x 28.3 cm. (11¼ x 11⅛ in.)
Gift of Edward Jackson Holmes

**Girolamo di Benvenuto di Giovanni del
Guasta**
Italian (Sienese), 1470-about 1524

44.832
Saint Vincent Ferrer
Tempera on panel
28.5 x 28.3 cm. (11¼ x 11⅛ in.)
Gift of Edward Jackson Holmes

Giuliano di Simone
Italian (Lucchese), active fourth quarter, 14th
century

22.403
*The Crucifixion with the Virgin, Saints John and
Mary Magdalen and Two Donors; and The
Annunciation*
Tempera on panel
Overall: 82.2 x 47.5 cm. (32⅜ x 18¾ in.)
Design: 68.5 x 36.5 cm. (27 x 14⅜ in.)
Falsely inscribed, lower left: Taddeo Bartoli
Seth K. Sweetser Fund

Glauber, Johannes
Dutch, 1646-about 1726

1979.287
*Landscape with King Midas Judging the Musical
Contest between Pan and Apollo*
Oil on canvas
67.3 x 90.8 cm. (26½ x 35¾ in.)
Lower right: I GLAUB[...]
Juliana Cheney Edwards Collection

Gobert, Pierre
French, 1662-1744

17.3220
Portrait of a Woman as Venus
Oil on canvas
135.5 x 103.5 cm. (53⅜ x 40¾ in.)
Robert Dawson Evans Collection

Goerg, Edouard Joseph
Australian (worked in France), 1893-1969
54.1419
Temptation
Oil on canvas
54.5 x 45.5 cm. (21½ x 17⅞ in.)
Lower center: E. Goerg / 45
Reverse: la tentation / E J. Goerg / 7/8 1945
Gift of Arthur Wiesenberger

Gogh, Vincent van
Dutch (worked in France), 1853-1890
35.1982
Postman Joseph Roulin
Oil on canvas
81.2 x 65.3 cm. (32 x 25¾ in.)
Gift of Robert Treat Paine, 2nd

Gogh, Vincent van
Dutch (worked in France), 1853-1890
48.548
Lullaby: Madame Augustine Roulin Rocking a Cradle (La Berceuse)
Oil on canvas
92.7 x 72.8 cm. (36½ x 28⅝ in.)
Lower right, along chair: La Berceuse
Bequest of John T. Spaulding

Gogh, Vincent van
Dutch (worked in France), 1853-1890
48.549
Houses at Auvers
Oil on canvas
75.5 x 61.8 cm. (29¾ x 24⅜ in.)
Bequest of John T. Spaulding

Gogh, Vincent van
Dutch (worked in France), 1853-1890
52.1524
Ravine
Oil on canvas
73.0 x 91.7 cm. (28¾ x 36⅛ in.)
Bequest of Keith McLeod

Gogh, Vincent van
Dutch (worked in France), 1853-1890
58.356
Weaver
Oil on canvas
62.5 x 84.4 cm. (24⅝ x 33¼ in.)
Tompkins Collection

Goltzius, Scipio
Flemish, active 16th century
67.752
Fruit and Vegetable Vendors
Oil on canvas
138.2 x 203.3 cm. (54⅜ x 80 in.)
Lower left, on bucket lid: SCIPIO GOLTZ.
ANTWERPIENSIS. FECIT I.5.7.7.
Gift of Mr. and Mrs. Robert L. Henderson

Gore, Spencer Frederick
British, 1878-1914
Res. 32.10
Back Gardens from Houghton Place
Oil on canvas
61.2 x 66.5 cm. (24⅛ x 26⅛ in.)
Stamped, lower right: S.F.GORE
Tompkins Collection

Gore, Spencer Frederick
British, 1878-1914
Res. 32.22
Mornington Crescent
Oil on canvas
41.0 x 51.0 cm. (16⅛ x 20⅛ in.)
Stamped, lower left: S.F.GORE
Gift by Contribution

Goya y Lucientes, Francisco de
Spanish, 1746-1828
10.33
Portrait of a Man in a Brown Coat
Oil on canvas
105.3 x 83.2 cm. (41½ x 32¾ in.)
Gift of Mrs. W. Scott Fitz

Goya y Lucientes, Francisco de
Spanish, 1746-1828
27.1330
Time, Truth, and History (sketch for *Allegory on the Spanish Constitution,* Nationalmuseum, Stockholm)
Oil on canvas
41.6 x 32.6 cm. (16⅜ x 12⅞ in.)
Gift of Mrs. Horatio Greenough Curtis in Memory of Horatio Greenough Curtis

Goya y Lucientes, Follower of
39.748
Officer on Horseback
Oil on canvas
94.4 x 76.4 cm. (37⅛ x 30⅛ in.)
The Henry C. and Martha B. Angell Collection, by exchange

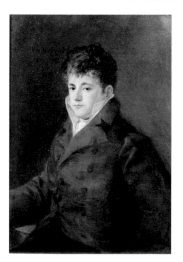

Goya y Lucientes, Imitator of
48.558
Portrait of a Man
Oil on canvas
81.3 x 58.0 cm. (32 x 22⅞ in.)
Bequest of John T. Spaulding

Goyen, Jan Josephsz. van
Dutch, 1595-1656
07.502
River Landscape with a Ferry and a Church
Oil on panel
47.2 x 66.7 cm. (18⅝ x 26¼ in.)
Lower right, on side of boat: VG / 165[6?]
James Fund

Goyen, Jan Josephsz. van
Dutch, 1595-1656
47.235
Fort on a River
Oil on panel
42.5 x 75.5 cm. (16¾ x 29¾ in.)
Lower left, on side of boat: VG 1644
Francis Welch Fund

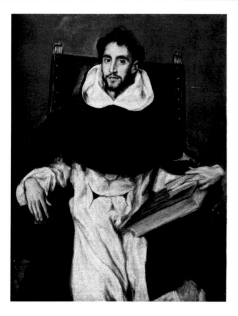

Grant, Duncan James Corrows
British, 1885-1978
43.2
Waterloo Bridge, London
Oil on paperboard
40.5 x 55.2 cm. (16 x 21¾ in.)
*Gift of the American Academy and National
Institute of Arts and Letters Fund,
American-British Art Center*

Greco, El (Domenicos Theotocopoulos, called
El Greco)
Greek (worked in Spain), 1541-1614
04.234
Fray Hortensio Félix Paravicino
Oil on canvas
112.0 x 86.1 cm. (44⅛ x 33⅞ in.)
Center right: doménikos theotokópoulos /
e'poīei (in Greek characters)
Isaac Sweetser Fund

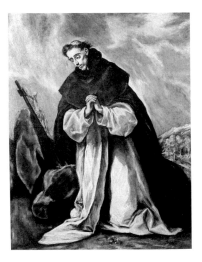

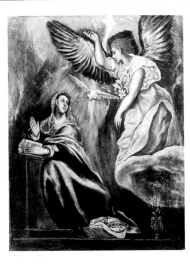

Greco, El (Domenicos Theotocopoulos, called
El Greco)
Greek (worked in Spain), 1541-1614
23.272
Saint Dominic in Prayer
Oil on canvas
104.7 x 83.0 cm. (41¼ x 32⅝ in.)
Lower left, on rock: doménikos theotokópoulos /
e'poïei (in Greek characters)
Maria Antoinette Evans Fund

Greco, El, Copy after
1975.636
The Annunciation (after a painting in the
Museum of Art, Toledo, Ohio)
Oil on canvas
82.8 x 62.3 cm. (32⅝ x 24½ in.)
Gift of Mrs. Richard E. Danielson

Greek (Macedonian or Balkan), 18th century
Res. 25.14
Virgin and Child (fragment)
Tempera on panel
30.7 x 10.5 cm. (12⅛ x 4⅛ in.)
Gift of Mrs. Philip L. Carbone

Greek (or Rumanian), 17th or 18th century
Res. 25.17
Christ the Almighty
Tempera on panel
42.1 x 31.0 cm. (16⅝ x 12¼ in.)
Gift of Mrs. Philip L. Carbone

Greek (or Rumanian), 18th century
Res. 25.16
Saint John the Baptist
Tempera on panel
42.0 x 28.2 cm. (16½ x 11⅛ in.)
Gift of Mrs. Philip L. Carbone

Greek (Veneto-Cretan), 16th century
01.6221
Virgin and Child with Saint Lucy
Tempera on panel
28.5 x 25.7 cm. (11¼ x 10⅛ in.)
The Gardner Brewer Collection

Greek (Veneto-Cretan), 17th or 18th century
19.182
Virgin and Child with Saint Roch
Tempera on panel
38.4 x 47.0 cm. (15⅛ x 18½ in.)
Gift of Mr. and Mrs. W. deForest Thomson

Greuze, Jean Baptiste
French, 1725-1805

1975.808
Young Woman in a White Hat
Oil on canvas
56.8 x 46.5 cm. (22⅜ x 18¼ in.)
Gift of Jessie H. Wilkinson Fund, Grant Walker Fund, Seth K. Sweetser Fund, and Abbott Lawrence Fund

Greuze, Jean Baptiste
French, 1725-1805

1982.140
Portrait of a Man (said to be the Chevalier de Damery)
Oil on canvas
65.1 x 55.1 cm. (25⅝ x 21¾ in.)
Charles H. Bayley Picture and Paintings Fund

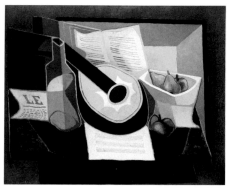

Greuze, Follower of
49.1145
Portrait of a Child
Oil on canvas
40.7 x 32.6 cm. (16 x 12⅞ in.)
Gift of Edwin H. Abbot, Jr., in Memory of his mother, Martha T. Abbot

Grimaldi, Giovanni Francesco
Italian (Roman), 1606-1680

26.167
Landscape with the Holy Family and the Infant Saint John the Baptist
Oil on canvas mounted on masonite
96.6 x 134.6 cm. (38 x 53 in.)
Gift of Clara Bowdoin Winthrop

Gris, Juan
Spanish (worked in France), 1887-1927

67.1161
Still Life with a Guitar
Oil on canvas
73.0 x 92.0 cm. (28¾ x 36¼ in.)
Lower left: Juan Gris 25
Gift of Joseph Pulitzer, Jr.

Grolleron, Paul Louis Narcisse
French, 1848-1901
20.1866
Skirmish on the Outskirts of Paris during the
Franco-Prussian War
Oil on canvas
87.6 x 130.8 cm. (34½ x 51½ in.)
Lower left: P. Grolleron 82
Gift of Louisa W. and Marian R. Case

Grolleron, Paul Louis Narcisse
French, 1848-1901
41.114
French Soldiers Resting
Oil on canvas
41.0 x 60.5 cm. (16⅛ x 23⅞ in.)
Lower right: P. Grolleron 80
Gift of Edward Jackson Holmes

Grolleron, Paul Louis Narcisse
French, 1848-1901
64.2087
Soldiers at a Breach in a Wall
Oil on panel
35.0 x 26.7 cm. (13¾ x 10½ in.)
Lower right: P. Grolleron 81
Bequest of Mrs. Edward Jackson Holmes

Grolleron, Paul Louis Narcisse
French, 1848-1901
67.672
French Soldiers in the Snow
Oil on panel
24.0 x 33.0 cm. (9½ x 13 in.)
Lower right: P. Grolleron
Gift of the Estate of Francis A. Foster

Gros, Antoine Jean, Baron and Studio
French, 1771-1835
47.1059
General Bonaparte Visiting the Plague-Stricken
At Jaffa
Oil on canvas
118.5 x 164.0 cm. (46¾ x 64½ in.)
S. A. Denio Collection

Grundmann, Emil Otto
German (worked in United States), 1844-1890
92.2641
Union Army Veteran
Oil on canvas
91.2 x 60.6 cm. (35⅞ x 23⅞ in.)
Lower left: Otto Grun[...]
Gift of the Boston Art Students Association

Grundmann, Emil Otto
German (worked in United States), 1844-1890
Res. 09.213
Study of a Hindu
Oil on canvas
76.0 x 63.2 cm. (29⅞ x 24⅞ in.)
Gift of Mrs. Thomas Riley

Grundmann, Emil Otto
German (worked in United States), 1844-1890
Res. 10.23a
H. D. Chapin
Oil on canvas
61.0 x 45.5 cm. (24 x 17⅞ in.)
Upper right: Otto Grundmann / 1884
Bequest of Mr. and Mrs. H. D. Chapin

Grundmann, Emil Otto
German (worked in United States), 1844-1890
Res. 10.23b
Mrs. H. D. Chapin
Oil on canvas
61.0 x 45.2 cm. (24 x 17¾ in.)
Upper right: Otto Grundmann 78.
Bequest of Mr. and Mrs. H. D. Chapin

Grundmann, Emil Otto
German (worked in United States), 1844-1890
19.15
Interior of a German House
Oil on canvas mounted on panel
42.2 x 56.5 cm. (16⅝ x 22¼ in.)
A. Shuman Collection

Guardi, Francesco
Italian (Venetian), 1712-1793
11.1451
Procession of Gondolas in the Bacino di San Marco
Oil on canvas
98.0 x 138.0 cm. (38⅝ x 54⅜ in.)
Picture Fund

Guardi, Francesco, Workshop of
Italian (Venetian), 1712-1793
27.1328
Entrance to the Arsenal, Venice
Oil on canvas
39.5 x 47.9 cm. (15½ x 18⅞ in.)
Gift of Mrs. Horatio Greenough Curtis in Memory of
Horatio Greenough Curtis

Guardi, Copy after
26.776
Rio dei Mendicanti, Venice (after a painting in
the Accademia Carrara, Bergamo)
Oil on panel
19.3 x 13.8 cm. (7⅝ x 5⅜ in.)
William Sturgis Bigelow Collection

Guardi, Imitator of
51.448
The Dogana and Santa Maria della Salute,
Venice
Oil on canvas
47.0 x 62.0 cm. (18½ x 24⅜ in.)
Bequest of William K. Richardson

Guercino (Barbieri, Giovanni Francesco, called
Guercino)
Italian (Bolognese), 1591-1666
48.1028
Semiramis Receiving Word of the Revolt of
Babylon
Oil on canvas
112.5 x 154.5 cm. (44¼ x 60⅞ in.)
Francis Welch Fund

Guigou, Paul Camille
French, 1834-1871
22.669
View of Triel
Oil on panel
28.5 x 45.7 cm. (11¼ x 18 in.)
Lower left: Paul Guigou. 65
Gift of Ananda K. Coomaraswamy

Guillaumin, Jean Baptiste Armand
French, 1841-1927
48.560
Bridge in the Mountains
Oil on canvas
65.5 x 81.8 cm. (25¾ x 32¼ in.)
Lower right: Guillaumin
Bequest of John T. Spaulding

Haas, Maurits Frederik de
Dutch (worked in United States), 1832-1895
15.884
Coastal View with Three Figures by a Fire
Oil on canvas
71.5 x 111.8 cm. (28⅛ x 44 in.)
Lower right: M F H de Haas NA
William R. Wilson Donation

Haeften, Nicolas van, Attributed to
Dutch, about 1663-1715
1982.139
Portrait of a Family in an Interior
Oil on canvas
46.4 x 55.5 cm. (18¼ x 21⅞ in.)
Charles H. Bayley Picture and Painting Fund

Hall, Oliver
British, 1869-1957
47.1567
Autumn Color in Bardsea Forest
Oil on canvas mounted on masonite
33.0 x 46.0 cm. (13 x 18⅛ in.)
Lower left: Oliver Hall
Gift of Colonel and Mrs. Alcott Farrar Elwell

Hallé, Noël
French, 1711-1781
1978.123
The Death of Seneca
Oil on canvas
153.7 x 122.0 cm. (60½ x 48 in.)
Juliana Cheney Edwards Collection

Hals, Frans
Dutch, 1581/85-1666
66.1054
Portrait of a Man
Oil on canvas
85.8 x 66.9 cm. (33¾ x 26⅜ in.)
Lower right: FH (monogram)
*Gift of Mrs. Antonie Lilienfeld in Memory of
Dr. Leon Lilienfeld*

Hals, Frans, Follower of
21.1449
Portrait of an Old Woman
Oil on canvas
47.2 x 41.2 cm. (18⅝ x 16¼ in.)
William Sturgis Bigelow Collection

Hals, Frans, Imitator of
59.1003
Portrait of a Woman
Oil on panel
38.8 x 30.2 cm. (15¼ x 11⅞ in.)
Bequest of Edwin H. Abbot, Jr.

Hals, Jan
Dutch, active about 1630-1650
01.7445
Portrait of a Woman
Oil on canvas
127.5 x 101.5 cm. (50¼ x 40 in.)
Center left: AETATIS · SUA 47 / 1648 / IH
(monogram)
Henry Lillie Pierce Fund

Hamen y Léon, Juan van der
Spanish, 1596-before 1632
62.172
Still Life with Sweetmeats
Oil on canvas
39.7 x 72.2 cm. (15⅝ x 28⅜ in.)
M. Theresa B. Hopkins Fund

Hamilton, William, Attributed to
British, 1750/51-1801
22.10
Portrait of an Actress as Omphale
Oil on canvas
70.0 x 43.2 cm. (27½ x 17 in.)
William Sturgis Bigelow Collection

Harpignies, Henri Joseph
French, 1819-1916
23.486
Evening at St.-Privé
Oil on canvas
73.7 x 54.5 cm. (29 x 21½ in.)
Lower left: hjharpignies 90.
Bequest of Ernest Wadsworth Longfellow

Harpignies, Henri Joseph
French, 1819-1916
39.650
Landscape with an Old Dam
Oil on paperboard mounted on panel
40.0 x 33.4 cm. (15¾ x 13⅛ in.)
Lower left: hjharpignies. 82
Juliana Cheney Edwards Collection

Heath, Adrian
British, 1920-

63.2769
Composition 1960
Gouache, enamel and dye on paper
56.6 x 76.0 cm. (22¼ x 29⅞ in.)
Lower right: Heath '60
Gift of Mr. and Mrs. E. Anthony Kutten

Heiss, Johann
German, 1640-1704

Res. 22.304
Death of Dido
Oil on canvas
83.0 x 116.0 cm. (32⅝ x 45⅝ in.)
Gift of the Estate of Margaret Holly

Hélion, Jean
French, 1904-

57.153
Composition: Standing Figure
Oil on canvas
129.7 x 89.1 cm. (51 x 35⅛ in.)
Reverse: Helion / Paris 35
Gift of Mrs. Peggy Guggenheim

Hélion, Jean
French, 1904-

1982.401
Untitled
Oil on canvas
64.7 x 53.8 cm. (25½ x 21⅛ in.)
Fanny P. Mason Fund in Memory of Alice Thevin

Henner, Jean Jacques
French, 1829-1905

17.3265
Portrait of a Young Woman in a Red Robe
Oil on canvas
61.0 x 37.0 cm. (24 x 14⅝ in.)
Lower left: JJ Henner
Robert Dawson Evans Collection

Henner, Jean Jacques
French, 1829-1905

23.487
Girl with Auburn Hair
Oil on panel
27.5 x 21.4 cm. (10⅞ x 8⅜ in.)
Upper left: J HENNER
Bequest of Ernest Wadsworth Longfellow

Henner, Jean Jacques
French, 1829-1905
39.651
Young Woman with Brown Hair
Oil on panel
46.8 x 37.5 cm. (18⅜ x 14¾ in.)
Lower left: JJ Henner
Juliana Cheney Edwards Collection

Henry, Paul
Irish, 1876-1958
38.1550
Mountain Village
Oil on canvasboard
30.0 x 35.0 cm. (11¾ x 13¾ in.)
Lower right: PAUL HENRY
Gift of Henry L. Shattuck

Herbin, Auguste
French, 1882-1960
Res. 32.11
Landscape at Le Cateau, France
Oil on canvas
46.0 x 55.0 cm. (18⅛ x 21⅝ in.)
Lower right: herbin 1921
Tompkins Collection

Herkomer, Sir Hubert von
German (worked in Britain), 1849-1914
10.269
Dudley Williams
Oil on canvas
76.5 x 63.4 cm. (30⅛ x 25 in.)
Upper left: To my friend / H.D. Williams
Center left: H.H. 83
Gift of Hetty B. Williams

Herri met de Bles
Flemish, about 1480-after 1550
46.1143
Landscape with Burning City
Oil on panel
13.1 x 25.7 cm. (5⅛ x 10⅛ in.)
Seth K. Sweetser Fund

Herring, John Frederick, Sr.
British, 1795-1865
74.17
Ducks and Ducklings
Oil on paperboard
24.8 x 30.5 cm. (10¾ x 12 in.)
Upper center, along grass: J. F. Herring Sen 18[50?]
Bequest of Charles Sumner

Heusch, Jacob de
Dutch, 1657-1701
Res. 24.21
River Landscape with Mountains
Oil on canvas
78.7 x 135.8 cm. (31 x 53½ in.)
Gift of the Children of William Sohier

Heusch, Willem de
Dutch, 1625-1692
17.1420
Italian Landscape with Peasants and Donkeys
Oil on canvas
93.6 x 111.0 cm. (36⅞ x 43¾ in.)
Lower right: WDH (joined); and falsely, JBoth f
Gift of Arthur Brewster Emmons

Hobbema, Meindert, Imitator of
Dutch, 1638-1709
17.3251
Wooded Landscape with a Farm
Oil on canvas
60.2 x 82.3 cm. (23¾ x 32⅜ in.)
Robert Dawson Evans Collection

Hoesslin, Georg von
German, 1851-1923
Res. 08.13
Landscape with Classical Ruins
Oil on canvas
92.2 x 152.5 cm. (36¼ x 60 in.)
Gift of the Estate of Thomas Wigglesworth

Hogarth, William
British, 1697-1764
64.1602
Portrait of a Woman
Oil on canvas mounted on masonite
75.0 x 62.5 cm. (29½ x 24⅝ in.)
Gift of Mrs. Wingate Rollins

Hoin, Claude
French, 1750-1817
65.2660
Mademoiselle Rosalie Duthé
Pastel on paper
45.7 x 36.8 cm. (18 x 14½ in.)
The Forsyth Wickes Collection

Holm, Niels Emil Severin
Danish, 1823-1863
1980.209
View of the Straits of Messina from a Country House
Oil on canvas
82.5 x 130.5 cm. (32½ x 51½ in.)
Lower left: N. Emil Holm, / Messina 1859.
Tompkins Collection and Gift of John Goelet

Hölzel, Adolf
German, 1853-1934
09.207
In a Garden Restaurant
Oil on canvas
68.2 x 84.2 cm. (26⅞ x 33⅛ in.)
Lower right: A. Hölzel
Gift of the Bostoner Deutsche Gesellschaft through Hugo Münsterberg

Hondecoeter, Melchior d'
Dutch, 1636-1695
07.501
Barnyard Fowl and Peacocks
Oil on canvas
122.0 x 156.5 cm. (48 x 61⅝ in.)
Upper center, on stone wall:
Melchior d hondecoeter
James Fund

Hondecoeter, Melchior d', Workshop of
Dutch, 1636-1695
21.1451
Barnyard Fowl and Pigeons
Oil on canvas
85.5 x 127.1 cm. (33⅝ x 50 in.)
William Sturgis Bigelow Collection

Hondecoeter, Follower of
26.767
Barnyard Fowl
Oil on canvas
97.5 x 116.5 cm. (38⅜ x 45⅞ in.)
William Sturgis Bigelow Collection

Honthorst, Gerard van, Copy after
Dutch, 1590-1656
Res. 22.6
Itinerant Toothpuller (after a painting in the Musée du Louvre, Paris)
Oil on canvas
130.8 x 162.6 cm. (51½ x 64 in.)
William Sturgis Bigelow Collection

Hooch, Horatius de, Attributed to
Dutch, active 1642–died 1686
Res. 21.90
Italianate Landscape with Ruins, Peasants, and Cattle
Oil on canvas
83.9 x 108.4 cm. (33 x 42⅝ in.)
William Sturgis Bigelow Collection

Hooch, Pieter de
Dutch, 1629–after 1684
03.607
Interior of a Dutch House
Oil on canvas
57.5 x 69.8 cm. (22⅝ x 27½ in.)
Lower left: P · d · Hoogh / A°168[0?]
Bequest of Susan Cornelia Warren

Hoppner, John, Attributed to
British, 1758–1810
17.3263
Portrait of a Young Woman
Oil on canvas
69.0 x 57.5 cm. (27⅛ x 22⅝ in.)
Robert Dawson Evans Collection

Hoppner, Copy after
22.8
Horatio, First Viscount Nelson
(after a full length portrait in the Royal Collection,
St. James's Palace, London)
77.2 x 64.3 cm. (30⅜ x 25¼ in.)
William Sturgis Bigelow Collection

How, B. A.
British (?), first half, 19th century
37.1213
Interior of a Stable
Oil on canvas
71.5 x 92.0 cm. (28⅛ x 36¼ in.)
Lower left: B. A. How
Gift of Miss Amelia Peabody

Hudson, Thomas, Follower of
British, 1701–1779
23.539
Portrait of a Man Wearing an Embroidered Waistcoat
Oil on canvas
128.0 x 102.0 cm. (50⅜ x 40⅛ in.)
Bequest of David P. Kimball in Memory of his wife, Clara Bertram Kimball

Hughes-Stanton, Sir Herbert Edwin Pelham
British, 1870-1937
39.604
Landscape near Avignon
Oil on canvas
41.0 x 51.0 cm. (16⅛ x 20⅛ in.)
Lower left: Hughes-Stanton 1928
Gift of C. E. Delbos in Memory of his mother

Huguet, Victor Pierre
French, 1835-1902
37.601
Arabs on the March
Oil on canvas
64.7 x 85.1 cm. (25½ x 33½ in.)
Lower right: P. Huguet
Bequest of Ernest Wadsworth Longfellow

Hunt, E. Aubrey
American (worked in England), 1855-1922
Res. 21.267
Boat Houses on a River
Oil on canvas
59.7 x 92.6 cm. (23½ x 36½ in.)
Lower right: E. Aubrey Hunt.
Gift of Mrs. Livingston Davis

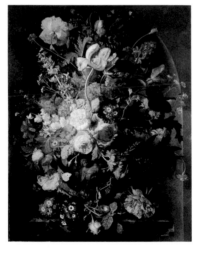

Huysmans, Cornelis
Flemish, 1648-1727
Res. 22.5
Rocky Landscape with Classical Figures
Oil on canvas
168.5 x 241.0 cm. (66⅜ x 94⅞ in.)
William Sturgis Bigelow Collection

Huysum, Jan van
Dutch, 1682-1749
89.503
Vase of Flowers in a Niche
Oil on panel
88.9 x 70.0 cm. (35 x 27½ in.)
Lower right, on marble slab: Jan Van Huysum
fecit
Bequest of Stanton Blake

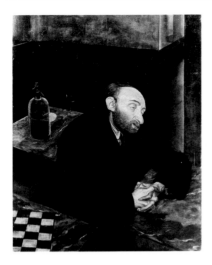

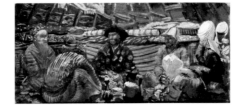

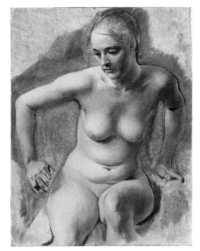

Iacovleff, Alexandre Evguenievitch
Russian (worked in France), 1887-1938

35.637
In the Café de la Rotonde, Paris
Tempera on canvas
99.8 x 81.5 cm. (39¼ x 32⅛ in.)
Lower right: A. Jacovleff 1921
Tompkins Collection

Iacovleff, Alexandre Evguenievitch
Russian (worked in France), 1887-1938

64.2082
Interior of a Kirgis Tent
Tempera on canvas
32.5 x 70.7 cm. (12¾ x 27⅞ in.)
Lower left: A Jacovleff
Bequest of Mrs. Edward Jackson Holmes

Iacovleff, Alexandre Evguenievitch
Russian (worked in France), 1887-1938

1984.979
Study of a Seated Nude
Oil on pressed-wood board
88.8 x 68.8 cm. (35 x 27⅛ in.)
Gift of Mr. and Mrs. David R. Pokross

Isabey, Louis Gabriel Eugène
French, 1803-1886

19.101
Harbor View
Oil on canvas
33.3 x 47.9 cm. (13⅛ x 18⅞ in.)
Lower right: E. Isabey
The Henry C. and Martha B. Angell Collection

Isabey, Louis Gabriel Eugène
French, 1803-1886

46.363
Courtiers in an Interior
Oil on panel
24.1 x 32.8 cm. (29½ x 12⅞ in.)
Lower right: E. Isabey / 64.
Bequest of Miss Sarah C. Bradlee

Isenbrant, Adriaen, Follower of
Flemish, active 1510-died 1551

Res. 27.152
The Crucifixion
Oil on panel
53.0 x 40.2 cm. (20⅞ x 15⅞ in.)
Bequest of Arthur P. Tarbell

Israels, Jozef
Dutch, 1824-1911
87.411
Convalescent Mother and a Child
Oil on panel
27.8 x 36.5 cm. (11 x 14⅜ in.)
Lower left: Jozef Israels.
Gift of George A. Goddard

Israels, Jozef
Dutch, 1824-1911
15.885
Young Girl Sewing
Oil on canvas
58.5 x 84.5 cm. (23 x 33¼ in.)
Lower left: Jozef Israels.
William R. Wilson Donation

Israels, Jozef
Dutch, 1824-1911
18.278
The Day before Parting
Oil on canvas
102.5 x 126.2 cm. (40⅜ x 49⅝ in.)
Lower left: Jozef Israels - 1862
Gift of Alice N. Lincoln

Israels, Jozef
Dutch, 1824-1911
23.535
Fisherwomen and Children on the Beach
Oil on canvas
47.0 x 60.5 cm. (18½ x 24 in.)
Lower right: Jozef Israels
Bequest of David P. Kimball in Memory of his wife Clara Bertram Kimball

Israels, Jozef
Dutch, 1824-1911
24.228
At the Spinning Wheel
Oil on panel
43.7 x 32.0 cm. (17¼ x 12½ in.)
Lower left: Josef Israels
Gift of Robert Jordan from the Collection of Eben D. Jordan

Italian, 14th century
45.514
The Crucifixion with Saint Francis and a Hermit Saint and *The Virgin and Child with Saint Lawrence* (reliquary diptych)
Tempera on panel
Overall: 18.4 x 26.2 cm. (7¼ x 10¼ in.)
Design: 11.0 x 7.0 cm. (4⅜ x 2¾ in.), each wing
Gift of Mr. and Mrs. J. Templeman Coolidge

Italian, 15th century, Imitator of
17.3229
Virgin and Child with the Crucifixion and Saints
Oil on linen on panel
Overall: 294.0 x 200.0 cm. (115¾ x 78¾ in.)
Robert Dawson Evans Collection

Italian, second half, 16th century
04.265
Portrait of a Man Wearing Armor
Oil on canvas
120.8 x 100.5 cm. (47½ x 39⅝ in.)
Isaac Sweetser Fund

Italian, 16th century
Res. 19.131
Virgin and Child and the Infant Saint John the Baptist
Oil on panel
38.7 x 28.9 cm. (15¼ x 11⅜ in.)
Gift of Mr. and Mrs. W. deForest Thomson

Italian, 16th century
Res. 19.134
The Risen Christ Appearing to Mary Magdalen
Oil on panel
42.7 x 37.4 cm. (16¾ x 14¾ in.)
Gift of Mr. and Mrs. W. deForest Thomson

Italian, 16th century
66.260
The Annunciation
Oil on panel
72.7 x 56.1 cm. (28⅝ x 22⅛ in.)
Bequest of Daisy Virginia Holde

Italian, second quarter, 17th century
13.2903
Portrait of a Young Nobleman
Oil on canvas
63.3 x 52.7 cm. (24⅞ x 20¾ in.)
Gift of Mrs. Lydia A. Barnard

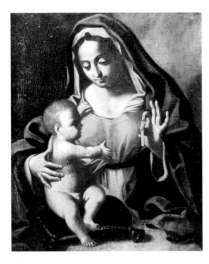

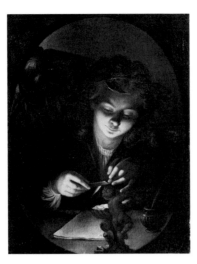

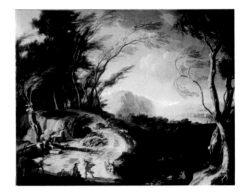

Italian, 17th century
07.861
Virgin and Child with a Cross
Oil on canvas
76.2 x 63.5 cm. (30 x 25 in.)
Gift of Mrs Richard H. Morgan

Italian, fourth quarter, 17th century - first quarter, 18th century
20.853
Poet Cutting a Pen
Oil on canvas
63.5 x 47.9 cm. (25 x 18⅞ in.)
Bequest of Dr. Emma B. Culbertson

Italian, fourth quarter, 17th century - first quarter, 18th century
51.2775
Windstorm
Oil on canvas
173.0 x 227.3 (68⅛ x 89½ in.)
Falsely signed, lower right, on rock: SR (monogram)
Anonymous Gift

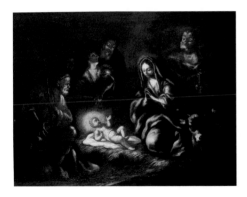

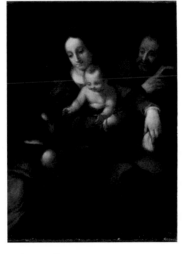

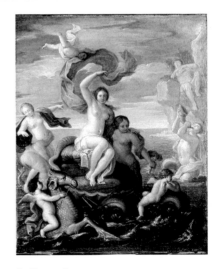

Italian, 17th or 18th century
Res. 24.78
Adoration of the Shepherds
Oil on canvas
76.3 x 102.5 cm. (30 x 40⅜ in.)
Bequest of Miss Anne Capen

Italian, 18th century
82.107
The Holy Family with the Young Saint John the Baptist
Oil on canvas
122.4 x 89.6 cm. (48⅛ x 35¼ in.)
Manner of acquistion unknown

Italian, 18th century
94.183
Triumph of Galatea
Oil on canvas
32.5 x 26.9 cm. (12¾ x 10⅝ in.)
Turner Sargent Collection

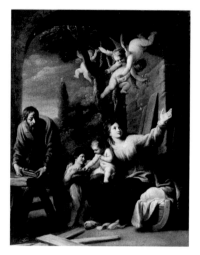

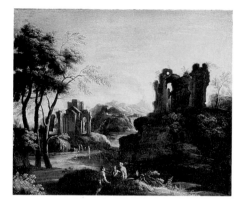

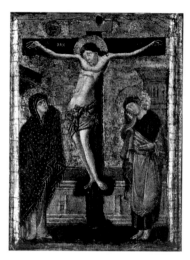

Italian, 18th century
12.380
The Holy Family with the Infant Saint John the Baptist in the Carpenter Shop
Oil on canvas
48.7 x 37.8 cm. (19⅛ x 14⅞ in.)
Gift of the Heirs of John Adams Blanchard

Italian, 18th century
Res. 15.6
Mountain Landscape with Ruins and Fishermen
Oil on canvas
61.2 x 75.0 cm. (24⅛ x 29½ in.)
Gift of George A. Goddard

Italian (Bolognese), fourth quarter, 13th century
28.886
The Crucifixion with the Virgin and Saint John
Tempera on panel
22.9 x 16.8 cm. (9 x 6⅝ in.)
Gift of Edward Jackson Holmes

Italian (Apulian), 14th century
37.410
Virgin and Child with Saints Christopher, Augustine, Stephen, John the Baptist, Nicholas and Sebastian (polyptych from the abbey of San Stefano, Bari)
Tempera on panel
Center panel: 229.0 x 72.0 cm. (90⅛ x 28⅜ in.)
Each of six side panels: 175.0 x 34.0 cm. (68⅞ x 13⅜ in.)
Gift of Dr. Eliot Hubbard

Italian (Bolognese), first half, 17th century
Res. 10.17
Rape of Europa
Oil on canvas
74.3 x 102.8 cm. (29¼ x 40½ in.)
Bequest of Catharine A. Barstow

Italian (Bolognese), second half, 17th century
74.27
Saint Mary Magdalen Penitent (fragment)
Oil on canvas
Design: 52.0 x 62.0 cm. (20½ x 24⅜ in.)
Bequest of Charles Sumner

Italian (Ferrarese), 15th century
17.198
The Meeting of Solomon and the Queen of Sheba
and *Cherub Holding Cornucopias of Cherries*
(recto and verso of a salver)
Oil on panel
61.0 x 61.0 cm. (24 x 24 in.)
Gift of Mrs. W. Scott Fitz

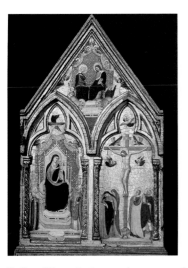

Italian (Florentine), second quarter, 14th century
38.1840
Virgin and Child with Saints and *The Crucifixion,* with *The Virgin and Christ Enthroned*
Tempera on panel
Overall: 57.1 x 34 cm. (22½ x 13⅜ in.)
Principal designs: 31.2 x 13.0 cm. (12¼ x 5⅛ in.) each
Zoe Oliver Sherman Collection
Gift of Zoe Oliver Sherman, in Memory of Henry H. Sherman

Italian (Florentine), 14th century
10.37
Saint Lucy
Tempera on panel
92.3 x 35.9 cm. (36⅜ x 14⅛ in.)
Gift of the Massachusetts Historical Society

Italian (Florentine), second half, 15th century
01.6220
Virgin and Child
Tempera on panel
62.8 x 40.2 cm. (24¾ x 15⅞ in.)
The Gardner Brewer Collection

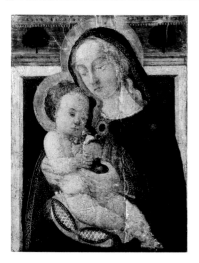

Italian (Florentine), second half, 15th century
03.565
Virgin and Child with a Goldfinch
Tempera on panel
50.5 x 37.7 cm. (19⅞ x 14⅞ in.)
Bequest of George Washington Wales

Italian (Florentine), second half, 15th century
06.2441b,c
(b) Rape of Ganymede
(c) Io and Argus (end panels of reassembled cassone; for main panel see **Appollonio de Giovanni**)
Tempera on panel
(b) 38.0 x 40.0 cm. (15 x 15¾ in.)
(c) 38.0 x 40.0 cm. (15 x 15¾ in.)
Bequest of Mrs. Martin Brimmer

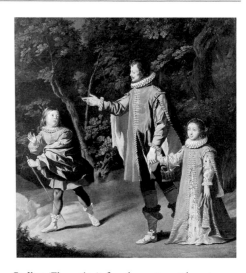

Italian (Florentine), first quarter, 16th century
63.1259
Portrait of a Young Man Reading a Letter
Oil on panel
Design: 32.0 x 24.9 cm. (12⅝ x 9¾ in.)
Charles Potter Kling Fund

Italian (Florentine), first half, 16th century
11.1263
The Holy Family with Saint Anne and the Young Saint John the Baptist
Oil on panel
146.0 x 109.0 cm. (57½ x 42⅞ in.)
Gift of Mary Ogden Adams and Charles Francis Adams

Italian (Florentine), fourth quarter, 16th century
65.1320
Nobleman with Two Children in a Landscape
Oil on canvas
93.4 x 84.6 cm. (36¾ x 33¼ in.)
M. Theresa B. Hopkins Fund

Italian (Florentine), 17th century
Res. 19.44
Saint Catherine
Oil on panel
43.0 x 36.8 cm. (16⅞ x 14½ in.)
Gift of Mrs. C. E. Danforth

Italian (Florentine ?), 17th century
Res. 27.118
The Holy Family
Oil on canvas
72.4 x 54.5 cm. (28¼ x 21½ in.)
*Gift of S. Richard Fuller in Memory of his wife Lucy
Derby Fuller*

Italian (Genoese), fourth quarter, 17th century
Res. 11.6
Diana (fragment)
Oil on canvas
Present design: 65.2 x 49.1 cm. (25⅝ x 19⅜ in.)
Gift of the Estate of Martha E. Dowse

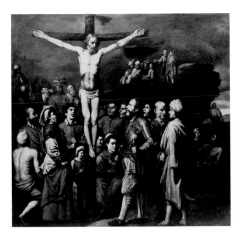

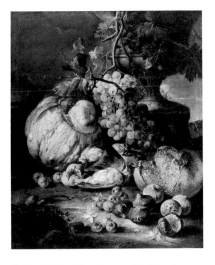

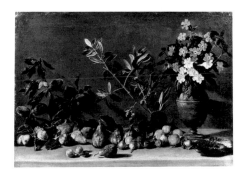

Italian (Neapolitan), second quarter, 17th century
Res. 21.81
Crucifixion of Saint Andrew
Oil on canvas
105.2 x 112.0 cm. (41⅜ x 44⅛ in.)
William Sturgis Bigelow Collection

Italian (Neapolitan), second half, 17th century
90.82
*Still Life with Fruit and Dead Birds in a
Landscape*
Oil on canvas
75.0 x 62.0 cm. (29½ x 24⅜ in.)
Bequest of Mrs. Henry Edwards

Italian (Neapolitan), second half, 17th century
39.42
Fruit and a Vase of Flowers on a Ledge
Oil on canvas
53.6 x 78.2 cm. (21⅛ x 30¾ in.)
Ernest Wadsworth Longfellow Fund

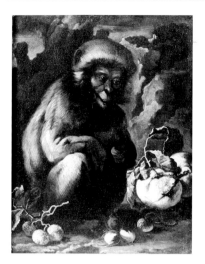

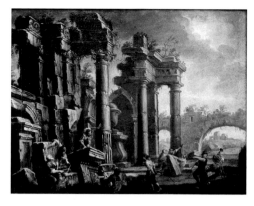

Italian (Neapolitan), 17th century
44.585
Monkey with Fruit
Oil on canvas
45.4 x 34.8 cm. (17⅞ x 13¾ in.)
Gift of the firm of Jacob Heimann

Italian (Neapolitan), second half, 18th century or
first quarter, 19th century

43.43
Roman Ruins with Quarriers at Work
Oil on canvas
44.0 x 58.4 cm. (17⅜ x 23 in.)
*Bequest of Sarah Elizabeth Lawton in Memory of her
husband, Mark A. Lawton*

Italian (Northern), second half, 15th century
26.166
Virgin and Child (*Virgin of Humility*)
Oil on panel
43.4 x 32.0 cm. (17⅛ x 12⅝ in.)
Gift of Edward Jackson Holmes

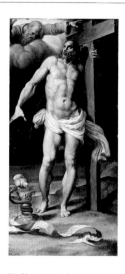

Italian (Northern), second half, 15th century
64.2085
***Apparition of the Virgin and Child to a
Bedridden Woman and her Family*** (ex voto)
Tempera on panel
29.5 x 41.0 cm. (11⅝ x 16⅛ in.)
Bequest of Mrs. Edward Jackson Holmes

Italian (Northern), mid-16th century
11.1262
Cherub (fragment)
Oil on panel
32.2 x 27.2 cm. (12⅝ x 10¾ in.)
Gift of Mrs. William LeBrun

Italian (Northern), second half, 16th century
74.22
The Risen Christ (*Allegory of Redemption*)
Oil on panel
33.3 x 15.3 cm. (13⅛ x 6 in.)
Bequest of Charles Sumner

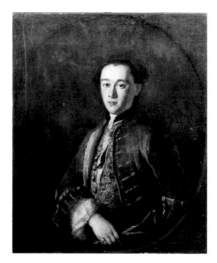

Italian (Northern), second half, 17th century
Res. 08.14
The Stigmatization of Saint Francis
Oil on canvas mounted on panel
36.8 x 27.3 cm. (14½ x 10¾ in.)
Gift of the Estate of Thomas Wigglesworth

Italian (Northern), second quarter, 18th century
17.588
Portrait of a Man
Oil on canvas
99.3 x 81.5 cm. (39⅛ x 32⅛ in.)
Denman Waldo Ross Collection

Italian (Northern), first half, 18th century
12.318
Triumph of Bacchus
Oil on canvas
72.0 x 92.2 cm. (28⅜ x 36¼ in.)
Gift of George N. Faught

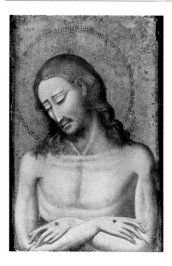

Italian (Riminese), 14th century
28.887
Christ as the Man of Sorrows
Tempera on panel
26.7 x 17.2 cm. (10½ x 6¾ in.)
Gift of Edward Jackson Holmes

Italian (Roman ?), first quarter, 17th century
50.651
Poppies in a Wine Flask
Oil on canvas
65.0 x 56.5 cm. (25⅝ x 22¼ in.)
Falsely signed, lower right: MA¹ Cariva[...]i fe
Charles Potter Kling Fund

Italian (Roman), second quarter, 17th century
21.751
Huntresses Resting
Oil on canvas
68.5 x 52.5 cm. (27 x 20⅝ in.)
Denman Waldo Ross Collection

Italian (Roman), second quarter, 17th century
21.752
Wrestlers in a Landscape
Oil on canvas
67.8 x 52.8 cm. (26¾ x 20¾ in.)
Denman Waldo Ross Collection

Italian (Roman), second half, 17th century
59.193
Peaches and Pears in a Glass Bowl
Oil on canvas
61.2 x 76.0 cm. (24⅛ x 29⅞ in.)
M. Theresa B. Hopkins Fund

Italian (Roman), second half, 17th century
1970.604
Mountain Landscape with Fishermen
Oil on canvas
75.0 x 96.5 cm. (29½ x 38 in.)
Gift of G. Peabody Gardner

Italian (Roman), 17th century
Res. 15.7
River Landscape with Armed Horsemen
Oil on canvas
60.0 x 73.0 cm. (23⅝ x 28¾ in.)
Gift of George A. Goddard

Italian (Roman), 17th century
34.141
The Colosseum and the Arch of Constantine
Oil on canvas
118.7 x 171.5 cm. (46¾ x 67½ in.)
Gift of George B. Dorr

Italian (Roman), first quarter, 18th century
1970.603
Landscape with Hunters
Oil on canvas
58.1 x 157.8 cm. (22⅞ x 62⅛ in.)
Gift of G. Peabody Gardner

Italian (Roman), second quarter, 18th century
Res. 10.22
Satyr, Nymph, and Cupid
Oil on canvas
29.9 x 24.3 cm. (11¾ x 9⅝ in.)
Bequest of Miss Catharine A. Barstow

Italian (Roman), 18th century
65.1712
Classical Buildings along a Quay
Oil on canvas
128.3 x 116.8 cm. (50½ x 46 in.)
Gift of Louis and Lawrence Curtis

Italian (Sienese), fourth quarter, 14th century
15.953
Bishop Saint (Saint Gregory the Great ?)
Tempera on panel
Panel: 40.0 x 20.4 cm. (15¾ x 8 in.)
Design: 36.5 x 16.8 cm. (14⅜ x 6⅝ in.)
Gift of Mrs. W. Scott Fitz

Italian (Sienese), 1364
50.5
The Commune of Siena (biccherna [tax registry] book cover)
Tempera on panel
45.0 x 33.3 cm. (17¾ x 13⅛ in.)
Below: Questo e libro de lentrate et de lescite de la general / e bicherna del com di Siena al tenpo de savi e diseti hu / omin [...] di Marchovaldo e di ser Petro Lenzi e di [...] Bonisegna [...] miss Sandro de Bandigli & di ma / [...] ceccho & di [...] dia di

Ghuccio Chamarlengho & / [...] di biccherna a di pmo di genaio milletrecet / [...] chale de [...]uglio ·M·CCCLXIIII· Bartalome / [...] loro scrittore
Charles Potter Kling Fund

Italian (Sienese), 14th century, Imitator of
03.566
Virgin and Child Enthroned with Four Saints
Oil on panel
Overall: 46.5 x 34.8 cm. (18¼ x 13¾ in.)
Design: 41.3 x 29.8 cm. (16¼ x 11¾ in.)
Bequest of George Washington Wales

Italian (Sienese), 15th century

60.536

The Crucifixion with the Virgin and Saint John,
with *Saint John the Baptist* above; *Franciscan
Saint in Prayer before a Vision of Christ and
Saints,* with a *Male Saint* above (recto and verso
of a reliquary)
Tempera on panel
Overall: 70.0 x 37.5 cm. (27½ x 14¾ in.)
Principal design: 22.5 x 8.5 cm. (8⅞ x 3⅜ in.)
Charles Potter Kling Fund

Italian (Spoletan), first quarter, 14th century

24.115

The Infant Christ (fragment)
Fresco transferred to canvas and mounted on panel
Dimensions: 42.8 x 49.5 cm. (16 x 19½ in.)
Gift of René Gimpel

Italian (Tuscan), first quarter, 15th century

03.563

*Virgin and Child with Saints John the Baptist,
James, Peter, and a Virgin Martyr*
Tempera on panel
76.5 x 47.0 cm. (30⅛ x 18½ in.)
Bequest of George Washington Wales

Italian (Umbrian), fourth quarter, 15th century

19.183

*Virgin and the Young Saint John the Baptist
Adoring the Child*
Tempera on panel
44.7 x 38.1 cm. (17⅝ x 15 in.)
Gift of Mr. and Mrs. W. deForest Thomson

Italian (Umbrian), 15th century

47.233

Saint Sebastian with a Donor
Fresco transferred to canvas
148.0 x 66.0 cm. (58¼ x 26 in.)
Charles Potter Kling Fund

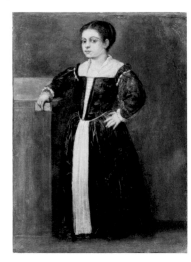

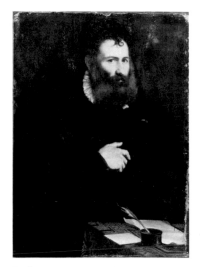

Italian (Venetian ?), fourth quarter, 16th century
Res. 19.130
Virgin and Child with the Infant Saint John the Baptist
Oil on panel
50.8 x 42.8 cm. (20 x 16⅞ in.)
Gift of Mr. and Mrs. W. deForest Thomson

Italian (Venetian), 16th century
23.463
Portrait of a Girl
Oil on canvas
120.4 x 88.8 cm. (47⅜ x 35 in.)
Bequest of Ernest Wadsworth Longfellow

Italian (Venetian), 16th century
27.188
Portrait of a Man at a Writing Desk
Oil on canvas
95.6 x 70.3 cm. (37⅝ x 27⅝ in.)
Gift of Mrs. W. Scott Fitz

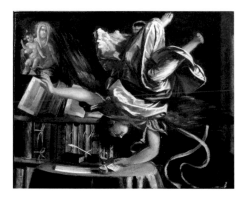

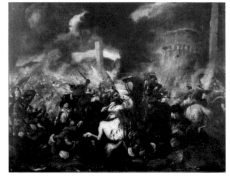

Italian (Venetian ?), last quarter, 16th century - first quarter, 17th century
55.983
Angel in a Scholar's Study (fragment)
Oil on canvas
48.2 x 63.5 cm. (19 x 25 in.)
Charles Potter Kling Fund

Italian (Venetian), first half, 18th century
1970.602
Battle Scene
Oil on canvas
151.0 x 202.4 cm. (59½ x 79⅝ in.)
Gift of Mrs. Ernest Brummer

Italian (Venetian), 18th century
17.1407
Venetian Card Party
Oil on canvas
83.6 x 101.7 cm. (32⅞ x 40 in.)
Denman Waldo Ross Collection

Italian (Venetian), fourth quarter, 18th century
07.483
The Frozen Lagoon, Venice
Oil on canvas
34.2 x 49.5 cm. (13½ x 19½ in.)
Denman Waldo Ross Collection

Italian (Venetian), 18th century
44.833
Cherub (fragment)
Fresco transferred to canvas
Octagonal: 61.6 x 54.0 cm. (24¼ x 21¼ in.)
Gift of Edward Jackson Holmes

Italian (Venetian), late 18th or 19th century
08.163
Head of an Old Man
Oil on canvas
58.7 x 49.5 cm. (23⅛ x 19½ in.)
Gift of Mrs. Andrew C. Wheelwright

Italian (Veronese), 15th century
44.659
Judgement of Paris
Tempera and oil on panel
Panel: 108.0 x 187.5 cm. (42½ in. x 73⅞ in.)
Design: 106.0 x 185.2 cm. (41⅝ x 72⅞ in.)
Herbert James Pratt Fund

Italian (Veronese), about 1700
Res. 37.242
Lot and his Daughters
Oil on canvas
122.7 x 92.5 cm. (48¼ x 36⅜ in.)
Gift of the Estate of William A. Sargent

Italian (?), 18th or 19th century
Res. 19.132
The Nativity
Tempera on panel
34.3 x 29.2 cm. (13½ x 11½ in.)
Gift of Mr. and Mrs. W. deForest Thomson

Italian (?), 18th or 19th century
Res. 19.133
The Annunication
Tempera on panel
38.0 x 31.9 cm. (15 x 12½ in.)
Gift of Mr. and Mrs. W. deForest Thomson

Italian (?), mid-19th century
06.2417
Portrait of a Man
Oil on panel
42.3 x 34.1 cm. (16⅝ x 13⅜ in.)
Upper left: G[...] FACEB [...]
Bequest of Mrs. Martin Brimmer

Jacopo da Valenza
Italian (Venetian), active 1485-about 1509
26.141
Saint Jerome in the Wilderness
Oil on panel
59.7 x 42.7 cm. (23½ x 16¾ in.)
Seth K. Sweetser Fund and Contribution from
Edward Jackson Holmes

Jacque, Charles Emile
French, 1813-1894
18.399
Shepherd and Sheep on the Edge of a Plain
Oil on canvas
32.5 x 60.5 cm. (12¾ x 23⅞ in.)
Lower left: ch. Jacque
Gift from the Isaac Fenno Collection through
Mrs. Isaac Fenno-Gendrot

Jacque, Charles Emile
French, 1813-1894
20.1867
Shepherdess Watering Sheep
Oil on canvas
81.9 x 100.3 cm. (32¼ x 39½ in.)
Lower left: ch. Jacque 1881
Gift of Louisa W. and Marian R. Case

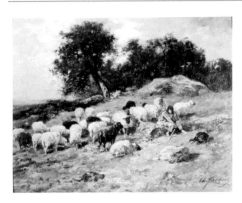

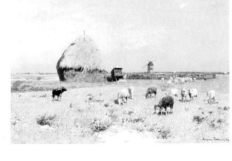

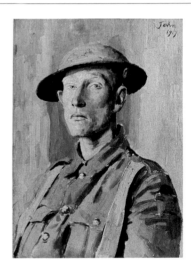

Jacque, Charles Emile
French, 1813-1894
23.568
Shepherd and Sheep
Oil on paperboard mounted on canvas
23.0 x 30.0 cm. (9 x 11¾ in.)
Lower right: ch. Jacque
Bequest of Ernest Wadsworth Longfellow

Jettel, Eugène
Austrian, 1845-1901
23.485
Landscape near Cayenz with a Sheepdog and
Flock
Oil on canvas
55.9 x 79.9 cm. (22 x 31½ in.)
Lower right: Eugène Jettel paris 89.
Bequest of Ernest Wadsworth Longfellow

John, Augustus Edwin
British, 1878-1961
48.566
Canadian Soldier
Oil on canvas
58.5 x 43.3 cm. (23 x 17 in.)
Upper right: John / 1917
Bequest of John T. Spaulding

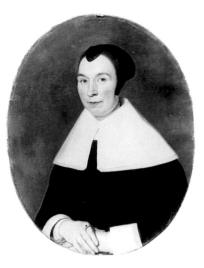

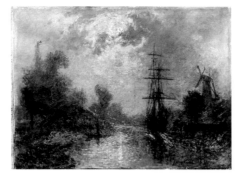

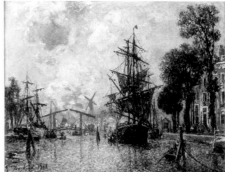

Jongh, Ludolf de, Follower of
Dutch, 1616-1679

17.591
Portrait of a Woman
Oil on canvas
72.0 x 57.5 cm. (28⅜ x 22⅝ in.)
Denman Waldo Ross Collection

Jongkind, Johan Barthold
Dutch, 1819-1891

19.95
Harbor by Moonlight
Oil on canvas
34.0 x 46.2 cm. (13⅜ x 18⅛ in.)
Lower right: Jongkind 1871
The Henry C. and Martha B. Angell Collection

Jongkind, Johan Barthold
Dutch, 1819-1891

61.1242
Harbor Scene in Holland
Oil on canvas
42.0 x 56.0 cm. (16½ x 22 in.)
Lower left: Jongkind 1868
Gift of Count Cecil Pecci-Blunt

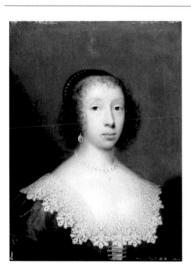

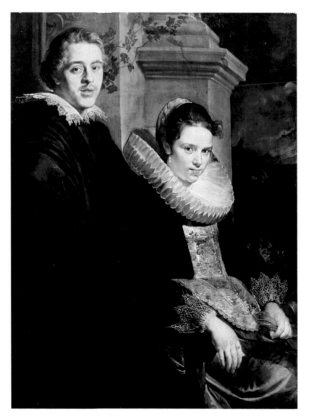

Jonson van Ceulen, Cornelis, the Elder
Dutch (worked in Britain), 1593-1664/65

48.504
Portrait of a Woman
Oil on panel
43.2 x 33.0 cm. (17 x 13 in.)
Lower right: C. J. fecit / 1631.
*Gift of Mrs. Albert J. Beveridge in Memory of Delia
Spencer Field*

Jordaens, Jacob
Flemish, 1593-1678

17.3232
Portrait of a Young Married Couple
Oil on panel
124.5 x 92.4 cm. (49 x 36⅜ in.)
Robert Dawson Evans Collection

Jordaens, Jacob
Flemish, 1593-1678

54.134
Bacchus Discovering Ariadne
Oil on canvas
121.0 x 127.2 cm. (47⅝ x 50⅛ in.)
M. Theresa B. Hopkins Fund

Jordaens, Imitator of
Res. 21.266
Drinking Scene
Oil on canvas
87.4 x 103.0 cm. (34⅜ x 40½ in.)
Gift of Miss Elizabeth Howard Bartol

Jorn, Asger
Danish (worked in France), 1914-1973

63.2666
Male Flower
Oil on canvas
81.0 x 65.0 cm. (31⅞ x 25⅝ in.)
Lower right: Jorn
Tompkins Collection

Joyant, Jules Romain
French, 1803-1854

76.762
The Grand Canal, with Santa Maria della Salute, Venice
Oil on canvas
140.2 x 195.6 cm. (55¼ x 77 in.)
Lower left: J. JOYANT / 1850
Manner of acquisition unknown

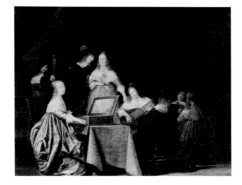

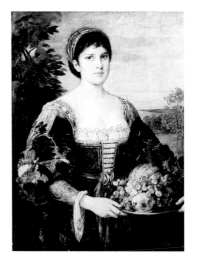

Kaiser, Peter
German, 1918-
61.1093
Abstract Painting
Oil on burlap
130.3 x 89.5 cm. (51¼ x 35¼ in.)
Lower right: Kaiser 5[5?]
Gift of Mrs. Peggy Guggenheim

Kamper, Godaert
German (worked in Holland), 1613/14-1679
46.842
Musical Party
Oil on panel
37.5 x 48.0 cm. (14¾ x 18⅞ in.)
Lower center, on edge of table: G. Kamp[...]
Gift of Mrs. Albert J. Beveridge in Memory of Delia Spencer Field

Kaulbach, Friedrich August von
German, 1850-1920
11.1453
Portrait of a Woman
Oil on canvas
100.0 x 76.0 cm. (39⅜ x 29⅞ in.)
Lower right: F A. Kaulbach
Gift of the estate of Francis B. Greene in Memory of Mr. and Mrs. Francis B. Greene

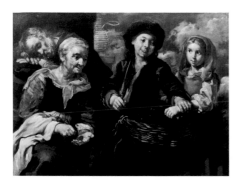

Keil, Bernard (called Monsu Bernardo)
Danish (worked in Rome), 1624-1687
39.805
Young Boy Selling Vegetables
Oil on canvas
95.8 x 133.2 cm. (37¾ x 52⅜ in.)
Gift of Mrs. William G. Nickerson

Keil, Bernard (called Monsu Bernardo)
Danish (worked in Rome), 1624-1687
39.806
Young Boy Selling Kindling Wood
Oil on canvas
95.6 x 133.2 cm. (37⅝ x 52⅜ in.)
Gift of Mrs. William G. Nickerson

Keil, Follower of
74.25
Old Man with a Guitar and a Boy with a Recorder
Oil on canvas
104.2 x 94.0 cm. (41 x 37 in.)
Bequest of Charles Sumner

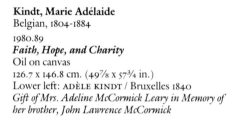

Keirincx, Alexander
Flemish, 1600-1652
22.641
Rest on the Flight into Egypt
Oil on panel
49.0 x 36.7 cm. (19¼ x 14½ in.)
Zoe Oliver Sherman Collection

Kindt, Marie Adélaide
Belgian, 1804-1884
1980.89
Faith, Hope, and Charity
Oil on canvas
126.7 x 146.8 cm. (49⅞ x 57¾ in.)
Lower left: ADÈLE KINDT / Bruxelles 1840
Gift of Mrs. Adeline McCormick Leary in Memory of her brother, John Lawrence McCormick

Kirchner, Ernst Ludwig
German, 1880-1938
56.13
Mountain Landscape from Clavadel
Oil on canvas
135.0 x 200.5 cm. (53⅛ x 78⅞ in.)
Incised, upper right: K; and lower left: K
Lower right: ELKiRcHneR
Reverse: E L Kirchner / 25-26 / Berglandschaft von Clavadel
Tompkins Collection

Kirchner, Ernst Ludwig
German, 1880-1938
57.2
Reclining Nude
Oil on canvas
74.0 x 151.5 cm. (29⅛ x 59⅝ in.)
Lower left: E. L Kirchner 09
Tompkins Collection

Kneller, Sir Godfrey, Studio of
British, 1646-1723
29.789
Portrait of a Woman (said to be Anne Churchill, Countess of Sunderland)
Oil on canvas
73.3 x 53.0 cm. (28⅞ x 20⅞ in.)
Bequest of George Nixon Black

Kneller, Sir Godfrey, Studio of
British, 1646-1723
1332.12
Portrait of a Woman (said to be Mary Bentinck, Countess of Essex)
Oil on canvas
126.5 x 101.2 cm. (49¾ x 39⅞ in.)
Deposited by the Trustees of the White Fund, Lawrence, Massachusetts

Købke, Christen
Danish, 1810-1848

1972.979
Marina Piccola, Capri
Oil on canvas
35.5 x 51.7 cm. (14 x 20⅜ in.)
Gift of John Goelet in Honor of Perry T. Rathbone

Kokoschka, Oskar
Austrian, 1886-1980

1973.196
Two Nudes (Lovers)
Oil on canvas
163.0 x 97.5 cm. (64¼ x 38⅜ in.)
Lower center: OK
Bequest of Mrs. Sarah Reed Blodgett Platt

Kokoschka, Oskar
Austrian, 1886-1980

61.1138
Double Portrait of Trudl
Oil on canvas
101.0 x 71.5 cm. (39¾ x 28⅛ in.)
Upper left: OK / 1931
Seth K. Sweetser Fund

Koninck, Salomon
Dutch, 1609-1656

04.266
Portrait of an Old Woman
Oil on panel
92.3 x 70.3 cm. (36⅜ x 27⅝ in.)
Center left: S Konin[ck]
Isaac Sweetser Fund

Krčal, Karel
Austrian, 1888-

Res. 32.12
Three Women
Tempera on canvas
169.5 x 140.5 cm. (66¾ x 55¼ in.)
Tompkins Collection

Ladvocat, M.
French, active, mid-17th century
65.2646
Portrait of a Woman Wearing a Pearl Necklace
Oil on panel
34.4 x 25.5 cm. (13½ x 10 in.)
Upper left: m. ladvocat
The Forsyth Wickes Collection

Lagye, Victor
Belgian, 1829-1896
Res. 08.15
Prayers for a Sick Child
Oil on panel
71.0 x 56.7 cm. (28 x 22⅜ in.)
Lower right: V. Lagye / Anvers / 1864
Gift of the Estate of Thomas Wigglesworth

Lamb, Henry
British, 1885-1960
Res. 32.13
Boris Anrep and his Family
Oil on panel
95.4 x 157.5 cm. (37½ x 62 in.)
Tompkins Collection

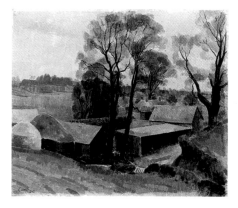

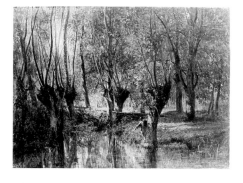

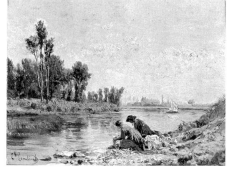

Lamb, Henry
British, 1885-1960
Res. 32.23
Farm at Wimborne, Dorset
Oil on canvas
46.0 x 56.0 cm. (18⅛ x 22 in.)
Lower left: Lamb / 25
Gift by Contribution

Lambinet, Emile Charles
French, 1815-1877
94.311
Young Man Fishing beneath Willow Trees
Oil on canvas
74.2 x 92.8 cm. (29¼ x 36½ in.)
Lower left: 1856 Emile Lambinet.
Bequest of James William Paige

Lambinet, Emile Charles
French, 1815-1877
17.1622
Washerwomen
Oil on canvas
16.3 x 21.8 cm. (6⅜ x 8⅝ in.)
Lower left: Eˡᵉ Lambinet
Bequest of John R. Hall

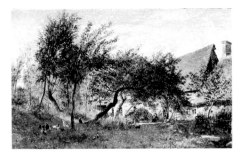

Lambinet, Emile Charles
French, 1815-1877
20.1868
Farmyard
Oil on panel
37.7 x 61.2 cm. (14⅞ x 24⅛ in.)
Lower left: 62 Emile Lambinet
Gift of Louisa W. and Marian R. Case

Lambinet, Emile Charles
French, 1815-1877
23.567
Fishing on the Banks of the Seine
Oil on canvas
24.4 x 32.4 cm. (9⅝ x 12¾ in.)
Lower left: Emile Lambinet 72
Bequest of Ernest Wadsworth Longfellow

Lambinet, Emile Charles
French, 1815-1877
37.599
Road through the Fields
Oil on canvas
32.8 x 46.5 cm. (12⅞ x 18¼ in.)
Lower left: Emile Lambinet 72.
Bequest of Ernest Wadsworth Longfellow

 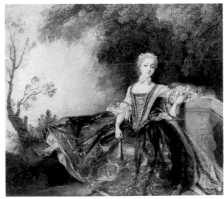

Lambinet, Emile Charles
French, 1815-1877
37.600
Village on the Sea
Oil on panel
29.4 x 46.0 cm. (11⅝ x 18⅛ in.)
Lower right: 66. Emile Lambinet
Bequest of Ernest Wadsworth Longfellow

Lancret, Nicolas
French, 1690-1745
40.478
Young Woman and a Servant with an Empty Birdcage
Oil on canvas
46.2 x 54.7 cm. (18⅛ x 21½ in.)
Martin Brimmer Fund, Ernest Wadsworth Longfellow Fund, and Mrs. Edward Wheelwright Fund

Lancret, Nicolas
French, 1690-1745
65.2647
Portrait of a Woman in a Landscape
Oil on panel
28.1 x 33.1 cm. (11 x 13 in.)
The Forsyth Wickes Collection

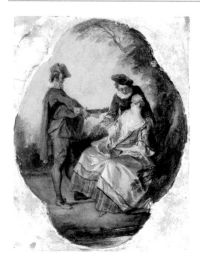

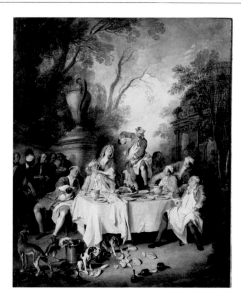

Lancret, Nicolas
French, 1690-1745

65.2648
Serenade
Oil on panel
28.8 x 22.2 cm. (11⅜ x 8¾ in.)
The Forsyth Wickes Collection

Lancret, Nicolas
French, 1690-1745

65.2649
Luncheon Party in a Park (*Le Déjeuner de jambon*)
Oil on canvas
55.7 x 46.0 cm. (21⅞ x 18⅛ in.)
The Forsyth Wickes Collection

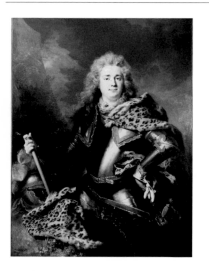

Largillierre, Nicolas de
French, 1656-1746

1981.283
François Armand de Gontaut, Duc de Biron
Oil on canvas
138.8 x 106.6 cm. (54⅝ x 42 in.)
Reverse of original canvas: peint par N de Largillierre / 1714
Juliana Cheney Edwards Collection

Lastman, Pieter
Dutch, 1583-1633

62.985
Wedding Night of Tobias and Sarah
Oil on panel
41.2 x 57.9 cm. (16¼ x 22¾ in.)
Lower right: PLastman (P and L joined) fecit / 1611
Juliana Cheney Edwards Collection

La Tour, Maurice Quentin de
French, 1704-1788

65.2661
Portrait of a Woman in a Rose-colored Gown
Pastel on paper
63.5 x 53.3 cm. (25 x 21 in.)
The Forsyth Wickes Collection

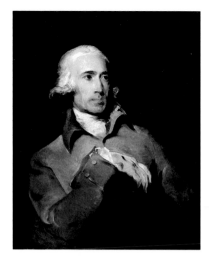

Laurencin, Marie
French, 1885-1956
48.569
Three Creole Women
Oil on canvas
54.0 x 66.0 cm. (21¼ x 26 in.)
Lower right: Marie Laurencin / 1929
Bequest of John T. Spaulding

Lavery, John
British, 1856-1941
1983.373
Lila Lancashire
Oil on canvas
76.4 x 63.6 cm. (30⅛ x 25 in.)
Lower Right: J Lavery
Gift of Mr. and Mrs. Richard W. Southgate

Lawrence, Sir Thomas
British, 1769-1830
02.514
William Lock of Norbury
Oil on canvas
76.3 x 63.7 cm. (30 x 25⅛ in.)
Gift of Denman W. Ross as a Memorial to Charles G. Loring

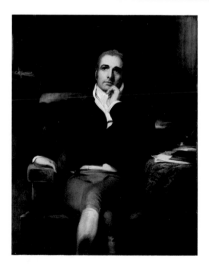

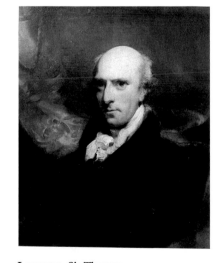

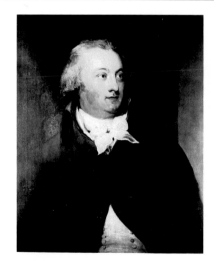

Lawrence, Sir Thomas
British, 1769-1830
09.183
John Philip Kemble
Oil on canvas
145.5 x 113.1 cm. (57¼ x 44½ in.)
Gift of Francis Bartlett

Lawrence, Sir Thomas
British, 1769-1830
24.212
Sir Uvedale Price, Baronet
Oil on canvas
76.2 x 63.5 cm. (30 x 25 in.)
Gift of Robert Jordan from the Collection of Eben D. Jordan

Lawrence, Sir Thomas
British, 1769-1830
29.790
Portrait of a Man in a Blue Coat
Oil on canvas
76.2 x 63.5 cm. (30 x 25 in.)
Bequest of George Nixon Black

Lawrence, Copy after
99.304
John Julius Angerstein (after a painting in the
collection of Lloyds, London)
Oil on canvas
61.0 x 51.0 cm. (24 x 20⅛ in.)
Bequest of Miss Lucy Ellis

Lawrence, Copy after
07.484
The Prince Regent, later George IV (after one
of several versions, principal painting in the
Royal Collection, Windsor)
Oil on canvas
30.5 x 21.8 cm. (12⅛ x 8⅝ in.)
Gift of Edward W. Forbes

Lawrence, Follower of
17.3261
Lady Leicester and her Son
Oil on canvas
238.5 x 137.0 cm. (93⅞ x 53⅞ in.)
Robert Dawson Evans Collection

Lawrence, Follower of
37.1209
*Portrait of a Young Woman in a Green Gown
and Plumed Hat*
Oil on canvas
104.0 x 76.0 cm. (41 x 29⅞ in.)
Gift of Miss Amelia Peabody

Lawrence, Follower of
35.1225
Portrait of a Woman
Oil on canvas
76.5 x 63.4 cm. (30⅛ x 25 in.)
Gift of Frederick L. Jack

Lawrence, Imitator of
17.3221
Portrait of a Woman Sketching
Oil on canvas
127.5 x 101.5 cm. (50¼ x 40 in.)
Robert Dawson Evans Collection

LeBrun, Charles, Copy after
French, 1619-1690
Res. 21.308
Alexander at the Battle of Arbella (after a
painting in the Chateau de Versailles)
Oil on canvas
122.5 x 206.5 cm. (48¼ x 81¼ in.)
Gift of Miss Elizabeth Bartol

Leclerc, Sébastien Jacques (called Leclerc des
Gobelins)
French, 1734-1785
Res. 27.117
***Amorous Couples and Musicians in a Park with
a Fountain***
Oil on canvas mounted on masonite
50.8 x 60.5 cm. (20 x 23⅞ in.)
*Gift of S. Richard Fuller in Memory of his wife Lucy
Derby Fuller*

Ledoux, Jeanne Philiberte, Attributed to
French, 1767-1840
87.409
Portrait of a Boy
Oil on canvas
41.8 x 33.0 cm. (16½ x 13 in.)
Gift of George A. Goddard

Lefèvre, Robert Jacques François Faust
French, 1755-1830
26.789
Napoleon in his Coronation Robes
Oil on canvas
Design: 251.1 x 191.5 cm. (98⅞ x 75⅜ in.)
Lower right: Robert Lefèvre fᵗ· 1812.
William Sturgis Bigelow Collection

Leighton, Frederick, Lord
British, 1830-1896
10.81
Stella
Oil on canvas
34.2 x 27.0 cm. (13½ x 10⅝ in.)
Gift of the Estate of Dana Estes

Leighton, Frederick, Lord
British, 1830-1896
1981.258
Painter's Honeymoon
Oil on canvas
83.5 x 76.8 cm. (32⅞ x 30¼ in.)
Charles H. Bayley Picture and Painting Fund

Lely, Sir Peter (Pieter van der Faes, called
Peter Lely), Studio of
German (worked in England), 1618-1680

35.1228
Barbara Villiers, Duchess of Cleveland (version
of a three-quarter length portrait formerly in
the Bolingbroke Collection)
Oil on canvas
67.5 x 54.5 cm. (26⅝ x 21½ in.)
Gift of Frederick L. Jack

Lely, Copy after
Res. 33.216
Oliver Cromwell (after a painting in the City
Museum and Art Gallery, Birmingham)
Oil on canvas
76.3 x 63.3 cm. (30 x 24⅞ in.)
Gift of Mrs. Paul Revere Frothingham

Lely, Copy after
43.1319
Sir Henry Vane (after a painting in Raby
Castle, County Durham)
Oil on canvas
76.5 x 64.2 cm. (30⅛ x 25¼ in.)
Bequest of Charles M. Davenport

Lemoine, François, Copy after
French, 1688-1737

27.153
Hercules and Omphale (after a painting in the
Musée du Louvre, Paris)
Oil on canvas
152.8 x 119.0 cm. (60⅛ x 46⅞ in.)
Bequest of Arthur P. Tarbell

Le Nain, Louis, Copy after
French, 1600/10-1648

22.611
Peasants in front of a House (after a painting
in the Fine Arts Museums of San Francisco)
Oil on canvas
56.4 x 66.0 cm. (22¼ x 26 in.)
Clara Bertram Kimball Fund

Le Nain, Mathieu
French, about 1607-1677

1978.225
The Entombment of Christ
Oil on canvas
81.3 x 105.2 cm. (32 x 41⅜ in.)
*Gift of John Goelet in Memory of George Peabody
Gardner*

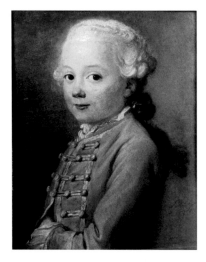

Le Nain, Mathieu, Attributed to
French, about 1607-1677

58.1197
***The Crucifixion with the Virgin,* and *Saints John
and Mary Magdalen***
Oil on canvas
153.0 x 105.5 cm. (60¼ x 41¾ in.)
M. Theresa B. Hopkins Fund

Lenbach, Franz von
German, 1836-1904

24.224
Otto Bismarck
Oil on paperboard
67.3 x 53.3 cm. (26½ x 21 in.)
Lower right: f. Lenbach (f and L joined)
*Gift of Robert Jordan from the Collection of Eben D.
Jordan*

Lenoir, Simon Bernard
French, 1729-1789

65.2662
Portrait of a Young Boy (said to be Marc René de
Heere)
Pastel on paper
46.5 x 39.0 cm. (18¼ x 15⅜ in.)
Lower right: LeNoir pxit / 1760
The Forsyth Wickes Collection

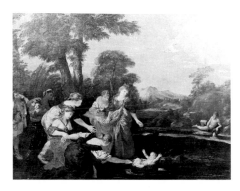

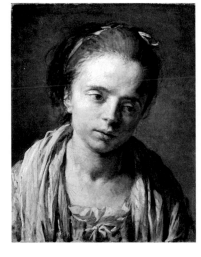

Leone, Andrea di
Italian (Neapolitan), 1610-1685

20.1630
Moses Saved from the Waters
Oil on canvas
94.0 x 130.5 cm. (37 x 51⅜ in.)
Denman Waldo Ross Collection

Lépicié, Nicolas Bernard
French, 1735-1784

1981.278
Portrait of a Young Girl
Oil on canvas
39.4 x 31.6 cm. (15½ x 12⅜ in.)
Charles H. Bayley Picture and Painting Fund

Lerolle, Henry
French, 1848-1929

84.248
By the Riverside
Oil on canvas
471.0 x 300.0 cm. (185⅜ x 118⅛ in.)
Lower left: H. Lerolle
Gift of Francis C. Foster

Le Sidaner, Henri Eugène Augustin
French, 1862-1939
39.658
Garden by a Pool
Oil on canvas
65.7 x 81.6 cm. (25⅞ x 32⅛ in.)
Lower right: LeSidaneR
Juliana Cheney Edwards Collection

Le Sidaner, Henri Eugène Augustin
French, 1862-1939
68.567
Grand Trianon
Oil on canvas
70.5 x 94.5 cm. (27¾ x 37¼ in.)
Lower right: Le SidaneR
Bequest of Katherine Dexter McCormick

Leslie, Charles Robert
British, 1794-1859
96.945
Sir Walter Scott
Oil on canvas
91.5 x 71.0 cm. (36 x 28 in.)
Bequest of Miss Anna Eliot Ticknor

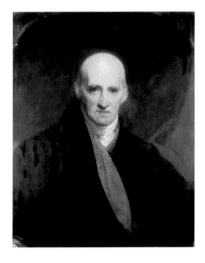

Leslie, Charles Robert
British, 1794-1859
15.876
John Howard Payne
Oil on canvas
76.0 x 63.5 cm. (29⅞ x 27 in.)
Gift of George R. White and Howard Payne

Leslie, Charles Robert
British, 1794-1859
36.354
Benjamin West
Oil on panel
79.0 x 63.5 cm. (31⅛ x 25 in.)
Gift of the Heirs of Stephen Higginson

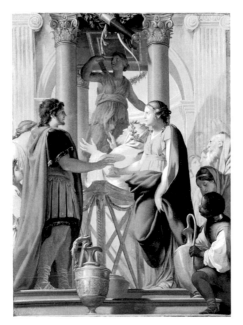

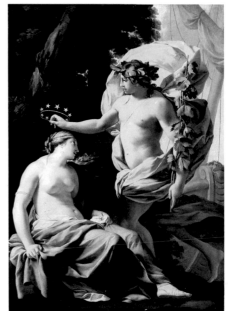

Le Sueur, Eustache
French, 1616-1655
48.16
Sacrifice to Diana
Oil on canvas
171.8 x 125.7 cm. (67⅝ x 49½ in.)
M. Theresa B. Hopkins Fund

Le Sueur, Eustache
French, 1616-1655
68.764
Bacchus Crowning Ariadne with Stars
Oil on canvas
175.3 x 125.7 cm. (69 x 49½ in.)
*Ernest Wadsworth Longfellow Fund, and
Grant Walker Fund*

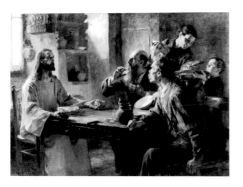

Lhermitte, Léon Augustin
French, 1844-1925
92.2657
Friend of the Humble *(Supper at Emmaus)*
Oil on canvas
155.5 x 223.0 cm. (61¼ x 87¾ in.)
Lower left: L. Lhermitte / 1892
Gift of J. Randolph Coolidge

Lhermitte, Léon Augustin
French, 1844-1925
44.38
Wheatfield *(Noonday Rest)*
Oil on canvas
53.2 x 77.5 cm. (21 x 30½ in.)
Lower right: L. Lhermitte
*Bequest of Julia C. Prendergast in Memory of her
brother, James Maurice Prendergast*

Lhermitte, Léon Augustin
French, 1844-1925
1981.279
Women and Children Bathing in a River
Pastel on paper
43.8 x 54.0 cm. (17¼ x 21¼ in.)
Lower right: L. Lhermitte
Gift of Dr. Henry Kemble Oliver, by exchange

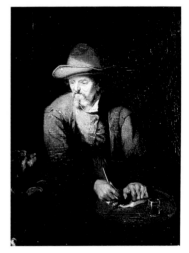

Lhote, André
French, 1885-1962

48.570
Nude Woman
Pastel on paper
62.2 x 33.7 cm. (24½ x 13¼ in.)
Upper right: A. LHOTE
Bequest of John T. Spaulding

Licinio, Bernardino
Italian (Venetian), 1489/91-1549/65

Res. 19.43
The Holy Family with the Infant Saint John the Baptist
Oil on panel
49.9 x 57.3 cm. (19⅝ x 22½ in.)
Lower left: [B]ERN / [A]RDI / [...]I·LYC / [...]NII· / [...]PVS
Gift of Mrs. C. E. Danforth

Linnig, Willem, the Elder
Belgian, 1819-1885

94.177
Man Filling a Pipe
Oil on panel
29.7 x 22.4 cm. (11¾ x 8¾ in.)
Lower right: WLinnig
Turner Sargent Collection

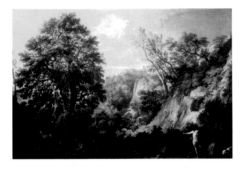

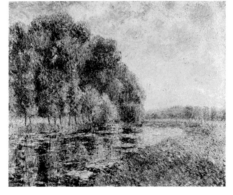

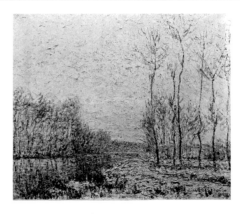

Locatelli, Andrea
Italian (Roman), 1693/95-1741

Res. 24.25
Landscape with Hunters
Oil on canvas
90.0 x 136.0 cm. (35⅜ x 53½ in.)
Lower right, on rock: AL (monogram)
Gift of the Children of William Sohier

Loiseau, Gustave
French, 1865-1935

19.1319
On the Banks of the Eure
Oil on canvas
65.8 x 81.3 cm. (25⅞ x 32 in.)
Lower right: G. Loiseau 1904
John Pickering Lyman Collection

Loiseau, Gustave
French, 1865-1935

19.1320
Winter on the Banks of the Eure
Oil on canvas
65.8 x 81.3 cm. (25⅞ x 32 in.)
Lower right: G Loiseau / 90
John Pickering Lyman Collection

Lombard, Lambert, Copy after
Flemish, 1505/06-1566

15.290
The Last Supper (after an engraving by Giorgio
Ghisi from a design by Lambert Lombard)
Oil on panel
78.8 x 134.7 cm. (31 x 53 in.)
Gift of George A. Goddard

Longhi, Alessandro
Italian (Venetian), 1733-1813

40.722
Portrait of a Man
Oil on canvas
65.7 x 54.4 cm. (25⅞ x 21⅜ in.)
*Bequest of Ernest Wadsworth Longfellow, by
exchange*

Longhi, Alessandro, Attributed to
Italian (Venetian), 1733-1813

17.589
Portrait of a Man in a Brown Cloak
Oil on canvas
66.7 x 50.5 cm. (26¼ x 19⅞ in.)
Denman Waldo Ross Collection

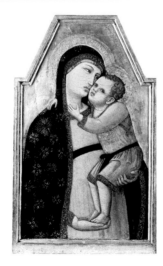

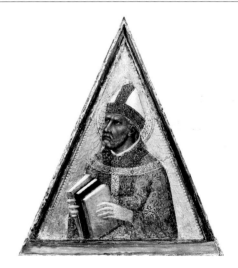

Longhi, Pietro
Italian (Venetian), 1702-1785

41.922
Young Woman Winding a Skein of Yarn
Oil on canvas
61.8 x 50.7 cm. (24⅜ x 20 in.)
Gift of Edward Jackson Holmes

Lorenzetti, Ambrogio
Italian (Sienese), active 1319-1347

39.536
Virgin and Child
Tempera on panel
Design: 75.5 x 45.3 cm. (29¾ x 17⅞ in.)
Charles Potter Kling Fund

Lorenzetti, Ambrogio
Italian (Sienese), active 1319-1347

51.738
Bishop Saint
Tempera on panel
Panel: 36.7 x 32.0 cm. (14½ x 12⅝ in.)
Design: 26.2 x 26.3 cm. (10¼ x 10⅜ in.)
Charles Potter Kling Fund

Lotto, Lorenzo
Italian (Venetian), about 1480-1556
60.154
Virgin and Child with Saints Jerome and Anthony
Oil on canvas
94.3 x 77.8 cm. (37⅛ x 30⅝ in.)
Charles Potter Kling Fund

Lotto, Lorenzo, Workshop of
Italian (Venetian), about 1480-1556
27.189
The Mystical Marriage of Saint Catherine
(version of a painting in the Alte Pinakothek, Munich)
Oil on panel
41.8 x 48.6 cm. (16½ x 19⅛ in.)
Francis Bartlett Fund

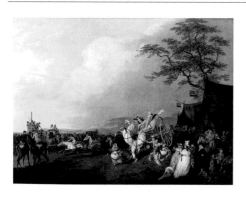

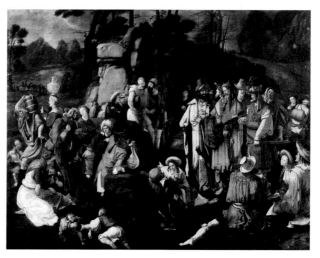

Loutherbourg, Philippe Jacques de, II,
Attributed to
French (worked in Britain), 1740-1812
37.469
Gig Upsetting at the Races
Oil on canvas
132.0 x 183.5 cm. (52 x 72¼ in.)
Bequest of Mary Lee Ware

Lucas van Leyden (Lucas Hugensz., called Lucas van Leyden)
Dutch, 1494-1538
54.1432
Moses and the Israelites after the Miracle of Water from the Rock
Glue tempera on linen
182.5 x 237.0 cm. (71⅝ x 93½ in.)
Lower center, on rock: 1527 / L
William K. Richardson Fund

Luini, Bernardino
Italian (Milanese), active 1512 - died 1532

21.2287
Salome with the Head of Saint John the Baptist
Oil on panel
61.2 x 50.5 cm. (24⅛ x 19⅞ in.)
Gift of Mrs. W. Scott Fitz

Luminais, Evariste Vital
French, 1822-1896

24.230
Captives
Oil on canvas
56.0 x 46.3 cm. (22 x 18¼ in.)
Lower left: EV. Luminais
*Gift of Dorothy Jordan Robinson, from the Collection
of Eben D. Jordan*

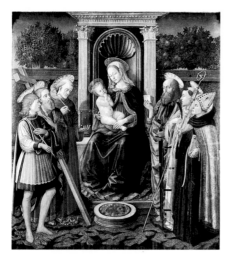

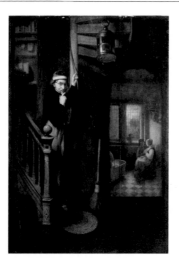

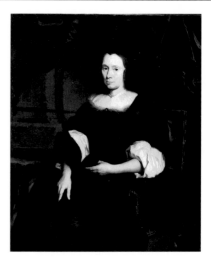

Machiavelli, Zanobi di Jacopo
Italian (Florentine), 1418-1479
48.297
Virgin and Child with Saints Sebastian, Andrew,
Bernardino, Paul, Lawrence and Augustine
Oil and tempera on panel
Panel: 234.3 x 219.7 cm. (92¼ x 86½ in.)
Design: 234.3 x 205.9 cm. (92¼ x 81 in.)
Charles Potter Kling Fund

Maes, Nicolaes
Dutch, 1634-1693
89.504
Jealous Husband
Oil on panel
72.7 x 50.4 cm. (28⅝ x 19⅞ in.)
Gift by Subscription

Maes, Nicolaes
Dutch, 1634-1693
10.104
Portrait of a Woman
Oil on canvas
115.0 x 94.6 cm. (45¼ x 37¼ in.)
Lower right: AEᵀ 67 · 167[...] / N. MAES.
Gift of Mrs. W. Scott Fitz

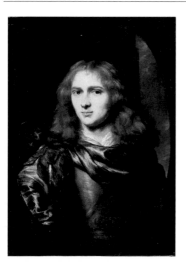

Maes, Nicolaes
Dutch, 1634-1693
1973.447
Portrait of a Young Man
Oil on canvas
44.1 x 32.1 cm. (17⅜ x 12⅝ in.)
Lower left: M[...]S
Lower right: 16[...]I
Gift of the Heirs of Samuel Cabot

Maes, Follower of
57.199
Pancake Maker
Oil on panel
44.0 x 32.7 cm. (17⅜ x 12⅞ in.)
Seth K. Sweetser Fund

Maganza, Giovanni Battista, I, Attributed to
Italian (Vicenzan), 1509-1586
43.192
Healing in the Temple (fragment)
Oil on canvas
144.6 x 175.8 cm. (56⅞ x 69¼ in.)
Gift of George E. and Lucia E. Farrington

Maggiotto (Domenico Fedeli, called Maggiotto)
Italian (Venetian), 1713-1794

38.1733
Two Peasant Boys with a Basket
Oil on canvas
59.8 x 44.6 cm. (23½ x 17½ in.)
Charles Edward French Fund

Magnasco, Alessandro
Italian (Genoese), 1667-1749

36.219
Soldiers Playing Cards in a Rocky Landscape
Oil on canvas
118.3 x 94.2 cm. (46⅝ x 37⅛ in.)
Herbert James Pratt Fund

Magnasco, Follower of

42.491
Shipwreck
Oil on canvas
79.3 x 67.5 cm. (31¼ x 26⅝ in.)
*Bequest of Ernest Wadsworth Longfellow; Bequest of
Nathaniel T. Kidder; The Henry C. and Martha B.
Angell Collection; William Sturgis Bigelow
Collection; Gift of Dr. Harold W. Dana; and Gifts by
Subscription, by exchange*

Mainardi, Sebastiano di Bartolo
Italian (Florentine), active 1474-died 1513

46.1429
Virgin Adoring the Child
Oil on panel
54.5 x 36.0 cm. (21½ x 14⅛ in.)
Gift of Quincy A. Shaw

Malherbe, William
French, 1894-1951

45.646
Barrows' House, Thetford Hill, Vermont
Oil on canvasboard
46.0 x 38.0 cm. (18⅛ x 15 in.)
Lower left: WILLIAM MALHERBE. 1944.
Anonymous Gift

Malherbe, William
French, 1894-1951

45.647
Young Woman Dressing
Oil on canvas
61.1 x 51.0 cm. (24 x 20⅛ in.)
Lower right: WILLIAM MALHERBE. 1945.
Anonymous Gift

Mallet, Jean Baptiste
French, 1759-1835
1982.640
Young Woman Kneeling before a Priest
Oil on canvas mounted on masonite
24.1 x 32.6 cm. (9½ x 12⅞ in.)
Lower right: Mall[...]t / 1826
Gift of Julia Appleton Bird

Mancini, Antonio
Italian, 1852-1930
20.850
Saint John the Baptist
Oil on canvas
200.0 x 80.5 cm. (78¾ x 31¾ in.)
Tompkins Collection

Mancini, Antonio
Italian, 1852-1930
21.1842
Italian Peasant Boy
Oil on canvas
170.0 x 87.0 cm. (66⅞ x 34¼ in.)
Upper right: A Mancini Roma
Francis Bartlett Fund

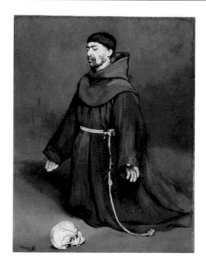

Manet, Edouard
French, 1832-1883
30.444
Execution of the Emperor Maximilian
Oil on canvas
196.0 x 259.8 cm. (77⅛ x 102¼ in.)
Gift of Mr. and Mrs. Frank Gair Macomber

Manet, Edouard
French, 1832-1883
35.67
Monk in Prayer
Oil on canvas
146.5 x 115.0 cm. (57⅝ x 45¼ in.)
Lower left: manet
Anna Mitchell Richards Fund

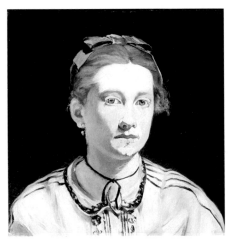

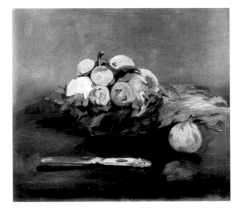

Manet, Edouard
French, 1832-1883
37.621
René Maizeroy
Pastel on canvas
56.2 x 35.0 cm. (22⅛ x 13¾ in.)
Lower right: manet
Presented in Memory of Robert Jordan by his wife

Manet, Edouard
French, 1832-1883
46.846
Victorine Meurend
Oil on canvas
42.9 x 43.7 cm. (16⅞ x 17¼ in.)
Upper right: manet
Gift of Richard C. Paine in Memory of his father, Robert Treat Paine 2nd

Manet, Edouard
French, 1832-1883
48.576
Basket of Fruit
Oil on canvas
37.7 x 44.4 cm. (14⅞ x 17½ in.)
Lower right: Manet
Bequest of John T. Spaulding

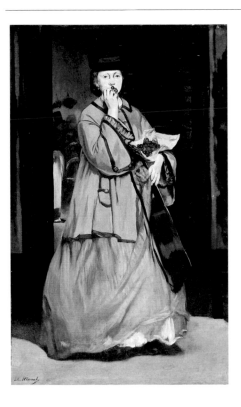

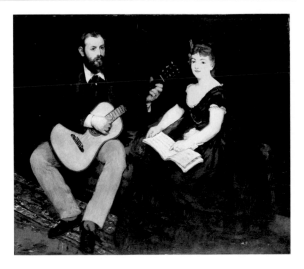

Manet, Edouard
French, 1832-1883
66.304
Street Singer
Oil on canvas
Design: 171.3 x 105.8 cm. (67⅜ x 41⅝ in.)
Lower left: éd. Manet
Bequest of Sarah Choate Sears in Memory of her husband, Joshua Montgomery Sears

Manet, Edouard
French, 1832-1883
69.1123
Music Lesson
Oil on canvas
141.1 x 173.1 cm. (55½ x 68⅛ in.)
Lower left: Manet
Anonymous Centennial Gift in memory of Charles Deering

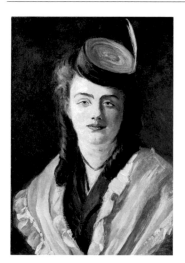

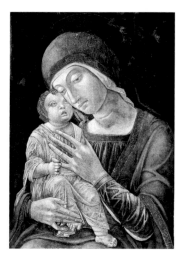

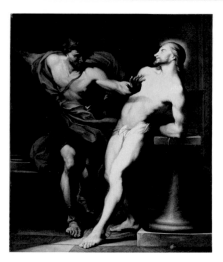

Manet, Follower of
60.1458
Portrait of a Young Woman
Oil on canvas
54.7 x 38.0 cm. (21½ x 15 in.)
Juliana Cheney Edwards Collection

Mantegna, Andrea, Follower of
Italian (Paduan), about 1430-1506
33.682
Virgin and Child
Tempera on panel
48.5 x 34.6 cm. (19⅛ x 13⅝ in.)
George Nixon Black Fund

Maratta, Carlo
Italian (Roman), 1625-1713
1983.387
The Flagellation of Christ
Oil on canvas
143.5 x 122.1 cm (56½ x 48⅛ in.)
Henry H. and Zoe Oliver Sherman Fund

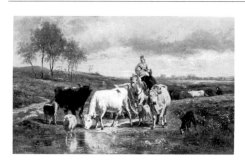

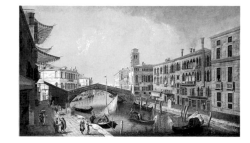

Marcke de Lummen, Emil van, Imitator of
French, 1827-1890
1972.230
Peasants Taking their Animals to Water
Oil on canvas
42.0 x 70.5 cm. (16½ x 27¾ in.)
Falsely signed, lower left: Em. Van Marcke
Gift of Misses Aimée and Rosamond Lamb

Marco del Buono Giamberti
see
Apollonio di Giovanni di Tomaso
and
Marco del Buono Giamberti

Marieschi, Michele, Follower of
Italian (Venetian), 1710-1744
27.1329
The Canaregio, Venice
Oil on canvas
61.5 x 101.5 cm. (24¼ x 40 in.)
Gift of Mrs. Horatio Greenough Curtis in Memory of Horatio Greenough Curtis

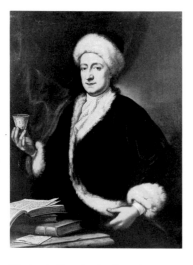

Marinari, Onorio, Attributed to
Italian (Florentine), 1627-1715
Res. 27.23
Portrait of a Scholar
Oil on canvas
115.5 x 87.3 cm. (45½ x 34⅜ in.)
Gift of William Davies Sohier

Maris, Jacobus Hendrikus
Dutch, 1837-1899
24.231
Farm in Holland
Oil on canvas
46.8 x 54.0 cm. (18⅜ x 21¼ in.)
Lower right: J. Maris
*Gift of Dorothy Jordan Robinson, from the Collection
of Eben D. Jordan*

Maris, Matthijs
Dutch, 1839-1917
13.467
Woman Trussing a Fowl
Oil on panel
34.1 x 26.7 cm. (13⅜ x 10½ in.)
Bequest of Mrs. Edward Wheelwright

Maris, Willem
Dutch, 1844-1910
25.118
River Landscape with Cattle
Oil on canvas
54.7 x 75.0 cm. (21½ x 29½ in.)
Lower right: Willem Maris
Juliana Cheney Edwards Collection

Martin, John
British, 1789-1854
60.1157
Seventh Plague of Egypt
Oil on canvas
144.1 x 214.0 cm. (56¾ x 84¼ in.)
Lower left: J. Martin 1823
Francis Welch Fund

Martin, Copy after

61.394

Sadak in Search of the Waters of Oblivion (after a painting in the City Art Gallery, Southampton)
Oil on canvas
76.1 x 64.1 cm. (30 x 25¼ in.)
Gift of Philip Hofer

Martini, Simone
Italian (Sienese), active 1315–died 1344

51.2397

Male Saint Holding a Book
Tempera on panel
Panel: 21.2 x 22.3 cm. (8⅜ x 8¾ in.)
Design: 18.5 x 19.6 cm. (7¼ x 7¾ in.)
Charles Potter Kling Fund

Martini, Simone, Follower of

16.117

The Crucifixion with the Virgin and Saint John
Tempera on panel
Panel: 21.9 x 15.2 cm. (8⅝ x 6 in.)
Design: 18.0 x 11.5 cm. (7⅛ x 4½ in.)
Gift of Mrs. W. Scott Fitz

Marzal de Sas, Andrés
Spanish (?) (worked in Valencia), active 1393–1410

37.328

Virgin and Child Enthroned
Tempera on panel
194.5 x 87.5 cm. (76⅝ x 34½ in.)
Herbert James Pratt Fund

Massari, Lucio
Italian (Bolognese), 1569–1633

83.176

The Entombment of Christ
Oil on canvas
83.0 x 58.4 cm. (32⅝ x 23 in.)
Gift of Martin Brimmer

Massys, Jan
Flemish, 1509–1575

12.1048

Judith with the Head of Holofernes
Oil on panel
102.4 x 75.7 cm. (40¼ x 29¾ in.)
Lower right, along back edge of sword blade:
OPVS JOHANNES MATSIIS
Lower right, on blade near hilt: [...] 1543
Abbott Lawrence Fund and Picture Fund

Mastenbroek, Johann Hendrik van
Dutch, 1875-1945

23.471
Rotterdam Harbor
Oil on canvas
64.5 x 90.6 cm. (25⅜ x 35⅝ in.)
Lower right: J. H. v. Mastenbroek. 1907.
Bequest of Ernest Wadsworth Longfellow

Master of Alkmaar, Attributed to
Dutch, active about 1504-1540

1980.356
Christ before Pilate and *Christ as the Man of Sorrows*
Oil on panel
Design: 87.5 x 36.0 cm. (34½ x 14⅛ in.)
Marion F. Winnek Fund

Master of Alkmaar, Attributed to
Dutch, active about 1504-1540

1980.357
Pilate Washing his Hands and *Saint Martin of Tours with a Beggar and the Donor*
Oil on panel
Design: 87.5 x 41.0 cm. (34½ x 16⅛ in.)
Marion F. Winnek Fund

Master of the Bambino Vispo (possibly Gherardo Starnina)
Italian (Florentine), active first quarter, 15th century

20.1855a
Saint Vincent
Tempera on panel
67.0 x 34.0 cm. (26⅜ x 13⅜ in.)
Gift of Mrs. Thomas O. Richardson

20.1855b
Saint Stephen
Tempera on panel
66.5 x 33.0 cm. (26⅛ x 13 in.)
Gift of Mrs. Thomas O. Richardson

20.1856
Isaiah with Two Angels
Tempera on panel
31.8 x 74.1 cm. (12½ x 29⅛ in.)
On scroll: isaia pro
Gift of Mrs. Thomas O. Richardson

20.1857
Jeremiah with Two Angels
Tempera on panel
31.8 x 73.6 cm. (12½ x 29 in.)
On scroll: gieremia profeta
Gift of Mrs. Thomas O. Richardson

Master of the Barberini Panels
see
Bartolomeo Corradini

Master of Belmonte
Spanish (Aragonese), active third quarter, 15th century

24.338
Saint Martin of Tours Dividing his Cloak for a Beggar
Tempera on panel
Overall: 177.0 x 115.0 cm. (69⅝ x 45¼ in.)
Design: 166.7 x 105.7 cm. (65⅝ x 41⅝ in.)
Herbert James Pratt Fund

Master of Bonastre
Spanish (Valencian), active mid-15th century

10.36
Coronation of the Virgin
Oil on panel
134.5 x 107.2 cm. (53 x 42¼ in.)
Denman Waldo Ross Collection
Gift of Denman W. Ross in Memory of Samuel Dennis Warren

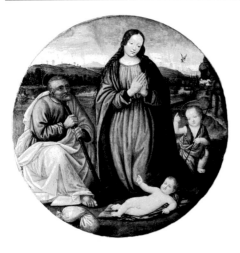

Master of the Holden Tondo, Attributed to
Italian (Florentine), active about 1500

03.568
The Holy Family with the Young Saint John the Baptist in a Landscape
Oil transferred from panel to canvas
Diameter: 101.3 cm. (39⅞ in.)
Bequest of George Washington Wales

Master of the Holy Kinship
German (Cologne School), active last quarter, 15th century and first quarter, 16th century

07.646
Saint Matthias and Saint Matthew
Oil on panel
48.0 x 32.4 cm. (18⅞ x 12¾ in.)
Denman Waldo Ross Collection

Master of the Miraculous Annunciation of Ss. Annunziata, Copy after
Italian (Florentine), mid-14th century

1978.685
Archangel Gabriel (after a fresco in the church of Ss. Annunziata, Florence)
Oil on copper
Oval: 19.0 x 14.0 cm. (7½ x 5½ in.)
Gift of Misses Aimée and Rosamond Lamb

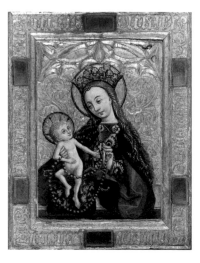

Master of the Miraculous Annunciation of Ss. Annunziata, Copy after
Italian (Florentine), mid-14th century
1978.684
The Virgin of the Annunciation (after a fresco in the church of Ss. Annunziata, Florence)
Oil on copper
Oval: 19.0 x 14.0 cm.(7½ x 5½ in.)
Gift of Misses Aimée and Rosamond Lamb

Master of the Saint Barbara Altar
Silesian, active mid-15th century
1970.77
Virgin and Child (reliquary)
Oil and tempera on panel
Overall: 43.7 x 34.2 cm. (17¼ x 13½ in.)
Design: 28.5 x 22.6 cm. (11¼ x 8⅞ in.)
M. Theresa B. Hopkins Fund

Master of Saint Giles
French, active about 1500
25.48
Portrait of a Man
Oil on panel
18.5 x 14.8 cm. (7¼ x 5⅞ in.)
Maria Antoinette Evans Fund

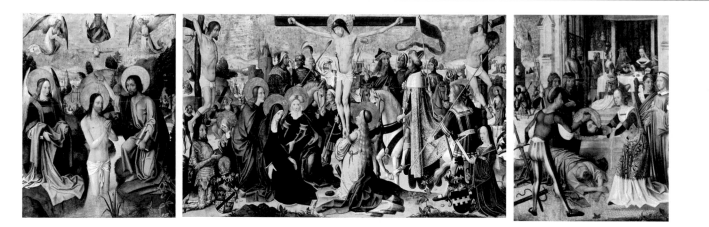

Master of Saint Severin
German (Cologne School), active about 1480-1520
12.169
The Crucifixion and *Scenes from the Life of Saint John the Baptist* with *Saint Christopher and the Virgin and Child and Saints John the Baptist and Catherine of Alexandria, with the Donors* (triptych)
Oil on panel
Center panel: 128.0 x 216.0 (50⅜ x 85 in.)
Left wing: 127.5 x 100.0 cm. (50¼ x 39⅜ in.)
Right wing: 127.0 x 100.0 cm. (50 x 39⅜ in.)
Picture Fund

Master of Saint Severin
12.169
Outer wings of triptych

Master of San Miniato, Follower of
Italian (Florentine), active second half, 15th
century

03.562
*Virgin Adoring the Child with Two Angels and
the Holy Spirit*
Tempera on panel
86.0 x 46.8 cm. (33⅞ x 18⅜ in.)
Bequest of George Washington Wales

Master of San Miniato, Follower of
Italian (Florentine), active second half, 15th
century

17.3223
Virgin and Angel Adoring the Child
Tempera on panel
60.0 x 45.5 cm. (23⅝ x 17⅞ in.)
Robert Dawson Evans Collection

Master of the Sansepolcro Resurrection
Italian (Sienese), 14th century

1978.466
*Angel with the Instruments of the Flagellation of
Christ*
Tempera on panel
Panel: 30.5 x 20.9 cm. (12 x 8¼ in.)
Design: 26.2 x 16.6 cm. (10¼ x 6½ in.)
Bequest of Mrs. Edward Jackson Holmes

Master of the Schretlen Circumcision,
Attributed to
Spanish (Andalusian), active early 16th century

44.756
Flight into Egypt
Oil transferred from panel to canvas mounted on
masonite
Design: 118.5 x 91.5 cm. (46⅝ x 36 in.)
*Gift of Mrs. Albert S. Bonner, Dr. Helen B. Coulter,
Mrs. Robert Parsons, and Mr. Eliot B. Coulter, in
Memory of their parents, Mr. and Mrs. Eugene C.
Coulter*

Master of the Sherman Predella
Italian (Florentine), active first quarter, 15th
century
22.635
*The Flagellation of Christ, with the Martyrdom of
a Female Saint and Saint Jerome in the
Wilderness* (the Sherman Predella Panel)
Tempera on panel
28.6 x 52.5 cm. (11¼ x 20⅝ in.)
Zoe Oliver Sherman Collection
*Gift of Zoe Oliver Sherman in Memory of Samuel
Parkman Oliver*

Master of Villalobos
Spanish, active mid-15th century
37.543
Flight into Egypt
Oil and tempera on panel
Design: 71.3 x 70.8 cm. (28⅛ x 27⅞ in.)
Gift of Miss Amelia Peabody

Master of the Urbino Coronation
Italian (Riminese), active about 1350-1375
40.91
The Crucifixion (from the church of Santa Lucia,
Fabriano)
Fresco transferred to canvas
338 x 276 cm. (133 x 108½ in.)
Augustus Hemenway Fund

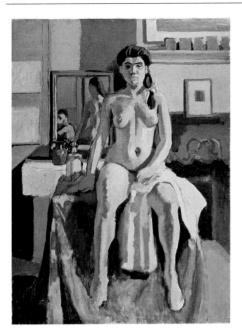

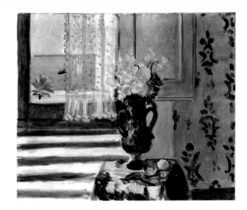

Matisse, Henri
French, 1869-1954

Res. 32.14
Carmelina
Oil on canvas
81.3 x 59.0 cm. (32 x 23¼ in.)
Lower left: Henri · Matisse
Tompkins Collection

Matisse, Henri
French, 1869-1954

48.577
Vase of Flowers
Oil on canvas
60.5 x 73.7 cm. (23⅞ x 29 in.)
Lower right: Henri Matisse
Bequest of John T. Spaulding

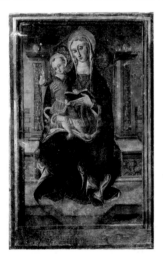

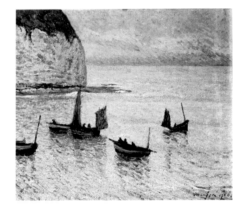

Matteo da Gualdo (Matteo di Pietro di Giovanni di Ser Bernardo, called Matteo da Gualdo)
Italian (Umbrian), active about 1462-died 1503

47.234
Virgin and Child Enthroned
Fresco transferred to canvas
172.0 x 108.0 cm. (67¾ x 42½ in.)
Charles Potter Kling Fund

Maufra, Maxime Emile Louis
French, 1861-1918

19.1316
Departure of Fishing Boats, Yport
Oil on canvas
55.0 x 65.5 cm. (21⅝ x 25¾ in.)
Lower right: Maufra 1900
John Pickering Lyman Collection

Maufra, Maxime Emile Louis
French, 1861-1918

19.1317
Winter Twilight, Douarnenez
Oil on canvas
54.0 x 65.0 cm. (21¼ x 25⅝ in.)
Lower left: Maufra · 96.
John Pickering Lyman Collection

Maufra, Maxime Emile Louis
French, 1861-1918
63.278
Gust of Wind
Oil on canvas
151.0 x 351.5 cm. (59½ x 138¼ in.)
Lower right: Maufra 1899.
Gift of Walter P. Chrysler, Jr.

Mauve, Anton
Dutch, 1838-1888
17.3238
Sheep Grazing in an Open Field
Oil on canvas
55.2 x 66.0 cm. (21¾ x 26 in.)
Lower left: A Mauve
Robert Dawson Evans Collection

Mauve, Anton
Dutch, 1838-1888
17.3248
Shepherd and Sheep under the Trees
Oil on canvas
40.0 x 72.5 cm. (15¾ x 28½ in.)
Lower right: A Mauve. f
Robert Dawson Evans Collection

Mauve, Anton
Dutch, 1838-1888
22.587
Winter Landscape with Sheep
Oil on canvas
108.5 x 86.5 cm. (42¾ x 34 in.)
Lower right: A. Mauve f
Bequest of Miss Ellen Gray

Mauve, Anton
Dutch, 1838-1888
23.492
Seaweed Gatherer
Oil on panel
21.7 x 29.5 cm. (8½ x 11⅝ in.)
Lower right: A Mauve
Bequest of Ernest Wadsworth Longfellow

Mauve, Anton
Dutch, 1838-1888
24.222
Return of the Flock
Oil on canvas
63.7 x 47.0 cm. (25⅛ x 18½ in.)
Lower right: Atelier / A Mauve.
Gift of Robert Jordan from the Collection of Eben D. Jordan

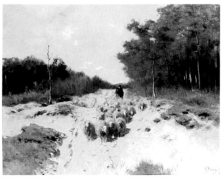

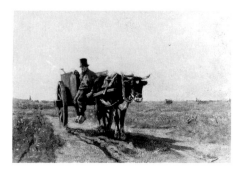

Mauve, Anton
Dutch, 1838-1888

24.229
Horses Drinking
Oil on panel
25.5 x 33.0 cm. (10 x 13 in.)
Lower left: A Mauve
Gift of Robert Jordan from the Collection of Eben D. Jordan

Mauve, Anton
Dutch, 1838-1888

33.323
Shepherd and Sheep on a Woodland Road
Oil on canvas
60.5 x 80.5 cm. (23⅞ x 31¾ in.)
Lower left: A Mauve f
William C. Cotton Collection

Mauve, Anton
Dutch, 1838-1888

38.1419
Carter on a Country Road
Oil on canvas
61.3 x 91.2 cm. (24⅛ x 35⅞ in.)
Lower right: A Mauve
Bequest of Nathaniel T. Kidder

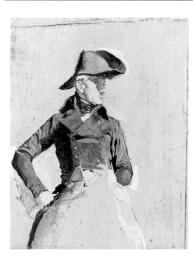

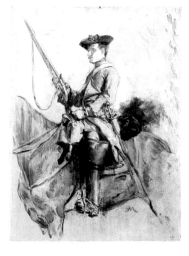

Meissonier, Jean Louis Ernest
French, 1815-1891

03.623
Officer
Oil on panel
10.6 x 8.4 cm. (4⅛ x 3¼ in.)
Once signed lower right: EM (monogram)
Abbott Lawrence Fund

Meissonier, Jean Louis Ernest
French, 1815-1891

03.624
Horseman (study for *Scout*)
Oil on panel
15.7 x 11.5 cm. (6⅛ x 4½ in.)
Lower right: EM (monogram)
Abbott Lawrence Fund

Meissonier, Jean Louis Ernest
French, 1815-1891

Res. 29.30
Two Soldiers
Oil on panel
18.3 x 12.5 cm. (7¼ x 4⅞ in.)
Lower left: EMeissonier 1849 (initials in monogram)
Gift of the Estate of Henry P. Kidder

Meléndez, Luis
Italian (worked in Spain), 1716-1780
39.40
Still Life with Bread, Ham, Cheese, and Vegetables
Oil on canvas
62.0 x 85.2 cm. (24⅜ x 33½ in.)
Lower right, on edge of table: L. EG[...]O M.
Margaret Curry Wyman Fund

Meléndez, Luis
Italian (worked in Spain), 1716-1780
39.41
Still Life with Melon and Pears
Oil on canvas
63.8 x 85.0 cm. (25⅛ x 33½ in.)
Lower right, on edge of table: EG L M D. S. P.
Margaret Curry Wyman Fund

Meloni, Marco, Copy after
Italian (Emilian), active 1504-1537
41.296
Zacharias Meeting Elizabeth (after the predella of an altarpiece of the *Virgin Enthroned* in the Galleria Estense, Modena)
Oil and tempera on panel
23.8 x 63.8 cm. (9⅜ x 25⅛ in.)
Gift of the Estate of Mrs. Theodore C. Williams

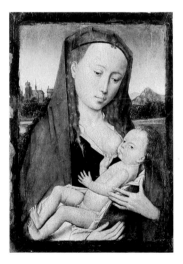

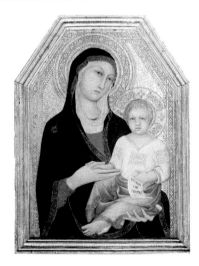

Memling, Hans, Follower of
Flemish, active about 1465-died 1494
02.3
Virgin and Child
Oil on panel
Panel: 27.0 x 19.5 cm. (10⅝ x 7⅝ in.)
Design: 24.4 x 16.8 cm. (9⅝ x 6⅝ in.)
Elton Fund and James Fund

Memmi, Lippo (Filippo di Memmo, called Lippo Memmi), Follower of
Italian (Sienese), active 1317-1347
36.144
Virgin and Child
Tempera on panel
Panel: 75.4 x 55.5 cm. (29¾ x 21⅞ in.)
Design: 65.6 x 46.8 cm. (25⅞ x 18⅜ in.)
Charles Potter Kling Fund

Menard, Marie Auguste Emile René
French, 1862-1930
19.114
Ancient Astronomers
Oil on canvas
90.0 x 117.0 cm. (35⅜ x 46 in.)
Lower right: E.R. MENARD. 1883.
The Henry C. and Martha B. Angell Collection

Mera, Pietro (called Il Fiammingo)
Flemish (worked in Venice), about 1571-about 1611

61.661
Pan and Syrinx with River Gods and Nymphs
Oil on copper
30.7 x 39.8 cm. (12⅛ x 15⅝ in.)
Lower center: [...]RO ME[...]A
Abbot Lawrence Fund

Merck, Jacob Fransz. van der
Dutch, about 1610-1664

74.10
Portrait of a Young Woman Holding a Basket of Fruit
Oil on panel
72.7 x 59.3 cm. (28⅝ x 23⅜ in.)
Bequest of Charles Sumner

Merson, Luc Olivier
French, 1846-1920

18.652
Rest on the Flight into Egypt
Oil on canvas
71.8 x 128.4 cm. (28¼ x 50½ in.)
Lower right:·LVC OLIVIER-MERSON / MDCCCLXXIX
Bequest of George Golding Kennedy

Metsu, Gabriel
Dutch, 1629-1667

89.501
Usurer with a Tearful Woman
Oil on canvas
74.0 x 67.2 cm. (29⅛ x 26½ in.)
Center left, on papers: GMetsu
(G and M joined) / 1654
Sidney Bartlett Bequest

Metsu, Gabriel, Attributed to
Dutch, 1629-1667

83.22
Woman in Agony (The Death of Sophonisba?)
Oil on panel
78.5 x 72.5 cm. (30⅞ x 28½ in.)
Lower left, on letter: GMA f
Gift of Francis Brooks

Metzinger, Jean
French, 1883-1956

57.3
Fruit and a Jug on a Table
Oil on canvas
116.0 x 81.0 cm. (45⅝ x 31⅞ in.)
Lower left: Metzinger
Reverse: Peint par moi / en 1916 / Metzinger
Fanny P. Mason Fund in Memory of Alice Thevin

Meyer, Johann Georg (called Meyer von Bremen)
German, 1813-1886

1981.497
Young Woman Looking through a Window
Oil on panel
22.2 x 15.2 cm. (8¾ x 6 in.)
Lower right: Meyer von Bremen / Berlin
Gift of Erwin and Helen Starr

Michel, Georges
French, 1763-1843

Res. 22.298
Landscape with a Windmill
Oil on paper mounted on canvas
34.0 x 47.0 cm. (13⅜ x 18½ in.)
Gift of John H. Sturgis

Michel, Georges
French, 1763-1843

30.467
Landscape with a Storm Passing
Oil on paper mounted on canvas
56.0 x 70.2 cm. (22 x 27⅝ in.)
Samuel Putnam Avery Fund

Michel, Georges
French, 1763-1843

66.1056
Three Windmills beneath a Stormy Sky
Oil on paper mounted on canvas
52.0 x 70.5 cm. (20½ x 27¾ in.)
Gift of Mrs. Samuel H. Wolcott

Michel, Georges
French, 1763-1843

1325.12
Windmill on a Bluff
Oil on paper mounted on canvas
46.0 x 55.5 cm. (18⅛ x 21⅞ in.)
Deposited by the Trustees of the White Fund, Lawrence, Massachusetts

Michel, Georges, Attributed to
French, 1763-1843

06.2420
Castle in Ruins
Oil on paper mounted on canvas
54.0 x 76.0 cm. (21¼ x 29⅞ in.)
Bequest of Mrs. Martin Brimmer

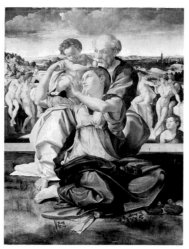

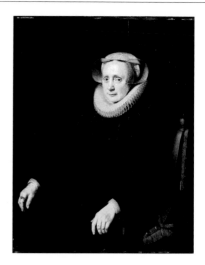

Michel, Georges, Attributed to
French, 1763-1843
30.669
Two Windmills on a Wooded Hillside
Oil on canvas
50.5 x 65.0 cm. (19⅞ x 25⅝ in.)
Gift of Mary Eaton Brown

Michelangelo (Michelangelo Buonarroti called
Michelangelo), Copy after
Italian (Florentine), 1475-1564
 by
Flemish, 16th century
07.486
The Holy Family (free copy after the Doni tondo
in the Galleria degli Uffizi, Florence)
Oil on panel
138.2 x 108.2 cm. (54⅜ x 42⅝ in.)
Gift of Edward W. Forbes

Miereveld, Michiel Jansz. van
Dutch, 1567-1641
11.1452
Adriana van Ijlen
Oil on panel
104.8 x 89.0 cm. (41¼ x 35 in.)
Upper right: Aetatis 66 / Anno 1616
*Gift of the estate of Francis B. Greene in Memory
of Mr. and Mrs. Francis B. Greene*

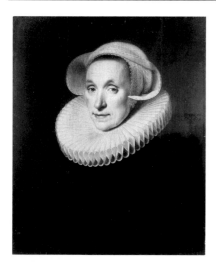

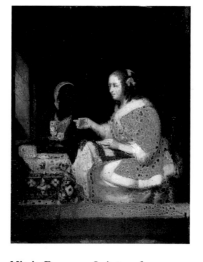

Miereveld, Michiel Jansz. van, Workshop of
Dutch, 1567-1641
29.975
Sara van Bosschaert (version of ¾-length portrait
in the Prinsenhof, Delft)
Oil on panel
64.0 x 53.5 cm. (25¼ x 21 in.)
Center right: AEtatis. 56. / A°. 1619.
*Bequest of Mrs. Annie P. Vinton in Memory of
Frederic Porter Vinton*

Mieris, Frans van, Imitator of
Dutch, 1635-1681
74.26
Woman Making Lace Attended by a Servant Girl
Oil on panel
27.5 x 21.5 cm. (10⅞ x 8½ in.)
Bequest of Charles Sumner

Millet, Jean François
French, 1814-1875
76.1
Sewing Lesson (unfinished)
Oil on canvas
81.7 x 65.4 cm. (32⅛ x 25¾ in.)
Stamped, lower right: J. F. Millet
Gift of Martin Brimmer

Millet, Jean François
French, 1814-1875

77.249
Young Shepherdess
Oil on canvas
162.0 x 113.0 cm. (63¾ x 44½ in.)
Stamped, lower right: J. F. Millet
Gift of Samuel Dennis Warren

Millet, Jean François
French, 1814-1875

92.2640
Killing the Hog (colored underdrawing)
Charcoal and pastel on canvas
68.0 x 88.4 cm. (26¾ x 35 in.)
Stamped, lower right: J.F.M.
Gift of Mrs. Samuel Dennis Warren

Millet, Jean François
French, 1814-1875

93.154
Self-Portrait
Oil on canvas
63.5 x 47.0 cm. (25 x 18½ in.)
Lower left: J. F. Millet
Gift by Contribution

Millet, Jean François
French, 1814-1875

93.1461
Millet's Family Home at Gruchy
Oil on canvas
59.7 x 74.0 cm. (23½ x 29 in.)
Stamped, lower right: J. F. Millet
Gift of the Reverend and Mrs. Frederick A. Frothingham

Millet, Jean François
French, 1814-1875

06.2421
Harvesters Resting (Ruth and Boaz)
Oil on canvas
Support: 67.4 x 119.8 cm. (26½ x 47⅛ in.)
Design: 62.8 x 119.8 cm. (24¾ x 47⅛ in.)
Lower right: [J. F.] Millet [18]5[3]
Bequest of Mrs. Martin Brimmer

Millet, Jean François
French, 1814-1875

06.2422
Washerwomen
Oil on canvas
43.5 x 53.8 cm. (17⅛ x 21⅛ in.)
Lower right: J. F. Millet
Bequest of Mrs. Martin Brimmer

Millet, Jean François
French, 1814-1875

06.2425
Buckwheat Harvest (I)
Pastel and black conté crayon on paper
75.8 x 97.8 cm. (29⅞ x 38½ in.)
Lower right: J. F. Millet
Bequest of Mrs. Martin Brimmer

Millet, Jean François
French, 1814-1875

06.2423
Knitting Lesson (I)
Oil on canvas
47.0 x 38.1 cm. (18½ x 15 in.)
Lower right: J. F. Millet
Bequest of Mrs. Martin Brimmer

Millet, Jean François
French, 1814-1875

06.2426
Coming Storm
Pastel on paper
Design: 42.0 x 53.7 cm. (16½ x21⅛ in.)
Lower left: J.F. Millet
Bequest of Mrs. Martin Brimmer

Millet, Jean François
French, 1814-1875

17.1481
Woman Reclining in a Landscape
Oil on canvas
18.8 x 33.2 cm. (7⅜ x 13⅛ in.)
Lower left: J. F. Millet
Gift of Quincy Adams Shaw through Quincy A. Shaw, Jr. and Mrs. Marian Shaw Haughton

Millet, Jean François
French, 1814-1875
17.1482
Two Reclining Figures (unfinished)
Oil on canvas
72.8 x 100.2 cm. (28⅝ x 39½ in.)
Gift of Quincy Adams Shaw through Quincy A. Shaw, Jr. and Mrs. Marian Shaw Haughton

Millet, Jean François
French, 1814-1875
17.1483
Peasant Girl Daydreaming
Oil on panel
22.5 x 16.5 cm. (8⅞ x 6½ in.)
Lower left: J. F. Millet
Gift of Quincy Adams Shaw through Quincy A. Shaw, Jr. and Mrs. Marian Shaw Haughton

Millet, Jean François
French, 1814-1875
17.1484
Shepherdess Sitting at the Edge of the Forest
Oil on canvas
32.4 x 24.7 cm. (12¾ x 9¾ in.)
Lower right: J. F. Millet
Gift of Quincy Adams Shaw through Quincy A. Shaw, Jr. and Mrs. Marian Shaw Haughton

Millet, Jean François
French, 1814-1875
17.1485
The Sower
Oil on canvas
101.6 x 82.6 cm. (40 x 32½ in.)
Lower left: J. F. Millet
Gift of Quincy Adams Shaw through Quincy A. Shaw, Jr. and Mrs. Marian Shaw Haughton

Millet, Jean François
French, 1814-1875
17.1486
Forest with Shepherdess and Sheep
Oil on panel
27.3 x 14.9 cm. (10¾ x 5¾ in.)
Lower right: J. F. Millet
Gift of Quincy Adams Shaw through Quincy A. Shaw, Jr. and Mrs. Marian Shaw Haughton

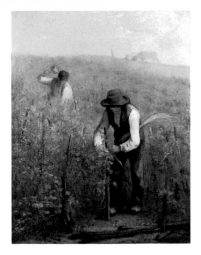

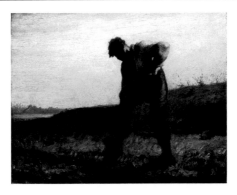

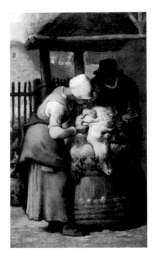

Millet, Jean François
French, 1814-1875
17.1487
In the Vineyard
Oil on canvas
37.6 x 29.6 cm. (14¾ x 11⅝ in.)
Lower right: J. F. Millet
Gift of Quincy Adams Shaw through Quincy A. Shaw, Jr. and Mrs. Marian Shaw Haughton

Millet, Jean François
French, 1814-1875
17.1488
Man Turning over the Soil
Oil on canvas
25.0 x 32.5 cm. (9⅞ x 12¾ in.)
Lower right: J. F. Millet
Gift of Quincy Adams Shaw through Quincy A. Shaw, Jr. and Mrs. Marian Shaw Haughton

Millet, Jean François
French, 1814-1875
17.1489
Shearing Sheep
Oil on canvas
40.7 x 24.8 cm. (16 x 9¾ in.)
Lower right: J. F. Millet
Gift of Quincy Adams Shaw through Quincy A. Shaw, Jr. and Mrs. Marian Shaw Haughton

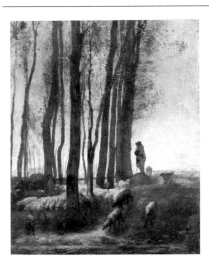

Millet, Jean François
French, 1814-1875
17.1490
Shepherd and Flock at the Edge of the Forest, Evening
Oil on canvas
60.0 x 49.5 cm. (23⅝ x 19½ in.)
Lower right: J. F. Millet
Gift of Quincy Adams Shaw through Quincy A. Shaw, Jr. and Mrs. Marian Shaw Haughton

Millet, Jean François
French, 1814-1875
17.1491
Entrance to the Forest at Barbizon in Winter
Black conté crayon and pastel on paper
Design: 51.5 x 40.6 cm. (20¼ x 16 in.)
Lower right: J. F. Millet
Gift of Quincy Adams Shaw through Quincy A. Shaw, Jr. and Mrs. Marian Shaw Haughton

Millet, Jean François
French, 1814-1875
17.1492
Women Sewing by Lamplight (La Veillée)
Oil on panel
35.0 x 27.0 cm. (13¾ x 10½ in.)
Lower right: J. F. Millet
Gift of Quincy Adams Shaw through Quincy A. Shaw, Jr. and Mrs. Marian Shaw Haughton

Millet, Jean François
French, 1814-1875

17.1493
Woman Sewing beside her Sleeping Child
Oil on panel
34.0 x 27.2 cm. (13⅜ x 10¾ in.)
Lower right: J. F. Millet
Gift of Quincy Adams Shaw through Quincy A.
Shaw, Jr. and Mrs. Marian Shaw Haughton

Millet, Jean François
French, 1814-1875

17.1494
Shepherdess Knitting, outside the Village of
Barbizon
Pastel over black conté crayon on paper
40.2 x 28.5 cm. (15⅞ x 11¼ in.)
Lower right: J. F. Millet
Gift of Quincy Adams Shaw through Quincy A.
Shaw, Jr. and Mrs. Marian Shaw Haughton

Millet, Jean François
French, 1814-1875

17.1495
Millet's Birthplace at Gruchy
Pastel over black conté crayon and pen and ink on
paper
31.2 x 45.5 cm. (12¼ x 17⅞ in.)
Lower right: J. F. Millet
Gift of Quincy Adams Shaw through Quincy A.
Shaw, Jr. and Mrs. Marian Shaw Haughton

Millet, Jean François
French, 1814-1875

17.1496
House with a Well at Gruchy
Pastel over black conté crayon and pen and ink on
paper
32.2 x 43.2 cm. (12⅝ x 17 in.)
Lower right: J. F. Millet
Gift of Quincy Adams Shaw through Quincy A.
Shaw, Jr. and Mrs. Marian Shaw Haughton

Millet, Jean François
French, 1814-1875

17.1497
Manor House near Gréville
Watercolor and pastel over black conté crayon and
pen and ink on paper
34.3 x 45.5 cm. (13½ x 17⅞ in.)
Lower right: J. F. Millet
Gift of Quincy Adams Shaw through Quincy A.
Shaw, Jr. and Mrs. Marian Shaw Haughton

Millet, Jean François
French, 1814-1875

17.1498
Seated Spinner (Emélie Millet)
Oil on panel
35.2 x 26.8 cm. (13⅞ x 10½ in.)
Lower right: [...] F. Millet
Gift of Quincy Adams Shaw through Quincy A.
Shaw, Jr. and Mrs. Marian Shaw Haughton

Millet, Jean François
French, 1814-1875

17.1499
Standing Spinner
Oil on canvas
Support: 46.5 x 38.1 cm. (18¼ x 15 in.)
Design: 45.3 x 32.5 cm. (17⅞ x 12¾ in.)
Lower right: J. F. Millet
Gift of Quincy Adams Shaw through Quincy A.
Shaw, Jr. and Mrs. Marian Shaw Haughton

Millet, Jean François
French, 1814-1875

17.1500
Cooper Tightening Staves on a Barrel
Oil on canvas
Support: 46.4 x 38.9 cm. (18¼ x 15¼ in.)
Design: 45.1 x 33.0 cm. (17¾ x 13 in.)
Lower left: J. F. Millet
Gift of Quincy Adams Shaw through Quincy A.
Shaw, Jr. and Mrs. Marian Shaw Haughton

Millet, Jean François
French, 1814-1875

17.1501
End of the Hamlet of Gruchy (I)
Oil on canvas
46.5 x 55.9 cm. (18¼ x 22 in.)
Lower right: J. F. Millet
Gift of Quincy Adams Shaw through Quincy A.
Shaw, Jr. and Mrs. Marian Shaw Haughton

Millet, Jean François
French, 1814-1875

17.1502
Morning Toilette
Black conté crayon and pastel on paper
37.1 x 25.7 cm. (14⅝ x 10⅛ in.)
Lower right: J. F. Millet
Gift of Quincy Adams Shaw through Quincy A.
Shaw, Jr. and Mrs. Marian Shaw Haughton

Millet, Jean François
French, 1814-1875

17.1503
In the Garden
Pastel and watercolor over black conté crayon on
paper
31.5 x 37.5 cm. (12⅜ x 14¾ in.)
Lower right: J. F. Millet
Gift of Quincy Adams Shaw through Quincy A.
Shaw, Jr. and Mrs. Marian Shaw Haughton

Millet, Jean François
French, 1814-1875

17.1504
Knitting Lesson (II)
Oil on panel
40.4 x 31.5 cm. (15⅞ x 12⅜ in.)
Lower right: J. F. Millet
Gift of Quincy Adams Shaw through Quincy A.
Shaw, Jr. and Mrs. Marian Shaw Haughton

Millet, Jean François
French, 1814-1875

17.1505
Potato Planters
Oil on canvas
82.5 x 101.3 cm. (32½ x 39⅞ in.)
Lower right: [J. F. Millet]
Gift of Quincy Adams Shaw through Quincy A.
Shaw, Jr. and Mrs. Marian Shaw Haughton

Millet, Jean François
French, 1814-1875

17.1506
Return of the Flock
Black conté crayon and pastel on paper
38.7 x 50.3 cm. (15¼ x 19¾ in.)
Lower right: J. F. Millet
Gift of Quincy Adams Shaw through Quincy A.
Shaw, Jr. and Mrs. Marian Shaw Haughton

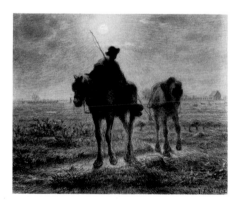

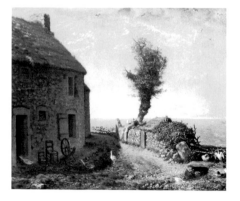

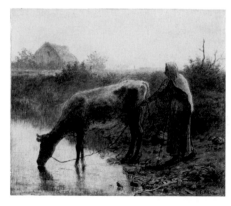

Millet, Jean François
French, 1814-1875

17.1507
After the Day's Work
Black conté crayon and pastel on paper
37.0 x 45.7 cm. (14⅝ x 18 in.)
Lower right: J. F. Millet
Gift of Quincy Adams Shaw through Quincy A.
Shaw, Jr. and Mrs. Marian Shaw Haughton

Millet, Jean François
French, 1814-1875

17.1508
End of the Hamlet of Gruchy (II)
Oil on canvas
81.5 x 100.5 cm. (32⅛ x 39⅝ in.)
Lower right: J. F. Millet
Gift of Quincy Adams Shaw through Quincy A.
Shaw, Jr. and Mrs. Marian Shaw Haughton

Millet, Jean François
French, 1814-1875

17.1509
Peasant Watering her Cow
Oil paint over black conté crayon on canvas
46.0 x 55.5 cm. (18⅛ x 21⅞ in.)
Lower right: J.F.M.
Gift of Quincy Adams Shaw through Quincy A.
Shaw, Jr. and Mrs. Marian Shaw Haughton

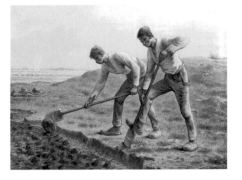

Millet, Jean François
French, 1814-1875

17.1510
Two Men Turning over the Soil
Pastel and black conté crayon on paper
Design: 69.9 x 94.5 cm. (27½ x 37¼ in.)
Lower right: J. F. Millet
Gift of Quincy Adams Shaw through Quincy A.
Shaw, Jr. and Mrs. Marian Shaw Haughton

Millet, Jean François
French, 1814-1875

17.1511
Noonday Rest
Pastel and black conté crayon on paper
Design: 28.8 x 42.0 cm. (11⅜ x 16½ in.)
Lower right: J. F. Millet
Gift of Quincy Adams Shaw through Quincy A.
Shaw, Jr. and Mrs. Marian Shaw Haughton

Millet, Jean François
French, 1814-1875

17.1512
Shepherdesses Watching a Flight of Wild Geese
Pastel and black conté crayon on paper
Design: 57.2 x 41.9 cm. (22½ x 16½ in.)
Lower right: J. F. Millet
Gift of Quincy Adams Shaw through Quincy A.
Shaw, Jr. and Mrs. Marian Shaw Haughton

Millet, Jean François
French, 1814-1875

17.1513
Newborn Lamb
Pastel and black conté crayon on paper
Design: 40.4 x 47.1 cm. (15⅞ x 18½ in.)
Lower right: J. F. Millet
Gift of Quincy Adams Shaw through Quincy A.
Shaw, Jr. and Mrs. Marian Shaw Haughton

Millet, Jean François
French, 1814-1875

17.1514
Watering Horses, Sunset
Pastel and black conté crayon on paper
Design: 37.5 x 47.6 cm. (14¾ x 18¾ in.)
Lower center: J. F. Millet
Gift of Quincy Adams Shaw through Quincy A.
Shaw, Jr. and Mrs. Marian Shaw Haughton

Millet, Jean François
French, 1814-1875

17.1515
Watering Cows
Black conté crayon and pastel on paper
30.8 x 46.4 cm. (12⅛ x 18¼ in.)
Lower right: J. F. Millet
Gift of Quincy Adams Shaw through Quincy A.
Shaw, Jr. and Mrs. Marian Shaw Haughton

Millet, Jean François
French, 1814-1875
17.1516
Peasant Girl with Two Cows
Black conté crayon and pastel on paper
29.7 x 47.0 cm. (11¾ x 18½ in.)
Lower right: J. F. Millet
*Gift of Quincy Adams Shaw through Quincy A.
Shaw, Jr. and Mrs. Marian Shaw Haughton*

Millet, Jean François
French, 1814-1875
17.1517
Shepherdess and Flock at Sunset
Pastel and black conté crayon on paper
36.7 x 44.3 cm. (14½ x 17⅜ in.)
Lower right: J. F. Millet
*Gift of Quincy Adams Shaw through Quincy A.
Shaw, Jr. and Mrs. Marian Shaw Haughton*

Millet, Jean François
French, 1814-1875
17.1518
Twilight
Black conté crayon and pastel on paper
50.5 x 38.9 cm. (19⅞ x 15⅜ in.)
Upper right: J. F. Millet
*Gift of Quincy Adams Shaw through Quincy A.
Shaw, Jr. and Mrs. Marian Shaw Haughton*

Millet, Jean François
French, 1814-1875
17.1519
Pears
Oil on panel
18.5 x 25.5 cm. (7¼ x 10 in.)
Lower right: J. F. Millet
*Gift of Quincy Adams Shaw through Quincy A.
Shaw, Jr. and Mrs. Marian Shaw Haughton*

Millet, Jean François
French, 1814-1875
17.1520
Winter Evening
Pastel and black conté crayon on paper
Design: 44.2 x 54.0 cm. (17⅜ x 21¼ in.)
Lower right: J. F. Millet
*Gift of Quincy Adams Shaw through Quincy A.
Shaw, Jr. and Mrs. Marian Shaw Haughton*

Millet, Jean François
French, 1814-1875
17.1521
Path through the Wheat
Pastel and black conté crayon on paper
Design: 40.3 x 50.6 cm. (15⅞ x 19⅞ in.)
Lower right: J. F. Millet
*Gift of Quincy Adams Shaw through Quincy A.
Shaw, Jr. and Mrs. Marian Shaw Haughton*

Millet, Jean François
French, 1814-1875

17.1522
Rabbit Warren, Dawn
Pastel and black conté crayon on paper
Design: 49.5 x 59.5 cm. (19½ x 23⅜ in.)
Lower right: J. F. Millet
*Gift of Quincy Adams Shaw through Quincy A.
Shaw, Jr. and Mrs. Marian Shaw Haughton*

Millet, Jean François
French, 1814-1875

17.1523
Primroses
Pastel on paper
Design: 40.2 x 47.8 cm. (15⅞ x 18⅞ in.)
Lower right: J. F. Millet
*Gift of Quincy Adams Shaw through Quincy A.
Shaw, Jr. and Mrs. Marian Shaw Haughton*

Millet, Jean François
French, 1814-1875

17.1524
Dandelions
Pastel on paper
Design: 40.2 x 50.2 cm. (15⅞ x 19¾ in.)
Lower right: J. F. Millet
*Gift of Quincy Adams Shaw through Quincy A.
Shaw, Jr. and Mrs. Marian Shaw Haughton*

Millet, Jean François
French, 1814-1875

17.1525
Farmyard by Moonlight
Pastel and black conté crayon on paper
Design: 70.9 x 86.7 cm. (27⅞ x 34⅛ in.)
Lower right: J. F. Millet
*Gift of Quincy Adams Shaw through Quincy A.
Shaw, Jr. and Mrs. Marian Shaw Haughton*

Millet, Jean François
French, 1814-1875

17.1526
Farmyard in Winter
Pastel and black conté crayon on paper
Design: 68.0 x 88.1 cm. (26¾ x 34⅝ in.)
Lower right: J. F. Millet
*Gift of Quincy Adams Shaw through Quincy A.
Shaw, Jr. and Mrs. Marian Shaw Haughton*

Millet, Jean François
French, 1814-1875

17.1527
Little Goose Girl
Pastel and black conté crayon on paper
Design: 41.6 x 51.8 cm. (16⅜ x 20⅜ in.)
Lower left: J. F. Millet
*Gift of Quincy Adams Shaw through Quincy A.
Shaw, Jr. and Mrs. Marian Shaw Haughton*

Millet, Jean François
French, 1814-1875

17.1528
Training Grape Vines
Pastel on paper
43.8 x 64.1 cm. (17¼ x 25¼ in.)
Gift of Quincy Adams Shaw through Quincy A.
Shaw, Jr. and Mrs. Marian Shaw Haughton

Millet, Jean François
French, 1814-1875

17.1529
Cliffs at Gruchy
Oil on canvas
60.1 x 73.9 cm. (23⅝ x 29⅛ in.)
Lower right: J. F. Millet
Reverse: Fait à Cherbourg 1870
Gift of Quincy Adams Shaw through Quincy A.
Shaw, Jr. and Mrs. Marian Shaw Haughton

Millet, Jean François
French, 1814-1875

17.1530
Fishing Boat
Oil on canvas
24.7 x 33.0 cm. (9¾ x 13 in.)
Lower right: [...]llet
Gift of Quincy Adams Shaw through Quincy A.
Shaw, Jr. and Mrs. Marian Shaw Haughton

Millet, Jean François
French, 1814-1875

17.1531
Peasant Watering her Cow, Evening
Oil on canvas
81.5 x 100.3 cm. (32⅛ x 39½ in.)
Lower right: J. F. Mill[...]
Gift of Quincy Adams Shaw through Quincy A.
Shaw, Jr. and Mrs. Marian Shaw Haughton

Millet, Jean François
French, 1814-1875

17.1532
Priory at Vauville, Normandy
Oil on canvas
90.0 x 116.7 cm. (35⅜ x 46 in.)
Lower right: J. F. Millet
Gift of Quincy Adams Shaw through Quincy A.
Shaw, Jr. and Mrs. Marian Shaw Haughton

Millet, Jean François
French, 1814-1875

17.1533
Buckwheat Harvest, Summer (II)
Oil on canvas
85.5 x 111.1 cm. (33⅝ x 43¾ in.)
Stamped, lower right: J. F. Millet
Gift of Quincy Adams Shaw through Quincy A.
Shaw, Jr. and Mrs. Marian Shaw Haughton

Millet, Jean François
French, 1814-1875

17.3235
Shepherdess Seated in the Shade
Oil on canvas
65.3 x 54.8 cm. (25¾ x 21⅝ in.)
Lower left: J. F. Millet
Robert Dawson Evans Collection.

Millet, Jean François
French, 1814-1875

17.3245
Shepherdess Leaning on her Staff
Oil on canvas
29.2 x 21.9 cm. (11½ x 8⅝ in.)
Lower right: J F M
Robert Dawson Evans Collection.

Millet, Jean François
French, 1814-1875

19.97
Seated Nude (Les Regrets)
Oil on panel
25.2 x 18.4 cm. (9⅞ x 7¼ in.)
Lower right: J F Millet
The Henry C. and Martha B. Angell Collection

Millet, Jean François
French, 1814-1875

35.1162
Shepherdess with her Flock and Dog
Black conté crayon and pastel on paper
37.2 x 50.2 cm. (14⅝ x 19¾ in.)
Lower right: J. F. Millet
Bequest of Mrs. Henry L. Higginson in Memory of her sister, Pauline Agassiz Shaw

Millet, Jean François
French, 1814-1875

44.73
Madame J. F. Millet (Pauline Virginie Ono)
Oil on canvas
41.8 x 32.3 cm. (16½ x 12¾ in.)
Upper right: J. F. M.
Stamped, lower left: J. F. Millet
Tompkins Collection

Millet, Jean François
French, 1814-1875

66.1052
Young Woman Churning Butter
Oil on panel
57.0 x 35.8 cm. (22⅜ x 14⅛ in.)
Lower right: J. F. Millet
Gift of Mrs. John S. Ames

Millet, Jean François
French, 1814-1875

73.14
Three Men Shearing Sheep in a Barn
Oil on canvas mounted on panel
24.5 x 39.3 cm. (9⅝ x 15½ in.)
Lent by Mrs. Enid Hunt Slater

Miro, Joan
Spanish, 1893-1983

1980.273
Cloud and Birds
Oil on canvas
146.0 x 114.0 cm. (57½ x 44⅞ in.)
Lower right: Miro / 1927
Reverse: Joan Miro / 1927
Sophie M. Friedman Fund and Charles H. Bayley Picture and Painting Fund

Molenaer, Jan Miense
Dutch, 1609/10-1668

07.500
Peasants Carousing
Oil on canvas
112.8 x 130.2 cm. (44⅜ x 51¼ in.)
Lower left, on bench: Jan · Molenaer 1662
James Fund

Mommers, Hendrik
Dutch, about 1623-1693

28.858
Peasants and Animals by an Italian Lake
Oil on canvas
69.5 x 81.8 cm. (27⅜ x 32¼ in.)
Lower left: HMommers F. (H and M joined)
Bequest of Sarah Hammond Blane in Memory of her father, Walter Cooper Greene

Mommers, Hendrik
Dutch, about 1623-1693

28.860
Women and Mules in an Italianate Landscape
Oil on canvas
69.5 x 82.1 cm. (27⅜ x 32⅜ in.)
Lower right: HMommers f. (H and M joined)
Bequest of Sarah Hammond Blane in Memory of her father, Walter Cooper Greene

Momper, Frans de
Flemish, 1603-1660

48.505
Mountain Landscape with Peasants beside a Road
Oil on panel
43.8 x 62.5 cm. (17¼ x 24⅝ in.)
Gift of Mrs Albert J. Beveridge in Memory of Delia Spencer Field

Momper, Joos de, the Younger
Flemish, 1564-1635
59.659
Forest Gorge
Oil on panel
50.4 x 93.2 cm. (19⅞ x 36¾ in.)
Lower left: I D M
Francis Welch Fund

Monet, Oscar Claude
French, 1840-1926
06.115
Ravine of the Creuse at Twilight
Oil on canvas
65.5 x 81.2 cm. (25⅜ x 32 in.)
Lower left: Claude Monet 89
Denman Waldo Ross Collection

Monet, Oscar Claude
French, 1840-1926
06.116
Cliffs of the Petites Dalles
Oil on canvas
60.5 x 80.2 cm. (23⅞ x 31⅝ in.)
Lower left: Claude Monet 1880
Denman Waldo Ross Collection

Monet, Oscar Claude
French, 1840-1926
06.117
Ships in a Harbor
Oil on canvas
50.0 x 61.0 cm. (19⅝ x 24 in.)
Lower right: Claude Monet
Denman Waldo Ross Collection

Monet, Oscar Claude
French, 1840-1926
11.1261
Branch of the Seine near Giverny (II)
Oil on canvas
81.4 x 92.7 cm. (32 x 36½ in.)
Lower left: Claude Monet 97
Gift of Mrs. W. Scott Fitz

Monet, Oscar Claude
French, 1840-1926
19.170
Water Lilies (II)
Oil on canvas
89.3 x 93.4 cm. (35⅛ x 36¾ in.)
Lower right: Claude Monet 1907
Bequest of Alexander Cochrane

Monet, Oscar Claude
French, 1840-1926

25.106
Poppy Field in a Hollow near Giverny
Oil on canvas
65.2 x 81.2 cm. (25⅝ x 32 in.)
Lower left: Claude Monet 85
Juliana Cheney Edwards Collection

Monet, Oscar Claude
French, 1840-1926

25.107
Ravine of the Creuse in Sunlight
Oil on canvas
65.0 x 92.4 cm. (25⅝ x 36⅜ in.)
Lower left: Claude Monet 89
Juliana Cheney Edwards Collection

Monet, Oscar Claude
French, 1840-1926

25.112
Haystack at Sunset
Oil on canvas
73.3 x 92.6 cm. (28⅞ x 36½ in.)
Lower left: Claude Monet 91
Juliana Cheney Edwards Collection

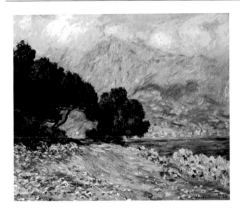

Monet, Oscar Claude
French, 1840-1926

25.128
Cap Martin, near Menton
Oil on canvas
67.2 x 81.6 cm. (26½ x 32⅛ in.)
Lower right: Claude Monet 84
Juliana Cheney Edwards Collection

Monet, Oscar Claude
French, 1840-1926

27.1324
Old Fort at Antibes (I)
Oil on canvas
66.0 x 82.5 cm. (26 x 32½ in.)
Lower left: Claude Monet 88
Gift of Samuel Dacre Bush

Monet, Oscar Claude
French, 1840-1926

39.655
Branch of the Seine near Giverny (I)
Oil on canvas
73.8 x 93.0 cm. (29 x 36⅝ in.)
Lower left: Claude Monet 96
Juliana Cheney Edwards Collection

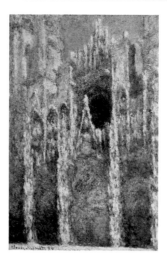

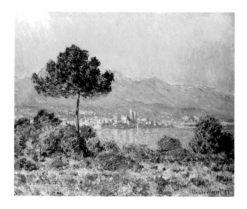

Monet, Oscar Claude
French, 1840-1926

39.670
Meadow at Giverny
Oil on canvas
92.0 x 81.5 cm. (36¼ x 32⅛ in.)
Lower right: Claude Monet
Juliana Cheney Edwards Collection

Monet, Oscar Claude
French, 1840-1926

36.671
Rouen Cathedral in Full Sunlight
Oil on canvas
100.5 x 66.2 cm. (39⅝ x 26 in.)
Lower left: Claude Monet 94
Juliana Cheney Edwards Collection

Monet, Oscar Claude
French, 1840-1926

39.672
Antibes Seen from the Plateau Notre-Dame
Oil on canvas
65.7 x 81.3 cm. (25⅞ x 32 in.)
Lower right: Claude Monet 88
Juliana Cheney Edwards Collection

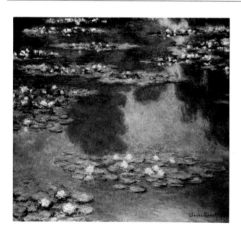

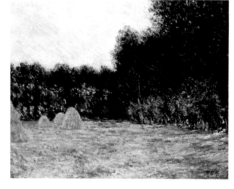

Monet, Oscar Claude
French, 1840-1926

39.804
Water Lilies (I)
Oil on canvas
89.5 x 100.3 cm. (35¼ x 39½ in.)
Lower right: Claude Monet 1905
Gift of Edward Jackson Holmes

Monet, Oscar Claude
French, 1840-1926

42.541
Meadow with Haystacks near Giverny
Oil on canvas
74.0 x 93.5 cm. (29⅛ x 36¾ in.)
Lower right: Claude Monet 85
Bequest of Arthur Tracy Cabot

Monet, Oscar Claude
French, 1840-1926

42.542
Cap d'Antibes, Mistral
Oil on canvas
66.0 x 81.3 cm. (26 x 32 in.)
Lower left: Claude Monet 88
Bequest of Arthur Tracy Cabot

Monet, Oscar Claude
French, 1840-1926
48.580
Rue de la Bavolle, Honfleur
Oil on canvas
55.9 x 61.0 cm. (22 x 24 in.)
Lower left: Claude Monet
Bequest of John T. Spaulding

Monet, Oscar Claude
French, 1840-1926
56.147
La Japonaise (Camille Monet in Japanese Costume)
Oil on canvas
231.6 x 142.3 cm. (91¼ x 56 in.)
Lower left: Claude Monet 1876
1951 Purchase Fund

Monet, Oscar Claude
French, 1840-1926
61.959
Monet's Water Garden and Japanese Footbridge, Giverny
Oil on canvas
89.2 x 92.8 cm. (35⅛ x 36½ in.)
Lower left: Claude Monet 1900
Given in Memory of Governor Alvan T. Fuller by the Fuller Foundation

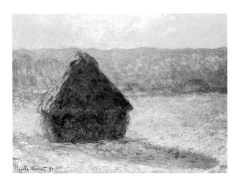

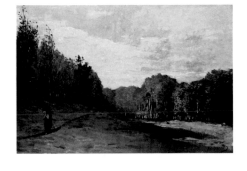

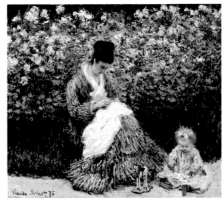

Monet, Oscar Claude
French, 1840-1926
1970.253
Haystack in Winter
Oil on canvas
65.4 x 92.3 cm. (25¾ x 36⅜ in.)
Lower left: Claude Monet 91
Gift of Misses Aimée and Rosamond Lamb in Memory of Mr. and Mrs. Horatio A. Lamb

Monet, Oscar Claude
French, 1840-1926
1974.325
Woodgatherers at the Edge of the Forest
Oil on panel
59.7 x 90.2 cm. (23½ x 35½ in.)
Lower right: C. Monet
Henry H. and Zoe Oliver Sherman Fund

Monet, Oscar Claude
French, 1840-1926
1976.833
Camille Monet and a Child in the Artist's Garden in Argenteuil
Oil on canvas
55.3 x 64.7 cm. (21¾ x 25½ in.)
Lower left: Claude Monet 75
Anonymous Gift in Memory of Mr. and Mrs. Edwin S. Webster

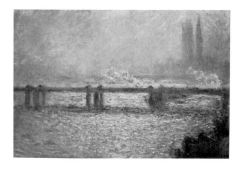

Monet, Oscar Claude
French, 1840-1926
1978.465
Charing Cross Bridge, London
Oil on canvas
60.6 x 91.5 cm. (23⅞ x 36 in.)
Lower right: Claude Monet 1900
*Given by Janet Hubbard Stevens in Memory of her
mother, Janet Watson Hubbard*

Monet, Oscar Claude
French, 1840-1926
1978.633
Boulevard St.-Denis, Argenteuil, in Winter
Oil on canvas
60.9 x 81.5 cm. (24 x 32⅛ in.)
Lower right: Claude Monet 75
Gift of Richard Saltonstall

Monet, Oscar Claude
French, 1840-1926
1978.634
Old Fort at Antibes (II)
Oil on canvas
65.5 x 81.0 cm. (25¾ x 31⅞ in.)
Lower left: Claude Monet 88
Anonymous Gift

Monet, Oscar Claude
French, 1840-1926
1328.12
Field of Poppies near Giverny
Oil on canvas
60.8 x 101.0 cm. (23⅞ x 39¾ in.)
Lower right: Claude Monet 90
*Deposited by the Trustees of the White Fund,
Lawrence, Massachusetts*

Monnoyer, Jean Baptiste, Copy after
French, 1634-1699
39.648
Still Life with Flowers and Fruit
(after painting in the Chateau de Versailles)
Oil on canvas
123.0 x 113.0 cm. (48⅜ x 44½ in.)
Juliana Cheney Edwards Collection

Monsu Bernardo
see
Keil, Bernard

Monticelli, Adolphe Joseph Thomas
French, 1824-1886

19.107
Two Women with Horses, a Dog, and an Attendant
Oil on panel
34 x 48.5 cm. (13⅜ x 19⅛ in.)
Lower left: Monticelli
The Henry C. and Martha B. Angell Collection

Monticelli, Adolphe Joseph Thomas
French, 1824-1886

22.704
Party on a Terrace
Oil on panel
41.4 x 57.1 cm. (16¼ x 22½ in.)
Gift of the Estate of Mrs. Lucien Carr

Monticelli, Adolphe Joseph Thomas
French, 1824-1886

26.21
Landscape with Two Figures (Hagar and Ishmael?)
Oil on panel
39.2 x 32.7 cm. (15⅜ x 12⅞ in.)
Lower left: M[...]t[...]lli
Bequest of Miss Sophie Moen

Monticelli, Adolphe Joseph Thomas
French, 1824-1886

37.1214
Women and Cherubs in a Glen
Oil on panel
36.8 x 44.5 cm. (14½ x 17½ in.)
Lower left: Monticelli
Gift of Miss Amelia Peabody

Monticelli, Adolphe Joseph Thomas
French, 1824-1886

39.657
Women on the Terrace of a Classical Building
Oil on panel
40.4 x 60.8 cm. (15⅞ x 23⅞ in.)
Lower right: Monticelli
Juliana Cheney Edwards Collection

Monticelli, Adolphe Joseph Thomas
French, 1824-1886

57.155
Figures in Renaissance Costume
Oil on panel
44.0 x 63.5 cm. (17⅜ x 25 in.)
Lower right: Monticelli
Gift of Miss Amelia Peabody

Moor, Carel de, Attributed to
Dutch, 1656-1738
64.606
Woman with a Basket of Fruit
Oil on canvas
88.3 x 71.5 cm. (34¾ x 28⅛ in.)
Bequest of Maxim Karolik

Morales, Luis de
Spanish, about 1509-1586
1978.680
Virgin and Child
Oil on panel
46.2 x 34.5 cm. (18⅛ x 13⅝ in.)
Gift of Misses Aimée and Rosamond Lamb

Morandi, Giorgio
Italian, 1890-1964
61.662
Still Life of Bottles and Pitcher
Oil on canvas
25.0 x 45.2 cm. (9⅞ x 17¾ in.)
Lower center: Morandi
Tompkins Collection

Moreelse, Paulus
Dutch, 1571-1638
46.559
Portrait of a Young Woman as Flora
Oil on panel
74.4 x 59.5 cm. (29¼ x 23⅜ in.)
Upper right: PM (monogram) / 1633
*Gift of Mrs. Albert J. Beveridge in Memory of
Delia Spencer Field*

Morel, Jan Evert
Dutch, 1777-1808
1972.231
Still Life with Pumpkin and Fruit
Oil on panel
52.0 x 67.4 cm. (20½ x 26½ in.)
Lower left: JEM
Reverse: J. E. Morel / 1800
Gift of Misses Aimée and Rosamond Lamb

Moret, Henry
French, 1856-1913
19.1315
Cliffs at Ouessants, Brittany
Oil on canvas
65.2 x 81.0 cm. (25⅝ x 31⅞ in.)
Lower left: Henry Moret 1901
John Pickering Lyman Collection

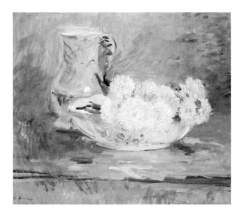

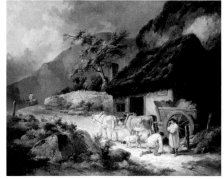

Morisot, Berthe
French, 1841-1895
48.581
White Flowers in a Bowl
Oil on canvas
46.0 x 55.0 cm. (18⅛ x 21⅝ in.)
Lower left: B Morisot
Bequest of John T. Spaulding

Morland, George
British 1763-1804
37.468
Man and Woman in a Landscape (fragment)
Oil on canvas
28.3 x 31.4 cm. (11⅛ x 12⅜ in.)
Bequest of Miss Mary Lee Ware

Morland, George
British, 1763-1804
40.589
Carters with a Load of Slate
Oil on canvas
99.4 x 127.6 cm. (39⅛ x 50¼ in.)
Lower right: G. Morland pinxt
Gift of Miss Amelia Peabody

Morland, Imitator of
13.548
Man and Child on Horseback Taking Cows to Water
Oil on canvas mounted on composition board
53.8 x 77.2 cm. (21⅛ x 30⅜ in.)
Falsely signed, lower left: G Morland 1798
Gift of Alexander Cochrane

Morland, Imitator of
35.1483
Farmer and Pigs before a Cottage
Oil on canvas
62.5 x 75.5 cm. (24⅝ x 29 ¾ in.)
Falsely signed, lower left: G. M 1795
Gift of Miss Miriam Shaw and Francis Shaw, Jr.

Moroni, Giovanni Battista
Italian (Venetian), 1520/25-1578
95.1371
Portrait of a Man and a Boy (said to be Count
Alborghetti and his son)
Oil on canvas
98.2 x 83.7 cm. (38⅝ x 32⅞ in.)
*Amelia Jackson Sargent Fund in Memory of Turner
Sargent*

Morren, George
Belgian, 1868-1941
1326.12
Garden Wall
Oil on canvas
54.0 x 67.0 cm. (21¼ x 26⅜ in.)
Lower right: George Morren / Octo - 92
*Deposited by the Trustees of the White Fund,
Lawrence, Massachusetts*

Moucheron, Frederik de
Dutch, 1633-1686
77.137
Mountain Cascade
Oil on canvas
99.2 x 83.5 cm. (39 x 32⅞ in.)
Gift of Nathaniel Thayer

Munch, Edvard
Norwegian, 1863-1944
57.744
Artist's Model (Ingeborg Onsager)
Oil on canvas
163.0 x 98.2 cm. (64⅛ x 38⅝ in.)
Lower right: E. Munch / 1[9]
Tompkins Collection

Munch, Edvard
Norwegian, 1863-1944
59.301
Summer Night's Dream (The Voice)
Oil on canvas
87.8 x 108.0 cm. (34⅝ x 42½ in.)
Lower left: E. Munch 1893
Ernest Wadsworth Longfellow Fund

Murillo, Bartolomé Esteban
Spanish, 1617/18-1682

53.1
Christ after the Flagellation
Oil on canvas
113.0 x 147.4 cm. (44½ x 58 in.)
Ernest Wadsworth Longfellow Fund

Murillo, Bartolomé Esteban, Workshop of
Spanish, 1617/18-1682

50.3793
The Prodigal Son among the Pigs
Oil on canvas
28.0 x 37.4 cm. (11 x 14¾ in.)
Given in memory of Robert Treat Paine by Robert Treat Paine, 2nd, Mrs. John H. Storer, Mrs. John F. Moors, Mrs. Charles K. Cummings, and George L. Paine

Murillo, Bartolomé Esteban, Workshop of
Spanish, 1617/18-1682
58.1425
The Young Christ as the Good Shepherd
(version of a painting in a private collection, London)
Oil on canvas
55.0 x 39.6 cm. (21⅝ x 15⅝ in.)
Gift of Mr. and Mrs. Rudolf J. Heinemann

Murillo, Copy after
90.78
Virgin and Child (after a painting in the Galleria Corsini, Rome)
Oil on canvas
163.0 x 110.0 cm. (64⅛ x 43¼ in.)
Bequest of Mrs. Henry Edwards

Naiveu, Matthijs
Dutch, 1647-1721

89.506
Boy and Girl Blowing Soap Bubbles
Oil on canvas
49.6 x 41.5 cm. (19½ x 16⅜ in.)
Gift by Subscription

Nardi, Pietro
 see
Fra Angelico, Copy after

Nash, John
British, 1895-1977

Res. 32.15
Meadle
Oil on canvas
76.7 x 56.0 cm. (30¼ x 22 in.)
Lower left: John Nash
Tompkins Collection

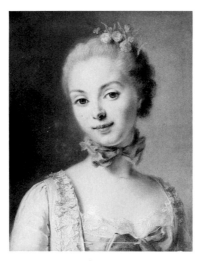

Nash, John
British, 1895-1977

Res. 32.24
Garden in Winter
Oil on canvas
76.2 x 60.5 cm. (30 x 23⅞ in.)
Lower left: John NasH.
Gift by Contribution

Nattier, Jean Marc, Attributed to
French, 1685-1766

65.2664
*Portrait of a Young Woman Wearing a Blue
Ribbon at her Throat*
Pastel on paper
46.5 x 37.5 cm. (18¼ x 14¾ in.)
The Forsyth Wickes Collection

Nattier, Copy after

68.737
Portrait of a Woman (said to be Sophie
Charlotte de La Tour d'Auvergne, Princesse de
Beauvau; after a portrait known in several
versions)
Pastel on paper
39.7 x 31.4 cm. (15⅝ x 12⅜ in.)
Gift of Misses Aimée and Rosamond Lamb

Neeffs, Pieter, I
Flemish, about 1578-1657/61

21.1456
Interior of Antwerp Cathedral at Night
Oil on panel
39.3 x 49.8 cm. (15½ x 19⅝ in.)
Lower right, on base of pier: P. NEFS. / 1.6.3.8.
William Sturgis Bigelow Collection

Neeffs, Pieter, I
Flemish, about 1578-1657/61

25.228
Interior of a Catholic Church
Oil on panel
27.3 x 39.8 cm. (10¾ x 15⅝ in.)
Center, on wall: Peeter / neeffs / 1648
Bequest of Mrs. Thomas O. Richardson

Neer, Eglon van der
Dutch, 1634-1703

41.935
Portrait of a Man and a Woman in an Interior
Oil on panel
73.9 x 67.6 cm. (29⅛ x 26⅝ in.)
Lower right: E. vander Neer f.
Seth K. Sweetser Fund

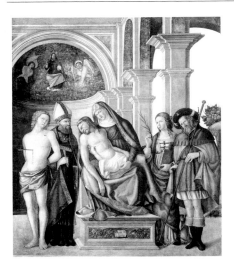 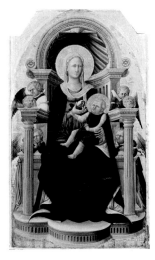 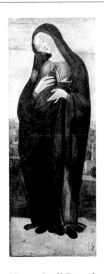

Negro, Gaspare
Italian (Venetian), active 1503-1544

02.681
Virgin Holding the Dead Christ, with Saints Sebastian, Blaise, Margaret and James the Great
Oil transferred from panel to canvas mounted on panel
199.0 x 177.5 cm. (78⅜ x 69¾ in.)
Lower center, on base of throne: Gaspar Niger Veneto / [...] 1513 / V [...]
Gift of Cornelius Conway Felton

Neri di Bicci
Italian (Florentine), 1419-about 1491

1983.300
Virgin and Child Enthroned with Angels
Tempera on panel
Panel: 155.9 x 93.6 cm. (61⅜ x 36⅞ in.)
Design: 154.5 x 88.9 cm. (60⅞ x 35 in.)
Charles Potter Kling Fund

Neroccio di Bartolomeo di Benedetto de' Landi
Italian (Sienese), 1447-1500

39.802
The Virgin of the Annunciation
Oil and tempera on panel
Panel: 68.9 x 29.9 cm. (27⅛ x 11¾ in.)
Design: 62.0 x 23.9 cm. (24⅜ x 9⅜ in.)
Gift of J. Templeman Coolidge

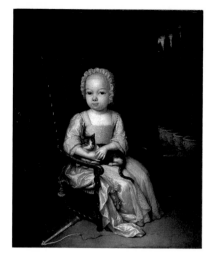

Netscher, Constantijn
Dutch, 1668-1723
61.176
Portrait of a Young Girl Holding a Cat
Oil on panel
49.2 x 40.0 cm. (19⅜ x 15¾ in.)
Lower left: Const Netscher / 1711
*Gift of Howland Warren, Richard Warren, and
Mary W. Murphy*

Neuhuijs, Johannes Albert
Dutch, 1844-1914
23.464
Mid-day Meal
Oil on panel
55.8 x 45.3 cm. (22 x 17⅞ in.)
Lower left: Alb. Neuhuijs f.
Bequest of Ernest Wadsworth Longfellow

Newton, Herbert Herman
British, 1881-1959
53.2373
Towards the Sea, near Sanary, France
Oil on canvas
40.7 x 61.0 cm. (16 x 24 in.)
Lower right: H. H. Newton / 1937
Gift of Mrs. C. I. Stralem

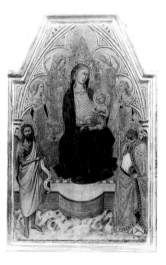

Niccolò da Foligno (Niccolò di Liberatore, called
Niccolò Alunno and Niccolò da Foligno)
Italian (Umbrian), active about 1456-died 1502
20.1858a,b,c
Saints Vittorino, Sebastian, and Jerome (three
panels in modern frame)
Tempera on panel
Design, each panel: 33.3 x 9.5 cm. (13⅛ x
3¾ in.)
Gift of Mrs. Thomas O. Richardson

Niccolò da Foligno (Niccolò di Liberatore, called
Niccolò Alunno and Niccolò da Foligno)
Italian (Umbrian), active about 1456-died 1502
20.1859a,b,c
Saints Lawrence, Gregory, and Augustine (three
panels in modern frame)
Tempera on panel
Design, each panel: 33.3 x 9.8 cm. (13⅛ x
3⅞ in.)
Gift of Mrs Thomas O. Richardson

Niccolò di Buonaccorso
Italian (Sienese) active 1372-died 1388
20.1860
*Virgin and Child Enthroned with Saints John the
Baptist and Augustine and Four Angels*
Tempera on panel
43.8 x 31.3 cm. (17¼ x 12⅜ in.)
Gift of Mrs. Thomas O. Richardson

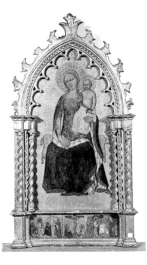

Niccolò di Tommaso
Italian (Florentine), active about 1343-1376

37.409
Virgin and Child with predella scenes of *Saint Nicholas, The Crucifixion,* and *Christ with the Woman of Samaria*
Tempera on panel
Panel: 97.9 x 57.0 cm. (38½ x 22⅜ in.)
Principal design: 76.8 x 40.6 cm. (30 x 16 in.)
Predella design: 11.4 x 43.8 cm. (4½ x 17¼ in.)
Gift of Dr. Eliot Hubbard

Nicholson, Ben
British, 1894-1982

60.961
April 1957 (celestial blue)
Oil on masonite
108.0 x 122.0 cm. (42½ x 48 in.)
Verso: Ben Nicholson / April 1957
Tompkins Collection

Nichon, Pierre
 see
Stoskopff, Sébastien, Copy after

Nicol, Erskine
British, 1825-1904

06.4
Good News
Oil on canvas
66.0 x 51.0 cm. (26 x 20⅛ in.)
Lower left: ENicol. A.R.A. 1866 (E and N joined)
Bequest of Francis Skinner

Noort, Adam van, Copy after
Flemish, 1562-1641

15.291
Adoration of the Magi (after a painting in the Rubenshuis, Antwerp)
Oil on panel
104.3 x 62.3 cm. (41 x 24½ in.)
Gift of George A. Goddard

Normann, Eilert Adelsteen
Norwegian, 1848-1918

23.160
Norwegian Fiord
Oil on canvas
105.5 x 162 cm. (41½ x 63 in.)
Lower left: A. Normann
Bequest of Albert R. Whittier

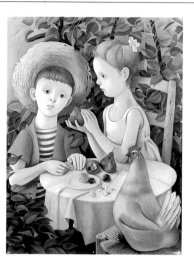

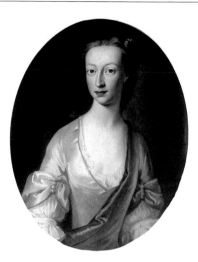

Norwegian, 14th century

52.375
The Holy Trinity with Nine Scenes from the Passion of Christ (altar frontal)
Tempera (?) on panel
Panel: 100.5 x 175.0 cm. (39⅝ x 68⅞ in.)
Design: 91.5 x 166.0 cm. (36 x 65⅜ in.)
Juliana Cheney Edwards Collection

Noyer, Philippe Henri
French, 1917-

54.1420
Children's Picnic
Oil on canvas
65.0 x 50.0 cm. (25⅝ x 19¾ in.)
Lower left: Ph Noyer / 45
Gift of Arthur Wiesenberger

Nune, William de
British, active 1729-died 1750

25.101
Portrait of a Woman
Oil on canvas
75.7 x 62.9 cm. (29¾ x 24¾ in.)
Lower right: Will De Nune / Pinx: 1738
Bequest of Susan Greene Dexter in Memory of Charles and Martha Babcock Amory

Nuvolo
Italian, 1926-

61.1094
Collage
Oil and silk on canvas
69.2 x 49.5 cm. (27¼ x 19½ in.)
Gift of Mrs. Peggy Guggenheim

Nuvolo
Italian, 1926-

64.2054
Composition, 1957
Oil and fabric on canvas
171.5 x 116.0 cm. (67½ x 45⅝ in.)
Verso: Nuvolo 1957
Gift of Mrs. Peggy Guggenheim

Oever, Hendrick ten, Attributed to
Dutch, 1639-1716

52.109
Cattle and Horses with a Herdsman
Oil on canvas
63.5 x 84.2 cm. (25 x 33⅛ in.)
Francis Welch Fund

Oost, Jacob van, the Younger
Flemish, 1637-1713

17.1410
Portrait of a Man
Oil on canvas
73.0 x 58.5 cm. (28¾ x 23 in.)
Denman Waldo Ross Collection

Orpen, Sir William
Irish (worked in England), 1878-1931

48.582
Summer Afternoon (The Artist in his Studio with a Model)
Oil on canvas
96.5 x 86.5 cm. (38 x 34 in.)
Lower right: ORPEN
Bequest of John T. Spaulding

Orrizonte
see
Bloemen, Jan Frans van, Attributed to

Ostade, Adriaen van
Dutch, 1610-1685

45.735
Peasants Merrymaking
Oil on panel
47.4 x 63.0 cm. (18⅝ x 24¾ in.)
Seth K. Sweetser Fund

Oudinot, Achille François
French, 1820-1891

41.112
Trees and Cattle by a Pool
Oil on canvas
52.5 x 85.7 cm. (20⅝ x 33¾ in.)
Lower left: A. Oudinot
Gift of Edward Jackson Holmes

Oudot, Roland
French, 1897-

37.274
Two Young Women Bathing in the Woods
Oil on canvas
100.2 x 81.0 cm. (39½ x 31⅞ in.)
Lower left: Roland Oudot 1929
Gift of Betty Prather

Oudry, Jean Baptiste, Copy after
French, 1686-1755

19.1369
Italian Comedians in a Park (after a painting in a private collection)
Oil on canvas
61.8 x 82.5 cm. (24⅜ x 32½ in.)
Anonymous Gift in Memory of Marian Russell

Ovens, Jürgen
German, 1623-1678

09.184
Hendrik van Halmale with his Horse and Groom
Oil on canvas
228.4 x 158.0 cm. (89⅞ x 62¼ in.)
Lower right: MESSIRE HEE[...] / DE HALMA[...] / BARON·DE·[...]
Gift of Francis Bartlett

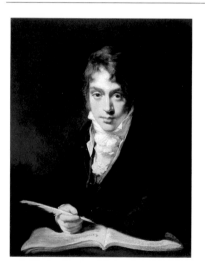

Owen, William
British, 1769-1825

97.444
Thomas John Dibdin
Oil on canvas
71.4 x 64.0 cm. (28⅛ x 25¼ in.)
Abbot Lawrence Fund

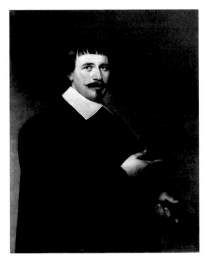

Palamedesz., Antonie
Dutch, 1601-1673

47.1620
Portrait of a Minister
Oil on canvas
82.6 x 67.6 cm. (32½ x 26⅝ in.)
Center right: AET. 41 / A° 1654 / A. Palamedes.
pinxit
*Gift of Edwin H. Abbot, Jr. in Memory of his wife,
Sarah Otis Ernst*

Palma, Jacopo (called Palma Giovane)
Italian (Venetian), 1544-1628

01.5
The Annunciation with God the Father
Oil on canvas
390.0 x 177.8 cm. (153½ x 70 in.)
Gift of Quincy Adams Shaw

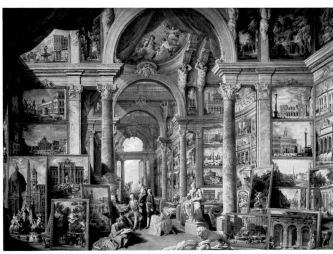

Pannini, Giovanni Paolo
Italian (Roman), 1691-1765

57.66
Fountain of Trevi, Rome
Oil on canvas
50.2 x 64.8 cm. (19¾ x 25½ in.)
Gift of William Truman Aldrich

Pannini, Giovanni Paolo
Italian (Roman), 1691-1765

1975.805
Picture Gallery with Views of Modern Rome
Oil on canvas
170.0 x 244.5 cm. (67 x 96¼ in.)
Lower left, on face of block of stone: I. PAUL
PANINI. ROMAE; on edge of stone: 1757
Charles Potter Kling Fund

Pannini, Copy after
48.583
Capriccio of Roman Ruins with a Statue of Silenus and Dionysus
Oil on canvas
123.5 x 92.5 cm. (48⅝ x 36⅜ in.)
Bequest of John T. Spaulding

Pannini, Copy after
48.584
Capriccio of Roman Ruins with a Bas-relief of a Charioteer (after a painting in the Galleria dell'Accademia di San Luca, Rome)
Oil on canvas
123.8 x 92.0 cm. (48¾ x 36¼ in.)
Bequest of John T. Spaulding

Paolini, Pietro
Italian (Lucchese), 1603-1681
47.118
Young Artist Working by Lamplight
Oil on canvas
68.4 x 121.2 cm. (26⅞ x 47¾ in.)
Ernest Wadsworth Longfellow Fund

Papety, Dominique Louis Ferreol
French, 1815-1849
21.753
Jean Fleury
Oil on canvas
62.1 x 49.8 cm. (24½ x 19⅝ in.)
Upper left: JEAN fleury / RO[...]N 1787
Upper right: PAR DOM PAPETY
Denman Waldo Ross Collection

Pasini, Alberto
Italian, 1825-1899
Res. 19.38
Courtyard in Constantinople
Oil on canvas
26.0 x 46.0 cm. (10¼ x 18⅛ in.)
Lower left: Constantinople
Lower right: A. Pasini. 1868.
Bequest of Mrs. W. P. P. Longfellow

Passerotti, Bartolomeo
Italian (Bolognese), 1529-1592
48.55
Portrait of a Man Playing a Lute
Oil on canvas
77.0 x 60.0 cm. (30¼ x 23⅝ in.)
Upper right: ANNO·IVBILEI·BON / ·M·D· LXXVI
Bequest of Mrs. William de Forest Thomson

Pata, Cherubino
see
Courbet, Imitator of

Patinir, Joachim, Follower of
Flemish, active 1515-died 1524

53.2860
River Landscape with the Baptism of Christ
Oil on panel
17.8 x 23.2 cm. (7 x 9⅛ in.)
Anonymous Gift

Patinir, Style of

52.1525
Mountain Landscape with the Flight into Egypt
Oil on panel
53.3 x 69.3 cm. (21 x 27¼ in.)
Bequest of Keith McLeod

Pellegrini, Giovanni Antonio
Italian (Venetian), 1675-1741

36.892
Nobility Holding a Statue of Athena
Oil on canvas
127.5 x 100.1 cm. (50¼ x 39⅜ in.)
Gift of Frank Gair Macomber

Peploe, Samuel John
British, 1871-1935

48.586
Still Life with Roses in a Glass Vase
Oil on canvas
61.0 x 51.0 cm. (24 x 20 in.)
Lower right: peploe
Bequest of John T. Spaulding

"Peregrinus" (presumably Pellegrino di Giovanni di Antonio), Attributed to
Italian (Perugian), active 1428

68.22
Archangel Michael
Tempera on panel
100.0 x 37.2 cm. (39⅜ x 14⅝ in.)
Charles Potter Kling Fund

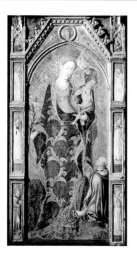

Peréz, Gonzalo, Attributed to
Spanish (Valencian), active first quarter, 15th
century

29.1129
*Virgin and Child with a Donor; and Prophets and
Music-making Angels*
Tempera on panel
Panel (exclusive of modern mouldings at upper
and lower edges): 153.8 x 77.4 cm. (61⅜ x 30½ in.)
Principal design: 128.5 x 56.5 cm. (50⅝ x 22¼ in.)
Maria Antoinette Evans Fund

Perronneau, Jean Baptiste
French, 1715-1783

65.2652
Francis Hastings, Earl of Huntingdon
Oil on canvas
60.5 x 50.2 cm. (23⅞ x 19¾ in.)
The Forsyth Wickes Collection

Perronneau, Jean Baptiste
French, 1715-1783

65.2665
*Portrait of a Woman Wearing Pearls and a
Corsage of Blue Flowers*
Pastel on paper
54.0 x 45.0 cm. (21¼ x 17¾ in.)
Upper right: Perronneau
The Forsyth Wickes Collection

Pether, Sebastian
British, 1790-1844

1978.157
*Eruption of Vesuvius with the Destruction of a
Roman City*
Oil on canvas
71.4 x 92.0 cm. (28⅛ x 36¼ in.)
Lower center, on rock: S. Pether / 1824
Grant Walker Fund

Piazzetta, Giovanni Battista
Italian (Venetian), 1683-1754

46.461
Peasant Girl Catching a Flea
Oil on canvas
74.5 x 96.4 cm. (29⅜ x 38 in.)
Ernest Wadsworth Longfellow Fund

Piazzetta, Giovanni Battista
Italian (Venetian), 1683-1754

46.462
Peasant Boy at a Market
Oil on canvas
74.3 x 96.5 cm. (29¼ x 38 in.)
Ernest Wadsworth Longfellow Fund

Picasso, Pablo (Pablo Ruiz Blasco, called Pablo Picasso)
Spanish (worked in France), 1881-1973
58.976
Standing Figure
Oil on canvas
150.3 x 100.3 cm. (59⅛ x 39½ in.)
Reverse of original canvas: Picasso
Juliana Cheney Edwards Collection

Picasso, Pablo (Pablo Ruiz Blasco, called Pablo Picasso)
Spanish (worked in France), 1881-1973
64.709
Rape of the Sabine Women
Oil on canvas
195.4 x 131.0 cm. (76⅞ x 51⅝ in.)
Upper right: Picasso; Reverse: 4.1.63./10. /11./12./ 13./14./15./16./17./ 18./19./20./21./22. /23./25./ 26./28./29./31./2.2.63. /7. (in irregular columns)
Julia Cheney Edwards Collection, Tompkins Collection, and Fanny P.Mason Fund in Memory of Alice Thevin

Picasso, Pablo (Pablo Ruiz Blasco, called Pablo Picasso)
Spanish (worked in France), 1881-1973
1970.475
Stuffed Shirts (*Les Plastrons*)
Oil on panel
13.6 x 22.5 cm. (5⅜ x 8⅞ in.)
Upper left: PR Picasio
Gift of Julia Appleton Bird

Picasso, Pablo (Pablo Ruiz Blasco, called Pablo Picasso)
Spanish (worked in France), 1881-1973
1977.15
Portrait of a Woman
Oil on canvas
100.5 x 81.4 cm. (39⅝ x 32 in.)
Charles H. Bayley Picture and Painting Fund, and Partial Gift of Mrs. Gilbert W. Chapman

Piero di Cosimo (Piero di Lorenzo, called Piero di Cosimo)
Italian (Florentine), 1462- about 1521
94.180
Two Angels
Oil transferred from panel to canvas
87.4 x 64.5 cm. (34⅜ x 25⅜ in.)
Turner Sargent Collection

Piero della Francesca, Follower of
Italian (Florentine), active 1439-died 1492
22.697
Virgin and Child with an Angel
Tempera on panel
59.0 x 40.5 cm. (23¼ x 16 in.)
Maria Antoinette Evans Fund

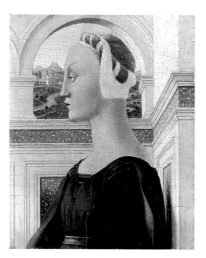

Piero della Francesca, Imitator of
40.237
Portrait of a Woman
Tempera on panel
31.4 x 25.4 cm. (12⅜ x 10 in.)
Lucy Houghton Eaton Fund

Pieters, Evert
Dutch, 1856-1932
25.117
Man on a White Horse
Oil on panel
38.7 x 23.5 cm. (15¼ x 9¼ in.)
Lower right: E. Pieters.
Juliana Cheney Edwards Collection

Pietro da Cortona
see
Berettini, Pietro, Attributed to

Pignoni, Simone, Attributed to
Italian (Florentine), 1611-1698
Res. 23.249
Saint Mary Magdalen Penitent
Oil on canvas
100.3 x 81.0 cm. (39½ x 31⅞ in.)
Gift of Colonel William D. Sohier

Piper, John
British, 1903-
56.14
Shobdon Folly: Romanesque Fragments
Oil on canvas
113.5 x 152 cm. (44⅝ x 59⅞ in.)
Lower right: John Piper
Otis Norcross Fund

Pissarro, Jacob Abraham Camille
Danish (worked in France), 1830-1903
19.1321
Morning Sunlight on the Snow, Eragny-sur-Epte
Oil on canvas
82.3 x 61.5 cm. (32⅜ x 24¼ in.)
Lower left: C. Pissarro. 95
John Pickering Lyman Collection

Pissarro, Jacob Abraham Camille
Danish (worked in France), 1830-1903
25.114
Sunlight on the Road, Pontoise
Oil on canvas
52.3 x 81.5 cm. (20⅝ x 32⅛ in.)
Lower right: C. Pissarro. 1874
Juliana Cheney Edwards Collection

Pissarro, Jacob Abraham Camille
Danish (worked in France), 1830-1903
25.115
View from the Artist's Window, Eragny
Oil on canvas
54.5 x 65.0 cm. (21½ x 25⅝ in.)
Lower right: C. Pissarro 85.
Juliana Cheney Edwards Collection

Pissarro, Jacob Abraham Camille
Danish (worked in France), 1830-1903
39.673
Turkey Girl
Gouache on millboard
81.0 x 65.5 cm. (31⅞ x 25¾ in.)
Lower right: C. Pissarro. 84
Juliana Cheney Edwards Collection

Pissarro, Jacob Abraham Camille
Danish (worked in France), 1830-1903
48.587
Pontoise, the Road to Gisors in Winter
Oil on canvas
59.8 x 73.8 cm. (23½ x 29 in.)
Lower right: C. Pissarro 1873
Bequest of John T. Spaulding

Pissarro, Jacob Abraham Camille
Danish (worked in France), 1830-1903
48.588
Poultry Market at Gisors
Gouache and black chalk on paper mounted on canvas
82.2 x 82.2 cm. (32⅜ x 32⅜ in.)
Lower right: C. Pissarro. 1885
Bequest of John T. Spaulding

Pissarro, Jacob Abraham Camille
Danish (worked in France), 1830-1903
1323.12
Spring Pasture
Oil on canvas
60.0 x 73.7 cm. (23⅝ x 29 in.)
Lower left: C. Pissarro. 1889
Deposited by the Trustees of the White Fund,
Lawrence, Massachusetts

Pissarro, Jacob Abraham Camille
Danish (worked in France), 1830-1903
1333.12
Two Peasant Women in a Meadow
Oil on canvas
93.0 x 73.2 cm. (36⅝ x 28⅞ in.)
Lower right: C. Pissarro. 1893.
Deposited by the Trustees of the White Fund,
Lawrence, Massachusetts

Pittoni, Giovanni Battista
Italian (Venetian), 1687-1767
67.968
Abraham Sacrificing his Son Isaac
Oil on canvas
81.6 x 64.8 cm. (32⅛ x 25½ in.)
Charles Potter Kling Fund

Plathner, Hermann
German, 1831-1902
Res. 30.7
Young Boy Feeding Chickens
Oil on canvas
36.5 x 30.2 cm. (14⅜ x 11⅞ in.)
Lower right: H Plathner. / 1863
Bequest of Mrs. Anna M. Richards

Poelenburgh, Cornelis van
Dutch, about 1586-1667
51.2776
Rest on the Flight into Egypt
Oil on panel
24.6 x 31.7 cm. (9⅝ x 12½ in.)
Anonymous Gift

Pointelin, Auguste Emmanuel
French, 1839-1933
23.565
Winter Twilight
Oil on canvas
51.0 x 72.0 cm. (20⅛ x 28⅜ in.)
Lower left: Aug. Pointelin
Bequest of Ernest Wadsworth Longfellow

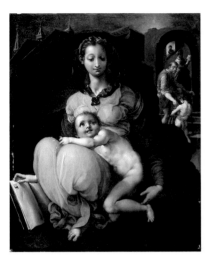

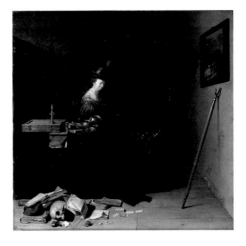

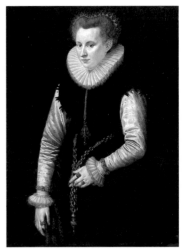

Pontormo, Jacopo Caruccida, Copy after
Italian (Florentine), 1494-1556/57
90.165
Virgin and Child (after a painting now lost)
Oil on panel
126.0 x 103.0 cm. (49⅝ x 40½ in.)
Upper right, on book: 1561
Gift of Edward Perry Warren

Pot, Hendrick Gerritsz.
Dutch, about 1585-1657
48.1165
Woman Seated at a Table (Vanitas)
Oil on panel
46.3 x 49.1 cm. (18¼ x 19⅜ in.)
*Gift of Mrs. Antonie Lilienfeld in memory of
Dr. Leon Lilienfeld*

Pourbus, Frans, the Elder
Flemish, 1545-1581
27.176
Portrait of a Woman
Oil on panel
143.0 x 78.3 cm. (56¼ x 30⅞ in.)
William Sturgis Bigelow Collection

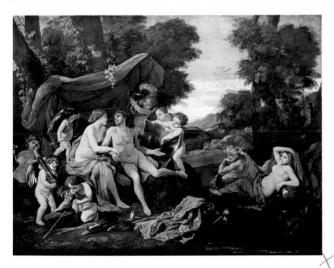

Poussin, Nicolas
French (worked in Rome), 1594-1665
40.89
Mars and Venus
Oil on canvas
154.9 x 213.5 cm. (61 x 84⅛ in.)
*Augustus Hemenway Fund and Arthur William
Wheelwright Fund*

Poussin, Nicolas
French (worked in Rome), 1594-1665
46.463
Discovery of Achilles on Skyros
Oil on canvas
97.5 x 131.0 cm. (38⅜ x 51⅝ in.)
Juliana Cheney Edwards Collection

Procaccini, Giulio Cesare
Italian (Bolognese), 1574-1625

1981.353
The Scourging of Christ
Oil on canvas
216.6 x 148.8 cm. (85¼ x 58⅝ in.)
Paintings Special Purchase Fund

Prud'hon, Pierre Paul
French, 1758-1823

13.391
Abundance (unfinished)
Oil on canvas
116.5 x 89.0 cm. (45⅞ x 35 in.)
Special Fund for Purchase of Pictures

Pseudo Ambrogio di Baldese
Italian (Florentine), active first quarter, 15th century

03.564
Virgin and Child with Saints Mary Magdalen and John the Baptist
Tempera on panel
80.5 x 50.3 cm. (31¾ x 19¾ in.)
Bequest of George Washington Wales

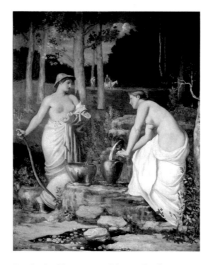

Puligo, Domenico
 see
Andrea del Sarto, Copy after

Puvis de Chavannes, Pierre Cécile
French, 1824-1898

17.3228
At the Fountain
Oil on canvas
181.5 x 145.5 cm. (71½ x 57¼ in.)
Lower left: P. Puvis de Chavannes
Robert Dawson Evans Collection

Puvis de Chavannes, Pierre Cécile
French, 1824-1898

23.506
Homer: Epic Poetry (reduction of a mural in Boston Public Library)
Oil on canvas
124.5 x 63.2 cm. (49 x 24⅞ in.)
Lower left: P. Puvis de Chavannes
Bequest of David P. Kimball in Memory of his wife, Clara Bertram Kimball

Pynacker, Adam
Dutch, 1622-1673

65.615
Landscape with Goats
Oil on canvas
96.9 x 84.5 cm. (38⅛ x 33¼ in.)
Lower center: APynacker (A and P joined)
Bequest of Mrs. Jasper Whiting

Quellinus, Erasmus
see
Fyt, Jan
and
Quellinus, Erasmus

Raeburn, Sir Henry
British, 1756-1823

17.3258
The Right Honorable Charles Hope
Oil on canvas
76.6 x 63.8 cm. (30⅛ x 25⅛ in.)
Robert Dawson Evans Collection

Raeburn, Sir Henry
British, 1756-1823

29.894
Robert Hay
Oil on canvas
77.5 x 64.3 cm. (30½ x 25¼ in.)
Gift of Mrs. William Arthur Gallup

Raeburn, Sir Henry
British, 1756-1823

48.590
Portrait of a Man Seated in an Armchair (said to
be William Fairlie)
Oil on canvas
127.0 x 101.7 cm. (50 x 40 in.)
Bequest of John T. Spaulding

Raeburn, Copy after

35.1219
The Paterson Children (after a painting at
Polesden Lacey, Surrey)
Oil on canvas
127.3 x 101.0 cm. (50⅛ x 39¾ in.)
Gift of Frederick L. Jack

Raeburn, Sir Henry, Follower of

96.30
Portrait of a Young Man
Oil on canvas
76.4 x 64.2 cm. (30⅛ x 25¼ in.)
Falsely signed, lower left: HR 1817
Abbott Lawrence Fund

Raffaëlli, Jean François
French, 1850-1924

19.103
Garlic Seller
Oil on paper mounted and extended on canvas
Canvas support: 71.8 x 49.0 cm.
(28¼ x 19¼ in.)
Lower right: J. F. RAFFAËLLI
The Henry C. and Martha B. Angell Collection

Raffaëlli, Jean François
French, 1850-1924
19.108
Place du Parvis, Notre Dame, Paris
Oil on canvas
71.0 x 81.2 cm. (28 x 32 in.)
Lower right: JFRAFFAËLLI
The Henry C. and Martha B. Angell Collection

Raffaëlli, Jean François
French, 1850-1924
23.524
St.-Etienne-du-Mont, Paris
Oil on panel
21.6 x 25.5 cm. (8½ x 10 in.)
Lower right: JFRAFFAËLLI
*Bequest of David P. Kimball in Memory of his wife,
Clara Bertram Kimball*

Raffaëlli, Jean François
French, 1850-1924
23.533
Street Scene
Oil on panel
56.2 x 73.6 cm. (22⅛ x 29 in.)
Lower left: JFRAFFAËLLI
*Bequest of David P. Kimball in Memory of his wife,
Clara Bertram Kimball*

Raggio, Giuseppe
Italian, 1823-1916
Res. 11.15
Donkeys in the Campagna
Oil on canvas
45.4 x 71.1 cm. (17⅞ x 28 in.)
Lower right: G. Raggio. ROMA. 83
Gift of Dr. Harold W. Dana

Raphael (Raffaello Sanzio or Santi, called
Raphael), Copy after
Italian (Florentine), 1483-1520
74.23
Vision of Ezekiel (after a painting in the Palazzo
Pitti, Florence)
Oil on panel
41.5 x 31.9 cm. (16⅜ x 12½ in.)
Bequest of Charles Sumner

Raphael, Copy after
76.422
*Virgin and Child with Young Saint John the
Baptist* (after the *Madonna della Sedia* in the
Palazzo Pitti, Florence)
Oil on canvas
74.2 x 74.4 cm. (29¼ x 29¼ in.)
Gift of Charles W. Galloupe

Raphael, Copy after
84.561
The Three Graces (after a fresco in the Villa
Farnesina, Rome)
Oil on canvas
267.0 x 195.5 cm. (105⅛ x 77 in.)
*Gift of W. D. Pickman, Thomas Gold Appleton, and
William F. Weld*

Raphael, Copy after
90.74
The Transfiguration of Christ (after a painting in
the Pinacoteca Vaticana, Rome)
147.3 x 98.2 cm. (58 x 38⅝ in.)
Bequest of Mrs. Henry Edwards

Raphael, Copy after
17.3227
Virgin and Child (after central figures in the
Madonna of the Baldachino, Palazzo Pitti, Florence)
Oil on panel
86.0 x 65.4 cm. (33⅞ x 25¾ in.)
Robert Dawson Evans Collection

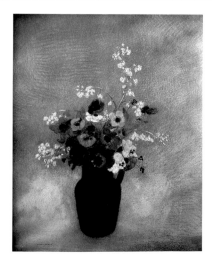

Raphel, Copy after
23.458
The Holy Family (*Notre Dame de Lorette;* after a
lost painting)
Oil on panel
45.6 x 35.5 cm. (18 x 14 in.)
Bequest of Ernest Wadsworth Longfellow

Raphael, Imitator of
06.120
Saint Sebastian (free copy after a painting in the
Accademia Carrara, Bergamo)
Oil on panel
46.2 x 37.0 cm. (18⅛ x 14⅝ in.)
Denman Waldo Ross Collection

Redon, Odilon
French, 1840-1916

48.591
Large Green Vase with Mixed Flowers
Pastel on paper
74.3 x 62.2 cm. (29¼ x 24½ in.)
Lower left: ODILON REDON
Bequest of John T. Spaulding

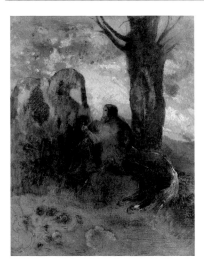

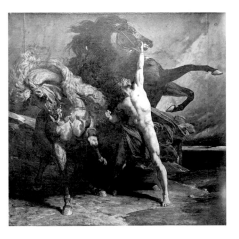

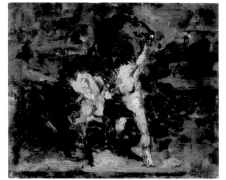

Redon, Odilon
French, 1840-1916

64.2206
Centaur
Pastel on canvas
73.0 x 60.2 cm. (28¾ x 23¾ in.)
Lower left: ODILON REDON
Gift of Laurence K. Marshall

Regnault, Henri Alexandre Georges
French, 1843-1871

90.152
Automedon with the Horses of Achilles
Oil on canvas
315 x 329 cm. (124 x 129½ in.)
Lower left: H. Regnault / Rome. / 1868
Gift by Subscription

Regnault, Henri Alexandre Georges,
Attributed to
French, 1843-1871

96.25
Sketch for Automedon with the Horses of Achilles
Oil on panel
19.0 x 24.5 cm. (7½ x 9⅝ in.)
Gift of Edward Brandus

Rembrandt (Rembrandt Harmensz. van Rijn, called Rembrandt)
Dutch, 1606-1669

93.1475
Portrait of a Man Wearing a Black Hat
Oil on panel
70.0 x 53.0 cm. (27½ x 20⅞ in.)
Lower right: Rembrandt fe / 1634
Gift of Mrs. Frederick L. Ames in the name of Frederick L. Ames

Rembrandt (Rembrandt Harmensz. van Rijn, called Rembrandt)
Dutch, 1606-1669

93.1474
Portrait of a Woman Wearing a Gold Chain
69.5 x 53.0 cm. (27⅜ x 20⅞ in.)
Upper right: Rembrandt f. / 1634
Gift of Mrs. Frederick L. Ames in the name of Frederick L. Ames

Rembrandt (Rembrandt Harmensz. van Rijn, called Rembrandt)
Dutch, 1606-1669

38.1838
Artist in his Studio
Oil on panel
24.8 x 31.7 cm. (9¾ x 12½ in.)
Zoe Oliver Sherman Collection
Given in memory of Lillie Oliver Poor

Rembrandt (Rembrandt Harmensz. van Rijn, called Rembrandt)
Dutch, 1606-1669

56.510
Reverend Johannes Elison
Oil on canvas
174.1 x 124.5 cm. (68½ x 49 in.)
Lower right: Rembrandt · f · 1634
William K. Richardson Fund

Rembrandt, (Rembrandt Harmensz. van Rijn, called Rembrandt)
Dutch, 1606-1669

56.511
Mevr. Johannes Elison
Oil on canvas
175.1 x 124.3 cm. (68⅞ x 48⅞ in.)
Lower right: Rembrandt · f · 1634
William K. Richardson Fund

Rembrandt, Pupil of
03.1080
Old Man in Prayer
Oil on panel
75.3 x 59.7 cm. (29⅝ x 23½ in.)
Arthur Rotch Fund

Rembrandt, Imitator of
39.581
Evangelist Writing
Oil on canvas
104.5 x 84.6 cm. (41⅛ x 33¼ in.)
Falsely signed, center right: Rembrandt f. 16
[canvas cut]
Francis Bartlett Fund

Renoir, Pierre Auguste
French, 1841-1919
19.173
Grand Canal, Venice
Oil on canvas
54.0 x 65.0 cm. (21¼ x 25⅝ in.)
Lower right: Renoir. 81.
Bequest of Alexander Cochrane

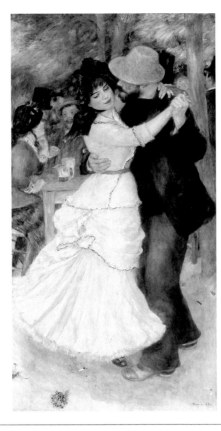

Renoir, Pierre Auguste
French, 1841-1919

19.771
The Seine at Chatou
Oil on canvas
73.5 x 92.5 cm. (28⅞ x 36⅜ in.)
Lower right: Renoir
Gift of Arthur Brewster Emmons

Renoir, Pierre Auguste
French, 1841-1919

37.375
Dance at Bougival
Oil on canvas
181.8 x 98.1 cm. (71⅝ x 38⅝ in.)
Lower right: Renoir. 83.
Picture Fund

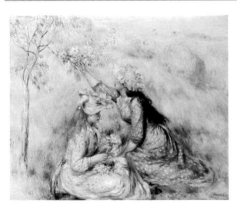

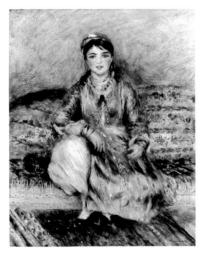

Renoir, Pierre Auguste
French, 1841-1919

39.675
Girls Picking Flowers in a Meadow
Oil on canvas
65.0 x 81.0 cm. (25⅝ x 31⅞ in.)
Lower right: Renoir.
Juliana Cheney Edwards Collection

Renoir, Pierre Auguste
French, 1841-1919

39.677
Algerian Girl
Oil on canvas
50.8 x 40.5 cm. (20 x 16 in.)
Lower right: Renoir 81.
Juliana Cheney Edwards Collection

Renoir, Pierre Auguste
French, 1841-1919

39.678
Rocky Crags at L'Estaque
Oil on canvas
66.5 x 81.0 cm. (26⅛ x 31⅞ in.)
Lower left: Renoir 82.
Juliana Cheney Edwards Collection

Renoir, Pierre Auguste
French, 1841-1919

48.592
Mixed Flowers in an Earthenware Pot
Oil on paperboard mounted on canvas
64.9 x 54.2 cm. (25½ x 21⅜ in.)
Lower right: Renoir.
Bequest of John T. Spaulding

Renoir, Pierre Auguste
French, 1841-1919

48.593
Woman with a Parasol and a Small Child on a Sunlit Hillside
Oil on canvas
47.0 x 56.2 cm. (18½ x 22⅛ in.)
Lower left: Renoir
Bequest of John T. Spaulding

Renoir, Pierre Auguste
French, 1841-1919

48.594
Children on the Seashore, Guernsey
Oil on canvas
91.5 x 66.5 cm. (36 x 26⅛ in.)
Stamped, lower right: Renoir.
Bequest of John T. Spaulding

Renoir, Pierre Auguste
French, 1841-1919

48.595
Jacques Bergeret as a Child
Oil on canvas
41.0 x 32.3 cm. (16⅛ x 12⅝ in.)
Upper right: Renoir.
Bequest of John T. Spaulding

Renoir, Pierre Auguste
French, 1841-1919

48.596
Landscape on the Coast, near Menton
Oil on canvas
65.8 x 81.3 cm. (25⅞ x 32 in.)
Lower right: Renoir. 83.
Bequest of John T. Spaulding

Renoir, Pierre Auguste
French, 1841-1919

48.597
Mademoiselle Dieterle (La Merveilleuse)
Pastel over a lithograph on paper
51.0 x 40.1 cm. (20⅛ x 15¾ in.)
Lower right: Renoir
Bequest of John T. Spaulding

Renoir, Pierre Auguste
French, 1841-1919

61.393
Boating Couple (said to be Aline Charigot and
Renoir)
Pastel on paper
45.0 x 58.5 cm. (17¾ x 23 in.)
Lower right: Renoir.
Given in Memory of Governor Alvan T. Fuller by the
Fuller Foundation

Renoir, Pierre Auguste
French, 1841-1919

61.960
Gabrielle and Coco Playing Dominoes
Oil on canvas
52.0 x 46.2 cm. (20½ x 18⅛ in.)
Upper left: Renoir.
Given in Memory of Governor Alvan T. Fuller by the
Fuller Foundation

Renoir, Pierre Auguste
French, 1841-1919

1972.1084
Portrait of a Young Child
Oil on canvas
20.7 x 14.0 cm. (8⅛ x 5½ in.)
Lower right: Renoir.
Gift of Dr. and Mrs. Harold S. Tannenbaum

Renoir, Pierre Auguste
French, 1841-1919

1973.513
Coco (Claude Renoir)
Oil on canvas
55.0 x 46.5 cm. (21⅝ x 18¼ in.)
Stamped, lower left: Renoir.
Gift of Mrs. George Putnam

Reschi, Pandolfo
Polish (worked in Tuscany), 1643-1699

83.21
Landscape with Huntsmen
Oil on canvas
120.5 x 170.5 cm. (47⅜ x 67⅛ in.)
Gift of Francis Foster

Reschi, Pandolfo
Polish (worked in Tuscany), 1643-1699

84.240
Landscape with Herdsmen
Oil on canvas
119.5 x 171.3 cm. (47 x 67⅜ in.)
Bequest of Mrs. Peter Chardon Brooks

Reschi, Pandolfo
Polish (worked in Tuscany), 1643-1699
84.241
Landscape with Horsemen on a Road
Oil on canvas
119.8 x 172.2 cm. (47⅛ x 67¾ in.)
Bequest of Mrs. Peter Chardon Brooks

Reyn, Jean de, Attributed to
French, about 1610-1678
34.541
Lute Player
Oil on canvas
157.5 x 113.9 cm. (62 x 44⅞ in.)
Maria Antoinette Evans Fund

Reyna, Antonio
Spanish (worked in Italy), active first quarter, 20th century
15.2
Canal in Venice
Oil on canvas
75.0 x 43.0 cm. (29½ x 17 in.)
Lower right: A Reyna / Venezia
Bequest of Maurice Longstreth

Reynolds, Sir Joshua
British, 1723-1792
95.178
Anne Vansittart, Lady Palk
Oil on canvas
76.7 x 65.0 cm. (30¼ x 25⅝ in.)
Henry Lillie Pierce Fund

Reynolds, Sir Joshua
British, 1723-1792
17.3264
Henrietta Edgcumbe
Oil on canvas
76.5 x 63.5 cm. (30⅛ x 25 in.)
Robert Dawson Evans Collection

Reynolds, Sir Joshua
British, 1723-1792
30.492
Portrait of a Woman (said to be Lady Scott)
Oil on canvas
76.5 x 64.0 cm. (30⅛ x 25¼ in.)
Bequest of Mrs. Harriet J. Bradbury

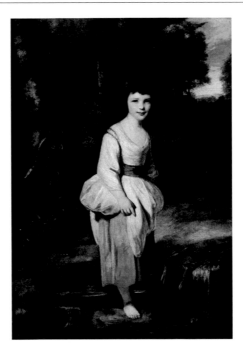

Reynolds, Sir Joshua
British, 1723-1792

35.1226
Colonel John Barrington
Oil on canvas
76.0 x 63.5 cm. (29⅞ x 25 in.)
Gift of Frederick L. Jack

Reynolds, Sir Joshua
British, 1723-1792

61.961
Lady Gertrude Fitzpatrick as Sylvia
Oil on canvas
144.5 x 101.5 cm. (56⅞ x 40 in.)
Given in Memory of Governor Alvan T. Fuller by the Fuller Foundation

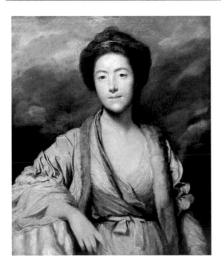

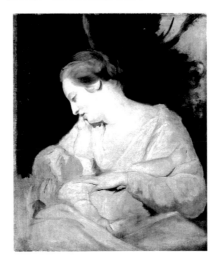

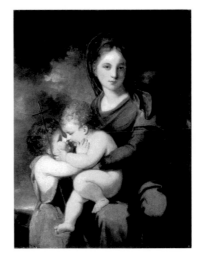

Reynolds, Sir Joshua
British, 1723-1792

54.1412
Portrait of a Woman
Oil on canvas mounted on composition board
76.5 x 63.5 cm. (30⅛ x 25 in.)
Bequest of Walter J. Noonan

Reynolds, Sir Joshua
British, 1723-1792

1982.138
Mrs. Richard Hoare Holding her Son, Henry
(unfinished variant of painting in the Wallace Collection, London)
Oil on canvas
76.0 x 63.5 cm. (29⅞ x 25 in.)
Charles H. Bayley Picture and Painting Fund

Reynolds, Sir Joshua, Attributed to
British, 1723-1792

30.499
The Virgin and Child with the Infant Saint John the Baptist
Oil on canvas
91.4 x 71.0 cm. (36 x 28 in.)
Bequest of Mrs. Harriet J. Bradbury

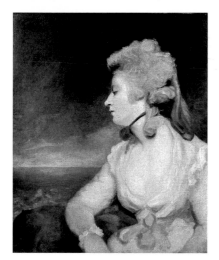

Reynolds, Sir Joshua, Studio of
British, 1723-1792
25.109
Mrs. Robinson (Mary Darby Robinson)
Oil on canvas
76.5 x 63.5 cm. (30⅛ x 25 in.)
Juliana Cheney Edwards Collection

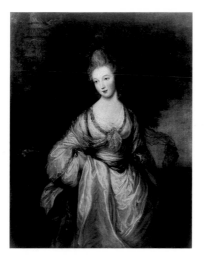

Reynolds, Copy after (?)
17.3257
Miss Arcedeckne (after a painting of uncertain
attribution, private collection, London)
Oil on canvas
128.0 x 102.0 cm. (50⅜ x 40⅛ in.)
Robert Dawson Evans Collection

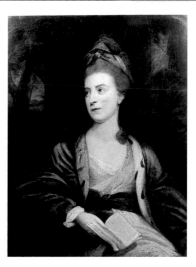

Reynolds, Copy after
24.213
Mrs. Yates (after a painting known from an
engraving by James Scott)
Oil on canvas
92.5 x 71.5 cm. (36⅜ x 28⅛ in.)
*Gift of Robert Jordan from the Collection of Eben D.
Jordan*

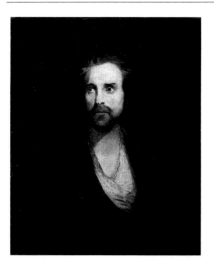

Reynolds, Copy after
36.353
Banished Lord (after a painting in the Tate
Gallery, London)
Oil on canvas
73.5 x 63.0 cm. (28⅞ x 24¾ in.)
Gift of the heirs of Stephen Higginson Perkins

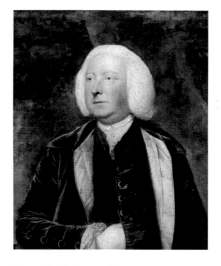

Reynolds, Follower of
30.491
Portrait of a Man (said to be Lord Anson)
Oil on canvas
75.5 x 62.3 cm. (29¾ x 24½ in.)
Bequest of Harriet J. Bradbury

Reynolds, Style of
76.490
Portrait of a Young Girl
Oil on canvas
80.3 x 63.5 cm. (31⅝ x 25 in.)
Bequest of Thomas Gold Appleton

Reynolds, Style of
30.493
Portrait of a Woman
Oil on canvas
127.6 x 102.1 cm. (50¼ x 40¼ in.)
Bequest of Mrs. Harriet J. Bradbury

Ribera, Jusepe de
Spanish (worked in Italy), 1591-1652
36.891
Saint Onuphrius
Oil on canvas
129.7 x 101.2 cm. (51 x 39⅞ in.)
Lower center: Jusepe de Ribera es / panol F 1642
Gift of Frank Gair Macomber

Ribera, Follower of
99.315
Geographer
Oil on canvas
Design: 128.1 x 96.0 cm. (50⅜ x 37¾ in.)
James Fund

Ribot, Théodule Augustin
French, 1823-1891
24.223
Portrait of the Artist's Mother
Oil on panel
55.5 x 46.0 cm. (21⅞ x 18⅛ in.)
Lower right: t. Ribot
Gift of Robert Jordan from the Collection of Eben D. Jordan

Ricci, Sebastiano
Italian (Venetian), 1659-1734
1980.275
Phineas and the Sons of Boreas
Oil on canvas
83.2 x 100.3 cm. (32¾ x 39½ in.)
Charles Potter Kling Fund

Richardson, Jonathan, Attributed to
British, 1665-1745
24.19
Alexander Pope
Oil on canvas
76.5 x 63.2 cm. (30⅛ x 24⅞ in.)
James T. Fields Collection

Rigaud (Hyacinthe François Rigau y Ros, called
Hyacinthe Rigaud), Copy after
French, 1659-1743

74.16
Portrait of an Artist (free copy after an engraving
by Pierre Drevet after a self-portrait by Rigaud)
Oil on canvas
28.1 x 22.9 cm. (11 x 9 in.)
Bequest of Charles Sumner

Rigaud, Style of

50.188
Portrait of a Magistrate
Oil on canvas
Design: 64.0 x 55.6 cm. (25¼ x 21⅞ in.)
Gift of Mr. and Mrs. William Tudor Gardiner

Robert, Hubert
French, 1733-1808

65.2653
Stairway of the Washerwomen
Oil on canvas
60.3 x 41.6 cm. (23¾ x 16⅜ in.)
Lower right, on wall: H. ROBERT / 1796
The Forsyth Wickes Collection

Roberts, Arthur Henry
French, 1819-1900

42.423
*The Port aux Pierres on the Quai d'Orsay, with
the Tuileries Palace, Paris*
Oil on canvas
57.0 x 81.5 cm. (22⅜ x 32⅛ in.)
Lower left: Arthur Rob[...] / 1848
Bequest of Daniel Berkeley Updike

Robie, Jean Baptiste
Belgian, 1821-1910

1984.169
Study of a Flowering Branch
Oil on panel
53.5 x 34.8 cm. (21 x 13¾ in.)
Lower left: J Robie mai 1871
Fanny P. Mason Fund in Memory of Alice Thevin

Rodriquez de Guzman, Manuel
Spanish, 1818-1867

1981.591
Battle of Otumba
Oil on canvas
125.7 x 167.6 cm. (49½ x 66 in.)
Lower right: M. Rodriguez Sevilla / 1842
*Gift of the heirs of Frederick Hastings Rindge and
May K. Rindge*

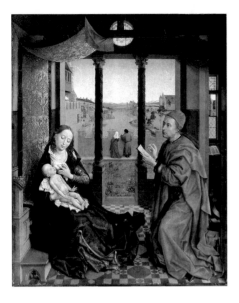

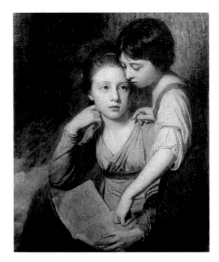

Rogier van der Weyden
Flemish, about 1400-1464

93.153
Saint Luke Painting the Virgin and Child
Oil and tempera on panel
Panel: 137.5 x 110.8 cm. (54⅛ x 43⅝ in.)
Design: 135.0 x 108.2 cm. (53⅛ x 42⅝ in.)
Gift of Mr. and Mrs. Henry Lee Higginson

Romney, George
British, 1734-1802

17.3259
Portrait of Two Girls (said to be the Misses Cumberland)
Oil on canvas
75.8 x 63.5 cm. (29⅞ x 25 in.)
Robert Dawson Evans Collection

Romney, George
British, 1734-1802

23.397
Mrs. Billington as Saint Cecilia
Oil on canvas
127.7 x 102.0 cm. (50¼ x 40⅛ in.)
Bequest of Mrs. David P. Kimball

Romney, George
British, 1734-1802

23.461
John Dunlop
Oil on canvas
76.5 x 63.3 cm. (30⅛ x 24⅞ in.)
Bequest of Ernest Wadsworth Longfellow

Romney, George
British, 1734-1802

35.1218
William Chafyn Grove
Oil on canvas
127.0 x 100.2 cm. (50 x 39½ in.)
Gift of Frederick L. Jack

Romney, George
British, 1734-1802

61.392
Anne, Lady de la Pole
Oil on canvas
241.0 x 149.0 cm. (94⅞ x 58⅝ in.)
Given in Memory of Governor Alvan T. Fuller by the Fuller Foundation

Romney, George
British, 1734-1802

61.962
John Bensley Thornhill as a Boy
Oil on canvas
186.7 x 121.0 cm. (73½ x 47⅝ in.)
Given in Memory of Governor Alvan T. Fuller by the Fuller Foundation

Romney, George, Attributed to
British, 1734-1802

28.443
Portrait of a Man (said to be Charles Parkhurst)
Oil on canvas
75.7 x 63.3 cm. (29¾ x 24⅞ in.)
Gift of Eben Howard Gay

Roos, Philipp Peter (called Rosa da Tivoli)
German (worked in Rome), 1657-1706

82.269
Landscape with Goatherd and Goats
Oil on canvas
66.1 x 88.0 cm. (26 x 34⅝ in.)
Gift of Edward Wheelwright

Rosa, Salvator, Follower of
Italian (Neapolitan), 1615-1673

47.117
Hillside Landscape with a Passing Army
Oil on canvas
74.2 x 60.7 cm. (29¼ x 23⅞ in.)
Falsely signed, lower left: SR (in monogram)
Ernest Wadsworth Longfellow Fund

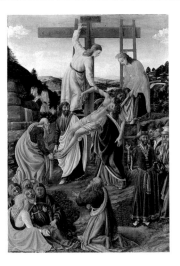

Rosselli, Cosimo
Italian (Florentine), 1439-1507
22.651
The Descent from the Cross
Oil and tempera on panel
50.8 x 36.0 cm. (20 x 14⅛ in.)
Zoe Oliver Sherman Collection

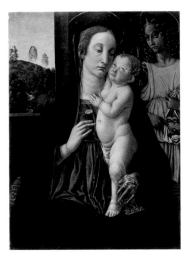

Rosselli, Cosimo
Italian (Florentine), 1439-1507
64.2077
Virgin and Child with an Angel
Oil and tempera on panel
Panel: 78.6 x 49.8 cm. (31 x 19⅝ in.)
Design: 73.0 x 45.5 cm. (28¾ x 17⅞ in.)
Bequest of Mrs. Edward Jackson Holmes

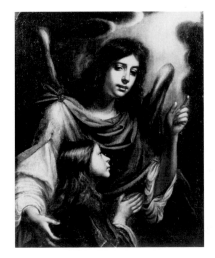

Rosselli, Matteo, Attributed to
Italian (Florentine), 1578-1650
78.7
Tobias and the Angel
Oil on canvas
87.6 x 72.3 cm. (34½ x 28½ in.)
Bequest of Mrs. James Warren Sever

Rossetti, Gabriel Charles Dante
British, 1828-1882
27.571
William J. Stillman
Pastel on two sheets of paper joined and mounted
on cardboard
65.5 x 51.5 cm. (25¾ x 20¼ in.)
Lower right: GCDR (in monogram) 1870
*Gift of Michael Spartali Stillman in Memory of his
mother, Marie Spartali Stillman*

Rossetti, Gabriel Charles Dante
British, 1828-1882
1980.261
Bocca Baciata (Lips That Have Been Kissed)
Oil on panel
32.2 x 27.1 cm. (12⅝ x 10⅝ in.)
Lower left: GCDR (monogram)
Reverse: Bocca Baciata non perde ventura, anzi
rinnova come fa la / Boccaccio
Gift of James Lawrence

Rosso Fiorentino (Giovanni Battista di Jacopo, called Rosso Fiorentino)
Italian (Florentine), 1496-1540

58.527
The Dead Christ with Angels
Oil on panel
133.5 x 104.1 cm. (52½ x 41 in.)
Lower right, on bench: RUBEVS / flo / FACIEBAT
Charles Potter Kling Fund

Rothenstein, Sir William
British, 1872-1945

50.3435
Exposition of the Talmud
Oil on canvas
114.8 x 145.2 cm. (45¼ x 57⅛ in.)
Lower left: W.R. 1904
Gift of Mrs. E. F. Hesslein

Rothwell, Richard
Irish, 1800-1868

35.1220
Sir William Beechey
Oil on canvas
78.0 x 63.2 cm. (30¾ x 24⅞ in.)
Gift of Frederick L. Jack

Rottenhammer, Johann, Style of
German, 1564-1625

66.854
Hebe
Oil on panel
32.2 x 26.8 cm. (12⅝ x 10½ in.)
Gift of Pieter de Boer

Rouault, Georges
French, 1871-1958

51.702
Profile of a Clown
Oil on paperboard mounted on panel
66.0 x 48.0 cm. (26 x 18⅞ in.)
Lower right: G Rouault
Fanny P. Mason Fund in Memory of Alice Thevin

Rousseau, Henri Julien Félix (called Le
Douanier Rousseau), Imitator of
French, 1844-1910
48.598
Lake of Geneva (Lac Léman)
Oil on panel
26.5 x 34.5 cm. (10⅜ x 13⅝ in.)
Lower left: Henri Rousseau
Bequest of John T. Spaulding

Rousseau, Pierre Etienne Théodore
French, 1812-1867
84.277
Landscape with a Peasant Watering her Cows
Oil on panel
26.5 x 38.1 cm. (10⅜ x 15 in.)
Lower left: TH. Rousseau
Bequest of Thomas Gold Appleton

Rousseau, Pierre Etienne Théodore
French, 1812-1867
17.1461
Wooded Stream
Oil on panel
53.2 x 74.5 cm. (21 x 29⅜ in.)
Lower left: Paris 185[...]
Lower right: TH. Rousseau
Gift of Mrs. Henry S. Grew

Rousseau, Pierre Etienne Théodore
French, 1812-1867
17.3241
Pool in the Forest
Oil on canvas
39.5 x 57.4 cm. (15½ x 22⅝ in.)
Lower right: TH Rousseau
Robert Dawson Evans Collection

Rousseau, Pierre Etienne Théodore
French, 1812-1867
23.399
Gathering Wood in the Forest of Fontainebleau
Oil on canvas
54.7 x 65.3 cm. (21½ x 25¾ in.)
Lower left: TH.Rousseau
Bequest of Mrs. David P. Kimball

Rousseau, Pierre Etienne Théodore
French, 1812-1867
43.1350
Cottage in a Clump of Trees
Oil on paperboard
20.6 x 27.6 cm. (8⅛ x 10⅞ in.)
Lower left: TH.Rousseau
Gift of Mrs. George H. Davenport

Rouvre, Yves
French, 1910-
56.1316
Pines and Hills
Tempera and oil on canvas
73.0 x 91.5 cm. (28¾ x 36 in.)
Lower right: Rouvre / 53
Gift of Mr. and Mrs. Arthur Wiesenberger

Roybet, Ferdinand
French, 1840-1920
02.85
Young Man in Medieval Costume
Oil on canvas
46.2 x 38.3 cm. (18⅛ x 15⅛ in.)
Upper left: f. Roybet
Bequest of Miss Ellen Frothingham

Roybet, Ferdinand
French, 1840-1920
20.596
Boy Holding a Tray
Oil on canvas
45.8 x 38.2 cm. (18 x 15 in)
Lower left: F. Roybet
Peter Chardon Brooks Memorial Collection
Gift of Mrs. Richard M. Saltonstall

Rubens, Peeter Pauwel
Flemish, 1577-1640
40.2
Mūlāy Ahmad
Oil on panel
99.7 x 71.5 cm. (39¼ x 28⅛ in.)
M. Theresa B. Hopkins Fund

Rubens, Peeter Pauwel
Flemish, 1577-1640
41.40
The Head of Cyrus Brought to Queen Tomyris
Oil on canvas
205.0 x 361.0 cm. (80¾ x 142⅛ in.)
Juliana Cheney Edwards Collection

Rubens, Peeter Pauwel
Flemish, 1577-1640

42.179
Mercury and a Sleeping Herdsman (figure studies
for the ceiling of the Banqueting House,
Whitehall)
Oil on panel
63.4 x 53.0 cm. (25 x 20⅞ in.)
Ernest Wadsworth Longfellow Fund

Rubens, Peeter Pauwel
Flemish, 1577-1640

43.1332
Landscape with an Avenue of Trees
Oil on paper mounted on panel
Overall: 56.0 x 71.8 cm. (22 x 28¼ in.)
Original design: 28.5 x 67.0 cm. (11¼ x 26⅜ in.)
Additions: at top 20.0 x 67.0 cm. (7⅞ x 26⅜ in.);
at bottom 7.5 x 67.0 cm. (3 x 26⅜ in.); on right
56.0 x 4.8 cm. (22 x 1⅞ in.)
Ernest Wadsworth Longfellow Fund

Rubens, Peeter Pauwel
Flemish, 1577-1640

47.1543
Hercules as Heroic Virtue Overcoming Discord
(study for the ceiling of the Banqueting House,
Whitehall)
Oil on panel
63.7 x 48.6 cm. (25⅛ x 19⅛ in.)
Ernest Wadsworth Longfellow Fund

Rubens, Copy after
 by
Farasyn, L.
Belgian, 1822-1899

84.250
The Descent from the Cross (after the center panel
of a triptych, Cathedral of Our Lady, Antwerp)
Oil on canvas
130.0 x 96.1 cm. (51⅛ x 37⅞ in.)
Lower left: FARASYN. 1865
Gift of William Hilton

Rubens, Copy after

Res. 27.89
Jan Brueghel and his Family (after a painting in
the Prince's Gate Collection, Courtauld Institute,
London)
Oil on canvas
130.2 x 97.2 cm. (51¼ x 38¼ in.)
Bequest of Miss Elizabeth Howard Bartol

Rubens, Copy after

97.443
Virgin and Child Adored by Saints (after an oil
sketch in the Gemäldegalerie, Staatliche Museen,
Berlin)
Oil on canvas
83.3 x 59.5 cm. (32¾ x 23⅜ in.)
Moses Kimball Fund

Rubens, Follower of
79.164
Drunken Bacchus with Faun and Satyr
Oil on copper
35.9 x 49.2 cm. (14⅛ x 19⅜ in.)
Everett Fund

Rubens, Follower of
38.1616
Isabella Brant as Glycera
Oil on panel
64.2 x 49.2 cm. (25¼ x 19⅜ in.)
Seth K. Sweetser Fund

Rubens, Imitator of
94.172
Portrait of Rubens and his Son Nikolaus
Oil on canvas
119.0 x 100.0 (46⅞ x 39⅜ in.)
Turner Sargent Collection

Rubens, Imitator of
48.599
Portrait of a Monk
Oil on canvas
74.0 x 63.5 cm. (29⅛ x 25 in.)
Bequest of John T. Spaulding

Ruisdael, Jacob Isaacksz. van
Dutch, 1628/29-1682
39.794
Haarlem Seen from the Dunes
Oil on canvas
44.4 x 43.4 cm. (17½ x 17⅛ in.)
Lower left: Ruisdael
Ernest Wadsworth Longfellow Fund

Ruisdael, Jacob Isaacksz. van
Dutch, 1628/29-1682
52.1757
Woodland Vistas
Oil on canvas
67.1 x 53.7 cm. (26⅜ x 21⅛ in.)
*Gift of Edwin H. Abbot, Jr. in Memory of his father,
Edwin H. Abbot*

Ruisdael, Jacob Isaacksz. van
Dutch, 1628/29-1682

57.4
Rough Sea
Oil on canvas
107.1 x 125.8 cm. (42⅛ x 49½ in.)
Lower left: Ruisdael
William Francis Warden Fund

Ruisdael, van, Copy after

17.3243
Sand Pit (after a painting whose present location is unknown)
Oil on panel
32.0 x 35.8 cm. (12⅝ x 14⅛ in.)
Falsely signed, lower right: JR
Robert Dawson Evans Collection

Ruisdael, van, Follower of
89.502
Ruined Cottage
Oil on canvas mounted on panel
42.0 x 51.8 cm. (16½ x 20⅜ in.)
Falsely signed, lower right: JR (in monogram)
Sidney Bartlett Bequest

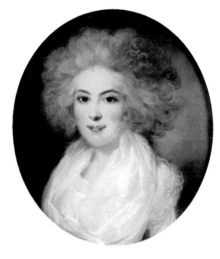

Ruiz de la Iglesia, Francisco Ignacio
Spanish, 1648-1704

18.622
The Virgin of the Immaculate Conception
Oil on canvas
228.2 x 167.7 cm. (89⅞ x 66 in.)
Lower right: Fran.co Inazio Ruiz / f.at ano
1682
Gift of the Heirs of Mrs. Mary Hemenway

Russell, John
British, 1745-1806

65.2666
Mrs. Thomas Raikes
Pastel on paper
29.8 x 24.8 cm. (11¾ x 9¾ in.)
The Forsyth Wickes Collection

Russian, 17th century

43.1351
Christ the Almighty with the Virgin, Saints John the Baptist, Peter and Paul, and the Archangels Michael and Gabriel (Deësis)
Tempera on panel
19.1 x 45.6 cm. (7½ x 18 in.)
Gift of Mrs. Samuel W. Ellsworth

Russian (or Balkan), fourth quarter, 17th century -
first quarter, 18th century

97.19
Virgin and Child Enthroned with Two Angels
(Our Lady of the Burning Bush)
Tempera on panel
Panel: 32.0 x 27.5 cm. (12⅝ x 10⅞ in.)
Design: 21.5 x 19.5 cm. (8½ x 7⅝ in.)
Gift of Mrs. Thomas O. Richardson, 1897

Russian, 18th century
17.1601
Christ the Almighty
Tempera on panel
31.8 x 27.4 cm. (12½ x 10¾ in.)
Gift of Horatio G. Curtis

Russian, first half, 19th century
1978.176
Saint Nicholas with Christ and the Virgin
Tempera on panel
27.4 x 23.2 cm. (10¾ x 9⅛ in.)
Gift of Misses Aimée and Rosamond Lamb

Russian, second half, 19th century
80.510
Virgin and Child, Saint Nicholas, Archangel
Michael, and Saint George
Tempera on wood
30.1 x 23.6 cm. (11⅞ x 9¼ in.)
Gift of Thomas N. Chandler

Russian (Novgorod School), 17th century
52.395
Council of Bishops with Chosen Saints, around the
Deësis
Tempera and oil on panel
16.5 x 14 cm. (6½ x 5½ in.)
Inscribed with names of the saints and, beneath
Deësis: [And the Novgorodians gathered all
together]
Gift of Vladimir G. Simkhovitch

Russian (Palekh School), 18th century
94.175
Scenes from the Life of the Virgin and the Life of
Christ
Tempera and oil on panel
34.7 x 30.5 cm. (13⅝ x 12 in.)
Turner Sargent Collection

Ruysdael, Jacob Salomonsz. van
Dutch, 1629/30-1681

74.19
Cattle at the Edge of a Wood
Oil on panel
55.2 x 81.5 cm. (21¾ x 32⅛ in.)
Bequest of Charles Sumner

Ruysdael, Salomon van
Dutch, 1602-1670

1982.396
View of Beverwijk
Oil on panel
75.2 x 65.6 cm. (29⅝ x 25⅞ in.)
Lower right: S. VRuysdael (V and R joined) /
1646
Charles H. Bayley Picture and Painting Fund and
Henry H. and Zoe Oliver Sherman Fund

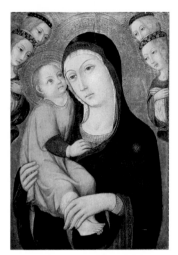

Saenredam, Pieter Jansz.
Dutch, 1597-1665
48.321
Church of Saint Odulphus, Assendelft
Oil on panel
40.5 x 36.5 cm. (16 x 14⅜ in.)
Juliana Cheney Edwards Collection

Sánchez-Perrier, Emilio
Spanish, 1855-1907
1979.4
Fishing on the Bank of the Oise, Pontoise
Oil on panel
26.7 x 35.0 cm. (10½ x 13¾ in.)
Lower left: E Sanchez Perrier / Pontoise
Fanny P. Mason Fund in Memory of Alice Thevin

Sano di Pietro (Ansano di Pietro di Mencio,
called Sano di Pietro)
Italian (Sienese), 1406-1481
97.229
Virgin and Child with Angels
Tempera on panel
Panel: 65.8 x 47.4 cm. (25⅞ x 18⅝ in.)
Design: 57.2 x 38.5 cm. (22½ x 15⅛ in.)
Bequest of Caroline Isabella Wilby

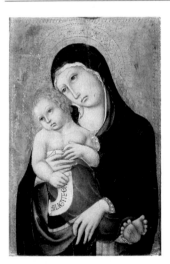

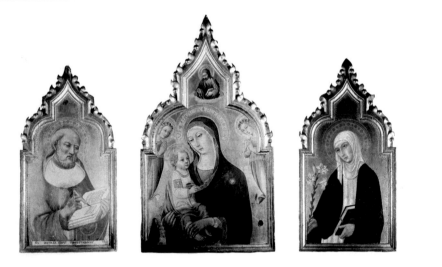

Sano di Pietro (Ansano di Pietro di Mencio,
called Sano di Pietro)
Italian (Sienese), 1406-1481
07.78
Virgin and Child
Tempera on panel
Panel: 37.6 x 25.0 cm. (14¾ x 9⅞ in.)
Design: 34.0 x 22.0 cm. (13⅜ x 8⅝ in.)
Gift of Mrs. Josiah Bradlee

Sano di Pietro (Ansano di Pietro di Mencio,
called Sano di Pietro)
Italian (Sienese), 1406-1481
07.515a,b,c
*Virgin and Child with a Donor and Saints Jerome
and Catherine of Siena* (triptych)
Tempera on panel
Center panel: 122.3 x 70.6 cm. (48⅛ x 27¾ in.);
design: 99.0 x 63.2 cm. (39 x 24⅞ in.)
Left wing panel: 95.0 x 51.0 cm. (37⅜ x 20⅛
in.); design: 81.0 x 45.6 cm. (31¾ x 17½ in.)

Right wing panel: 95.2 x 51.8 cm. (37½ x 20⅜
in.); design: 80.3 x 44.6 cm. (31⅝ x 17½ in.)
Anonymous Gift

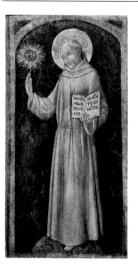

Sano di Pietro (Ansano di Pietro di Mencio, called Sano di Pietro)
Italian (Sienese), 1406-1481

39.801
Saint Bernardino Standing on the World
Tempera on vellum mounted on panel
Design: 40.0 x 20.4 cm. (15¾ x 8 in.)
Gift of J. Templeman Coolidge

Santerre, Jean Baptiste
French, 1658-1717

47.245
Mlle. Desmares
Oil on canvas
86.8 x 62.6 cm. (34⅛ x 24⅝ in.)
Gift of Mrs. Albert J. Beveridge in Memory of Delia Spencer Field

Santvoort, Dirck van, Attributed to
Dutch, 1610-1680

93.191
Portrait of a Woman
Oil on panel
61.4 x 49.8 cm. (24⅛ x 19⅝ in.)
Denman Waldo Ross Collection

Santvoort, Dirck van, Attributed to
Dutch, 1610-1680

37.1215
Portrait of a Woman Holding a Fan
Oil on panel
122.0 x 89.0 cm. (48 x 35 in.)
Gift of Miss Amelia Peabody

Saraceni, Carlo, Follower of
Italian (Venetian), about 1579-1620

1978.160
Saint Stephen Mourned by Saints Gamaliel and Nicodemus
Oil on canvas
113.1 x 155.3 cm. (44½ x 61⅛ in.)
M. Theresa B. Hopkins Fund and Charles Potter Kling Fund

Sassoferrato (Giovanni Battista Salvi, called
Sassoferrato), Copy after
 by
Agricola
Italian, active mid-19th century

90.75
The Virgin in Prayer (after a painting in the
Castello Sforzesco, Milan)
Oil on canvas
50.1 x 39.9 cm. (19¾ x 15¾ in.)
Bequest of Mrs. Henry Edwards

Savery, Roelant
Flemish, 1576-1639

67.769
Rocky Landscape with Animals
Oil on canvas
61.5 x 103.7 cm. (24¼ x 40⅞ in.)
Francis Welch Fund

Scarsellino (Scarsella, Ippolito, called Lo
Scarsellino)
Italian (Ferrarese), 1551-1620

1982.211
Christ on Calvary
Oil on canvas
52.1 x 45.1 cm. (20½ x 17¾ in.)
M. Theresa B. Hopkins Fund

Schall, Jean Frédéric
French, 1752-1825

65.2654
Sultana Valida
Oil on copper
17.8 x 20.3 cm. (7 x 8 in.)
The Forsyth Wickes Collection

Scheffer, Ary
Dutch (worked in France), 1795-1858

21.1283
Dante and Beatrice
Oil on canvas
180.0 x 99.0 cm. (70⅞ x 39 in.)
Lower left: Arij Scheffer
Seth K. Sweetser Fund

Schramm-Zittau, Max Rudolf
German, 1874-1929

11.9
Poultry Yard
Oil on canvas
125.0 x 201.0 cm. (49¼ x 79⅛ in.)
Upper right: RUDOLF SCHRAMM-ZITTAU
Gift of Hugo Reisinger

Schreyer, Adolf
German, 1828-1899

97.232
Arab Horsemen Resting at a Fountain
Oil on canvas
60.0 x 113.5 cm. (23⅝ x 44¾ in.)
Lower right: ad. Schreyer
Given in Memory of William G. Russell by his children, Mrs. Roger N. Allen, Marion Russell, and Thomas Russell

Schreyer, Adolf
German, 1828-1899

30.500
Two Arab Horsemen
Oil on canvas
29.8 x 23.0 cm. (11¾ x 9 in.)
Lower right: ad Schreyer
Bequest of Mrs. Harriet J. Bradbury

Scilla, Agostino
Italian, 1629-1700

25.230
Portrait of an Artist (said to be Andrea Sacchi)
Oil on copper
20.5 x 13.5 cm. (8⅛ x 5¼ in.)
Center right, on palette: Augu. Scilla
Bequest of Mrs. Thomas O. Richardson

Scorel, Jan van
Flemish, 1495-1562

50.293
Christ Preaching on the Sea of Galilee
Oil on panel
77.0 x 116.8 cm. (30¼ x 46 in.)
Seth K. Sweetser Fund

Scupula, Giovanni Maria
Italian (Veneto-Cretan School), active about 1500

64.2088
The Virgin with the Dead Christ, the Cruci-fixion, the Resurrection, and the Annunciation
Tempera on panel
Overall, closed: 13.9 x 10.5 cm. (5½ x 4⅛ in.)
Overall, open: 13.9 x 29.6 cm. (5½ x 11⅝ in.)
Verso of closed triptych: IOANES MARIA SCUPULA DE / ITRUNTO PINXIT IN OTRANTO
Bequest of Mrs. Edward Jackson Holmes

Seevagen, Lucien
French, 1887-1959

24.24
Boats in the Sunlight, Ile de Bréhat, Brittany
Oil on canvas
51.0 x 72.8 cm. (20⅛ x 28⅝ in.)
Lower right: Séevagen
Gift of Colonel Michael Friedsam

Segar, Sir William, Attributed to
British, active about 1580-died 1633
44.621
Robert Devereux, 2nd Earl of Essex, as a Knight of the Garter
Oil on panel
113.5 x 86.5 cm. (44⅝ x 34 in.)
Gift of Miss Helen Elizabeth Endicott and Mrs. Albion Dyer Wilde

Sellaio, Jacopo del, Attributed to
Italian (Florentine), about 1441-1493
12.1049
Story of Psyche (cassone panel)
Tempera on panel
43.8 x 152.5 cm. (17¼ x 60 in.)
Picture Fund

Serbian or Bulgarian, 19th century
Res. 25.15
Saint Barbara
Tempera on panel
25.9 x 9.3 cm. (10¼ x 3⅝ in.)
Gift of Mrs. Philip L. Carbone

Seurat, Georges Pierre, Imitator of
French, 1859-1891
68.75
Woman in a Park
Oil on panel
25.0 x 15.5 cm. (9⅞ x 6⅛ in.)
Anonymous Gift

Severini, Gino
Italian, 1883-1966
Res. 32.16
Cupids Carrying the Themes of the Picture
Oil on canvas
116.5 x 89.3 cm. (45⅞ x 35⅛ in.)
Lower right: G. Severini
Tompkins Collection

Severini, Gino
Italian, 1883-1966
Res. 32.17
Balcony in Paris
Oil on canvas
100.0 x 73.0 cm. (39⅜ x 28¾ in.)
Lower right: G. Severini
Tompkins Collection

Seybold, Christian, Attributed to
Austrian, 1710-1736

Res. 27.55
Woman Holding Flax and a Spindle
Oil on canvas
54.0 x 43.2 cm. (21¼ x 17 in.)
Gift of Mrs. Ellerton James

Sickert, Walter Richard
British, 1860-1942

Res. 32.18
Wonderful Month of May
Oil on canvas
58.0 x 65.0 cm. (22⅞ x 25⅝ in.)
Lower right: Sickert
Tompkins Collection

Sickert, Walter Richard
British, 1860-1942

38.774
Les Petites Belges *(Young Belgian Women)*
Oil on canvas
51.0 x 41.1 cm. (20⅛ x 16⅛ in.)
Lower left: Sickert
Anonymous Gift

Sickert, Walter Richard
British, 1860-1942

38.775
Carolina
Oil on canvas
46.0 x 38.0 cm. (18⅛ x 15 in.)
Lower left: Sickert
Anonymous Gift

Sickert, Walter Richard
British, 1860-1942

38.776
Les Vénétiennes *(Venetian Women)*
Oil on canvas
45.7 x 54.6 cm. (18 x 21½ in.)
Lower left: Sickert.
Anonymous Gift

Signac, Paul
French, 1863-1935

1980.367
View of the Seine at Vétheuil
Oil on canvas
33.2 x 46.4 cm. (13⅛ x 18¼ in.)
Lower left: Op 203
Lower right: P. Signac
Gift of Julia Appleton Bird

Simon, Lucien
French, 1861-1945

42.572
Breton Peasants Seated beside a Menhir
Oil on canvas
98.0 x 125.4 cm. (38⅝ x 49⅜ in.)
Lower right: LSimon (L and S joined)
Gift of George R. Fearing

Simone del Tintore
Italian (Lucchese), about 1630-1708

69.1059
Still Life with Flowers, Vegetables and Pigeons
Oil on canvas
118.1 x 87.8 cm. (46½ x 34⅝ in.)
Lucy Dalbiac Luard Fund

Sisley, Alfred
British (worked in France), 1839-1899

39.679
Overcast Day at Saint-Mammès
Oil on canvas
54.8 x 74.0 cm. (21⅝ x 29⅛ in.)
Lower right: Sisley.
Juliana Cheney Edwards Collection

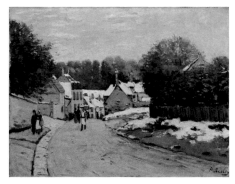

Sisley, Alfred
British (worked in France), 1839-1899

39.680
La Croix-Blanche at Saint-Mammès
Oil on canvas
65.3 x 92.3 cm. (25¾ x 36⅜ in.)
Lower right: Sisley. 84.
Juliana Cheney Edwards Collection

Sisley, Alfred
British (worked in France), 1839-1899

45.662
Waterworks at Marly
Oil on canvas
46.5 x 61.8 cm. (18¼ x 24⅜ in.)
Lower left: Sisley
Gift of Miss Olive Simes

Sisley, Alfred
British (worked in France), 1839-1899

48.600
Early Snow at Louveciennes
Oil on canvas
54.8 x 73.8 cm. (21⅝ x 29 in.)
Lower right: A. Sisley
Bequest of John T. Spaulding

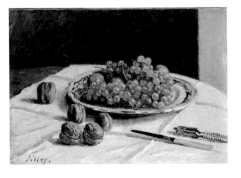

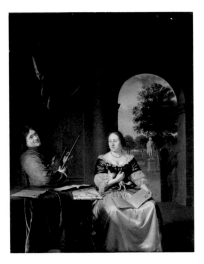

Sisley, Alfred
British (worked in France), 1839-1899
48.601
Grapes and Walnuts on a Table
Oil on canvas
38.0 x 55.4 cm. (15 x 21¾ in.)
Lower left: Sisley.
Bequest of John T. Spaulding

Sissa, Ugo
Italian, 1913-
66.941
Premonition Two
Oil on canvas
91.4 x 119.4 cm. (36 x 47 in.)
Lower right: Sissa 1965
Gift of Signora Teodora Olga Sammartini

Slingeland, Pieter Cornelisz. van
Dutch, 1640-1691
1981.133
Jan van Musschenbroek and his Wife
Oil on panel
62.0 x 50.0 cm. (24⅜ x 19⅝ in.)
Center right: PvSlingeland / 168[8]
Charles H. Bayley Picture and Painting Fund

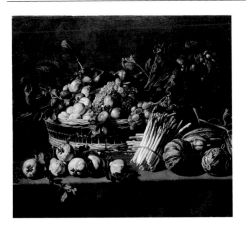

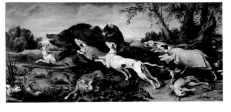

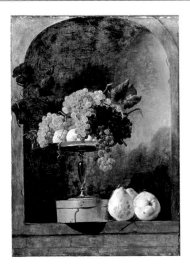

Snyders, Frans
Flemish, 1579-1657
89.499
Vegetables and a Basket of Fruit on a Table
Oil on canvas
83.8 x 95.9 cm. (33 x 37¾ in.)
Sidney Bartlett Bequest

Snyders, Frans
Flemish, 1579-1657
17.322
Boar Hunt
Oil on canvas
220.6 x 505.1 cm. (86⅞ x 198⅞ in.)
Lower right, on dog's collar: F. Snyders fecit
Gift of J. Templeman Coolidge, Jr.

Snyders, Frans
Flemish, 1579-1657
46.59
Grapes, Peaches, and Quinces in a Niche
Oil on panel
75.1 x 54.2 cm. (29⅝ x 21⅜ in.)
Charles Edward French Fund

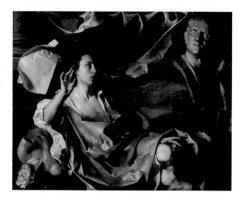

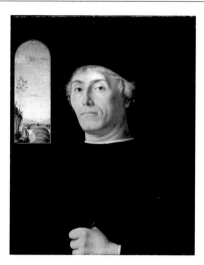

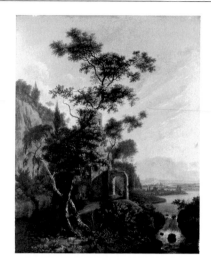

Soest, Gerard
Westphalian (worked in Britain), about 1600-
about 1680

49.1707
Inspiration of an Artist (Edward Pierce ?)
Oil on canvas
III.5 x 142.5 cm. (43⅞ x 56⅛ in.)
Ernest Wadsworth Longfellow Fund

Solario, Andrea
Italian (Milanese), about 1460-1524

II.1450
Portrait of a Man
Oil on panel
47.9 x 38.3 cm. (18⅞ x 15⅛ in.)
Picture Fund

Sonje, Jan Gabrielsz.
Dutch, about 1625-1707

85.254
Landscape with River and Ruins
Oil on panel
77.5 x 60.8 cm. (30½ x 23⅞ in.)
Falsely signed, lower right, on rock: A. Pynacker
Bequest of Mrs. Henry Sigourney

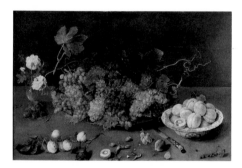

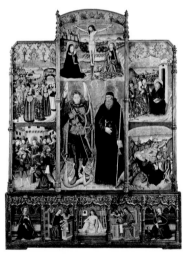

Soreau, Isaak
German, active second quarter, 17th century

62.1129
Still Life with Grapes on a Platter
Oil on panel
60.7 x 89.8 cm. (23⅞ x 35⅜ in.)
Juliana Cheney Edwards Collection

Soria, Martin de
Spanish (Aragonese), active about 1450-1487

42.42
Altarpiece of Saints Michael and Anthony Abbot
*(Saint Michael and Saint Anthony with the
Crucifixion, and Scenes from their Lives)*
Tempera on panel with parchment ground
Overall: 256.5 x 185.5 cm. (101 x 73 in.)
Design, central panel: 200.5 x 80 cm. (80¾ x
31½ in.)
Design, left panel: 166.0 x 53 cm. (65⅜ x 20⅞ in.)

Design, right panel: 166.5 x 53 cm. (65½ x 20⅞ in.)
Predella, each design: 40.5 x 34.5 cm. (16 x 13⅝ in.)
Herbert James Pratt Fund

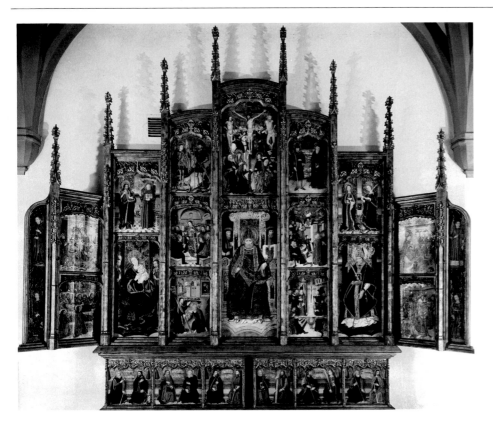

Soria, Martin de
Spanish (Aragonese), active about 1450-1487
46.856
Retable of Saint Peter (Saint Peter Enthroned with
the Crucifixion; Scenes from the Life of Saint Peter,
the Life of the Virgin and the Life of Saint Blaise;
Saints and the Apostles; and Angels with the
Instruments of the Passion)
Tempera on panel with parchment ground
Overall: 426.7 x 548.5 cm. (168 x 216 in.) on
fourteen panels
Gift of Robert Hall McCormick

Sorolla y Bastida, Joaquin
Spanish, 1863-1923
22.691
Lighthouse Walk at Biarritz
Oil on canvas
68.3 x 188.5 cm. (26⅞ x 74¼ in.)
Lower right: J Sorolla y Bastida / 1906
Peter Chardon Brooks Memorial Collection
Gift of Mrs. Richard M. Saltonstall

Spanish (Castilian), 12th century
27.785 a,b
The Last Supper and *Ribbon Meander Frieze*
(from the church of San Baudelio near Berlanga)
Fresco secco transferred to canvas
a. 179.0 x 380.0 cm. (70½ x 149⅝ in.)
b. 63.0 x 380 cm. (24¾ x 149⅝ in.)
Maria Antoinette Evans Fund

Spanish (Castilian), 12th century
27.786
The Three Marys at the Sepulchre (from the
church of San Baudelio near Berlanga)
Fresco secco transferred to canvas
195.0 x 387.3 cm. (76¾ x 152½ in.)
Maria Antoinette Evans Fund

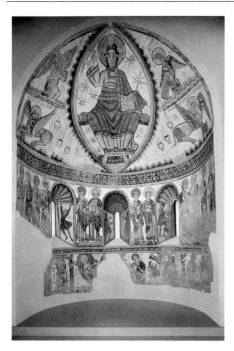

Spanish (Catalan), 12th century
21.1285
Christ in Majesty with Symbols of the Four Evangelists; the Apostles with Scenes from the story of Cain and Abel; and Scenes from the Life of Christ (chapel apse from the church of Santa Maria, Mur)
Fresco secco transferred to plaster and wood
645 cm. (254 in.) at greatest height;
282 cm. (111 in.) at greatest depth;
382 cm. (150⅜ in.) at greatest breadth.
Maria Antoinette Evans Fund

Spanish (?), 17th or 18th century
90.79
The Sorrowful Virgin
Oil on canvas mounted on panel
45.0 x 32.0 cm. (17¾ x 12⅝ in.)
Bequest of Mrs. Henry Edwards

Spanish, second half, 18th century
30.502
Portrait of a Young Woman with a Parrot
Oil on canvas
97.5 x 77.0 cm. (38⅜ x 30¼ in.)
Bequest of Mrs. Harriet J. Bradbury

Spanish, fourth quarter, 18th century
03.622
Portrait of a Young Man
Oil on canvas
73.5 x 50.2 cm. (28⅞ x 19¾ in.)
Julia Bradford Huntington James Fund

Spanish, mid-19th century
22.11
Street Brawl
Oil on canvas
51.2 x 69.3 cm. (20⅛ x 27¼ in.)
William Sturgis Bigelow Collection

Spanish Colonial (Mexican), 17th century
Res. 09.218
Virgin and Child with Angels Carrying the
Instruments of the Passion (freely copied from an
engraving after a painting by Maerten de Vos)
Oil on canvas
114.0 x 87.5 cm. (44⅞ x 34½ in.)
Gift of Mrs. Matilda Stewart Buck, through Dr.
Howard M. Buck

Spanish Forger (so called), active fourth quarter,
19th century
50.4051
Tournament
Tempera on panel
45.7 x 58.4 cm. (18 x 23 in.)
Elizabeth Day McCormick Collection

Springer, Cornelis
Dutch, 1817-1891
67.671
Street in Haarlem
Oil on panel
33.0 x 42.5 cm. (13 x 16¾ in.)
Lower right: CS 51 (S and C in monogram)
Gift of the Estate of Francis A. Foster

Staël, Nicolas de
Russian (worked in France), 1914-1955
57.385
Rue Gauguet
Oil on plywood panel
199.5 x 240.5 cm. (78½ x 94⅝ in.)
Lower left: Staël
Reverse: Nicolas / de / Staël / 1949
Tompkins Collection

Stanzione, Massimo, Workshop of
Italian (Neapolitan), 1585-1656
94.181
Judith with the Head of Holophernes
Oil on canvas
125.5 x 103.5 cm. (49⅜ x 40¾ in.)
Turner Sargent Collection

Steelink, Willem
Dutch, 1856-1928
23.569
Landscape with Shepherd and Sheep
Oil on canvas
55.5 x 80.7 cm. (21⅞ x 31¾ in.)
Lower right: Wilm. Steelink
Bequest of Ernest Wadsworth Longfellow

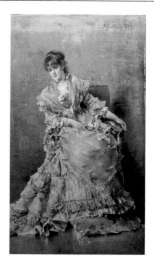

Steen, Jan Havicksz.
Dutch, 1625/26-1679

54.102
Twelfth-Night Feast
Oil on canvas
131.0 x 164.5 cm. (51⅝ x 64¾ in.)
Lower center, on bench: JSteen / 1662 (J and S joined)
1951 Purchase Fund

Stevens, Alfred
Belgian (worked in France), 1823-1906

19.111
Attentive Listener
Oil on panel
52.2 x 30.0 cm. (20½ x 11¾ in.)
Upper right: AStevens. 1879. (A and S in monogram)
The Henry C. and Martha B. Angell Collection

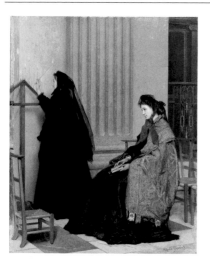

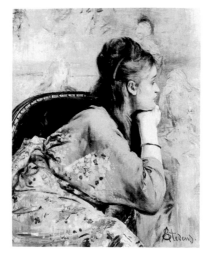

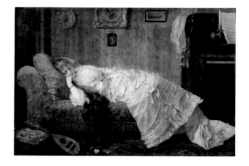

Stevens, Alfred
Belgian (worked in France), 1823-1906

23.491
Young Women in Mourning Lighting a Votive Candle
Oil on panel
55.7 x 45.2 cm. (21⅞ x 17¾ in.)
Lower right: Alfred Stevens
Bequest of Ernest Wadsworth Longfellow

Stevens, Alfred
Belgian (worked in France), 1823-1906

23.528
Meditation
Oil on canvas
40.7 x 32.6 cm. (16 x 12¾ in.)
Lower right: AStevens.(A and S in monogram)
Bequest of David P. Kimball in Memory of his wife, Clara Bertram Kimball

Stevens, Alfred, Attributed to
Belgian (worked in France), 1823-1906

1970.76
Young Woman Resting in a Music Room
Oil on canvas
40.0 x 61.2 cm. (15¾ x 24⅛ in.)
Lower right: AStevens (A and S in monogram)
Abbott Lawrence Fund

Stock, Ignatius van der, Attributed to
Flemish, active mid-17th century
Res. 21.91
Landscape with Diana and her Huntresses
Oil on canvas
71.0 x 105.8 cm. (28 x 41⅝ in.)
William Sturgis Bigelow Collection

Stoskopf, Sébastien, Copy after
German, 1597-1657
 by
Nichon, Pierre
French, active 1626-1655
63.1628
Still Life with a Dead Carp on a Box (after a
painting in a private collection, Montbéliard)
Oil on canvas
49.2 x 59.3 cm. (19⅜ x 23⅜ in.)
Lower left: PNichon · f (P and N joined)
Francis Welch Fund

Stothard, Thomas
British, 1755-1834
74.21
John Dryden
Oil on zinc (?)
20.6 x 15.0 cm. (8⅛ x 5⅞ in.)
Lower right: J. Dryden / T. Sto[...]hard
Bequest of Charles Sumner

Streitt, Franciszek
Polish, 1839-1890
69.66
Musicians at a Crossroad
Oil on canvas
42.3 x 85.6 cm. (16⅝ x 33¾ in.)
Lower left: F. Streitt / 879
Gift of Elizabeth D. Wright and Priscilla D. Smith

Strigel, Bernhard
German, 1460-1528
09.294
Saint John the Baptist
Oil on panel
77.8 x 25.8 cm. (30⅝ x 10⅛ in.)
Lower edge: SCTS IOHES BAPTISTA
Denman Waldo Ross Collection

Strozzi, Bernardo
Italian (Genoese), 1581-1644

1972.83
Saint Sebastian Tended by Saint Irene and her Maid
Oil on canvas
166.7 x 118.6 cm. (65⅝ x 46¾ in.)
Charles Potter Kling Fund and Francis Welch Fund

Stubbs, George
British, 1724-1806

49.6
Lion and Lioness
Oil on canvas
103.0 x 127.6 cm. (40½ x 50¼ in.)
Lower center: Geo Stubbs / pinxit. 1771
M. Theresa B. Hopkins Fund

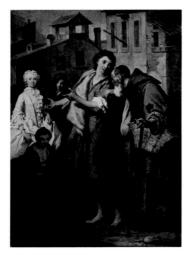

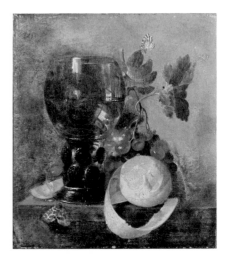

Subleyras, Pierre
French, 1699-1749

1983.592
Brother Luce, the Hermit, with the Widow's Daughter (from the *Tales* of La Fontaine)
Oil on canvas
29.7 x 22.4 cm. (11¾ x 8⅞ in.)
Gift of Colnaghi USA, Ltd.

Subleyras, Pierre
French, 1699-1749

1983.593
Brother Philippe's Geese (from the *Tales* of La Fontaine)
Oil on canvas
29.5 x 22.0 cm. (11⅝ x 8⅝ in.)
Gift of Colnaghi USA, Ltd.

Susenier, Abraham, Attributed to
Dutch, about 1620-after 1667

63.267
Wine Goblet, Grapes, and a Lemon on a Table
Oil on canvas
41.3 x 36.1 cm. (16¼ x 14¼ in.)
Bequest of Louise W. Brooks

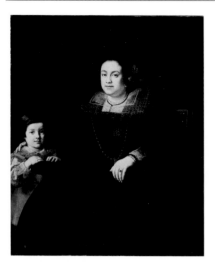 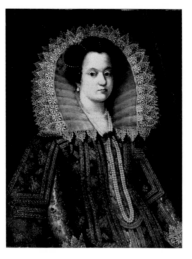

Sustermans, Justus
Flemish, 1597-1681

12.425
Portrait of a Woman and her Son
Oil on canvas
124.7 x 102.0 cm. (49⅛ x 40⅛ in.)
Picture Fund and with gift of William M. Bullivant

Sustermans, Justus, Style of

01.6217
Portrait of a Woman
Oil on canvas
85.5 x 64.5 cm. (33⅝ x 25⅜ in.)
Bequest of Mrs. Arthur Croft

Taillasson, Jean Joseph
French, 1745-1809
1981.79
Rodogune Discovers the Nuptial Cup Poisoned by Cleopatra of Syria
Oil on canvas
138.1 x 185.4 cm. (54⅜ x 73 in.)
Lower right, on base of bench: Taillasson 1791
Charles H. Bayley Picture and Painting Fund

Tavella, Carlo Antonio, Attributed to
Italian (Milanese), 1668-1738
Res. 21.87
Mountain Landscape with Fishermen beside a Cascade
Oil on canvas
112.1 x 152.1 cm. (44⅛ x 59⅞ in.)
William Sturgis Bigelow Collection

Tchelitchev, Pavel
Russian (worked in France), 1898-1957
Res. 32.25
Madame Bonjean
Oil on canvas
73.0 x 50.0 cm. (28¾ x 19⅝ in.)
Lower right: P. Tchelitchew
Gift by Contribution

Tegliacci, Niccolò di Ser Sozzo and Workshop
Italian (Sienese), active 1334-1363
 with pinnacle designs by an
Italian (Florentine), active mid-14th century
83.175a,b,c
The Death and Assumption of the Virgin with Saints Augustine, Peter and John the Evangelist and a Deacon Saint; and Christ Blessing with David, Saint John the Evangelist, Solomon and Ezekiel

Tempera on panel
Overall: 265.2 x 214.6 cm. (104⅜ x 84½ in.)
Design, central panel: 198.0 x 87.3 cm. (78 x 34⅜ in.)
Design, side panels: 122.5 x 50.5 cm. (48¼ x 19⅞ in.)
Design, pinnacle saints: 27.5 x 19.1 cm. (10⅞ x 7½ in.)
Design, pinnacle medallion: 20.0 cm. (7⅞ in), diameter
Gift of Martin Brimmer

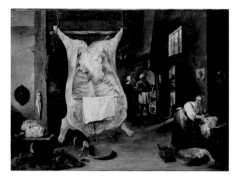

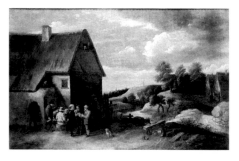

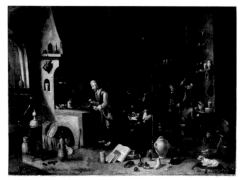

Teniers, David, the Younger
Flemish, 1610-1690

89.500
Butcher Shop
Oil on panel
68.4 x 98.0 cm. (26⅞ x 38⅝ in.)
Lower right: D. TENIERS F […]
Sidney Bartlett Bequest

Teniers the Younger, Copy after
94.179
Landscape with Men outside an Inn (after a
painting formerly in the Northbrook collection)
Oil on canvas
56.2 x 90.8 cm. (22⅛ x 35¾ in.)
Falsely signed, lower right, on a rock:
D. TENIERS. F.
Turner Sargent Collection

Teniers the Younger, Copy after
06.2407
Alchemist in his Laboratory (after an unlocated
painting known in several copies)
Oil on canvas
76.0 x 108.0 cm. (29⅞ x 42½ in.)
Gift of Dr. Joseph P. Oliver

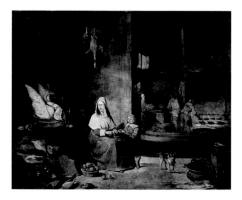

Teniers the Younger, Copy after
Res. 27.33
Kitchen Interior with a Woman Peeling Apples
(after a painting in the Mauritshuis, the Hague)
Oil on panel
28.5 x 36.9 cm. (11¼ x 14½ in.)
William Sturgis Bigelow Collection

Teniers, Imitator of
Res. 15.3
Old Man Caressing a Maidservant
Oil on canvas
59.8 x 86.0 cm. (23½ x 33⅞ in.)
Gift of George A. Goddard

See also **Titian,** Copy after
 by
David Teniers, the Younger

ter Borch, Gerard
 see
Borch, Gerard ter

ter Brugghen, Hendrick
 see
Brugghen, Hendrick ter

Thaulow, Johan Frederik
Norwegian, 1847-1906

23.498
Snow-covered Buildings along a Canal
Oil on canvas
62.3 x 52.3 cm. (24½ x 20⅝ in.)
Lower left: Frits Thaulow
Bequest of David P. Kimball, in Memory of his wife,
Clara Bertram Kimball

Thaulow, Johan Frederik
Norwegian, 1847-1906

23.523
Snow-covered Cottages
Pastel on canvas
50.0 x 61.0 cm. (19¾ x 24 in.)
Lower right: Frits Thaulow.
Bequest of David P. Kimball, in Memory of his wife,
Clara Bertram Kimball

Thaulow, Johan Frederik
Norwegian, 1847-1906

Res. 27.97
Near Christiana, Sweden
Oil on canvas
40.5 x 60.0 cm. (16 x 23⅝ in.)
Lower right: Frits Thaulow.
Bequest of Elizabeth Howard Bartol

Thaulow, Johan Frederik
Norwegian, 1847-1906

32.107
Moonlight on a Canal, Venice
Oil on canvas
65.3 x 81.2 cm. (25¾ x 32 in.)
Lower right: Frits Thaulow
Bequest of Arthur Tracy Cabot

Thaulow, Johan Frederik
Norwegian, 1847-1906

1972.980
Farmyard in the Snow
Pastel on canvas
49.0 x 68.7 cm. (19⅜ x 27 in.)
Lower right: Frits Thaulow 91.
Gift of Misses Aimée and Rosamond Lamb

Thaulow, Johan Frederik
Norwegian, 1847-1906

1978.681
Skiers at the Top of a Snow-covered Hill
Oil on canvas
52.7 x 98.3 cm. (20¾ x 38¾ in.)
Lower left: Frits Thaulow 94.
Gift of Misses Aimée and Rosamond Lamb

Thaulow, Johan Frederik
Norwegian, 1847-1906
1329.12
Abbeville
Oil on canvas
73.5 x 92.5 cm. (29 x 36⅜ in.)
Lower right: Frits Thaulow
Deposited by the Trustees of the White Fund, Lawrence, Massachusetts

Thomson, William
Canadian (works in England), 1926-
1981.27
Reclining Nude
Oil on canvas
66.0 x 81.3 cm. (26 x 32 in.)
Lower left: W Thomson
Sophie M. Friedman Fund

Tiepolo, Giovanni Battista
Italian (Venetian), 1696-1770
06.118
Apotheosis of a Poet
Oil on canvas
Support: 37.0 x 47.0 cm. (14⅝ x 18½ in.)
Oval design: 34.0 x 43.0 cm. (13⅜ x 16⅞ in.)
Denman Waldo Ross Collection

Tiepolo, Giovanni Battista
Italian (Venetian), 1696-1770
27.861
Apotheosis of Aeneas
Oil on canvas
67.3 x 51.0 cm. (26½ x 20⅛ in.)
Gift of Edward Jackson Holmes

Tiepolo, Giovanni Battista
Italian (Venetian), 1696-1770
30.539
Aurora Dispersing the Clouds of Night (ceiling from the Palazzo Mocenigo, Venice)
Oil on canvas
377.2 x 302.9 cm. (148½ x 119¼ in.)
Maria Antoinette Evans Fund

Tiepolo, Giovanni Battista
Italian (Venetian), 1696-1770

61.1200
Time Unveiling Truth
Oil on canvas
231.0 x 167.0 cm. (91 x 65¾ in.)
Charles Potter Kling Fund

Tiepolo, Giovanni Battista
Italian (Venetian), 1696-1770

1976.765
*The Virgin Receiving the Prayers of Saint
Dominic* (sketch for a ceiling painting in the
church of the Gesuati, Venice)
Oil on paper mounted on canvas
Design: 36.8 x 56.0 cm. (14½ x 22 in.)
*Gift of James Lawrence in Memory of Martina Louise
Lawrence*

Tintoretto, Domenico (Domenico Robusti,
called Domenico Tintoretto)
Italian (Venetian), 1560-1635

26.142
Adoration of the Magi
Oil on canvas
152.0 x 295.0 cm. (59⅞ x 116⅛ in.)
Herbert James Pratt Fund

Tintoretto, Domenico, (Domenico Robusti,
called Domenico Tintoretto)
Italian (Venetian), 1560-1635

60.1475
Portrait of a Man
Oil on canvas
103.5 x 92.3 cm. (40¾ x 36⅜ in.)
Center left: O AETATIS EIVS / XXXV
Lower left: COB.
Gift of Dr. Rudolf Heinemann

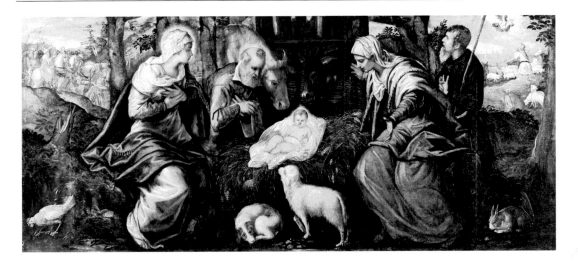

Tintoretto (Jacopo Robusti, called Tintoretto)
Italian (Venetian), 1518-1594

46.1430
The Nativity with Saint Anne and Scenes of the
Journey of the Magi and the Announcement to the
Shepherds
Oil on canvas
155.5 x 358.3 cm. (61¼ x 141 in.)
Gift of Quincy A. Shaw

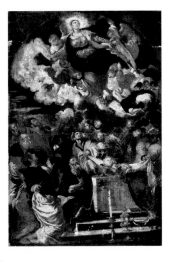

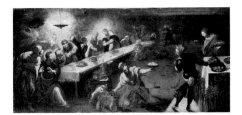

Tintoretto, (Jacopo Robusti, called Tintoretto)
Italian (Venetian), 1518-1594

27.862
Portrait of a Young Man
Oil on canvas
64.5 x 55.3 cm. (25⅜ x 21¾ in.)
Gift of Mrs. W. Scott Fitz and Robert Treat Paine,
2nd

Tintoretto, Copy after
84.282
The Assumption of the Virgin (after a painting in
the church of Santa Maria Assunta, Venice)
Oil on canvas
69.2 x 47.0 cm. (27¼ x 18½ in.)
Bequest of Thomas Gold Appleton

Tintoretto, Copy after
96.657
The Last Supper (after a painting in the church of
San Giorgio Maggiore, Venice)
Oil on canvas
63.6 x 137.0 cm. (25 x 54 in.)
Bequest of Mary Felton

Tisato, Orlando
Italian, 1926-

69.1130
Silence: Homage to Cimabue
Oil and pumice on plywood
103.0 x 91.1 cm. (40½ x 35⅞ in.)
Lower right: O. TISATO 69
Gift of Mrs. Quincy A. Shaw

Tissot, James Jacques Joseph
French, 1836-1902

58.45
Women of Paris: The Circus Lover
Oil on canvas
147.2 x 101.6 cm. (58 x 40 in.)
Lower left: J. J. Tissot
Juliana Cheney Edwards Collection

Titian (Tiziano Vecellio, called Titian)
Italian (Venetian), 1488/89-1576

43.83
Portrait of a Man Holding a Book
Oil on canvas
97.8 x 77.3 cm. (38½ x 30⅜ in.)
Lower left: TICIANUS
Charles Potter Kling Fund

Titian (Tiziano Vecellio, called Titian)
Italian (Venetian), 1488/89-1576

48.499
Saint Catherine of Alexandria at Prayer
Oil on canvas
119.2 x 100.0 cm. (46⅞ x 39⅜ in.)
Lower left: [canvas cut] TIANUS / F.
1948 Fund and Otis Norcross Fund

Titian, Copy after
by
Teniers, David, the Younger
Flemish, 1610-1690

66.266
Parma the Physician (after a painting in the
Kunsthistorisches Museum, Vienna)
Oil on panel
17.0 x 12.1 cm. (6¾ x 4¾ in.)
Gift of the Estate of Gardiner Howland Shaw

Tito, Ettore
Italian, 1859-1941
23.474
Breezy Day in Venice
Oil on canvas
54.0 x 80.5 cm. (21¼ x 31¾ in.)
Center right: E Tito / 1891 / VEN
Lower right: E Tito 95
Bequest of Ernest Wadsworth Longfellow

Tocqué, Louis
French, 1696-1772
74.1
Portrait of a Woman as Diana
Oil on canvas
91.5 x 73.0 cm. (36 x 28¾ in.)
Bequest of Charles Sumner

Tol, Dominicus van
Dutch, about 1635-1676
30.503
Woman in a Window, Holding a Dead Fowl
Oil on panel
41.5 x 30.3 cm. (16⅜ x 11⅞ in.)
Lower center, on parapet: D.V.TOL
Bequest of Mrs. Harriet J. Bradbury

Tommi, Alberto
Italian, 1917-
54.1109
San Miguel de Allende, Mexico
Oil on paperboard
49.5 x 69.0 cm. (19½ x 27½ in.)
Lower left: tommi
Gift of Dr. Fritz Talbot

Tonks, Henry
British, 1862-1937
37.627
Man by a Woman's Bedside
Pastel on paper mounted on paper
48.3 x 36.2 cm. (19 x 14¼ in.)
Gift of C. H. Collins Baker

Toorenvliet, Jacob
Dutch, 1635/36-1719
01.6218
Young Men and Women Playing Musical Instruments and Singing
Oil on canvas
53.8 x 66.5 cm. (21⅛ x 26⅛ in.)
Lower left: JT[...] F[...]t [...] 1670
The Gardner Brewer Collection

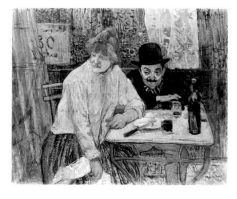

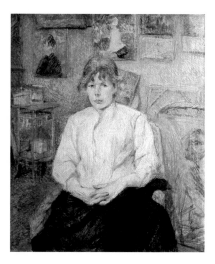

Toulmouche, Auguste
French, 1829-1890
24.1
Reading Lesson
Oil on canvas
36.5 x 27.5 cm. (14⅜ x 10⅞ in.)
Lower left, on music rack: A. TOULMOUCHE. 1865
Gift of Francis A. Foster

Toulouse-Lautrec-Monfa, Henri Raymond de
French, 1864-1901
40.748
At the Café La Mie
Watercolor and gouache on paper mounted on
millboard mounted on panel
53.0 x 67.8 cm. (20⅞ x 26¾ in.)
Upper right: TLautrec
S. A. Denio Collection, and General Income

Toulouse-Lautrec-Monfa, Henri Raymond de
French, 1864-1901
48.605
Carmen Gaudin in the Artist's Studio
Oil on canvas
56.0 x 46.8 cm. (22 x 18⅜ in.)
Lower right: HTLautrec (H, T and L in
monogram)
Bequest of John T. Spaulding

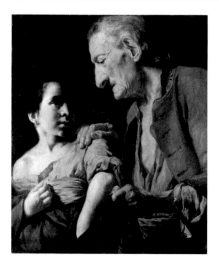

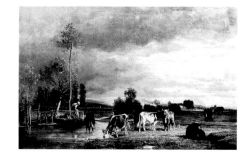

Traversi, Gaspare
Italian (Neapolitan), active 1749-died 1769
52.392
Old Man and a Child
Oil on canvas
73.8 x 62.0 cm. (29 x 24⅜ in.)
Seth K. Sweetser Fund

Troyon, Constant
French, 1810-1865
84.275
Landscape near Dieppe
Oil on canvas
52.5 x 82.0 cm. (20⅝ x 32¼ in.)
Lower left: C. TROYON
Bequest of Thomas Gold Appleton

Troyon, Constant
French, 1810-1865
84.276
Sheep and Shepherd in a Landscape
Oil on canvas
34.8 x 45.1 cm. (13¾ x 17¾ in.)
Lower right: C. TROYON
Bequest of Thomas Gold Appleton

Troyon, Constant
French, 1810-1865

84.284
Oxen Ploughing
Pastel on paper mounted on canvas
96.5 x 130.0 cm. (38 x 51⅛ in.)
Lower left: C. TROYON
Bequest of Thomas Gold Appleton

Troyon, Constant
French, 1810-1865

19.117
Fields outside Paris
Oil on paperboard
27.0 x 45.5 cm. (10⅝ x 17⅞ in.)
Lower right: C. Troyon
The Henry C. and Martha B. Angell Collection

Troyon, Constant
French, 1810-1865

21.8
Fox in a Trap
Oil on canvas
92.5 x 72.8 cm. (36⅜ x 28⅝ in.)
Lower left: C. TROYON.
Stamped, lower right: VENTE / TROYON
*Gift of Julia C. Prendergast in Memory of her brother,
James M. Prendergast*

Troyon, Constant
French, 1810-1865

24.345
Hound Pointing
Oil on canvas
163.8 x 130.5 cm. (64½ x 51⅜ in.)
Lower left: C. TROYON 1860.
Gift of Mrs. Louis A. Frothingham

Troyon, Constant
French, 1810-1865

35.1179
On the Cliff
Oil on paperboard
25.7 x 39.2 cm. (10⅛ x 15⅜ in.)
Stamped, lower left: VENTE / TROYON
Bequest of Mrs. Henry Lee Higginson

Troyon, Constant
French, 1810-1865

64.131
Cows and Cowherd (unfinished)
Oil on panel
50.4 x 68.2 cm. (19⅞ x 26⅞ in.)
Stamped, lower left: VENTE / TROYON
Gift of Misses Aimée and Rosamond Lamb

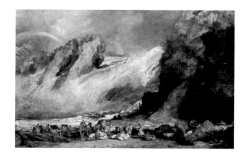

Turner, Joseph Mallord William
British, 1775-1851

99.22
Slave Ship *(Slavers Throwing Overboard the Dead and Dying, Typhon Coming On)*
Oil on canvas
90.8 x 122.6 cm. (35¾ x 48¼ in.)
Henry Lillie Pierce Fund

Turner, Joseph Mallord William
British, 1775-1851

13.2723
Fall of the Rhine at Schaffhausen
Oil on canvas
148.5 x 239.8 cm. (58½ x 94⅜ in.)
Bequest of Alice Marian Curtis, and Special Picture Fund

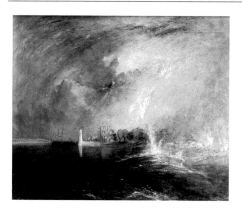

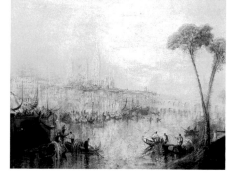

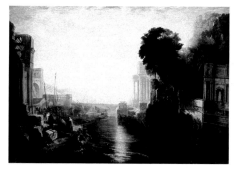

Turner, Copy after
00.369
Mouth of the Seine, Quille-Boeuf (after a painting in the Fondaçao Calouste Gulbenkian, Lisbon)
Oil on canvas
72.2 x 89.5 cm. (28⅜ x 35¼ in.)
General Funds

Turner, Copy after
17.3233
Rouen (free copy after an engraving from a watercolor by Turner in the British Museum, London)
Oil on canvas
87.5 x 112.7 cm. (34½ x 44⅜ in.)
Robert Dawson Evans Collection

Turner, Copy after
17.3252
Dido Building Carthage (after a painting in the National Gallery, London)
Oil on canvas
91.0 x 132.4 cm. (35⅞ x 52⅛ in.)
Robert Dawson Evans Collection

Turpin de Crissé, Lancelot Théodore, Comte de
French, 1782-1859

Res. 20.852
Temple of Antoninus and Faustina, Rome
Oil on canvas
114.5 x 163.1 cm. (45⅛ x 64¼ in.)
Lower left: T Turpin de Crissé. 1808.
Bequest of Emma B. Culbertson

Turpin de Crissé, Lancelot Théodore, Comte de
French, 1782-1859

1980.3
The Bay of Naples
Oil on canvas
97.0 x 146.0 cm. (38⅛ x 57½ in.)
Center left: crown symbol above T · T / 1840
Charles H. Bayley Picture and Painting Fund

Ugolino di Nerio (called Ugolina da Siena)
Italian (Sienese), active 1317-1327
15.952
Saint Mary Magdalen (fragment)
Tempera on panel
36.5 x 24.7 cm. (14⅜ x 9¾ in.)
Gift of Mrs. W. Scott Fitz

Ugolino di Nerio (called Ugolina da Siena)
Italian (Sienese), active 1317-1327
16.65
Virgin and Child
Tempera on panel
Panel: 91.5 x 61.5 cm. (36 x 24¼ in.)
Design: 81.5 x 52.2 cm. (32⅛ x 20½ in.)
Gift of Mrs. W. Scott Fitz

Utrillo, Maurice
French, 1883-1955
48.606
The Philosopher's Tower
Oil on millboard
38.5 x 55.0 cm. (15⅛ x 21⅝ in.)
Lower right: Maurice. Utrillo V.
Reverse: Vieux [...] La Tour de Philosophe /
L'Ancienne ferme de Bray et le Moulin de la
galette / Sacre Coeur dans le lointain. / Maurice
Utrillo. V.
Bequest of John T. Spaulding

Utrillo, Maurice
French, 1883-1955
48.607
Church of Le Sacré-Coeur, from rue Saint-Rustique
Oil on canvas
50.0 x 61.0 cm. (19⅝ x 24 in.)
Lower left: Sacré-Coëur de Montmartre, / et rue
Saint-Rustique
Lower right: Maurice. Utrillo. V.
Bequest of John T. Spaulding

Utrillo, Maurice
French, 1883-1955
48.608
Street Scene
Oil on panel
23.8 x 15.8 cm. (9⅜ x 6¼ in.)
Lower right: Maurice. Utrillo. V.
Bequest of John T. Spaulding

Utrillo, Maurice
French, 1883-1955
1980.404
Suburban Street Scene
Oil on canvas
50.4 x 65.1 cm. (19⅞ x 25⅝ in.)
Lower right: Maurice. Utrillo. V.
Gift of Mrs. George Putnam

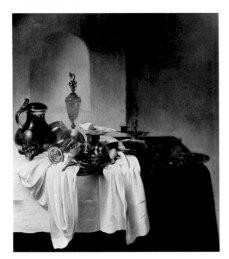

Uyl, Jan Jansz. den
Dutch, 1595/96-1640

54.1606
Breakfast Still Life with Glass and Metalwork
Oil on panel
130.5 x 115.5 cm. (51⅜ x 45½ in.)
Anonymous Gift

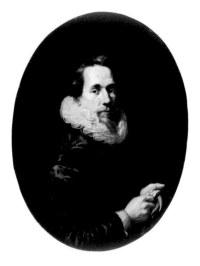

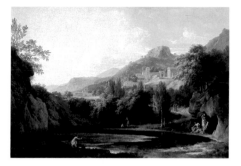

Valckert, Werner Jacobsz. van den
Dutch, about 1585-1627/8

06.1909
Portrait of a Man with a Ruff
Oil on panel
73.0 x 55.5 cm. (28¾ x 21⅞ in.)
Center right: AE 35 / A 1616 / W V VALCKERT [ALC
joined] / PINCET
Gift of Edward Waldo Forbes

Valenciennes, Pierre Henri de
French, 1750-1819

1980.658
Italian Landscape with Bathers
Oil on canvas
54.0 x 81.5 cm. (21¼ x 32⅛ in.)
Lower left: P deValenciennes. 1790
Gift of John Goelet

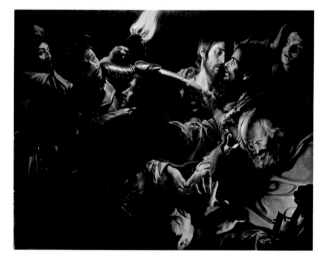

Valentin (called Valentin de Boulogne)
French (worked in Rome), 1591-1632

1979.154
The Taking of Christ
Oil on canvas
147.3 x 195.6 cm. (58 x 77 in.)
Juliana Cheney Edwards Collection

Van Loo, Jean Baptiste
French, 1684-1745

37.1211
Portrait of a Man with an Open Book
Oil on canvas
137.5 x 106.9 cm. (54⅛ x 42⅛ in.)
Center right, on spine of book: JEAN VANLOO
Gift of Miss Amelia Peabody

Vanni, Andrea
Italian (Sienese), active 1353-died 1413
22.3
Saint Peter
Tempera on panel
Panel: 155.8 x 42.2 cm. (61⅜ x 16⅝ in.)
Design: 152.5 x 41.7 cm. (60 x 16⅜ in.)
Gift of Mrs. W. Scott Fitz

Vanni, Andrea
Italian (Sienese), active 1353-died 1413
22.4
Saint Paul
Tempera on panel
Panel: 155.8 x 42.8 cm. (61⅜ x 16⅞ in.)
Design: 153.5 x 42.0 cm. (60⅜ x 16½ in.)
Gift of Mrs. W. Scott Fitz

Vassallo, Anton Maria
Italian (Genoese), active 1639-1648
36.893
Apollo as a Sheperd
Oil on canvas
96.5 x 123.5 cm. (38 x 48⅝ in.)
Gift of Frank Gair Macomber

Vecellio, Francesco, Attributed to
Italian (Venetian), about 1475-1559
22.639
Flight into Egypt
Oil on canvas
77.5 x 90.3 cm. (30½ x 35½ in.)
Zoe Oliver Sherman Collection

Veen, Pieter van
Dutch (worked in United States), 1875-1961
48.609
Sunflowers in a Vase
Oil on canvas
81.3 x 64.1 cm. (32 x 25¼ in.)
Lower left: P van Veen 1930
Bequest of John T. Spaulding

Velázquez, Diego Rodríquez de Silva y
Spanish, 1599-1660
32.79
Luis de Gongora y Argote
Oil on canvas
50.3 x 40.5 cm. (19¾ x 16 in.)
Maria Antoinette Evans Fund

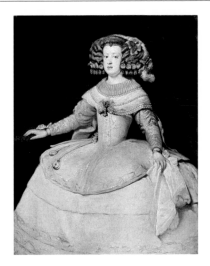

Velázquez, Diego Rodríquez de Silva y
Spanish, 1599-1660

01.104
Don Baltasar Carlos with a Dwarf
Oil on canvas
128.1 x 102.0 cm. (50⅜ x 40⅛ in.)
Center right: AETAT. S ANN[...] / MENS 4
Henry Lillie Pierce Fund

Velázquez, Diego Rodríquez de Silva y, and
Workshop
Spanish, 1599-1660

21.2593
Infanta Maria Theresa
Oil on canvas
128.5 x 100.5 cm. (50⅝ x 39⅝ in.)
*Gift of Charlotte Nichols Greene in Memory of her
father and mother, Mr. and Mrs. Howard Nichols*

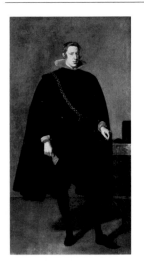

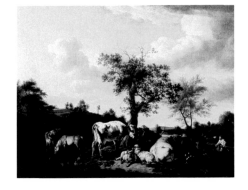

Velázquez, Diego Rodríquez de Silva y,
Workshop of
Spanish, 1599-1660

04.1606
Philip IV, King of Spain
Oil on canvas
208.5 x 110.3 cm. (82⅛ x 43⅜ in.)
Sarah Wyman Whitman Fund

Velde, Adriaen van de
Dutch, 1636-1672

50.864
Cattle and Sheep in a River Landscape
Oil on canvas
52.8 x 70.9 cm. (20¾ x 27⅞ in.)
Lower right: A. V. Velde. f / 1663
Ernest Wadsworth Longfellow Fund

Velde, Adriaen van de, Attributed to
Dutch, 1636-1672

94.169
Landscape with Cattle
Oil on panel
26.9 x 33.5 cm. (10⅝ x 13⅛ in.)
Turner Sargent Collection

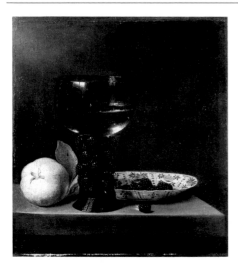

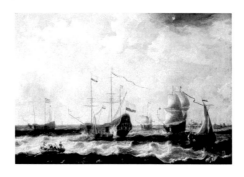

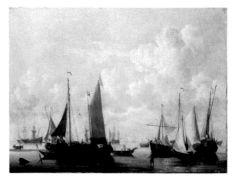

Velde, Jan Jansz. van de
Dutch, 1619/20-1662
27.465
Still Life with Goblet and Fruit
Oil on canvas
37.6 x 34.8 cm. (14¾ x 13¾ in.)
Lower right: Jan Vande Velde Ano 1656 / fecit
Gift by exchange

Velde, Pieter van de
Dutch, 1634-after 1687
74.6
Shipping off the Dutch Coast
Oil on canvas
81.5 x 122.7 cm. (32⅛ x 48¼ in.)
Bequest of Charles Sumner

Velde, Willem van de, the Younger, Workshop of
Dutch (worked in London), 1633-1707
37.59
Ships at Anchor
Oil on canvas
78.0 x 106.5 cm. (30¾ x 41⅞ in.)
*Bequest of Stephen Higginson Perkins
and gift of his Heirs*

Verelst, Simon Peeterz.
Dutch (worked in England), 1644-1721
90.202
Still Life with Dead Partridge and Kingfisher
Oil on canvas
74.7 x 62.9 cm. (29⅜ x 24¾ in.)
Lower left, on stone ledge: S. verelst F.
Gift by Subscription

Vernet, Claude Joseph, Follower of
French, 1714-1789
04.1750
Harbor Scene at Sunset
Oil on canvas
74.5 x 97.5 cm. (29⅜ x 38⅜ in.)
Gift of Ernest Wadsworth Longfellow

Vernet, Emile Jean Horace
French, 1789-1863
89.157
Judith (study for *Judith and Holofernes* in the
Musée des Beaux-Arts, Pau)
Oil on canvas
65.2 x 55.2 cm. (25⅝ x 21¾ in.)
Lower left: Rome 1830 / H Vernet
Gift of Mrs. Samuel Dennis Warren

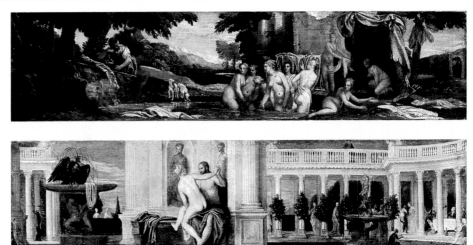

Vernon, Paul
French, active 1874-1882
21.1448
Landscape with a Peasant Woman on a Path
Oil on panel
26.1 x 36.0 cm. (10¼ x 14⅛ in.)
Lower right: P. Vernon.
William Sturgis Bigelow Collection

Veronese, Paolo (Paolo Caliari, called Veronese)
Italian (Venetian), 1528-1588
59.260
Actaeon Watching Diana and her Nymphs Bathing
Oil on canvas
26.0 x 101.0 cm. (10¼ x 39¾ in.)
Gift of Mrs. Edward J. Holmes

Veronese, Paolo (Paolo Caliari, called Veronese)
Italian (Venetian), 1528-1588
60.125
Jupiter and Venus
Oil on canvas
27.1 x 101.0 cm. (10⅝ x 39¾ in.)
Gift of Mrs. Edward J. Holmes

Veronese, Paolo (Paolo Caliari, called Veronese)
Italian (Venetian), 1528-1588
64.2078
Jupiter with Gods and Goddesses on Olympus
Oil on canvas
27.2 x 101.0 cm. (10¾ x 39¾ in.)
Bequest of Mrs. Edward J. Holmes

Veronese, Paolo (Paolo Caliari, called Veronese)
Italian (Venetian), 1528-1588
64.2079
Atalanta Receiving the Boar's Head from Meleager
Oil on canvas
25.6 x 101.0 cm. (10⅛ x 39¾ in.)
Bequest of Mrs. Edward J. Holmes

Veronese, Paolo (Paolo Caliari, called Veronese)
Italian (Venetian), 1528-1588
30.773
The Dead Christ Supported by Angels
Oil on canvas
98.1 x 71.6 cm. (38⅝ x 28⅛ in.)
Maria Antoinette Evans Fund

Veronese, Follower of
02.450
Allegorical Figure of Justice
Oil on canvas
53.1 x 41.9 cm. (20⅞ x 16½ in.)
Falsely signed, lower right Pˢ CAL[...]
Benjamin Pierce Cheney Fund

Veronese, Follower of
64.2083
Allegorical Figure of Faith
Oil on canvas
55.5 x 31.8 cm. (21⅞ x 12½ in.)
Bequest of Mrs. Edward J. Holmes

Veronese, Follower of
64.2084
Allegorical Figure of Charity
Oil on canvas
55.8 x 31.8 cm. (22 x 12½ in.)
Bequest of Mrs. Edward J. Holmes

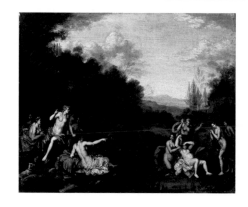

Verspronck, Johannes Cornelisz.
Dutch, 1597-1662
17.3270
Portrait of a Man in Black
Oil on canvas
81.8 x 65.7 cm. (32¼ x 25⅞ in.)
Center right: AEtatis 40 / J. Verspronk 1643:
(Vers in monogram)
Robert Dawson Evans Collection

Verspronck, Johannes Cornelisz.
Dutch, 1597-1662
17.3271
Portrait of a Lady in Black
Oil on canvas
80.4 x 65.2 cm. (31⅝ x 25⅝ in.)
Lower left: AEtatis 37: Verspronck an° 1643: (Vers
in monogram)
Robert Dawson Evans Collection

Vertangen, Daniel
Dutch, 1598-died before 1684
16.66
Diana and Callisto
Oil on panel
31.2 x 40.4 cm. (12¼ x 15⅞ in.)
Lower right: D Vertangen
Gift of Mrs. A. L. Coolidge

Vien, Marie Thérèse
French, 1738-1805

65.2667
Portrait of a Woman
Pastel on parchment
44.0 x 34.5 cm. (17⅜ x 13⅝ in.)
Lower left: TMVien (TMV in monogram) / Rom
le 20 [Aug] / 1757.
The Forsyth Wickes Collection

Vigée-Le Brun, Elisabeth Louise
French, 1755-1842

17.3256
Portrait of a Young Woman
Oil on canvas
82.2 x 70.5 cm. (32⅜ x 27¾ in.)
Robert Dawson Evans Collection

Vigée-Le Brun, Copy after

55.133
Self-Portrait (after a self-portrait in the Hermitage
Museum, Leningrad)
Oil on canvas
76.5 x 63.0 cm. (30⅛ x 24¾ in.)
Gift of Edwin H. Abbot, Jr.

Vincent, George
British, 1796-1831

43.373
Sluice on a Stream
Oil on panel
30.1 x 35.8 cm. (11⅞ x 14⅛ in.)
Center left, on bridge: GV (in monogram) 1827
Gift of the Salada Tea Company

Vinck, Abraham
German (worked in Holland) about 1580-1621

17.3272
Portrait of a Woman Standing beside a Chair
Oil on panel
123.3 x 92.3 cm. (48½ x 36⅜ in.)
Upper left: A[...]RAHAM VINCK
Upper right: AETA · SUAE 60 / AE 1610 [A and E,
all, joined]
Robert Dawson Evans Collection

Vinckboons, David, Copy after
Flemish, 1576-1632

74.3
*Men and Animals Struggling Against Death and
Father Time* (after a painting known through an
engraving by Boetius Bolswert)
Oil on panel
28.2 x 44.0 cm. (11⅛ x 17⅜ in.)
Bequest of Charles Sumner

Visscher, Cornelis, Copy after
Dutch, about 1619-1662
08.164
Pancake Woman (after an engraving)
Oil on panel
42.7 x 33.5 cm. (16¾ x 13⅛ in.)
William Sturgis Bigelow Collection

Vivarini, Bartolomeo (see below)
Italian (Venetian), active 1450-1491
01.4
The Virgin and the Dead Christ (sculpted
wooden relief), *with The Ascension and Saints
Jerome, Gregory, Mary Magdalen, Christopher,
Benedict, Andrew, George, and Scholastica*
Tempera and oil on panel
Overall: 263.0 x 198.0 cm. (103½ x 78 in.)
Central panel, lower register: 95.3 x 43.2 cm.
(37½ x 17 in.)

Side panels, lower register: 95.3 x 30.5 cm.
(37½ x 12 in.), each panel
Central panel, upper register: 59.4 x 42.9 cm.
(23⅜ x 16⅞ in.)
Side panels, upper register: 48.3 x 30.5 cm.
(19 x 12 in.), each panel
On base of sculpture: FACTVM VENETIIS PER
BARTHOLOMEVM / VIVA RINVM DE MVRIAHO
PINXIT 1485
Gift of Quincy Adams Shaw

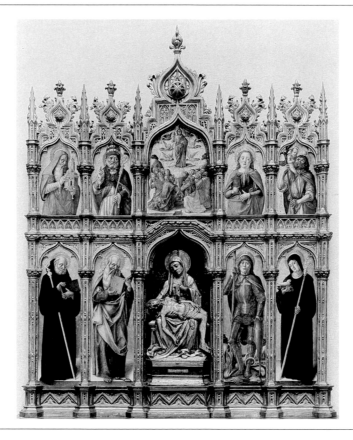

Vlaminck, Maurice de
French, 1876-1958
48.611
Winter Landscape
Oil on canvas
81.4 x 100.8 cm. (32 x 39⅝ in.)
Lower right: Vlaminck
Bequest of John T. Spaulding

Vleughels, Nicolas, Attributed to
French, 1668-1737
65.2651
Head of a Young Woman
Oil on canvas
42.0 x 34.5 cm. (16½ x 13⅝ in.)
The Forsyth Wickes Collection

Vliet, Hendrick Cornelisz. van
Dutch, 1611/12-1675
17.1411
Interior of the Oude Kerk, Delft
Oil on canvas
108.3 x 87.9 cm. (42⅝ x 34⅝ in.)
Denman Waldo Ross Collection

Voet, Jacob Ferdinand, Attributed to
Flemish, 1639-about 1700
35.3
Portrait of a Boy
Oil on canvas
89.8 x 69.7 cm. (35⅜ x 27⅜ in.)
Gift of Miss Mary Thacher

Vollon, Antoine
French, 1833-1900
17.3144
Fruit and a Wineglass
Oil on canvas
25.8 x 39.9 cm. (10⅛ x 15¾ in.)
Lower right: A Vollon
Gift of Mrs. Josiah Bradlee

Vollon, Antoine
French, 1833-1900
19.115
Sitting Room
Oil on canvas
40.1 x 26.6 cm. (15¾ x 10½ in.)
Lower left: A. Vollon
The Henry C. and Martha B. Angell Collection

Vollon, Antoine
French, 1833-1900

37.602
Meadows and Low Hills
Oil on panel
28.0 x 46.2 cm. (11 x 18⅛ in.)
Lower right: A · V
Bequest of Ernest Wadsworth Longfellow

Vonck, Elias, Attributed to
Dutch, 1605-1652

17.1409
Still Life with Dead Heron and Swan
Oil on canvas
127.0 x 109.3 cm. (50 x 43 in.)
Denman Waldo Ross Collection

Vuillard, Edouard
French, 1868-1940

41.107
Roses in a Glass Vase
Oil on canvas
37.2 x 47.0 cm. (14⅝ x 18½ in.)
Lower left: E Vuillard
*Bequest of Mrs. Edward Wheelwright, by exchange,
and Paintings Department Special Fund*

Vuillard, Edouard
French, 1868-1940

48.612
Woman Sewing before a Garden Window
Oil on paper mounted on canvas mounted on
panel
Design: 31.0 x 36.5 cm. (12¼ x 14⅜ in.)
Lower right: EVuillard 95
Bequest of John T. Spaulding

Wagemaker, Jaap
Dutch, 1906-

64.322
Gray Tension
Oil and acrylic paints with sand and burlap on canvas
94.1 x 114.9 cm. (37 x 45⅛ in.)
Lower right: Wagemaker '61
Gift of Mr. and Mrs. Samuel Glaser

Walker, Ethel
British, 1861-1951

47.1056
Portrait of a Young Woman (The Debutante)
Oil on canvas
60.8 x 50.8 cm. (23⅞ x 20 in.)
Gift of the American British Art Center

Walker, William
British, active 1782-1808

77.64
Washington Allston
Oil on canvas
76.2 x 63.7 cm. (30 x 25⅛ in.)
Bequest of John E. Allston

Watteau, Jean Antoine
French, 1684-1721

23.573
View through the Trees in the Park of Pierre Crozat (La Perspective)
Oil on canvas
46.7 x 55.3 cm. (18⅜ x 21¾ in.)
Maria Antoinette Evans Fund

Watts, Frederick Waters
British, 1800-1862

23.475
Ploughing
Oil on canvas
75.7 x 62.8 cm. (29¾ x 24¾ in.)
Bequest of Ernest Wadsworth Longfellow

Webb, Charles Meer
British (worked in Germany), 1830-1895

15.818
Arrest of a Poacher
Oil on canvas
72.8 x 105.0 cm. (28⅝ x 41⅜ in.)
Lower left: [...] Webb 187[4?]
Bequest of Caroline L. W. French

Webbe, William J.
British, active 1853-1878

1981.441
Rabbit amid Ferns and Flowering Plants
Oil on canvas
35.6 x 35.6 cm. (14 x 14 in.)
Lower left: W. J. WEBBE 1855
Gift of Mrs. Samuel Parkman Oliver

Weele, Herman Johannes van der
Dutch, 1852-1930

23.566
Shepherd and Sheep by a Stream
Oil on canvas
66.5 x 90.0 cm. (26⅛ x 35⅜ in.)
Lower left: HJvdWeele
Bequest of Ernest Wadsworth Longfellow

Weenix, Jan
Dutch, 1642-1719

41.744
Dead Birds and Hunting Equipment in a Landscape
Oil on canvas
97.8 x 83.7 cm. (38½ x 33 in.)
Lower right: JW [joined]
Gift of Mrs. Roger Merriman

Weiss, José
French, 1859-after 1919

23.468
Banks of a River
Oil on panel
16.8 x 27.2 cm. (6⅝ x 10¾ in.)
Lower right: Jose Weiss
Bequest of Ernest Wadsworth Longfellow

Weretshchagin, Wassili Wassilevitch
Russian, 1842-1904

92.2628
Pearl Mosque, Delhi
Oil on canvas
395.0 x 500.0 cm. (155½ x 196⅞ in.)
Gift by Contribution

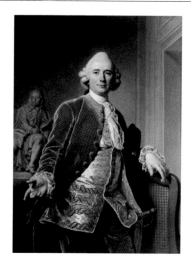

Weretshchagin, Wassili Wassilevitch
Russian, 1842-1904

25.229
Monks at the Door of a Mosque
Oil on panel
61.0 x 49.3 cm. (24 x 19⅜ in.)
Lower right: [cyrillic monogram]
Bequest of Mrs. T. O. Richardson

Wertinger, Hans von (called Hans Schwab)
German, about 1470-1533

74.2
Portrait of a Man Holding a Rosary
Oil on panel
43.6 x 32.3 cm. (17⅛ x 12¾ in.)
Bequest of Charles Sumner

Wertmuller, Adolf Ulrik
Swedish, 1751-1811

63.1082
Jean Jacques Caffieri
Oil on canvas
129.0 x 96.0 cm. (50¾ x 37¾ in.)
Lower left, on table: A Wertmüller / 1784
Ernest Wadsworth Longfellow Fund

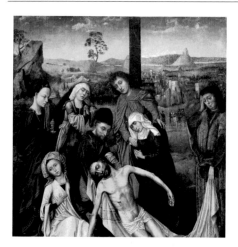

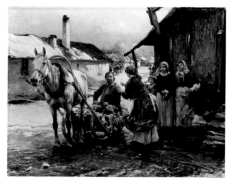

Weyden, Goswin van der
Flemish, about 1465-after 1538

29.725
The Deposition of Christ
Oil on panel
81.0 x 84.5 cm. (31⅞ x 33¼ in.)
Gift of J. Homer Price

Wicht, John van
German (worked in United States), 1888-

61.200
Reveries
Oil on canvas
122.0 x 152.0 cm. (48 x 59⅞ in.)
Lower left: von Wicht
Tompkins Collection

Wierusz-Kowalski, Alfred von
Polish, 1849-1915

24.227
In a Polish Village
Oil on canvas
36.5 x 49.0 cm. (14⅜ x 19¼ in.)
Lower right: A Wierusz-Kowalski
Gift of Robert Jordan from the Collection of Eben D. Jordan

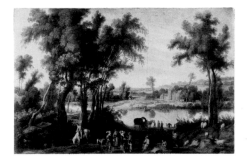

Wild, H.
(unknown)
13.462
Ischl, Austria
Oil on academy board
38.0 x 23.0 cm. (15 x 9 in.)
Lower right: H. WILD / Ishyl / '74
Verso: ISCHL. / AUG. 73.
Bequest of Mrs. Edward Wheelwright

Wildens, Jan
Flemish, 1586-1653
73.9
Landscape with Gentlefolk and Gipsys
Oil on canvas
129.8 x 203.3 cm. (51¼ x 80 in.)
Falsely signed, lower left: A. Kierincks F
Gift of the Heirs of J. H. Blanchard

Wilson, Richard
British, 1713-1782
94.171
Lake Avernus
Oil on canvas
40.5 x 53.0 cm. (16 x 20⅞ in.)
Turner Sargent Collection

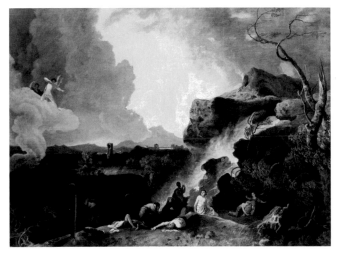

Wilson, Richard
British, 1713-1782
03.606
Tivoli and the Roman Campagna with a Man and a Woman by a Roadside Shrine
Oil on canvas
99 x 125.5 cm. (39 x 49⅜ in.)
Bequest of Susan Cornelia Warren

Wilson, Richard
British, 1713-1782
17.586
Apollo Destroying the Children of Niobe
Oil on canvas
127.2 x 178.0 cm. (50 x 70⅛ in.)
Denman Waldo Ross Collection

Wilson, Richard
British, 1713-1782
51.449
River Landscape with a Boy Fishing (On the Arno)
Oil on canvas
102.0 x 127.6 cm. (40⅛ x 50¼ in.)
Bequest of William K. Richardson

Wilson, Richard
British, 1713-1782
1983.36
Portrait of a British Naval Captain
Oil on canvas
127.0 x 101.6 cm. (50 x 40 in.)
Lower left, on cannon: R Wilson f. / [...]
Bequest of Henry Lee Shattuck in Memory of the late Morris Gray

Wilson, Richard, Imitator of
74.13
River Landscape with Fishermen
Oil on canvas
78.0 x 98.2 cm. (30¾ x 38⅝ in.)
Bequest of Charles Sumner

Wilson, Richard [of Birmingham]
British, 1751/2-1807
41.10
Chief Justice Peter Oliver
Oil on canvas
75.9 x 52.2 cm. (29⅞ x 20½ in.)
Center left, on letter: Miss Betsy Watson / Plimouth
Lower right, on base of column: R. Wilson Pix.
Gift of Mrs. W. Austin Wadsworth

Wint, Peter de
see
De Wint, Peter

Witte, Emanuel de
Dutch, 1617-1692
47.1314
Kitchen Interior
Oil on canvas mounted on panel
48.5 x 41.5 cm. (19⅛ x 16⅜ in.)
Center right, on mantelpiece: E. de Witte / 166[...]
Seth K. Sweetser Fund

Witte, Emanuel de
Dutch, 1617-1692

49.7
Interior of the Nieuwe Kerk, Amsterdam
Oil on canvas
127.5 x 116.9 cm. (50¼ x 46 in.)
Lower right: E • De • Witte / A° 1677
M. Theresa B. Hopkins Fund

Witte, Pieter de (called Pietro Candido)
Flemish (worked in Florence and Munich), about
1548-1628

1980.72
The Mystical Marriage of Saint Catherine
Oil on canvas
226.0 x 159.1 cm. (89 x 62⅝ in.)
Henry H. and Zoe Oliver Sherman Fund

Wohlgemut, Michael, Workshop of
German, 1434-1519

03.610
Death of the Virgin, with an Epitaph
Oil on panel
205.5 x 111.5 cm. (80⅞ x 43⅞ in.)
Lower center: Nach Christi geburt 1479, am /
Freitag vor S:Walburgen tag, / verschid die Erbar
Frau Hett, / wig Volkamerin der Gott gne, / dig
und barmherzig sey.
*Gift of the children of Mrs. Samuel Dennis Warren in
Memory of their mother*

Wolfsen, Aleijda, Attributed to
Dutch, 1648-after 1690

94.170
Duet
Oil on canvas
65.8 x 50.8 cm. (25⅞ x 20 in.)
Falsely signed, lower left: G. N[...]sch[...] / 1680
Turner Sargent Collection

Wou, Claes Claesz., Attributed to
Dutch, about 1592-1665

27.223
Storm at Sea
Oil on canvas
42.0 x 56.4 cm. (16½ x 22¼ in.)
William Sturgis Bigelow Collection

Wouwerman, Philips
Dutch, 1619-1668

1981.78
Knight Vanquishing Time, Death, and Monstrous Demons
Oil on panel
65.7 x 48.0 cm. (25⅞ x 18⅞ in.)
Lower left: PHILS:W / 1662 (PHILS in monogram)
Upper right, on crown: AVGVSTA PER / ANGVSTA

Center, on shield: PER VARIOS CASUS / ET TOT DISCRIMINA / RERVM / TENDITUR AD / SUPEROS
Charles H. Bayley Fund, and Picture and Painting Fund

Wouwerman, Philips, Style of
Res. 14.29
Horse Fair at the Edge of a Village
Oil on panel
46.5 x 63.3 cm. (18¼ x 24⅞ in.)
Signed or dated illegibly at lower center.
Gift of Mrs. L. K. Schuyler

Wright, Joseph (called Wright of Derby)
British, 1734-1797

51.1528
Mrs. Francis Boott
Oil on canvas
77.2 x 64.0 cm. (30⅜ x 25¼ in.)
Gift of Mrs. Guy Lowell

Wtewael, Joachim Anthoniesz.
Dutch, 1556-1638

57.119
Actaeon Watching Diana and Her Nymphs Bathing
Oil on panel
56.4 x 75.9 cm. (22¼ x 29⅞ in.)
Lower right, on bridge: Jo Wte Wael fecit An° 1612
[J and o in monogram]
Abbott Lawrence Fund

Wydenbruck, Nora
British, 1894-

41.858
Ghosts of Georgian London *(Clareville Grove,*
Kensington, after the Disaster)
Pastel on paper
25.5 x 36.0 cm. (10 x 14⅛ in.)
Lower left: Wydenbruck
Gift of Mrs. Richard M. Saltonstall

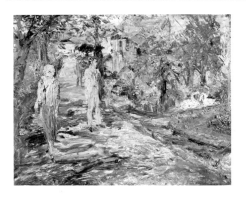

Yeats, Jack Butler
Irish, 1871-1957

50.3414
High Spring Tide, Cork
Oil on canvas
91.3 x 122.0 cm. (36 x 48 in.)
Upper right: JACK B YEATS
Gift of Henry L. Shattuck

Yeats, Jack Butler
Irish, 1871-1957

1971.156
Beautiful City of Sligo
Oil on canvas
51.0 x 67.8 cm. (20⅛ x 26¾ in.)
Lower left: JACK B YEATS
Bequest of Henry L. Shattuck

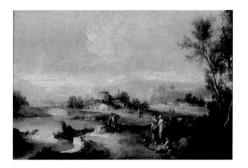

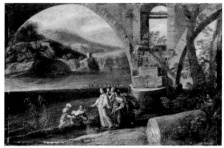

Zais, Giuseppe
Italian (Venetian), 1709-1784
21.1461
River Landscape with Figures
Oil on canvas
37.9 x 57.1 cm. (14⅞ x 22½ in.)
William Sturgis Bigelow Collection

Zais, Giuseppe, Attributed to
Italian (Venetian), 1709-1784
Res. 24.18
The Finding of Moses
Oil on canvas
44.6 x 72.2 cm. (17½ x 28⅜ in.)
Gift of Jane Ireson

Zais, Follower of
43.42
Peasants and Animals beside a Ruined Fountain
Oil on canvas
54.0 x 71.0 cm. (21¼ x 28 in.)
Bequest of Sarah Elizabeth Lawton in Memory of her husband, Mark A. Lawton

Zamacois y Zabala, Eduardo
Spanish, 1842-1871
Res. 29.29
Man in Sixteenth-century Costume in a Garden
Oil on panel
24.0 x 18.5 cm. (9½ x 7¼ in.)
Stamped, on reverse: VENTE / ZAMACOIS
Gift of the estate of Henry P. Kidder

Zaortiga, Bonanat
Spanish (Aragonese), active about 1420-1450
52.1523 a,b,c
Virgin and Child Enthroned with Saints Valerius and Vincent and *Scenes from the Life of Saint Vincent*
Tempera on panel
Overall: 198.0 x 219.0 cm. (78 x 86¼ in.)
Central design (ends at Virgin's halo): 145.5 x 80.0 cm. (57¼ x 31½ in.)

Left design: 163.4 x 57.8 cm. (64⅜ x 22¾ in.)
Right design: 161.8 x 57.7 cm. (63¾ x 22¾ in.)
Bequest of Keith McLeod

Zeitblom, Bartholome, Workshop of
German, 1455/60-1518/22

50.2720
Adoration of the Magi
Oil on panel with fabric ground
158.5 x 103.7 cm. (62⅜ x 40⅞ in.)
Gift of Mr. and Mrs. Frederick Starr

Ziem, Felix François Georges Philibert
French, 1821-1911

99.309
Venetian Sailboats
Oil on canvas
21.5 x 32.5 cm. (8½ x 12¾ in.)
Lower right: Ziem.
Bequest of Lucy Ellis

Ziem, Felix François Georges Philibert
French, 1821-1911

23.481
Bacino di San Marco, Venice
Oil on canvas
48.8 x 66.2 cm. (19¼ x 26 in.)
Lower left: Ziem.
Bequest of Ernest Wadsworth Longfellow

Zoppo, Paolo
Italian (Brescian), active 1505-1530

45.5
Christ before Caiaphas
Fresco transferred to canvas
211.5 x 180.3 cm. (83¼ x 71 in.)
Charles Potter Kling Fund

Zoppo, Paolo
Italian (Brescian), active 1505-1530

45.6
Judas Betraying Christ
Fresco transferred to canvas
211.5 x 260.3 cm. (83¼ x 102½ in.)
Charles Potter Kling Fund

Zoppo, Paolo
Italian (Brescian), active 1505-1530

45.7
Christ before Pilate
Fresco transferred to canvas
207.4 x 165.4 cm. (81⅝ x 65¼ in.)
Charles Potter Kling Fund

Zoppo, Paolo
Italian (Brescian), active 1505-1530

45.8
Crucifixion of a Thief
Fresco transferred to canvas
207.0 x 125.5 cm. (81½ x 49⅜ in.)
Charles Potter Kling Fund

Zoppo, Paolo
Italian (Brescian), active 1505-1530

45.768
Christ before Herod
Fresco transferred to canvas
211.5 x 180.2 cm. (83¼ x 71 in.)
Charles Potter Kling Fund

Zorn, Anders Leonard
Swedish, 1860-1920

28.513
Martha Dana (later Mrs. William Mercer)
Oil on canvas
68.5 x 51.0 cm. (27 x 20 in.)
Upper right: Zorn 99
Gift of Mrs. William R. Mercer

Zorn, Anders Leonard
Swedish, 1860-1920

59.66
George Peabody Gardner
Oil on canvas
182.9 x 106.7 cm. (72 x 42 in.)
Upper right: Zorn 99
Gift of G. Peabody Gardner

Zuloaga y Zabaleta, Ignacio
Spanish, 1870-1945

17.1598
My Uncle Daniel and his Family
Oil on canvas
205.0 x 289.5 cm. (80¾ x 114 in.)
Lower right: I Zuloaga
Caroline Louisa Williams French Fund

Zuloaga y Zabaleta, Ignacio
Spanish, 1870-1945

42.571
Castilian Landscape
Oil on canvas
57.5 x 61.3 cm. (22⅝ x 24⅛ in.)
Lower right: I. Zuloaga
Gift of George R. Fearing, Jr.

Zurbarán, Francisco de
Spanish, 1598-1664

38.1617
Saint Francis
Oil on canvas
207.0 x 106.7 cm. (81½ x 42 in.)
Herbert James Pratt Fund

Zurbarán, Francisco de
Spanish, 1598-1664

22.642
Saint Cyril of Constantinople
Oil on canvas
92.3 x 32.4 cm. (36⅜ x 12¾ in.)
On ledge beneath saint: S. CIRILO
Zoe Oliver Sherman Collection

Zurbarán, Francisco de
Spanish, 1598-1664

23.554
Saint Peter Thomas
Oil on canvas
92.3 x 32.2 cm. (36⅜ x 12⅝ in.)
On ledge beneath saint: S.Pº THOMAS
Zoe Oliver Sherman Collection

Zurbarán, Copy after

26.775
Saint Francis (after a painting in the National
Gallery, London)
Oil on canvas
46.3 x 38.6 cm. (18¼ x 15¼ in.)
William Sturgis Bigelow Collection

Index
of
Changed
Attributions

This index covers changes made in attributions previously published by the Museum in the *Summary Catalogue* of 1955 and includes only changes in attribution resulting in a substantive shift from one artist or school to another artist or school. Adjustments of the degree of certainty of attribution under an unchanged artist's name have not been listed, nor have changes in the attributions of paintings acquired since 1955 or of paintings excluded from that catalogue.

Former Attribution	Acc. No.	New Attribution
Albani	Res 10.17	Italian (Bolognese), 17th c.
Albani	28.856	Cignani (after)
Andalusian School	44.756	Master of the Schretlen Circumcision (attributed)
Andrea di Giusto (attributed)	03.563	Italian (Tuscan), 15th c.
Angelico, Fra (follower)	22.635	Master of the Sherman Predella
Anglo-Flemish School	44.621	Segar (attributed)
Anglo-Norwegian School	52.375	Norwegian, 14th c.
Aragonese School	52.1523a,b,c	Zaortiga
Barbieri	44.585	Italian (Neapolitan), 17th c.
Bartolo di Fredi	83.175a,b,c	Tegliacci and Workshop
Bastiani (attributed)	26.141	Jacopo da Valenza
Bayeu (attributed)	03.622	Spanish, 18th c.
Belgian School (?)	Res 14.24	Antigna (after)
Bellini, Giovanni (school)	23.502	Boccaccino (attributed)
Bolognese School	45.515	Gaddi
Bonington	46.58	British, 19th c.
Bordone (school)	74.24	Bonifazio di Pitati
Both	17.1420	de Heusch, W.
de Bray (attributed)	23.529	Dutch, 17th c.
British School	22.8	Hoppner (after)
British School	22.10	Hamilton (attributed)
British School	23.539	Hudson (follower)
Bruegel, P. (imitator)	20.787	Flemish, 17th c. (style)
Bruegel, P., the Elder (attributed)	46.1143	Herri met de Bles
Caravaggio	50.651	Italian, 17th c.
Carpeaux	40.18	French, 19th c.
Carracci, Agostino (attributed)	48.55	Passerotti
Chodowiecki (attributed)	Res 27.117	Leclerc
Coecke van Aelst (studio)	15.290	Lombard (after)
Cologne School	17.3267	Flemish, 16th c.
Constable, John	46.398	Constable, Lionel Bicknell
Corot	41.120	Benouville
Cotman (attributed)	1331.12	British, 19th c.
Cuyp (attributed)	74.10	van der Merck
David (attributed)	77.151	French, 18th c.
Domenichino	26.167	Grimaldi
Domenichino (after)	88.342	Conca
Dou	48.1165	Pot
Drouais, François	41.528	French, 18th c.
Dutch School	74.6	van de Velde, P.
Dutch School	74.11	Belgian, 18th/19th c.
Dutch School	94.168	Bloemaert
Dutch School	16.389	Flemish, 17th c.
Dutch School	17.1409	Vonck (attributed)
Dutch School	Res 19.129	van Brekelenkam (after)
Dutch School	Res 21.90	de Hooch, H. (attributed)
Dutch School	52.109	ten Oever (attributed)
van Dyck (imitator)	94.172	Rubens (imitator)
Edmonstone (attributed)	17.3255	Geddes (attributed)
Emilia, School of	42.422	Berrettini (attributed)
Flemish School	15.291	van Noort (after)
Flemish School	17.3222	Elle (attributed)

Former Attribution	Acc. No.	New Attribution
Flemish School	Res 27.152	Isenbrant (follower)
Flemish School	28.859	van Bredael (attributed)
Florentine School	90.165	Pontormo (after)
Florentine School	03.564	Pseudo Ambrogio di Baldese
Florentine School	03.567	Ghirlandaio (workshop)
Florentine School	03.568	Master of the Holden Tondo (attributed)
Florentine School	06.2441a	Apollonio di Giovanni and Marco del Buono
Florentine School	18.319	Apollonio di Giovanni and Marco del Buono (attributed)
Florentine School	22.5	Ghirlandaio (workshop)
Florentine School	23.252	Apollonio di Giovanni and Marco del Buono
Florentine School	25.103	Andrea del Sarto (after)
Florentine School	Res 27.118	Italian (Venetian), 17th c.
Florentine School	46.1429	Mainardi
Florentine School	51.1922	French, 16th c.
Fracanzano (attributed)	Res 21.81	Italian (Neapolitan), 17th c.
Franco-Flemish School	28.821	Corneille de la Haye (workshop)
Franco-Flemish School	34.541	de Reyn (attributed)
Franco-Flemish School	35.3	Voet (attributed)
French School	87.409	Ledoux (attributed)
French School	17.3220	Gobert
French School	Res 21.79	Amigoni (follower)
French School	Res 21.80	Amigoni (follower)
French School	21.137	Corneille de La Haye
French School	24.264	Corneille de La Haye
French School	24.342	Fabre
French School	27.449	Girodet (follower)
French School	39.647	Blin de Fontenay (style)
French School	39.648	Monnoyer (after)
Furini	Res 23.249	Pignoni (attributed)
Gainsborough	11.1374	British, 19th c.
Géricault	91.26	French, 19th c.
German School	74.16	Rigaud (after)
German School (?)	07.759	Austrian (?), 18th c.
Giordano	99.315	Ribera (follower)
Girolamo del Pacchia	94.180	Piero di Cosimo
Gosselin	03.602	Dupré, Jules
Greek School	23.161	Armenian or Turkish, 1806
Greek School	Res 25.15	Serbian or Bulgarian, 19th c.
Gregorio di Cecco	22.403	Giuliano di Simone
Hals, Frans	01.7445	Hals, Jan
Heda	54.1606	den Uyl
Holbein	35.1751	British, 16th c.
Italian School	74.7	Fieravino (style)
Italian School	74.8	Fieravino (style)
Italian School	74.25	Keil (follower)
Italian School	12.378	Correggio (after)
Italian School	37.108	Bartolomeo Corradini
Italian School	47.118	Paolini
Italian School (attributed)	Res 21.89	Gellée (imitator)
Italo-Dutch School	Res 17.104	Colonia
Italo-Flemish School	74.22	Italian (Northern) 16th c.

Former Attribution	Acc. No.	New Attribution
van Kessel	52.1831	Dutch, 17th c.
Key (attributed)	35.1482	French, 16th c.
Knapton	35.1227	British, 18th c.
Kneller (studio)	35.1229	Dahl and Workshop
Longhi, Pietro (attributed)	17.588	Italian (Northern), 18th c.
Lucas y Padilla (attributed)	22.11	Spanish, 19th c.
Menendez	39.42	Italian (Neapolitan), 17th c.
Michallon	43.130	Bidauld
Millet, Francisque (attributed)	52.393	Dughet
Mocetto	41.654	Bellini, Giovanni (after)
Mola	21.751	Italian (Roman), 17th c.
Mola	21.752	Italian (Roman), 17th c.
Murant (attributed)	89.502	van Ruisdael (follower)
Neapolitan School	94.181	Stanzione (workshop)
Netscher	94.170	Wolfsen (attributed)
Niccolò da Voltri (attributed)	85.2	Flemish (?), 15th c.
Nollekens	53.2856	Devis
Nollekens	53.2857	Devis
Nollekens	53.2858	Devis
Nollekens	53.2859	Devis
North European School	Res 21.82	French (?), 18th c.
North European School	29.1040	French, 19th c.
Opie	97.444	Owen
Parma, School of	17.3226	Puligo (attributed), see Andrea del Sarto, copy after
Perugino (school)	47.233	Italian (Umbrian), 15th c.
Piazzetta (attributed)	38.1733	Maggiotto
Poussin, Nicolas (school)	20.1630	di Leone
Previtali (attributed)	22.639	Vecellio (attributed)
Raphael (after)	94.183	Italian, 18th c.
Rembrandt (studio)	17.3231	Bol (imitator)
Rembrandt (school)	09.184	Ovens
Reynolds (after)	19.112	British, 19th c.
Rigaud	37.1211	Van Loo
Rimini School	40.91	Master of the Urbino Coronation
Romagna, School of	25.227	Costa
Roman School	94.173	Gennari
Roman School	Res 21.87	Tavella (attributed)
Roman School	22.637	French, 18th or 19th c.
Rombouts	17.3243	van Ruisdael (after)
Rosa, Salvator	51.2775	Italian, 17th/18th c.
Rosa, Salvator (school)	Res 15.6	Italian, 18th c.
Ruoppolo (attributed)	90.82	Italian (Neapolitan), 17th c.
Ryckaert (style)	Res 15.3	Teniers the Younger (imitator)
Santerre (attributed)	85.255	French, 17th c.
Sassoferrato (school)	90.76	Corvi
Schalcken	20.853	Italian, 17th or 18th c.
Schidone (attributed)	22.640	Flemish, 16th c.
Segna di Bonaventura	15.952	Ugolino di Nerio
Sienese School	Res 19.44	Italian (Florentine), 17th c.
Sienese School	16.117	Martini (follower)
Solario (attributed)	21.2287	Luini
de Soria	24.338	Master of Belmonte

Former Attribution	Acc. No.	New Attribution
Tiepolo (attributed)	44.833	Italian (Venetian), 18th c.
Turner (imitator)	Res 42.26	British, 19th c.
Uccello (follower of)	15.910	Apollonio di Giovanni and Marco del Buono
Unknown	20.854	British, 19th c.
Valencia, School of	10.36	Master of Bonastre
Valencia, School of	29.1129	Peréz (attributed)
de Valenciennes	47.236	French, 19th c.
Velázquez (attributed)	27.188	Italian (Venetian), 16th c.
Venetian School	84.282	Tintoretto (Jacopo Robusti)
Venetian School	Res 10.22	Italian (Roman), 18th c.
Venetian School	17.1080	Carpaccio (attributed)
Venetian School	Res 22.304	Heiss
Venetian School	23.459	Giordano
Venetian School	26.166	Italian (Northern), 15th c.
Venetian School (?)	38.1839	German (?), 15th c.
Venetian School	43.43	Italian (Neapolitan), 18th/19th c.
Venetian School	50.3412	Belliniani (attributed)
Veneto-Byzantine School	37.410	Italian (Apulian), 14th c.
Veronese (school)	Res 27.153	Lemoine (after)
Watteau (imitator)	19.1369	Oudry (after)
Weyden, Rogier van der (follower)	29.725	van der Weyden, Goswin
Wheatley (attributed)	31.975	British, 18th c.
Wilson (school)	Res 24.24	Barret
Zanchi (attributed)	Res 23.136	Giordano (attributed)
Zuccarelli (attributed)	Res 24.18	Zais (attributed)

Index
of
Titles

Index
of
Accession
Numbers

57.3	Metzinger	62.283	Giacometti	65.2666	Russell
57.4	van Ruisdael	62.985	Lastman	65.2667	Vien; also entered as French,
57.66	Pannini	62.1129	Soreau		18th c.
57.119	Wtewael	63.267	Susenier (attributed)	66.11	Bruyn
57.153	Hélion	63.278	Maufra	66.12	Bruyn
57.155	Monticelli	63.660	Flemish, 15th c.	66.23	Albers
57.182	de Gelder	63.1082	von Wertmuller	66.209	Arikha
57.199	Maes (follower)	63.1259	Italian (Florentine), 16th c.	66.260	Italian, 16th c.
57.385	de Staël	63.1628	Stoskopf (after, by Nichon)	66.266	Titian (after, by Teniers, the
57.523	Braque	63.2666	Jorn		Younger)
57.702	Courbet	63.2769	Heath	66.304	Manet
57.744	Munch	64.131	Troyon	66.854	Rottenhammer (style)
58.24	Beckmann, M.	64.322	Wagemaker	66.941	Sissa
58.45	Tissot	64.456	British, 18th/19th c.	66.1052	Millet
58.328	Fraser	64.606	de Moor (attributed)	66.1054	Hals, F.
58.356	van Gogh	64.709	Picasso	66.1056	Michel
58.357	Gijsbrechts	64.1602	Hogarth	67.647	Frumi
58.527	Rosso Fiorentino	64.1905	Boudin	67.671	Springer
58.721	Fraser	64.1947	Baschenis	67.672	Grolleron
58.975	ter Brugghen	64.2054	Nuvolo	67.752	Goltzius
58.976	Picasso	64.2077	Roselli, C.	67.769	Savery
58.1197	Le Nain, M. (attributed)	64.2078	Veronese	67.906	Boudin
58.1425	Murillo (workshop)	64.2079	Veronese	67.968	Pittoni
59.66	Zorn	64.2082	Iacovleff	67.984	Beckmann, M.
59.193	Italian (Roman), 17th c.	64.2083	Veronese	67.1161	Gris
59.260	Veronese	64.2084	Veronese	68.22	"Peregrinus" (attributed)
59.301	Munch	64.2085	Italian (Northern), 15th c.	68.23	Bourdon
59.341	Cox	64.2087	Grolleron	68.24	Bourdon
59.659	de Momper, J.	64.2088	Scupula	68.75	Seurat (imitator)
59.779	Diaz	64.2205	Gauguin	68.113	Bissier
59.1003	Hals, F. (imitator)	64.2206	Redon	68.567	Le Sidaner
59.1004	Basaldella	65.434	Alma-Tadema (attributed)	68.737	Nattier (after)
60.124	Ensor	65.435	Bartolomeo Veneto (workshop)	68.738	French, 18th c.
60.125	Veronese	65.436	Frère	68.764	Le Sueur
60.154	Lotto	65.503	Beckmann, H.	68.786	Antonio di Arcangelo
60.536	Italian (Sienese), 15th c.	65.615	Pynacker	68.787	Flemish, 16th c.
60.792	Fantin-Latour	65.1320	Italian (Florentine), 16th c.	69.49	Degas
60.960	Cornelis van Haarlem (after)	65.1683b	Gaudier-Brzeska	69.66	Streitt
60.961	Nicholson	65.1712	Italian (Roman), 18th c.	69.958	Crespi
60.982	Avercamp	65.2636	Boze	69.1059	Simone del Tintore
60.1157	Martin	65.2637	Boucher	69.1123	Manet
60.1458	Manet (follower)	65.2638	Boudin	69.1125	van Beest
60.1475	Tintoretto, Domenico	65.2639	French, 18th c.	69.1130	Tisato
61.165	Bernard	65.2640	Drouais, F. (attributed)	1970.76	Stevens (attributed)
61.176	Netscher	65.2641	Ducreux (follower)	1970.77	Master of the Saint Barbara
61.177	British, 18th c.	65.2642	French, 16th c.		Altar
61.198	Appel	65.2643	Duplessis	1970.251	Baertling
61.200	van Wicht	65.2644	Fragonard	1970.253	Monet
61.241	Constable, J.	65.2645	Gérard	1970.348	Cranach, the Elder
61.391	van Dyck (studio)	65.2646	Ladvocat	1970.372	Fromentin
61.392	Romney	65.2647	Lancret	1970.475	Picasso
61.393	Renoir	65.2648	Lancret	1970.602	Italian (Venetian), 18th c.
61.394	Martin (after)	65.2649	Lancret	1970.603	Italian (Roman), 18th c.
61.660	ter Borch	65.2650	German, 18th c.	1970.604	Italian, 17th c.
61.661	Mera	65.2651	Vleughels (attributed)	1971.156	Yeats
61.662	Morandi	65.2652	Perronneau	1971.425	Boudin
61.957	Boccaccino	65.2653	Robert	1972.83	Strozzi
61.958	Boucher	65.2654	Schall	1972.230	van Marcke (imitator)
61.959	Monet	65.2655	Carriera	1972.231	Morel
61.960	Renoir	65.2656	British, 18th c.	1972.950	Cézanne
61.961	Reynolds	65.2657	French, 18th c.	1972.979	Købke
61.962	Romney	65.2658	Frédou	1972.980	Thaulow
61.1093	Kaiser	65.2659	Gardner	1972.1084	Renoir
61.1094	Nuvolo	65.2660	Hoin	1973.89	Brandl
61.1138	Kokoschka	65.2661	de La Tour	1973.196	Kokoschka
61.1200	Tiepolo	65.2662	Lenoir	1973.447	Maes
61.1242	Jongkind	65.2663	French, 18th c.	1973.513	Renoir
62.172	van der Hamen	65.2664	Nattier (attributed)	1974.325	Monet
62.265	Farrer	65.2665	Perronneau	1974.565	Boudin